Theater *sans* *frontières*

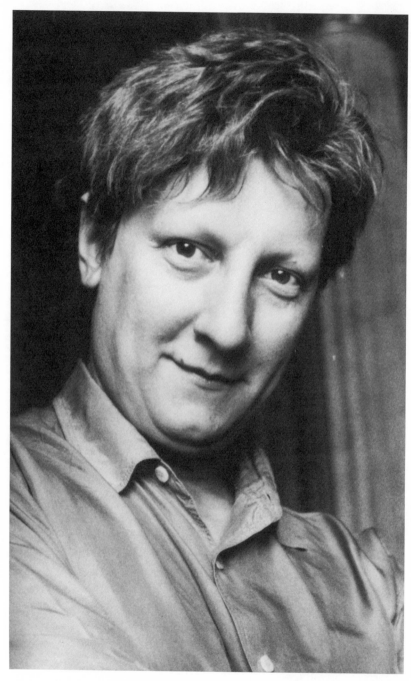

Robert Lepage. Reprinted with permission from *The Globe and Mail*.

Theater *sans frontières*

Essays on
the Dramatic
Universe of
Robert Lepage

Edited by Joseph I. Donohoe Jr. and Jane M. Koustas

Michigan State University Press
East Lansing
2000

∞The paper used in this publication meets the minimum requirements of
ANSI/NISO Z39.48–1992 (R 1997) (Permanence of Paper).

Michigan State University Press
East Lansing, Michigan 48823-5202
Printed and bound in the United States of America.
07 06 05 04 03 02 01 00 1 2 3 4 5 6 7 8 9 10
LIBRARY OF CONGRESS CATALOGING-IN-PUBLICATION DATA

Theater sans frontiéres : essays on the dramatic universe of Robert Lepage / edited
by Joseph I. Donohoe and Jane M. Koustas.
 p. cm.
Includes bibliographical references.
 ISBN 0-87013-568-6
1. Lepage, Robert—Criticism and interpretation. I. Koustas, Jane M.
PN2308.L46 T48 2000
792'.0233'092—dc21

 00-011428

Cover and text design by Michael J. Brooks

Cover photo of Robert Lepage is reprinted by permission of
The Montreal Gazette.

Visit Michigan State University Press on the World Wide Web at:
www.msu.edu/unit/msupress

For Lillemor and Bitti,
Alexandros and Andreas

Contents

Foreword

WITH THE RETIREMENT from the stage of Ingmar Bergman, the young Quebecer, Robert Lepage, "among the most innovative [metteur en scène] of our time" (Olivier Schmitt, Le Monde, 7 June 1997, 26), has become, along with Peter Brook and Pete Wilson, one of the most admired stage directors in the world. Lepage has staged Shakespeare at the National Theater in London, Strindberg at the Dramaten in Stockholm, opera in New York City and Paris, and has directed his own and other playwrights' work in virtually every major theatrical venue in the world including London, Paris, Berlin, Stockholm, Edinburgh, Dublin, New York, Chicago, and Tokyo.

In recent years, Lepage's efforts have typically been distributed about the globe and among various genres: a 1997 production of Elsinore at the Dublin Theater Festival; a performance of The Seven Streams of the River Ota at the Brooklyn Academy of Music's "Next Wave Festival" in New York at the end of the same year; and, in 1998, the Geometry of Miracles, which after its debut in Toronto embarked on a world tour. Nô, his third film, was released in autumn 1998 and a fourth film, Possible Worlds was screened at the Toronto Fim festival in the fall of 2000. Productions for the new millenium include the current Zulu Time, more a spectacle or a "show" as opposed to a traditional play and a one-man show, The Far Side of the Moon, starring Robert Lepage.

In response to the remarkable resonance of his work as actor, stage director, and playwright in the theater worldwide, a number of academics and theater people from England, Scotland, France, Sweden,

French and English Canada, and the United States have come together under the leadership of Professors Donohoe and Koustas to produce the first volume of critical essays in English to attempt the analysis of Robert Lepage's brilliant new theatrical idiom.

As happens with an international collection on this scale, the editors have benefitted from the good-humored support and assistance of scores of people scattered about the globe—not least of which our contributing authors—and to each and every one of them we would like to convey our sincere appreciation. In addition, we owe special thanks to Françoise Rochette of RLI and to Diane Garant of Ex Machina, for making available to us information and photographs from the archives at Lepage Headquarters in Quebec City. We would also like to recognize in a very special way the contributions of our colleagues at Brock University and Michigan State University, in particular Victoria Hoelzer-Maddox for technical assistance in the preparation of the manuscript for press and Professor Emeritus Jean Nicholas for a rigorous reading of the completed manuscript. Finally, we are happy to express our gratitude to the governments of Canada and Quebec, without whose generous support the present project would have been immeasurably more difficult to realize.

Introduction

IN A REVIEW of an early performance of Lepage's *Circulations,* Matthew Fraser recognized not only the remarkable talent of its creator but also his potential for transforming Canadian theater: extraordinary, innovative, different; Lepage's theater, Fraser observed, has "changed the way in which Canadians perceive and do theater" (*Globe and Mail,* 1 March 1985). Ten years later, J. Bemrose dubbed Lepage "Canada's greatest dramatic innovator" (*Maclean's,* 20 November 1995). Unlike the work of his notable predecessors from Quebec (Gélinas, Dubé, and Tremblay), the theater offered by Lepage to the world at large is no longer "Quebec Theater in English Translation" but international theater that twists the conventional language of the stage into "bizarre and fascinating shapes" (Fraser, op. cit.); a language that goes beyond translation and appears to thrive on the confrontation of different languages and cultures.

In a play like *The Dragons' Trilogy,* in which English, French, and Chinese are all spoken, the concept of "other" that had inevitably attended the creation and reception of Quebec theater outside of Quebec is no longer a significant presence. Moreover, cultural and linguistic difference, the basis for translation, is either at the very center of the play and hence exploited and exploded, as in *The Dragons' Trilogy,* or it is circumvented entirely in plays like *Elsinore* (the Lepage version of *Hamlet*) in which the operative language is that of the *mise-en-scène.* In a theater that relies on a plurality of idioms, notions of language and place of origin lose their traditional pertinence. Therefore, foreign audiences no longer interpret Lepage's theater as a lesson in Quebec culture, as they had sometimes done for other Quebec playwrights, but have

1

changed their way of viewing theater in order to appreciate Lepage's imagistic, multimedia, multilingual, and multicultural productions. In the same way that his productions break down, challenge, and transgress cultural and linguistic boundaries, Lepage's theater also defies geographical barriers. While, in general, Canadian theater companies continue to use a traditional formula, playing solely to home audiences, Lepage's plays tour the world to great acclaim. Though the personal costs of world success and touring may be high, the benefits of this new way of doing theater seem obvious: Ray Conlogue identifies Lepage as "the sole Canadian theatre director who has to juggle offers from Ingmar Bergman and Peter Gabriel or find time in his schedule for the Paris Opera," adding that a "surfeit of success in not a common Canadian problem" (*Globe and Mail*, 15 April 1995).

Lepage intends to take his way of doing theater even further: having established in 1997 La Caserne, the headquarters of Ex Machina, his production company, in a renovated fire house, he is currently working with troupes of actors from around the world who come to Quebec City to prepare spectacles that will be acted in their own countries. His goal is to wire the former *caserne* with the latest in video, computer, and satellite technology, creating what may be "the world's first virtual theater." He will in fact "rehearse actors who may be thousands of miles away to create virtual plays that will have everybody live on stage at the same time but in different cities." He will thus be able to "go global and stay home at the same time," showing more traditional companies still another way to create theater (Conlogue, ibid.).

Global theater for the computer age, Lepage's work disdains traditional linguistic and geographical boundaries by revolutionizing ways of viewing and doing theater. Rather than Quebec theater in translation, Lepage proposes theater beyond translation. Instead of merely exporting or transporting the theater of his homeland, he brings the audience to a space outside geography and cultural identity. Lepage's contribution to Quebec and Canadian theater thus goes well beyond the genius of his acclaimed performances. His work has opened up and expanded the definitions of theater and dramatic language and made them accessible to the world at large, creating in the process a "theater *sans frontières*."

Identity and Universality: Multilingualism in Robert Lepage's Theater[1]

Jeanne Bovet

ROBERT LEPAGE IS, in the literal sense, a man of the world. He is always on the move, his work is hailed on every continent, and the very content of his plays reflects his interest in travel and in other cultures, from his first productions with *Théâtre Repère* in Quebec City to the latest international successes such as *The Seven Streams of the River Ota*. Multilingualism is one of the means by which Lepage manages to convey on stage the idea of the plurality of human cultures. His use of various languages might, therefore, be considered as a realistic representation of the Babelistic world in which we live—and indeed that is how many critics have seen it. However, a closer examination shows that multilingualism in Lepage's work is more like a symbolic key to a larger, ideological philosophy of communication.

According to sociolinguist Jean A. Laponce,[2] human languages fulfill two social functions: identity and communication. Identity is ensured by what Laponce calls the "identity-tongue" (*langue-identité*), the language by which the individual fundamentally defines his own identity and that is usually the language of his childhood, though not necessarily his mother tongue. It is, therefore, closely linked to intimacy and is the best medium for the verbal expression of deep emotions. Communication in a unilingual context is, therefore, more efficient, since it allows direct expression and reception of emotions through a single identity-tongue. However, in a multilingual context, communication requires the identity-tongue of only one interlocutor, which makes the verbal exchange easier for one, harder for the other.[3]

3

Occasionally, both interlocutors adopt a language that is not their own—such is often the case with the use of English on an international level.

It might seem hazardous to apply such prosaic parameters to artistic works. However, as theatre theorist Anne Ubersfeld notes, "un énoncé mis dans la bouche d'un personnage de théâtre est rigoureusement privé de sens hors de ses conditions d'énonciation, exactement comme une parole humaine dans la vie: s'il est une fonction mimétique au théâtre, ce n'est pas celle des conditions de l'existence, mais celle des conditions de la parole."[4] It would appear reasonable then to study multilingualism in Robert Lepage's plays within realistic parameters such as those identified by sociolinguist Laponce, if only to evaluate and interpret correctly the deviations introduced by poetic license.

In Lepage's plays, multilingual conversations are marred by misunderstandings and prove incapable of ensuring real communication. They are progressively and successfully replaced by other non-verbal languages: the language of the body and the language of art, which ultimately merge to allow not only communication but true communion between human beings in an altogether sensorial and spiritual process. But this becomes possible only through the acceptance of one's identity-tongue, that is, through the acceptance of one's fundamental identity. Multilingualism in Lepage's work thus appears as the symbol of a conflict between identity and universality, between the need for self-expression *hic et nunc* and the need for true communication with one's fellow men beyond the limits of time and space. It is by struggling with multilingual communication that Lepage's characters come to discover that a strong sense of identity is the only way to reach awareness of the unity of mankind and, therefore, achieve universality. Beyond the fictional story of the characters, this revelation may also seem to apply to the situation of Quebec in today's world. I will attempt to demonstrate this through an analysis of multilingualism in two major works of the eighties: *Vinci* and *La Trilogie des dragons* (*The Dragons' Trilogy*) as they were staged, respectively, in 1986 and 1987 for *québécois* audiences.[5]

Vinci and *The Dragons' Trilogy* are two very different plays at opposite ends of Lepage's spectrum of realizations. *Vinci* is the first one-man show, and is set on an intimist level with minimalist yet

powerful effects. *The Dragons' Trilogy* is the first great saga, pulled together and refined year after year by a dedicated team of actors. *Vinci* consists of nine scenes and lasts an hour and a half; it tells the contemporary story of a young Quebecer's trip to Europe. The three acts of the *Trilogy*, on the other hand, go on for six hours and weave together the destinies of three generations and at least six cultures: *québécois*, British, English-Canadian, French, Chinese, and Japanese from 1932 to 1985. The differences in form and content of the two plays are pronounced, but as far as the treatment of multilingualism is concerned, the similarities between the plays are striking.

Philippe, the protagonist of *Vinci*, is a young *québécois* photographer, who decides, despite his fear of flying, to travel to Europe following a friend's suicide, in order to set things straight in his head again. In London, after having taken a guided bus-tour of the city, he is fascinated by Leonardo da Vinci's sketch of *The Virgin and Child with St. Ann* in the National Gallery and takes several pictures of it; upon developing them he discovers with awe "un détail: l'empreinte digitale d'un artiste . . . l'empreinte de Léonard de Vinci." In Paris, in a Burger King on Boulevard Saint-Germain, he meets a flamboyant reincarnation of the Mona Lisa who lectures him on the superiority of painting. Later, while camping in Cannes, Philippe dreams of his late friend Marc, the movie director who committed suicide in order to avoid artistic compromise; the dream turns into a nightmare as Marc challenges the terrified Philippe to release his fears and jump from a cliff. Continuing his trip to Italy, Philippe takes a guided tour of the cathedral in Florence and discovers that the architecture of the Renaissance is in total harmony with the proportions of the human body. In the city's public baths, he encounters none other than Leonardo da Vinci himself, literally represented through his left profile as the other half of Phillipe's own personality. From the great Renaissance artist, Philippe learns the ultimate lesson: artistic creation entails paradox, the result of a conflict between the heart and mind of the artist. Having accepted to live with that paradox, Philippe can symbolically wash away off his "*tache sur l'âme*," the stain that Marc's death had imprinted on his soul. His trip ends in the little village of Vinci, the place of Leonardo's birth, where he shares his discovery with Marc: "J'ai vu qu'entre l'humilité du petit village, et la grandeur universelle de Léonard de Vinci, il y a une falaise, Marc.

5

Marc, je suis venu à Vinci et j'ai vu. . . . Il me reste à vaincre."
Vaincre, to win, that is, to throw oneself from the symbolic cliff of
creation. With the help of bird-like wings reminiscent of one of da
Vinci's inventions, Philippe at last flies off into infinity.

Vinci thus appears as the story of a quest in the form of an initia-
tory voyage: the farther Philippe travels from his world of reference,
the closer he gets to his inner truth. His journey is set on two simulta-
neous levels: geographical as well as historical. On the spatial level (the
most obvious one), Philippe travels to Europe, setting foot first in
London, then Paris, Cannes, Florence, and finally in the village of
Vinci. He travels farther and farther away from his native province of
Québec, from North to South, from cold to warm, from Americanity
to Latinity, to use only a few suggestive clichés. In a realistic world
frame, such geographical distance would be doubled by linguistic dis-
tance, as Philippe would have to adjust to other languages along the
way, namely English in Great Britain and Italian in Italy.[6] But, strangely
enough, the farther Philippe travels from Québec, the more he hears
and speaks French. Stranger still, the only satisfying verbal exchange he
manages to have takes place in Italy. Realism, or at least linguistic
verisimilitude, is pretty much confounded. However, Philippe's journey
is more temporal than spatial, more symbolic than realistic.

Philippe's trip appears as a historical return to his cultural roots:
Europe, the Old Continent, from which the first settlers left for the
New World. Curiously, Philippe does not go straight to France where
his own ancestors obviously originated. His first stop is Great Britain,
the country that is not only geographically but also chronologically
closer to Québec than France, since the New France of the *habitants*
was taken from France by Great Britain in the eighteenth century. The
Conquest changed many things, particularly the linguistic make-up of
the colony. Although French continued to be spoken by the majority,
English became the official idiom, resulting in a dominator-dominated
linguistic relationship that it still a sensitive issue in present day
Québec.

The first scene in London shows Philippe in precisely such a rela-
tionship with his English tour guide. Actually, the audience sees only
the English guide, due to the limits of the one-man show—however,
Philippe is implicitly included in the group of Quebecers touring
London by bus. The British guide's condescension toward the tourists

is explicitly marked by his repeated references to "you little French-Canadians." The same disrespect is shown by the British guide's linguistic attitude: ignoring the basic rule of guided touring where the guide must address the tourists in *their* native tongue, he addresses his Francophone tourists in *his* own language, English. This unexpected linguistic behavior may be interpreted as an affirmation of cultural domination on the part of the English toward the "little French-Canadians." Obviously, beyond the story of Philippe's trip, the *québécois* audience is being guided through a staged picture of London and might, therefore, identify with the subordinate in this all too familiar, uneven bilingual relationship.

However, the notion of distance rather than of domination seems the more appropriate description of the use of multilingualism in this scene. The whole guided tour takes place on a very superficial level. The tourists are not in contact with the city since they can see it only through the windows of the bus. Neither are they in contact with their guide, whose speeded-up soliloquy discourages any possibility of dialogue. The play's audience itself does not get any closer to contact, since the guide appears on stage only as a silhouette behind a screen as if he were being seen from *outside* the bus. The combination of these factual, linguistic, and visual elements creates an impression of distance, or as a tape-recorded voice repeats sounds throughout the guide's speech: "*une impression de décalage.*" The domination relationship present in the scene is the opposite of the traditional sort, since it involves the guide's (i.e., the dominator's) fear of domination. Within the closed-in space of the bus, he is in the minority and needs to assert himself by keeping the foreigners at a distance. Do the silent "little French-Canadians" represent the growing threat of *québécois* separatism? . . . Whatever the interpretation, the cultural difference seems threatening enough for the guide to want to keep the tourists from trampling his city or speaking back to him. Unable physically to experience the English reality, unable to understand clearly or to speak to their so-called guide, Philippe and his fellow Quebecers are kept at a distance.

The situation improves in Paris. Although Philippe is no more seen or heard by the audience than in previous scenes, his individual presence is clearly pointed to by his interlocutor, the Mona Lisa. Unlike the British guide, Mona Lisa speaks French and so Philippe is

able to commiserate with her. Furthermore, although a prolix speaker herself, she leaves him the opportunity to answer her questions and formulate a few of his own. The spatial environment also plays a part in preventing any majority-minority, dominant-subordinate type of relationship. According to Mona Lisa, the Burger King restaurant is a neutral international space perfectly fit for multicultural exchanges such as "*des séances vaudou en buvant du Coca.*" All these factors turn Philippe's encounter with Mona Lisa into a one-on-one conversation wherein each interlocutor can use his identity-tongue within a safe, open context.

Cultural differences here have become irrelevant; if some distance remains, it is no longer on a linguistic but rather on an artistic level. Mona Lisa is deeply critical of Philippe's job as a commercial photographer. True art, she says, does not practice with such cold and prosaic objects as bathroom tiles, sinks, and bidets. True art is not a dull reflection of reality. It must lead the viewer into another universe: "Un tableau, ce n'est pas fait pour se mirer la tronche, merde, mais c'est fait pour y entrer, pour y pénétrer." She then recalls the day when a friend painted her and strikes the very pose found in the famous portrait by da Vinci. For a few seconds, all realistic parameters are shattered. The two dimensional surface of a painting suddenly gains the depth of real life, and time rushes back to the Italian Renaissance. In London, Philippe had already identified da Vinci's fingerprint as the mark of the indelible presence of the artist through time. Thanks to the Parisian reincarnation of the Mona Lisa, he goes a step further and experiences the timeless presence of the work of art itself. But the picture disappears as Mona Lisa starts moving again. Art remains an inaccessible vision.

It is the guided tour of Florence that will abolish the distance between vision and viewer. This tour is very different from the first one in London. It involves a group of French-Canadian photographers; the mention of their professional status personalizes them, setting them apart from undifferentiated groups such as the previous "little French-Canadians." The style of the tour is also more personal. There are no more frantic bus rides through the city: everything here is done on foot within the limited perimeter of the cathedral, which allows direct physical contact with the monuments. Moreover, the Florentine guide respects the basic rule of guided touring by speaking

French to his Francophone audience; he also speaks slowly in order to be well understood, a striking contrast with the manner of the British guide or the nervous speech of Mona Lisa. If some implausibility remains, it is no more in form but in content, not in the language the guide uses, but in the purpose for which he uses it.

The Florentine guide initially welcomes the tourists in Italian: "Benvenuto a Firenze." As he carries on in French, his cautious pronunciation and his strong accent remain constant reminders of his identity-tongue. But this does not create a distance, since he has a warm and welcoming attitude. Actually, the guide's openness takes a very intimate turn; he starts to share personal feelings with the tourists. Contrary to expectation, the use of French seems to be no obstacle to the expression of the guide's feelings. Rather it is a deliberate choice, for he knows it is the only way by which his feelings can be properly transmitted to Francophones. The focus here is not so much on the speaker as on his audience. The guide's sense of identity is not threatened; it remains firmly grounded in his accent. But his use of French to express intimate feelings shows that the desire to reach out and share has become more important than the need for self-expression that characterized the British guide and Mona Lisa.

What the Florentine guide has to share is actually beyond words. It is an intimate, emotional experience, the long-awaited entrance into the world of art. In London, Philippe had experienced art only through the mediation of glass screens: the highlights of the city through the bus windows, *The Virgin and Child with St. Ann*, through its protective glass and through the lens of his camera. In Paris, the protective glass abruptly disappeared as he caught a glance of a three-dimensional Mona Lisa. In Florence, the gap between vision and viewer is totally abolished. The baptistery, the campanile, and the cathedral are concrete three-dimensional works of art that can be perceived not only by the eye, but by the entire body. When Philippe steps into the buildings, he physically experiences the third dimension of art: "depth"; as Mona Lisa would put it, "he penetrates the picture." Art has literally become accessible, thanks, in part, to the architecture of the Renaissance.

The only realistic element in the staging of the scene is acoustical, the use of reverberation to produce the typical echo-like sound of church interiors. The visual representation of the buildings, on the contrary, is highly symbolic. Since the architectural aesthetics of the Italian

Renaissance were "à la dimension humaine," the guide uses his own body to illustrate what he describes. He becomes the cathedral, opens his jacket as he would open the door, portrays the ceiling dome with his own head. Entering the world of Renaissance art becomes synonymous with entering the human being. The guide's humble invitation as he opens his jacket says it all: "Si messieurs les photographes veulent bien entrer . . . " His body language thus appears as a physical translation of his welcoming and conciliating verbal speech. The use of the interlocutor's tongue is one way of transmitting efficiently an intimate message, but it is focused on the specific linguistic competence of a francophone audience. The use of the human body adds a dimension of universality; beyond verbal languages, physical sensations are common to all human beings. Eloquent gestures allow the guide's demonstration to be universally understood. Is it necessary to add here that universality was precisely *the* ideal of the Renaissance?

However, the main character in the play is no more the Florentine guide than the British guide or Mona Lisa. These are only milestones on Philippe's route. The relationship between verbal language and physical language must, therefore, be examined chiefly in the light of Philippe's progress. Although communication becomes progressively more efficient from London to Paris and finally to Florence, in those scenes Philippe's own body never appears on stage and his voice is never heard. Just like the real audience, he is in the shadows, the compliant onlooker to his own initiation. He becomes active only in the last dialogued scene where he meets his ultimate guide, none other than Leonardo da Vinci himself.

The scene takes place in the Florence public baths, evoked by sounds of dripping and spraying water produced with the same echo-like reverberation as in the cathedral. Philippe appears on stage with only a bath towel around his waist. His virtual nakedness makes him vulnerable, as if he had followed the Florentine guide's example by stripping body and soul, for in this scene the body is central in a quasi-metaphysical way. It is the object of almost religious care as it is being cleaned and purified. It is also an object of worship in a very explicit context of homosexual desire. The body is the final proof of the fundamental equality of men, socially and culturally undifferentiated in their nakedness. And it is, therefore, in his own flesh that Philippe will experience a spiritual encounter with Leonardo da Vinci.

This encounter is achieved visually as Philippe starts shaving himself in front of a mirror. By applying shaving cream to only one side of his face, Lepage demarcates two different profiles, the white-haired white-bearded one belonging to Leonardo, the beardless one belonging to Philippe. For the first and only time in the play, two characters are seen together on stage, making a "real" dialogue possible. They have different body languages, different voices, different accents, but there is not the smallest distance between them, since they are both incarnated in the same body. Even though it is totally unrealistic, this appears to be the most advanced context of communication according to the logic of the play. The dialogue that takes place through Leonardo is actually between Philippe and himself, between the two antagonist sides of his personality. As Leonardo puts it: "il y a en toi un jeune intellectuel québécois et un vieux cochon qui aime à profiter de la facilité." He helps Philippe discover that he has to accept rather than negate his inner contradictions in order to solve the issue of artistic integrity: "L'art, c'est le résultat d'un combat entre ta tête et ton coeur. L'art, c'est un conflit. S'il n'y a pas de conflit, il n'y a pas d'art, Philippe; il n'y a pas d'artiste sans conflit. L'art, c'est un paradoxe, une contradiction." The moral dilemma ends with the acceptance of the paradox, the conciliation of the contraries.

At the same time, another reconciliation between reality and art occurs. It had already been initiated by the Florentine guide in his demonstration of the similarities between the human body and Renaissance architecture. But in that case, it was reality that was transposed into art, the body into the building. Here, on the contrary, art appears within reality itself through the ever-present theme of the glass surface between art and reality. The public baths are full of mirrors in which men can see themselves and catch glimpses of others. The reflections of the mirrors in other mirrors reveal new angles and perspectives on reality as they create an endless depth, turning reality into a vision of infinity. It is reality as one never sees it, reversed, enlarged, and above all, focused on a most unusual figure, the one that generally stays invisible: the image of oneself. In front of the mirror, Philippe is both the observed and the observer, the picture and the reality. It is the typical position of self-analysis where, upon seeing oneself from a distance, one can paradoxically recognize and eventually accept one's place in the world. Far from narcissism, Philippe's

11

quest ends in open-mindedness as he learns that, no matter how irre-
ducible the multiplicity of human views and cultures might seem, they
appear united at a higher level. Through the mirror metaphor, art itself
appears to be present in everyday reality, in any given situation—
again, a mere question of perspective. Any possible gap can thus be
abolished as ultimately irrelevant, be it between the past and the pre-
sent, between art and reality, or between the various sides of one's own
personality. Leonardo's reincarnation in the body of Philippe says just
that: no matter the *décalage* in time, culture, and talent, the great
Renaissance artist and the "little *québécois*" photographer are akin,
united in mankind.

The linguistic behavior of Philippe and Leonardo plays a great part
in conveying this ideology of communion beyond culture. Just as the
Florentine guide did before him, Leonardo chooses to speak in
Philippe's "identity-tongue" in order to transmit efficiently an intimate
message. French here is not the cultural threat it appeared to be for the
British guide, nor the common cultural denominator it was between the
Parisian Mona Lisa and Philippe. For the Italian, French is almost acul-
tural, a mere instrument of communication that will allow an efficient
interpersonal exchange. For Philippe however, French is his "identity-
tongue" and it is only logical that it be through French that he come to
terms with his own identity.

But the revelation goes beyond the linguistic stage. The sense of
personal identity becomes one of universal identity as Leonardo unites
with Philippe in his own flesh. Contrary to self-assertion, the universal-
ity of the human condition needs no words but only the common expe-
rience of the body to be expressed. Leonardo finally sends Philippe to
the shower, so that he can be totally naked and immersed in the purify-
ing light of his revelation, with the spraying water represented by rays
of white light coming from above. Having "come and seen," Philippe
is now able to overcome his fears and take off into the sky of creation
or, as Mona Lisa had already put it, "plunge into infinity."

This last scene is set in Leonardo's birthplace, at the very roots of
the Renaissance; therefore, at the roots of modern man. It confirms
the definitive emancipation of the body and spirit from the constraint
of language. Language is put at a distance as Philippe's voice is heard
on a tape-recording, while his body, on the contrary, is seen in live
action, opening wings and expanding in flight. The body appears as a

metaphor of Philippe's spirit, and rightly so since it has been the very concrete, sensorial first step on his way to universal consciousness. Philippe's initiation to universality, therefore, finds its fulfillment under specific conditions: a one-on-one dialogue situation where the use of his own "identity-tongue" operates as a prerequisite to access of the universal and the concomitant languages of the body and of art, as if it were only through assessing and respecting his basic identity that he could shatter the contingencies of time and space symbolized by language and open up to infinite horizons. Not at all unique to *Vinci*, this pattern will reappear in a strikingly similar manner in *The Dragons' Trilogy*.

The Dragons' Trilogy revolves around the powerful attraction exercised by the Far East on Western cultures. It is divided into three parts: the Green, the Red, and the White Dragon. The first part of the story, The Green Dragon, begins in 1932 and centers on two cousins, Jeanne and Françoise, growing up in downtown Quebec City. The nearby Chinatown, surrounded by mystery and prejudice, attracts *québécois* gamblers and a peculiar Hong Kong-born English shoe-salesman, William S. Crawford, who befriends Wong, the old Chinese launderer, and his son, Lee. One night, out of desperation and drunkenness, Jeanne's father agrees to gamble his pregnant daughter in a poker game; he loses his bet and Jeanne has to become Lee's wife.

The Red Dragon takes place mostly in Toronto, where Jeanne works as a salesperson in William S. Crawford's shoe store. Her daughter, Stella, stricken by meningitis at age five, is left mentally impaired. Françoise, having enlisted in the Canadian army, comes to visit Jeanne in Toronto before leaving for the Second World War front. Simultaneously, in Japan, a geisha is abandoned à la Butterfly by the American officer who has made her pregnant. The four women's fates are subsequently included in a choreographic tableau where soldiers on skates trample savagely on pairs of shoes representing civilian war casualties. The story then takes a ten-year leap, as Françoise writes her cousin saying that she is finally pregnant after years of disappointment, while Jeanne simultaneously learns from her doctor that she is afflicted with breast cancer. Unable to take care of Stella any longer, Jeanne takes her against Lee's will to a mental hospital in Quebec City. There she meets one last time with Stella's father and returns to Toronto only to commit suicide in her kitchen.

The White Dragon takes place in 1985. Françoise has come to visit her son, Pierre, in Vancouver where he works as a visual artist. At the airport, they meet a young Japanese artist, Yukali, who later visits Pierre's art gallery to show him her own work, three dragons she had painted at the very moment Stella was dying in Quebec City. Pierre likes the dragons so much that he decides to make them a part of his own collection. The two artists become lovers. The last sequence of the play shows the aged William S. Crawford flying back to Hong Kong while Françoise and Pierre try to catch a glimpse of Halley's comet in the parking lot that once was Quebec City's Chinatown. Crawford never gets to Hong Kong; his plane crashes in the Pacific Ocean. Pierre and Françoise do not see the comet, but Pierre tells his mother of his own plans to go to China.

This summary does not do justice to the complexity of human interactions represented in the play as it leaves aside a number of secondary characters. However, two of the main characters, Pierre and William S. Crawford, stand out as being very close to Philippe in *Vinci*. Although they come from different generations and cultures, Pierre and Crawford are the only characters in *Trilogy* engaged in an identity quest very similar to Philippe's. Pierre in particular appears to be the spiritual brother of Philippe: he too is a young *québécois* artist who questions his own integrity; his fear of heights is the equivalent of Philippe's fear of flying; and so on. He has left Quebec City to work in Vancouver, as far away as possible from his origins and, more specifically, from his mother with whom he has a loving—yet conflicted—relationship.

Pierre's linguistic behavior betrays his personal uncertainties. Since he lives in Vancouver, he should be bilingual, but the closest he ever gets to bilingualism consists of speaking a peculiar blend of French and English: "I close in . . . cinq minutes. But l'exposition . . . it goes jusqu'au vingt décembre. Mais . . . you can look. . . . Not be shy! You look at mon travail, mon installation, I look at ton travail, tes dessins. . . ." Pierre seems both unable and unwilling to free himself from the ascendancy of his mother tongue. He clings to Francophone culture in every possible way—drinks Château Redon wine, refers to Tintin comic books, recognizes Yukali's French perfume thanks to his "French nose." Moreover, as his relation with Yukali evolves and becomes a love affair, Pierre definitively gives up

English for French, an unrealistic choice since Yukali does not speak or understand French, but a logical choice in terms of the symbolic initiation to universality that we have already seen at work in *Vinci*.

Pierre's first encounter with Yukali is as impersonal as the Vancouver airport in which it occurs. In this scene he acts essentially as a translator for his mother, who wants to buy a gift from Yukali at the souvenir shop. The whirling of people, the noise, and Pierre's own impatience create a very unfavorable context for any significant conversation to take place. It is only when they meet for the second time, on a one-on-one basis, that Pierre and Yukali have a real encounter. Significantly enough, this second meeting takes place on an artistic level. Though very different in form, the work of the two artists is similar in purpose. Pierre has woven a network of small lights on the floor of the art gallery to represent the universe, while Yukali has painted pictures of dragons that symbolize "a part of yourself that you have to fight to arrive at something larger." Pierre works "with the space around us," trying to put the universe in a small room. Yukali works "with the space inside," letting it come out of her. Both "try to make the light come out" of their art. The quest for something greater, the fascination for the universal, and the metaphor of light are all elements reminiscent of *Vinci*. Moreover, in the same way that Philippe had come to accept the complementary nature of the opposite sides of his personality, Pierre wishes to incorporate Yukali's three dragons into his own work because they strike him as complementary: "I want the people to see *les deux ensemble*."

Pierre and Yukali's third encounter takes place in the midst of another work of art, a zen garden made of stones and sand. In this scene however, the artists go a step further as they become part of the work of art, constitutive elements of the garden. Their names respectively mean "stone" and "precious stone, emerald," and so they can conclude: "we are like two stones in a zen garden." Despite their artistic and cultural differences, Pierre and Yukali appear identical in terms of the fundamental identity established by their first name. Or almost identical, since Yukali does not simply mean stone, but *precious* stone. In fact, in this scene Yukali acts as Pierre's initiator to her own culture through the oriental concept of yin-yang. As a group of Japanese villagers appear on stage to mime the traditional mating of the yin and the yang, Pierre and Yukali start telling the story, he in French, she in

15

English, from the opposite sides of the stage. They then join one another in the middle and, without a word, they re-enact the scene, moving their bodies simultaneously as if they were making love, yet without touching, as if to represent at once the complementary natures and the irreducibility of the male and female forces of the universe.

It would seem that Pierre's quest for identity is fulfilled in the same manner as that of Philippe in *Vinci*: an artistic revelation that combined with the use of his identity-tongue and, finally, in physical communion with another artist. However, Pierre's physical experience of universality does not take the form of a fusion as was the case in *Vinci*. For, while Philippe was actually discovering the universality of the human condition within himself, Pierre discovers it with and through someone else, by the grace of love. Pierre and Yukali maintain separate identities and yet are able to interact harmoniously. Their relationship is not a competition; as Yukali says, in the game of love "there are no winners and there are no losers." Hence Pierre's accession to universality appears more valuable than Philippe's for it results from real contact with alterity rather than from a retreat into the self.

Introspection is actually pictured in *The Dragons' Trilogy* as a very deceitful option, via the story of William S. Crawford. It is no coincidence that Crawford is played by the same actor who plays Pierre, as if to emphasize both their similarities and their divergent fates. William S. Crawford is a delightfully cliché British gentleman. Born in Hong Kong, he moved to England with his parents when he was ten; as an adult he traveled to Quebec City and then to Toronto to open his own shoe store. He breezes through the first two parts of the play speaking exclusively his elegantly accented English (his rare attempts to speak French or Chinese demonstrate more ignorance than his knowledge of these languages). Crawford personifies the somewhat condescending attitude of the English toward other cultures: without necessarily despising the *québécois* or the Chinese, he sincerely believes it is they who have to adjust to his language and not the reverse. And since, in the 1930s and 1940s, English was largely accepted as the dominant language in Canada, he encounters no resistance at all.

However, the last part of the play takes place in the 1980s where linguistic issues have become an important political problem. As if to

parallel the change, Crawford now appears in a very vulnerable state: having lost his mind and the use of his legs from smoking too much opium, he is isolated from his fellow men and reduced to speaking only to himself. As he is waiting in the Vancouver airport to board the plane that will take him back to Hong Kong, he starts recalling, in English, vivid scenes from his childhood. However his voice does not come from his body but from a tape-recording, just like Philippe's voice in the final scene of *Vinci*. When suddenly Crawford does open his mouth to speak, the words that pass his tired lips are not English but Chinese. First he speaks the Chinese name of Hong Kong, Yian Kian, and then he poses the question of his fundamental identity, "Wo tsia William S. Crawford ma?" ("Is my name William S. Crawford?") Am I really this old English gentleman, he seems to ask, or am I rather this child to which I return, the true son of Hong Kong? The answer is already in the question, that is in the language in which the question is formulated. To define his identity Crawford has spontaneously turned to Chinese, as if it were the only language in which such a question could be asked. Although he has no other mentor than his own memory to show him the way, he does experience the same kind of revelation as Philippe in *Vinci*, discovering his true self through the use of his "identity-tongue," in this case a long-forgotten one. His life-long traveling thus appears to end in a round trip that brings him back to the place of his birth and, through the use of Chinese, to his true identity. Moreover, when he stops speaking, he miraculously recovers, if only in his mind, the use of his legs, rises from his wheelchair, and walks toward his fantasized vision of Hong Kong. Once more the body shows the way and leads to the ultimate revelation.

But Crawford's introspective quest does not open him up to anything or anyone other than himself. Rather, it sends him to his death. He will never reach the reality of Hong Kong since the plane that is supposed to bring him back crashes in the ocean. Despite his efforts, Crawford does not manage to reconcile fantasy with reality, to get beyond the realm of self-delusion. Maybe it is because he does not have access to the world of art. Or maybe it is because he belongs to the colonial past of Quebec, since the one who will continue and very likely complete Crawford's journey in his place is no other than a young Quebecer.

At the very end of the play, Pierre tells his mother that he does not intend to go to England any more to perfect his art but instead . . . to China. It is as if the *québécois* character, having strengthened his own identity and opened up to the world, is ready to take over and succeed where the Englishman has failed. The political message is implicit: Quebec's place in the world can only be ensured by a strong sense of identity coupled with open-mindedness toward other cultures. While *Vinci* attempted to demonstrate the plural essence of the individual, *The Dragons' Trilogy* goes further in that it urges the individual to acknowledge that he exists in a complementary relationship with other human beings. Although Pierre's personal quest duplicates Philippe's in many ways, it ultimately leads beyond self-assertion as it emphasizes the necessity of Quebec's active involvement in the course of the world.

Notes

1. For a more ample discussion of the subject, cf. Jeanne Bovet, *Une impression de décalage. Le Plurilinguisme dans la production du Théâtre Repère* (Québec: Université Laval, 1991).
2. Jean A. Laponce, *Langue et territoire* (Québec, PUL [Travaux du Centre international de recherche sur le bilinguisme, A-19], 1984).
3. Scandinavians are one notable exception to that rule: due to the similarities in their languages, they can hold bilingual conversations in which each interlocutor keeps speaking his own native tongue.
4. Anne Ubersfeld, "Pédagogie du fait théâtral," in André Helbo et al., *Théâtre, modes d'approche* (Bruxelles: Labor/Méridiens Klincksieck, 1987), 184–85.
5. The question of the linguistic background of the audience is of crucial importance not only for their perception of multilingual situations but also for the linguistic content of the play itself. "Exportation" of a play to other countries implies readjustments that often alter its original linguistic state. For instance, when *The Dragons' Trilogy* was shown in the United States, the *québécois* characters were made to communicate together in a very unrealistic fashion in order to be understood by the English-speaking audiences: they kept their Francophone accent, but spoke to one another in English. It would be interesting to investigate what new dynamics might be created by such pragmatically oriented transformations. However, I will stick here to the original versions of the plays, since they were first conceived for *québécois* audiences and, therefore, should be analyzed in the light of a *québécois* perception of multilingual communication.

6. Actually, the kind of French spoken in France also requires adjustments: as every Quebecer knows, it definitely does *not* sound like the French spoken in Quebec, even though it is theoretically the same language.

Autobiography in the House of Mirrors: The Paradox of Identity Reflected in the Solo Shows of Robert Lepage

James Bunzli

Introduction

EARLY IN ROBERT Lepage's first solo show, *Vinci*, the protagonist, Philippe, talks to his therapist about a friend, Marc, a filmmaker whose unwillingness to compromise artistic integrity has recently led him to commit suicide: "It's inside me like a stain I can't remove, as if the fact that I'm not such an honest artist made me guilty of Marc's death. I used to look for my reflection in his courage, he was my mirror and today he is dead" (*Vinci*, 10). As the show proceeds, Philippe encounters a wide assortment of other characters, each of whom serves in some way as a mirror, as a medium for self-examination and discovery for Philippe. He looks for his reflection in a kinetic British tour bus driver, a Mona Lisa look-alike in a Paris Burger King, a blind Italian tour guide, and in Leonardo Da Vinci himself.

In this and subsequent solo shows, Lepage engages in a complex, fragmented autobiographical quest. Each of Lepage's solo shows deals with a particular problem or neurosis with which the central character must contend, and with which Lepage himself is dealing at the time of the show's conception. *Vinci* was created in response to Lepage's own struggle relating to artistic integrity (Robert Lepage, interview with the author, Chicago, Ill., 3 June 1994). In addition, Lepage did in fact have a friend, a painter, who attempted suicide in his effort to avoid sacrificing his integrity to commercialism (Manguel, 38). Similarly, Lepage created *Needles and Opium* while "going through a crisis" caused by the departure of a lover (Lepage, interview, 1994). The

impulse to create a one-man *Hamlet* began with a life-long fascination with the character and the play,[1] but was crystallized by his father's death and the realization that "everyone feels aggression toward their mother after their father dies" (Robert Lepage, interview with the author, Quebec City, Que., 15 February 1995).

Lepage's identity, in its many incarnations, is put into play in his creations—both in process and product, narrative and theatrical act. In each of his solo shows, Lepage presents a parade of characters, some given full-body portrayal, some represented only vocally or in silhouette, some merely evoked by implication. The many characters fragment Lepage's identity in an autobiography reminiscent of a "fun-house" hall of mirrors, a distortion of self-image rife with contradictions and paradox. Just as fun-house mirrors manipulate an image, Lepage's characterizations manipulate—literally and figuratively—the performer's voice, body, identity, and theatrical space. Fragmentation of identity allows Lepage to balance persona and character in a complex negotiation of self and other in which neither takes precedence.

Lepage's solo shows to date are *Vinci*[2] (1986), *Needles and Opium*[3] (1991), and *Elsinore*[4] (1996). He plans another solo based upon Serge Gainsboug's concept album, "*L'homme à tête de chou*," a tale of jealousy and murder in which Lepage envisions once again playing multiple characters. As they fill for Lepage "an obvious need" both to perform and to express himself in a very personal way (Lepage, interview, 1994), there looks to be no abatement in the periodic undertaking of one of these projects as part of the ongoing exploration of the limits of the self, the medium, and the world that Lepage's work as a whole constitutes.

One can trace in the evolution of Lepage's solo work an increasing incorporation of the texts of others. *Vinci* evokes a number of visual artists, but its text is entirely original. In *Needles and Opium*, Cocteau's *Lettre aux Américains* is quoted at length. *Elsinore* is based entirely upon Shakespeare's text, but is no less Lepage's than *Vinci*. (W. B. Worthen grants *Elsinore* only "quasi-Shakespearean" status [3].) Still, the selection of characters is clearly different in the case of *Elsinore*. In *Vinci* and *Needles and Opium*, Lepage's autobiography pervades every aspect of conception, creation, and performance. There is an autobiographical gap in *Elsinore* between the impulse to do a one-man *Hamlet* and the technical execution of the piece. While

22

Elsinore is certainly an important component of Lepage's ongoing autobiographical pursuit, it is my intent in this essay to focus on the role of paradox in the conception and creation of the multi-character one-man show, drawing chiefly from the two earlier works.

All three of Lepage's solo shows focus on the theme of solitude. Paradox of situation, such as travel to a different time zone, is either replaced by or becomes a metaphor for the internal paradox of the individual. Isolation in both the form and content of the two solo shows brings out stories and themes of solitude, as well as theatrical techniques which further emphasize solitude. Lepage responds to a personal concern, and brings it into relief through the examination of the work and lives of other artists. Lepage concedes that the solo format is by nature very personal. His own approach to it, however, makes it even more so. Each of his one-man shows must have a character that, as he puts it, "speaks directly for me, in my voice" (Lepage, interview 1995). In each one-man show, Lepage plays a central, apparently autobiographical character: "Philippe" in *Vinci*, "Robert" in *Needles and Opium*, "Hamlet" in *Elsinore*. In *Vinci* and *Needles and Opium*, however, he also plays at least one historical figure, such as Jean Cocteau and Leonardo da Vinci. In addition, fictional characters—either portrayed physically or implied—appear in each of the earlier shows. The importance given to solitude in a show which, although performed by one man, contains a multitude of characters, is a paradox in itself. This paradox allows solitude to work on many levels. In fact, the focus on solitude is as much metaphorical as it is literal. Paradox in Lepage's solo shows is expressed by his use of *décalage*, the term Lepage uses for differences—from changing time zones, to cultural and linguistic disparities, to personal, internal conflicts.

The way in which characters "other" than the central autobiographical character are brought to light in *Vinci* and *Needles and Opium* illustrates the relationship between character and persona in Lepage's dramaturgy. Like so much of Lepage's work, this unique relationship exists in both creation and performance. Lepage alternates between a backgrounded and a foregrounded persona. Character and persona coexist, neither having complete control—narrative, theatrical, technical, or thematic—over the other. While the persona is always present (if only by virtue of the solo format), full-body portrayals, costuming, and whole scenes where the narrator or central

character does not interject allow Lepage's other characters independence and an active role in the creation of the piece. Many of them exist in independent scenes, and while they might rely on Lepage (or Philippe or Robert) for their existence, that existence is always completely acknowledged within the time/space world of the scene.

In both *Vinci* and *Needles and Opium*, Lepage responds to the solo format by the imposition of a framing device, a character who narrates the story, directly addressing the audience as the audience for that evening's performance. *Vinci* is narrated by a blind Italian guide who begins the show by greeting the audience and explaining his presence:

> In order to insure a better understanding of the show, the artists responsible for the evening have invited me to hold forth on various aspects of the visual arts. I am not, however, a visual artist myself. Nor am I an eminent, highly qualified specialist from a prestigious academy well-known for its innovative ideas on art and its many ramifications. In fact, I am a fictional character played by an immensely talented actor, the production crew felt you would take their artistic preoccupations more seriously if they were exposed to you by someone speaking with a European accent (*Vinci* 3–4).

This character appears again later in the show to present "a brief anthology of artistic creations which have defied the rigid rules of the tape measure" (*Vinci* 22), and to guide a tour of the Duomo in Florence (29–31). This character plays on many levels, not the least of which is the paradox of a blind man as a guide to the visual arts.

In *Needles and Opium*, Robert begins as narrator, once again addressing the audience directly. His first words, "The practitioner delicately inserts needles into my skin," allow him to lay the thematic groundwork for the piece: "Nowadays, some people believe acupuncture can cure almost everything, but I'm sure of at least three things it can't heal: existential angst, low self-esteem, and a love sickness" (*Needles* 2). He then turns to the narrative: "While in France, I was working on a voice-over for a documentary film about Miles Davis' 1949 Paris visit, when I first felt the symptoms of my anguish" (*Needles* 2). Robert the narrator and the Robert we later see in scenes are, in fact, two different characters. But like all Lepage's portrayals in

24

the solo shows, they are also different parts of the same character. Their similarities and differences serve to point out the paradox of individual identity.

Paradox: Narrative and Theatrical Act

In selecting characters, Lepage expresses a preference for figures who are inherently paradoxical. In *Vinci*, Leonardo's paradoxical behaviors are frequently described. In *Needles and Opium*, Robert admits the paradox of the actor with low self-esteem. Even better if the paradox exists on many levels, Lepage holds: "Contradiction can be played out between the life-instinct and the death-instinct of a character, between the fact that he is in love with both a man and a woman, or, on a cultural level, that he is a Francophone who must speak English in order to make a living as an artist" (Fréchette 117).[5]

Indeed, the existential quest deals with human paradox in its most basic form. And that basic paradox can be translated into any and all modes of existence, including the artistic, the personal, and the geopolitical. Paradoxes exist within the central characters, but paradox is also an important component of the shows themselves. As a *québécois* artist creating very personal one-man shows, Robert Lepage himself is always dealing with paradox on all three of these levels. With the focus on the many parts of his own identity, as a result of both the format itself and Lepage's approach to it, his fascination with paradox colors the narrative, structural, theatrical, and thematic layers of the shows.

Both *Vinci* and *Needles and Opium* constitute and are constituted by a journey. The journey in *Vinci* is, among other things, literal. In the *Vinci* program, Lepage writes, "The VINCI we present does not trace the portrait of the artist but rather attempts to evoke, simply and directly, a series of questions asked, a journey made, a path taken" (1). In *Needles and Opium*, Robert's physical journey has already been made. We hear about it only in the past tense: "When the French customs officers searched my bags at the Charles de Gaulle international airport . . ." (*Needles* 2). The focus, for both Robert and Philippe, is on the effect of that journey. Airplanes aside, both central characters are on a journey toward identity. Both confront the other, as well as themselves. The existential journey made by the characters is paralleled

25

by the theatrical journey made by both persona and audience. All seek to build a coherent identity of some kind—as human, as performer, as interpreter—out of the series of fragments which make up the shows. All involved have an active role in constructing their own identities and contributing to the construction of the identity of others. All involved play a dual role. None of their quests are fully achieved.

The focus on the paradox of identity is sharpened by the fragmentation of that identity within the pieces. This paradoxical rendering of identity is further heightened by a theatrically simultaneous reconstruction of identity. This is, in fact, an instance of what Alain Knapp calls "mutual construction."[6] As Lepage's fragmentation of his own identity constructs the theater piece, the theater piece serves to reconstruct that same identity. According to Knapp, characters define each other. He stresses, however, the parallel facts that "When a character speaks, he speaks of himself," and that "when he speaks of others, again he speaks of himself" (Féral, "Pour," 58). Lepage as persona speaks toward his identity through others. To recast Knapp's sentence slightly, when Lepage speaks others, again he speaks himself.

By extending the capacity for mutual construction to all elements of the production—including the audience—Lepage creates a complex world of fragmentation and reconstruction, a world that revels in paradox. Lepage in performance comments on the theatrical nature of the story being told, while he simultaneously creates truth out of self-confessed fictions. There are many kinds of paradox present in both *Vinci* and *Needles and Opium*. Some exist within the narrative, such as characters seeking the impossible, be it complete artistic integrity or a painless cure from a love addiction. Paradox is related, via the show's main narrative thread, to identity. Paradox in the fable of *Vinci* is most prominently displayed in terms of art and the artist. Philippe asks Leonardo "a fundamental question about art": "An artist like you, who was inspired by the beauty of things, who loathed human suffering, and feared cataclysms—how do you explain that you invented war machines, engines of destruction?" (*Vinci* 32). Leonardo's response echoes, but does not resolve, the paradox: "If dere's no conflict dere's no art, Philippe, no artistas. Art is a paradox" (*Vinci* 34). In *Needles and Opium*, Robert complains to the hypnotherapist of "low self-esteem," which he finds "problematic for someone in theatre" (*Needles* 19). The phenomenon of the self-conscious actor may not be rare, but it is

certainly paradoxical. Philippe in *Vinci* is a timid photographer, an artist unwilling to take risks. He also, however, embodies another common paradox of the artist as he seeks integrity yet profits by allowing his photographs to be used to advertise bathroom fixtures.

Paradoxes between characters—played by the same actor—also bring into relief contradictions within the central character. Inasmuch as they are similar to "Robert" in *Needles and Opium*, Davis and Cocteau are in many ways opposites of each other. Indeed, it was this opposition that first interested Lepage in using the two of them together in one show: "One a black man, one white; one lives by night, the other by day; a demon who haunts the grottos of Saint-Germain-des-Prés, a poet who speaks of things ethereal and angelic; an American, a European; one injecting heroin, the other smoking that volatile airborne drug, opium" (cited, Lefebvre 19).

Specific instances of paradox also exist in the theatricality of the pieces. The characterizations of historical figures often encompass both parody (and the humor that results) and a serious attempt at a cultural bridge. In *Vinci*, the Mona Lisa character's accent and attitude parody French and Frenchness. She also, however, functions as "the keyhole through which da Vinci [and/or Lepage] allows us to catch a glimpse of creative freedom" (*Vinci* 25). Despite her comical portrayal, which is neither realistic nor a travesty, the physicalized character has a serious proposition for Philippe and the audience. The scene is in some ways simple, but it works on many levels at once and may be one of the most complex moments in the show. Although for different reasons, Lepage's Cocteau works in a similar way. This portrayal is simultaneously far removed from Robert and an intimate illustration of his psyche.

The method of creation of the shows is in its way paradoxical. Lepage sets out to express himself in a very personal way by constructing a complex fictitious world in which he plays a number of characters, only one of whom resembles him directly. In addition, the creation of the shows relies heavily on intuition and improvisation, but the products of this process of creation, while they certainly retain some of their flexibility, are in fact intricate and technologically precise works. The multi-character solo show is by its very nature paradoxical. A single actor is playing numerous roles. The paradox is augmented when some of these roles are performed "realistically." An

27

audience will know that a single actor is performing all the roles and is not likely to believe that the actor is actually the character being played. Still, while some of Lepage's portrayals are broad and would seem to approach caricature, others are much more subtle, less clearly distinguishable from Lepage himself. Lepage advocates "truthful acting." Within the solo format Lepage holds that "it's no use playing a character" and there must be no "feint," no sham in what one tells (Fréchette 121).

There can, of course, be "realistic" acting without realism. The way *Vinci* and *Needles and Opium* are constructed, the theatricality resides not in the portrayal of individual characters, but in the way these portrayals are contextualized by the performance stance. The portrayal of Jean Cocteau, for example, might seem to approach parody. The performance of the character is highly stylized. As an actor, however, Lepage simply plays a series of adjustments, some of them radical to be sure—the character is suspended in mid-air. The circumstances of the character—Frenchman, acrobat, poet—are incorporated into a truthful performance that is only made "unreal" by the context into which it is placed by the theatricality of the show as a whole. The portrayal of the Mona Lisa is similar in this way. Lepage performs a studied portrayal, making the extravagant accent and brash manner his own. Still, the physical characterization strongly (and purposefully) resembles the most famous work of art in history. Irony and humor are chiefly the result of the context in which a particular job of "acting" is placed. The paradoxical goals of actor and creator are here juxtaposed; they work together, but retain their individual identities. The mixing of stylistic approaches allows moments of performance to be both theatrical and truthful—and successfully so.

The complexity and completeness of the often paradoxical simultaneity that is built into *Vinci* and *Needles and Opium* is embodied in the working of *décalage*. Like each of the performance choices that lead to the complex stance taken by the productions, *décalage* works simultaneously on all levels of experience. It is a state of being inherent in live theatre, a technique that transcends theatrical convention, a thematic distillation of the many paradoxes in life, and a central narrative component of both solo shows.

In addition to the specific paradox of the artist, *Needles and Opium* explores paradoxes that relate to a broader group. In his

exposition of the "American paradox," Cocteau describes a New York that stands "between the breasts of its mother, one feeding it alcohol and the other one milk" (*Needles* 10). Earlier he positions New York, and the American paradox, in a global context:

> A city that believes it gives a poor reflection of others can reflect vast territories, with time variations, in such a way that night for some is day for others, and some are awake while others sleep. I mean that some are preoccupied by the absurd magnificence of dreams while others are functioning and not dreaming. This induces, without any-one realizing it, a strange circulation of contrary waves that the soul records, but the mind does not decipher. And it is this attraction, this fascination for enigmas and this repulsion for those same enig-mas that is the great paradox of the American mind (*Needles* 3).

Here paradox, through the narrative, is directly linked to the *décalage* that both performer and character are experiencing. There is also a kind of poetry in the text that constitutes an interruption of the narrative, as "theme" rears its head and takes control. While Lepage performs this speech—in mid-air, as if floating in space—he leans forward and inverts himself. Both gravity and the notion of up and down are subverted by production choices.

Décalage: The Mendacity of the Mirror

The term *décalage* first appears early in *Vinci*. "*Décalage*" is presented by the British tour bus driver as an affliction associated with travel to England. In his often-repeated litany, the guide provides us with the symptom and the cure: "This may give some of you little French-Canadians nausea, dizziness, or a strange impression of décalage . . . You're driving on the wrong side. You're Canadian, aren't you? Look into the mirror. Look into the mirror" (Lepage, *Vinci* 13–15). According to Lepage, as a North American in England, "you get the impression that you're in a mirror" (Lepage, interview, 1994). Thus, to look into an actual mirror is to reverse that effect. Two instances of *décalage* cancel each other out. Or do they? To "look into the mirror" is to see oneself reversed. One instance of *décalage* simply replaces another. A similar juxtaposition of two separate instances of *décalage*

exists in the dramatic structure of the scene. The tour is interspersed with a recorded voice describing Leonardo's paradoxes. For example: "Leonardo da Vinci could not bear ze human suffering, and yet he invented war machines. Zis leaves the reader reeling with a strange feeling of *décalage*—a feeling of *décalage*" (*Vinci* 14). Each taped segment ends with the same sentence, and is accompanied by projections of drawings and pages of text from Leonardo's notebooks. Leonardo himself appears later in the play and demonstrates yet another of his paradoxes, leaving Philippe and the audience "reeling." He discusses art while ogling naked "little Italians" in the shower room (*Vinci* 3).

For Lepage, *décalage* has many meanings. It begins as the jet lag that results from touring, "that physical feeling that day is night and night is day." In addition, there is "the language, the cultural *décalage*" (Lepage, interview 1994). *Décalage* is also, however, the expression of all that is paradoxical, all acts, objects, and situations in which there are disparate components. *Décalage* is most literally the result of physical displacement. However, the displacement may also be emotional or ideological. Philippe, for example, suffers from ideological *décalage*. He would like to be a "true" artist, but consents to the (lucrative, we assume) commercialization of his work. Despite the money (or perhaps because of it), Philippe's own conflicting goals and actions trouble him. This ideological *décalage* leads Philippe to take a trip and, therefore, to experience physical *décalage*. *Décalage* causes both the journey and its results.

In some cases, *décalage* results in discomfort. Leonardo da Vinci, on the other hand, lived a life of self-imposed *décalage*. As Lepage explains: "Vinci's was an upside-down world. He wrote backwards, all of his notes were written backwards. And he was a left-hander. And to be left-handed, to be officially left-handed and not fight against it in the Renaissance was quite a statement. Because it was the hand of the devil, it was the hand of the homosexuals, it was the hand of vice. . . ." (Lepage, Interview 1994). Diane Pavlovic notes in *Vinci* various kinds of *décalage*. It is, first of all, time zone related. Soon, however, *décalage* becomes a confrontation with the "diverse masks worn by reality" (Pavlovic, 97). Thus, *décalage* is seen as the realization that all is not as it seems, that "reality" has many contradictory faces. For Solange Lévesque, *décalage* in *Vinci* is most apparent in the theatrical object, especially Lepage's "impressionistic style." She discusses Lepage's skill

in "counterpoint," in allowing themes to "circulate freely throughout the text" (Harmonie 103). She identifies in the workings of imagery in the piece at "totally unexpected levels" (103).

Similar use of "counterpoint" pervades the staging of Robert's paradox in *Needles and Opium*. When Robert is in his hotel room trying to reach his lost love by telephone, he addresses the audience directly while he waits for various telephone operators. When beginning a section to the audience, Lepage turns sharply, still speaking into the telephone, but with a different energy. The breaks are clear. The arrangement of the portions of the scene is a theatrical imposition within which Lepage actually plays seven brief scenes. The main connection between these segments is technical. There is a microphone in the telephone and Lepage uses it to amplify his voice whether or not he is also using the phone as a realistic prop.

In this scene, the same character has two different identities. Robert is the relaxed narrator, in full control and able to tell jokes: "So every time I take a bath here I always have the impression I am marinating myself in all the sediments and the dirt of all the great artists and intellectuals of the 1940s and 50s" (*Needles* 7). Robert is also, however, the frustrated character, struggling to control his environment. The stage directions read: "The character 'Robert' tries to reach his former love by telephoning from Paris, encountering difficulties with both French and English telephone operators" (*Needles* 6). The two halves of the scene may be self-contained, but taken altogether, they point to the paradox within a single individual. This paradox exists in the narrative, but it is also present in theatrical terms. Lepage moves back and forth between open and closed focus, illustrating the paradox of the actor vis-à-vis his audience. As frame and scene are juxtaposed, the paradox within the theatrical act itself is brought to the fore.

This distinction between frame and scene is not always kept so clear. In the final moments of the show, Robert appears behind the screen, in much the same way as he does when establishing the frame at the beginning of the show. The dialogue, his "letter," however, is not addressed to the audience, but to "My dearest love" (*Needles* 33). Here frame and scene are integrated and become indistinguishable. The text of the letter is poetic and clearly of a different style than Robert's preceding dialogue. The character Robert has taken on some

31

of the assurance of the narrator Robert. The narrator Robert, in turn, has assimilated some of the character Robert's pain:

> Sometimes a restless heat into my dreams will roll,
> Transforming them into an aura of savage light,
> Leaving my body but a brazier of boiling coals
> That Bacchae rend throughout the night (*Needles* 33).

Despite the integration of the two figures, the character/narrator in this scene retains a basic paradox of human existence: he loves someone who causes him a great deal of pain.

In the many examples of paradox, the story, the performance, and the creator/creation are distinct but inseparable. The interactions of character, persona, and identity rely on *décalage* as the metaphoric thread—sometimes visible, sometimes invisible—that ravels and unravels the material of the show, taking and giving form, permitting independent, simultaneous existence of the many disparate pieces that make up these unified wholes.

The Many Mirrors

Mirrors and other optical devices pervade all of Lepage's work. In *Vinci*, the prominence of the mirror begins in Philippe's first scene, as he describes Marc as "my mirror" (*Vinci* 10). In the following scene, the British tour guide repeats "look into the mirror" as part of his manic litany. At times, the guide's rear-view mirror transforms into a fighter plane or the bell of a boxing match. Finally, in the scene between Philippe and Leonardo in the shower room, the two artists meet in front of a mirror. The mirror in this scene allows Philippe, at Leonardo's prompting, to "take a good look at [him]self" (*Vinci* 33). It also, however, due to a "basic optical principle," permits Leonardo to surreptitiously observe the "cute little Italians" bathing (*Vinci* 33).

In *Needles and Opium*, the mirror is literally used only in the sequence late in the play where Lepage as Robert interacts with himself on film, first as Davis, then as Cocteau. In both cases, Robert touches the screen on which the filmed segments are being projected, "causing" the mirror on film to break. The first time this happens, the mirror reforms, now containing a new image. The second time the mirror is

broken, there is a blackout. This image may be borrowed from Cocteau, for whom mirrors were very important. Mirrors in *Orpheus*, for example, are the doorways to "The Zone," a "no-man's-land between life and death," where some of the action of the film takes place (Steegmuller 481).

Less literal uses of the mirror and the idea of reflection are present throughout both solo shows. Photography, in which the image begins by being inverted and reversed, is a kind of mirroring process. Like the mirror, photography claims to reflect truth accurately. Lepage's representation of photography suggests that it may not be such an accurate medium. Philippe, in the National Gallery, photographs the audience, but develops images of *Virgin and Child with St. Anne*. The four photographs are not identical. Instead, they "progress," tracing the "creative evolution" of the sketch. In *Needles and Opium*, the Polaroid developing sequence raises similar doubts. We see Robert's face "develop" on the screen. While some of the images shown are indeed versions of Lepage's face, several are clearly not. The script states that these are "many different images of what could be the same visage" (15). The photograph of Robert does not develop according to the rules of photography.

As Cocteau describes the "eccentric photographs" taken of him for *Life* magazine, he confronts "the serious problem of the text" of the captions, and "how one could explain the inexplicable": "I suggested they should say the photographs they had taken were perfectly normal, that the camera had played a trick on them, that they apologize to the public for this, that machines were becoming dangerous in the same way as men" (*Needles* 16–17). For Cocteau, the "accuracy" of the medium depends not on the technical facts of photography, but the impact the photographs will have on, for example, "a man at the barber reading LIFE magazine in the far reaches of Massachusetts" (*Needles* 16). Cocteau's interaction with photography also raises the idea of "posing." Perhaps only a truly candid photograph could serve as the basis for self-examination.

In any case, whatever the medium—Robert photographs himself just as Philippe takes "a good look" at himself in the shower room mirror—the impulse within the central character seems to be an open and honest self-examination. The production choices which deconstruct the authority of the resulting images also universalize them.

Philippe sees a young intellectual "on one side" and a dirty old man "on the udder side" (*Vinci* 33). As Robert's photograph develops, the many images that "could be the same visage" include a line drawing of Cocteau and a black and white photograph of Davis.

As noted earlier, *Elsinore* employs a great deal of video technology, the camera often serving as a mirror. The characters of Rosencrantz and Guildenstern are represented by camera angles, as perspectives of Hamlet, one on either side of him. Images from the cameras are projected onto the front of the set and, as Lepage/Hamlet turns toward the camera "addressing" him, we see what Rosencrantz or Guildenstern "sees." We also, however, see what his counterpart sees, the back of Lepage's head. Rosencrantz and Guildenstern are represented here as spies, but they also constitute one of the most direct examples of the other as mirror in the Lepage canon. The images that result from mirrors and cameras in all three solo shows are, in fact, "other" characters who, through mutual construction, reflect the central character and the performer persona. Lepage looks to the characters he plays for a reflection of his identity; the characters look to him for a reflection of theirs. Further, as Lepage is the sole creator, both characters he chooses to play and the way in which he plays them are reflections of him as an artist.

The Self in the Other, the Most Other

Most of Lepage's shows, solo and collective, include more than one language. Even in "translation," both *Vinci* and *Needles and Opium* contain significant passages in languages other than English.[7]

Lepage talks about the way multiple languages work in "universalizing small things," helping the shows to "focus on humanity instead of regionalism" (cited, Hunt 117). This happens, however, from a *québécois* point of view. Not only is it always "a *Québécois* telling the story," but the concerns dealt with are fundamentally *québécois* concerns. Lepage states: "You get a very good idea of what Quebec is about if you go to France, to England, Switzerland. There is a clearer image of Quebec now that people are going away and coming back" (cited, Hunt 117).

Although Lepage uses the other characters to talk about himself, his use of characters also demonstrates the global outlook of the

shows. In *Vinci*, the other characters are mostly "foreigners," British and Italian. (As a product of Italy, in a way, Mona Lisa can be seen as Italian, although she also embodies Frenchness.) In *Needles and Opium*, the other characters are mostly American and French—the two halves of the paradoxical *québécois* identity. According to Lepage there is "a particular Quebec sensibility" that comes from the fact that the Quebecers "are both profoundly European and North American" (cited, Gravel, 149).

Just as Philippe seeks the "most other" characters in *Vinci*, Robert looks within the paradox of his own cultural makeup to find profound otherness. Identity is approached by the incorporation of similarities and differences. Not surprisingly, both similarities and differences are made manifest in the narrative, the theatrical act, and the imagistic/iconic lives of the shows.

In her analysis of language-identity in Lepage's early work, Jeanne Bovet singles out the climactic scene in *Vinci* between Philippe and Leonardo (74). In this scene, Lepage as Philippe "covers half his head with shaving cream and enters into a discussion with Leonardo" (*Vinci* 32). Lepage plays both Philippe and Leonardo, switching from one to the other with a turn of his head, a change in his accent. The self-interrogation that constitutes the main action of the show is clearly demonstrated in the technique used to play the scene. So also, however, is the paradox within a single human being clearly illustrated. The method of characterization of Leonardo—a cartoon-like profile—is contrasted immediately with the honest portrayal of Philippe. The simultaneous portrayal of two characters strengthens the focus on the performance persona. Fragmentation of identity is visited on the body of the performer and Lepage's "self-interrogation" becomes literal. *Décalage* informs the narrative and the theatrical act individually, as well as circumscribing their interaction. Leonardo, gesturing toward the unseen mirror and hence toward the audience, tells Philippe: "Did you ever take a good look at yourself in the mirror, Philippe? Go ahead, look at yourself. If you won't do it, I'll do it for you. Look. What do you see?" (*Vinci* 33).

Both cultural and language identity reach new heights of prominence when, once again using the audience as a mirror, Robert visits a hypnotherapist (Dr. Heurtebise on rue Mesmer) in *Needles and Opium*. The scene is staged in mid-air, the slanted screen serving as the floor, the

35

performer's focus directed toward the audience. Robert describes political and cultural history as "written like a bad play" (*Needles* 20). Despite its comic effect, this speech describes exactly not only the nature of the personal *quests* Robert and Lepage are engaged in, but also the precise manner in which they take place in both the world of the play and the world of the theatre. The self-interrogations by Robert and Lepage are carried out through references—to Quebec, to Orpheus, to Mesmer[8]—which lead the audience into the story. These same references, however, by evoking the actual and very complex history of Quebec, for example, distract the audience from that same story.[9] The interaction between narrative, theatrical practice, and the series of allusions in the hypnotherapist scene is complex. The many languages used by Lepage—verbal, visual, narrative, theatrical, technical, musical, iconic—all coexist; very different articulations of *décalage* coexist. At times a thematic touchstone, at times a theatrical technique, at times a narrative plot point, *décalage* is in fact at all times all of these. On other occasions, the phenomenon is more clearly situated in one or other of these arenas. But in the solo shows as a whole, *décalage* is everywhere. The paradox of performing a multi-character one-man show, a clear difference between the form and the content of the work, creates *décalage* in the audience's perception. The search for a single identity through numerous characters is an obvious, purposeful paradox.

Owing to the complex construction of identity that is at work, and the often indirect means of engaging that complexity, metaphor is an important tool in the creation of the shows. The implied comparison that it entails also necessarily implies a difference. Identity is subject to temporal and spatial displacement, but also all manner of other displacements. The individual in the solo shows enjoys a certain prominence, but in Lepage's dramaturgy, the fragmentation of the individual accompanies any hope for a unified identity. Josette Féral attributes a fragmentary power in performance to media technology and objects: "They can multiply the performer or reduce him to infinity; they can cut him up into pieces or reassemble him according to plans known only to the imagination" (Féral, "Performance," 89). For Lepage, all elements of performances create the kind of fragmentation and reconstruction to which Féral refers. The importance given to intuition and improvisation in the creative process gives rise to "plans known only to the imagination."

According to Deborah Geis, fragmentation is native to the postmodern subject. For Geis, there is a "detextualizing impulse" in postmodern theater, which gives rise to "an emphasis on the performance moment . . . over the text and on stage presence over representation." Given the autobiographical potential of the monologue, the positioning of a "postmodern subject" becomes especially important. Geis describes this subject as "the split, multiple, or contradictory 'I.'" This subject is "a decentered one" and, therefore, "the notion of 'character' is no longer holistic" (Geis 34). A self-examination in this mode cannot be simple, even if the impulse behind it and various moments of its execution are very much so.

The fragmentation of Lepage's identity as a postmodern subject begins with the interaction of character and persona in the solo shows. Their continuous coexistence is the central theatrical paradox in the shows and, therefore, a major source of *décalage*. Another important paradox lies in the fact that Lepage's exploration of his particular identity—an intuitive, personal, and highly autobiographical process—serves to "universalize" that same identity. One articulation of the fragmentation of identity comes from the several key types of identity that Lepage brings willy-nilly to his approach to the solo shows. The personal, artistic, and geopolitical explorations that are at the heart of the solo shows are given imagistic freedom in a kind of theatre that deals more with emotions than with facts, more with non-negotiable impressions than with debate. Lepage creates worlds in which truth and fiction comfortably coexist.

Truth and fiction coexist in metaphor. Characters and languages contribute to Lepage's "global" outlook. In this regard, "global" can be understood in its international and its creative sense. Lepage universalizes both his story and his approach to theatre. Just as he is many characters within the shows' narratives, he also plays many roles in their creation. Lepage as performer can be read as a metaphor for Lepage as creator. Since creation and performance are in fact simultaneous, the reverse is also true.

Even the paradox and *décalage* that exist between characters in the solo shows contribute to Lepage's metaphorical search for identity. The "other" characters in *Vinci* and *Needles and Opium* often function by opposing the central, autobiographical character. Even so, these "other" characters still contribute to the construction of Lepage's

identity. And this contribution goes beyond mere comparison. The other characters do not always represent facets of the central characters. Still, as characters Lepage has created and chosen to portray, they are always closely linked to his vision of and questions about himself. Like his friend Marc, the filmmaker mentioned at the outset, each of the characters serves as a mirror, but the simultaneous presence of the "original" (Lepage's persona in performance) is needed for the mirror to work. Once again, the strength of Lepage's creative presence, especially when foregrounded by the action, creates a simultaneity that both fragments and constructs identity, giving character and persona separate but equally potent constitutive power. In a brief scene in *Needles and Opium*, Robert telephones his lost love and is informed that "they" have left the hotel. He asks, "What do you mean 'They've left'?" (*Needles* 18), emphasizing the final "They've" to make clear that the ex was not alone and that the usage is not merely an avoidance of gender specificity. In playing this scene, Lepage's head appears above the screen on which is being projected an image of Miles Davis crossing the Atlantic, actually Lepage swimming in black and white. As the silhouette "surfaces," Lepage's head appears to complete the body below him. When the phone call ends, the body on the screen dives as Lepage's head ducks below the screen. Robert is lost, confused, and hurt in the scene. Lepage, by contrast, is the masterful stage magician, bringing about an optical illusion that is truly graceful and beautiful, which he effortlessly controls.

Conclusion: Reflections in the Mona Lisa

Philippe claims to have used Marc as his mirror, and he spends much of *Vinci* looking for another such mirror. As Bovet notes, he finds it through interaction with the most "other" character and situation he encounters (74), both in terms of the narrative and the theatrical act. Along the way, however, he is reflected in several other characters. The notion of self-examination through characterization becomes especially interesting in the case of Mona Lisa, a mirror who puts the "fun" in fun-house, but at the same time retains a complexity and profundity that makes her a serious proposition indeed.

It is worth noting that Lepage chose not to embody personally the chanteuse Juliette Gréco, in *Needles and Opium*, claiming that "it

would have been taken for a farce" (Lepage, interview 1995). A portrayal of Juliette Gréco would have been farcical chiefly because of its inevitable failure to be convincing. Portrayal of an actual but less-known woman presents an actor with specific problems, due to the ambiguity surrounding her identity. Such is not the case with Mona Lisa. Although Lepage is, in a way, playing a woman, he is also playing himself dressed up as a woman. The familiarity of the image permits Lepage to play on an existing image, rather than trying to create one. The narrative thread is by no means abandoned in this scene, but it is significantly informed by the very strong—albeit ambiguous—presence of Mona Lisa. The ambiguity surrounding the painting is mirrored in the scene itself. The character is a contemporary translator, but she is also Art personified. At one point in the scene she says: "I'm in the Louvre." Following Philippe's unheard reply, she then continues: "No, I work there" (*Vinci* 20). Sexual and gender ambiguity are also involved, since the audience knows that the character is being played by a man. As Philippe (and Lepage) are reflected in Mona Lisa, she becomes an important part of their characterizations.

The Mona Lisa as mirror takes an interesting new direction in light of Lillian Schwartz's claim that the long sought-after model for the famous painting is no other than Leonardo himself. Her position is based on comparisons made between Mona Lisa and the later red chalk *Self-Portrait*. The latter, scaled and inverted, matches the Mona Lisa almost exactly. According to Schwartz, in painting the Mona Lisa, Leonardo was indulging his "penchant for riddles" (52). She describes the painting in terms that speak of paradox, and of *décalage*. It is a painting "in which contrasts of life and death, light and darkness, male and female, barrenness and fertility play across the image" (52).

Irène Perelli-Contos calls the mirror the "object par excellence of the representation of the self" (Perelli-Contos 67). Leonardo's self-portrait both confirms this view and calls it into question. In fact, the Mona Lisa is the self-portrait inverted, "flopped left to right" (Schwartz 50), as if seen in a mirror. And the mirror image in this case differs markedly from the original. Just as looking into the literal mirror may not be the best way to cope with *décalage*, so might it not be the most effective way to accurately see oneself. The metaphorical mirrors that are "others," even fictitious others, may be our best chance. To recast Knapp's phrase once more, when Lepage looks at others, he looks at himself.

Lepage's mirrors are not mere optical devices, cold, authoritative, and unyielding. Like Cocteau's mirrors, they promise great depth and constitute an invitation into a "zone" of self-examination that at once fragments and reconstructs identity; they raise more questions than answers, revel in indeterminacy, and create a metaphorical and iconic texture rich in humor and in possibilities.

Notes

1. This is not the first work of Lepage's in which the specter of that character has appeared. In the film *Jesus of Montreal*, Lepage's character consents to play Pilate in the Passion, provided Hamlet's famous soliloquy can be incorporated into his role (Arcand). In *Polygraph*, Lucie is cast as Hamlet and we see her performing that same soliloquy in French (Brassard and Lepage 653).

2. Originally performed in the intimate Thèâtre Quat'Sous in Montreal, *Vinci* follows a young *québécois* photographer as he travels to Europe in response to a crisis of artistic integrity. The protagonist, Philippe, travels to London, Paris, Cannes, Florence, and finally to the village of Vinci. The show, filled with technological tricks, is narrated by a blind Italian guide, a self-confessed "fictional character" who frames the show. The set for the production was dominated by a large screen, behind which Lepage sometimes worked in silhouette. Also present on stage was the show's composer who underscored much of the production in real time.

3. Based upon the success of *Vinci*, *Needles and Opium* was designed to be performed in larger venues. It is the story of a young *québécois* actor stranded in a Paris hotel room and suffering from the loss of love. His story is juxtaposed with those of Miles Davis and Jean Cocteau, who were crossing the Atlantic in opposite directions at roughly the same time in 1949, "high on derivatives of the same drug" (Lahr 190). Addiction (to opium, heroin, or love) and coincidence link these three stories. The set for this show featured a device by which Lepage could be suspended in mid air, as well as the ubiquitous screen, behind which Davis was portrayed in silhouette, and upon which shadow plays of hands chronicled Davis's courtship of Juliette Gréco.

4. *Elsinore*, the most technically ambitious of Lepage's solo shows to date, is his retelling of *Hamlet*. Characterized by manipulations of the actor's body and voice, the show is peppered with tricks allowing differing perspectives of Hamlet to be presented. Relying heavily on video cameras and huge projection screens, Lepage is able to create the intimacy and solitude the piece demands, while performing it in very large venues.

5. Unless otherwise noted, all translations from French-language sources are my own.

6. Alain Knapp, Swiss director and teacher, introduced Lepage to collective creation, the importance of improvisation, and the concept of the "actor-creator." Knapp's theory and technique are brought out in an interview with Josette Féral in *Jeu* 63 (1992).

7. The British tour bus driver in *Vinci* speaks English in both French and English versions of the show, while Mona Lisa speaks in the version's principal language. The Italian guide speaks his native language in both versions. Robert addresses the hotel receptionist in French in both versions of *Needles and Opium*, but Cocteau's dialogue depends upon the version.

8. The scene ends with the line: "The spiral? What spiral?" after which Mesmer's famous spiral is projected onto the screen and Robert suffers under its influence (*Needles* 22).

9. Sherry Simon deals in some detail with this scene as "*jeu de références culturelles*" in *Le Trafic des Langues*.

From *The Dragons' Trilogy* to *The Seven Streams of the River Ota:* The Intercultural Experiments of Robert Lepage

Christie Carson

> Theatre never explains. . . . Television and film try to explain why a culture is different, what is extraordinary about this culture or that culture . . . but the ritual theater makes you live it, makes you take part in it. . . . I think we're wrong in theater when we try to explain what a culture is about . . . that's why people like going to *The Dragons' Trilogy* . . . They want to experience a culture; they don't want to learn about it. They don't want to have it explained to them.[1]

ROBERT LEPAGE'S COMMENTS about his intercultural theater are clear. It is not his aim to represent cultures in a naturalistic way. Rather, he aims to capture the essence of a culture, which he then communicates to his audience in a personal and experiential way. His comments make the relationship between the audience and his theater appear very simple, without conflict, but this is far from the case. What Lepage's intercultural theater does, in fact, with its multi-layered images, is force its audience members to recognize individually the gap between the representation they witness and their own position. In doing so, Lepage's theater sets up a complex dialogue that runs under the often banal details that comprise the piece's narrative. The intensely personal nature of this debate results in critical responses that reflect as much about the reviewer's own personality and experience as they reveal about Lepage's theater.

To look at Lepage's intercultural work from the period when his international success began, with *The Dragons' Trilogy*, to the completion

of the seven-hour version of *The Seven Streams of the River Ota*, is indeed to attempt to analyze a significant chapter in this director's history. In response to this challenge, I will present a series of specific moments when my life and that of the artist have intersected. Lepage's work, because of its ever-changing nature and performance location, demands specificity of time and place to pinpoint the position and perspective of the analyst. Unlike much "international" theater, which tries to mold its audience into a homogeneous mass, Lepage's work wanders the globe in search of an ever-changing environment in which it can create a new recipe of intercultural exchange. The work of Robert Lepage is always chasing the ephemeral and the personal. In a world of increasing standardization and commodification, this is a particularly important aspect of his work and it is this phenomenon which I would like to address.

Lepage is a creative catalyst both in terms of his work with co-creators and in terms of the audience relationships he establishes. Primarily, he is a consummate communicator whose greatest gift is to create ambiguous pieces of theater that use as their inspiration every aspect of contemporary culture. Like the cultures they describe, his work can be full of contradictions, prejudices, and rash judgements based on insufficient information. At the center of his work is the liberal humanist ideal of a universal human nature. This is a notion that he romanticizes to the point where it is unclear whether he embraces the Hollywood romantic spirit or uses it as parody. The fact that his work is multi-layered and often inconclusive actually proves to be one of its greatest strengths. Lepage's gift is his ability to act as a mirror to our society and to pick up on contemporary currents. As a result, his work can appear to be as profound and complex or as shallow and trivial as the viewers or reviewers themselves allow. The relationship established is a deeply personal one, which draws the viewer into a discussion, a debate with the creator. Only by tracing both the creative and receptive processes that occur during his productions can this extraordinary series of relationships be revealed.

Looking at three different productions that deal with cultural identity, *The Dragons' Trilogy*, *Tectonic Plates*, and *The Seven Streams of the River Ota*, we can trace not only Lepage's own creative journey, but also the journey of the reception of his work. By tracing these parallel paths, I aim to point out their interdependent relationship. Lepage's

theater has changed as his own view of interculturalism has been challenged by real experience and critical response to his work internationally. The reception of his work has also changed. As Lepage's work has traveled and grown it has increasingly drawn critics into its developmental process and into a personalized, contemplative style that reflects the scope and perspective of Lepage's own theater. The relationship between Lepage, his co-creators, and his critics has itself been developmental, resulting in a greater understanding and appreciation of the questions of cultural representation in the theater on both sides. The metaphor of the journey applies not only to the reception of individual performances of his work but to Lepage's career as a whole and his ongoing relationship with collaborators and critics.

The Dragons' Trilogy

The Dragons' Trilogy marked Lepage's first attempt to address the questions of culture, representation, and identity. Developed in Quebec with an entirely Francophone cast, this production helped to extend and solidify the creative practices of the Repère cycles. Working with a group of actors who all shared a similar cultural background allowed for the creation of a piece which presented a coherent view of the Chinese community in Canada. This view was one that was later challenged in reception for the narrowness of the perspective presented. In the Canadian context, however, *The Dragons' Trilogy* articulated a subtle and complex debate. Viewed inside the country, the resonances of the images created were specific and emotive; viewed from outside the country, the issues of this debate became generalized, romanticized, and trivialized.

The Creative Development of *The Dragons' Trilogy*

The action of the show spans seventy-five years of Canadian history and moves from the Chinatown in Quebec City (1910–35) to Toronto's Chinatown (1940–55) and finally to Vancouver's Chinatown (1985). The story describes the lives of Jeanne and Françoise, two young *québécois* women who have been profoundly influenced by the presence of the Chinese community. In the first piece, or Green Dragon (each piece is named after one of the dragon pieces in mah-jongg), the two girls play as

children and mock the strange, but seemingly harmless, owner of the laundry whose scant knowledge of English makes him the subject of their ridicule. It is not until Jeanne is impregnated by her first love, and lost to the laundry owner by her father in a poker game, that the two girls are forced to confront the Chinese family as real people. In the second section, or Red Dragon, set in wartime, Jeanne has moved to Toronto, married Lee, the son of the laundry owner, and had her baby whom she has named Stella because of her long red hair. Françoise, her cousin, has joined the army and has come to see Jeanne on leave. This section shows the devastation of war and the pain of a life spent longing for an absent lover. At the end of this section, Jeanne is diagnosed as having cancer. Rather than facing more pain in her life, she sends Stella to an institution and kills herself. The focus of the third section, White Dragon, is on Françoise's artist son, Pierre, who is living in Vancouver in 1985. With the help of his mother, he meets a young Japanese woman who, we learn, is the granddaughter of a geisha and an American officer who are briefly introduced in the second section. Stella dies in the institution in which she has been abandoned; raped, and murdered, her body is left lifeless on the stage. However, at the same time, there is a coming together of the two artists, one, Pierre, who has created a representation of the universe which he calls *Constellation*, and the other, Youlaki, who presents Pierre with three dragons she has painted that are meant to represent the soul. This provides an ending that indicates the optimism felt by those involved, represented by the coming together of eastern and western cultures and philosophies.

While the initial idea for the show was Lepage's, the other members of the group became intimately involved in its creation. In an issue of the Quebec theatrical journal, *Jeu*, devoted to the reconstruction of the process and the performance, Marie Gignac describes how the group used the pieces of mah-jongg and Chinese cards, and looked at the symbolism of colors in the Chinese dragons to build up a series of impressions of the culture. Lorraine Côté describes the first stage of creation in the following way:

Au début de la première étape, Robert nous a dit: "Donnez-moi vos idées, vos flashes."

(At the beginning of the first stage, Robert said to us: "Give me your ideas, your flashes.")[2]

Each of the actors came up with an object to contribute to the process. For Côté, it was the shoes that were to become integral to the production. She gives her reasons for making this choice:

> Un soulier donne beaucoup d'indications sur l'époque, le sexe, l'âge, la condition sociale, l'état physique. La position des souliers donne une image autant du personnage que d'une situation, d'un état intérieur. Nous avons improvisé des scènes, des situations drama-tiques avec des souliers.
>
> (A shoe gives a lot of information about the period, a person's sex, age, social condition, physical state. The position of shoes gives as much an image of the person as of a situation, of a mental state. We improvised scenes and dramatic situations with these shoes.)[3]

Once the objects were brought into the process, the group worked through improvisation to develop scenes. The objective of the first stage of creation was to tell a story of seventy-five years in just an hour and a half. The first production of *The Dragons' Trilogy* was performed at the Implanthéâtre in Quebec City in November of 1985 before a small audience that was not familiar with this new director's work.

The second stage, the three-hour version, was the result of more improvisational work based on the original outline that the group expanded. This stage of the production was performed first in Quebec City, and again at the Implanthéâtre, for nine performances in May 1986. Lepage says of this second stage:

> Dans la deuxième étape, nous avions vraiment l'impression de ne rien inventer, que le spectacle existait par lui-même, que nous le déterrions. La première étape avait mis en place toutes les régles. Nous avons laissé grandir le spectacle.
>
> (In the second stage, we really had the impression that we were not inventing anything, that the show existed on its own, that we were unearthing it. The first stage had put all the rules into place. We just let the show grow.)[4]

This version was also performed at the World Stage Festival in Toronto in the same month. In January 1987, it was performed in Montreal; in

March of that year it was performed in Ottawa; in May again in Quebec City and in June 1987 it was performed in Stony Brook, New York. The three-hour version has since traveled extensively to Galway, London, Limoges, Adelaide, Brussels, Poland, Paris, Amsterdam, Hamburg, Barcelona, Mexico City, Los Angeles, Boston, Milan, Copenhagen, and Jerusalem. It has won prizes at major theater festivals and received critical acclaim in all of these major centers.

The third and final stage, the six-hour version, was first performed in Montreal at the Festival de Théâtre des Amériques in June 1987. Marie Michaud, the actress who played Jeanne, the young mother in the show, describes how two years of work culminated in this six-hour performance:

> Pour construire les six heures, on a moins cherché, même si ce n'était pas plus facile. On a décidé de ce qu'on ajoutait, et le germe de tout ça était déjà dans les trois heures. On se connaissait mieux depuis deux ans, et c'est intéressant d'improviser avec des gens que l'on connaît, avec confiance, dans un jeu très physique. Au moment de créer les six heures, les personnages étaient déjà là, on ne les cherchait plus, ils étaient bien campés, précis. En fait, ce sont les personnages qui improvisaient, et c'est d'eux que sortaient les choses. On avait à peine le contrôle—des fois, on ne l'avait même pas—sur ce qu'ils avaient à dire, sur ce qu'ils faisaient. Ensuite, Robert plaçait tout ça.
>
> (Constructing the six-hour version involved less research, though it was not easier. We had decided on what to add and the germ of all that was already in the three hours. We knew each other better after two years, and it is interesting to improvise with people you know, with confidence, in a very physical show. By the time we created the six-hour show, the characters were already there, we weren't searching for them any more, they were well established, precise. In fact, it was the characters themselves who improvised, and it was from them that things emerged. We barely had control— sometimes we didn't—over what they had to say, and what they wanted to do. Then Robert would put it all into place.)[5]

This comment illustrates the cohesive nature of the creative group at this point and their increased ease in working together in a collaborative way. The six-hour production has toured slightly less, travelling to

Paris in 1989; Chicago and Los Angeles in 1990; and to Switzerland, Milan, Copenhagen, London, Glasgow, Jerusalem, Salzburg, Stockholm, and Helsinki in 1991. This production has touched audiences wherever it has traveled and has brought Lepage significant international attention. What I would next like to question is the specific nature of the response to this performance in different environments.

The Reception of *The Dragons' Trilogy*

My own response to this show was made more complex by the fact that I saw it for the first time in Toronto in 1988 in its three-hour version and saw it for the second time in 1991 in its six-hour version in Glasgow, where I was living as a doctoral student. Not only had the show itself changed over that period of time, but so had I, both personally and in my response to the culture around me. The production that I saw in Toronto was quite obviously an expression of cultural identity by a *québécois* company making themselves heard in Ontario, where their struggle for identity was both a familiar and an emotive subject. This was very different from the production that I witnessed as an expatriate viewing a generalized image of my home country while living abroad. What I saw as exciting and inspiring in the first context, I found limited and oversimplified in the second.

Ultimately *The Dragons' Trilogy* uses the Chinese community in Quebec as a metaphor for the situation of the province within the country as a whole. The extent to which the Quebec experience is projected onto the Chinese experience with the presumption of understanding, if taken literally, is disturbing. In fact, *The Dragons' Trilogy* actually places the Chinese characters in a position of misrepresentation while the performance simultaneously claims to condemn this attitude. As a result of these conflicting aims, a strange series of contradictions arise in this production, which can elicit very different responses depending upon the position of the spectator.

In the first section of the play, Crawford, an Englishman, arrives in Quebec City looking for a store where he can sell shoes. He encounters the Chinese laundry owner and asks him about a shop to which he has been sent. The Chinese man explains, "The store is burn." Crawford, misunderstanding, replies, "Are you telling me a star is born?"[6] Wong, the laundry owner, repeats himself, but when Crawford still fails to

49

understand, Wong sets a piece of paper on fire. The two men are exiles in the city of Quebec and their attempts to understand one another are hampered by language. Lorraine Camerlain explained how this scene, for a Quebec audience, addresses the very important question of language and its relationship to identity:

> La scène où se rencontrent les deux principaux personnnages d'étrangers prend curieusement racine, de façon originale et dramatiquement fort efficace, au coeur même d'une question constitutive de notre identité nationale: les problèmes linguistiques. Le dialogue entre le British et le Chinois s'amorce en effet sur une confusion engendrée anglaise de monsieur Wong et par l'incapacité de Crawford à saisir un anglais trop peu châtié. Les portraits du British et du Chinois, finement ciselés, puisent directement à ce qui est, pour nous, irrésistiblement drôle: les questions d'accent et les difficultés d'apprentissage de l'anglais.
>
> (The scene in which the two main characters who are foreigners meet makes surprising use, in a way that is original and dramatically effective, of an issue which is at the very heart of our national identity: linguistic problems. The dialogue between the British man and the Chinese man revolves around the confusion engendered by Mr. Wong's bad pronunciation of English and the inability of Mr. Crawford to grasp an English that is so poorly spoken. The portrait of the two characters, finely crafted, draws directly from what is, for us, irresistibly funny: the question of accent and the difficulties of learning English.)[7]

This comment shows very clearly the way in which the Chinese and the British characters are used: they are means of exploring the ideas, concerns, and issues of importance for a *québécois* theater company and for a *québécois* audience. The other cultures are being used here, on the one hand, as a means of making the Quebec experience seem new, and on the other hand, as a mirror against which the *québécois* characters can be explored. Transposing the difficulties the Quebecers have with the English language onto the Chinese characters gives an impression of empathy, but negates the importance of racism and economic disadvantage that members of this community face. Ultimately it is a disturbing simplification of the problems.

Lepage, in discussing the work, makes no secret of the fact that the purpose of exploring the influence of the Chinese community in Canada was not for the benefit of that community; rather, it was an exercise in exploring his own relationship and the relationship of the *québécois* characters in the piece to that community. Viewing his work, as I did in Toronto, as an outsider to the community in Quebec but still within the Canadian context, I was able to engage with the ideas he presented about the Chinese community in Canada in the metaphoric way in which they were intended. Seeing him speak on behalf of the country's multicultural traditions, as he seemed to do in the Glasgow viewing, I felt a sense of betrayal at its misrepresentation, which I wanted to debate or dismiss.

The Dragons' Trilogy has been repeatedly praised for achieving universality, and the strength of the visual and gestural language that Lepage has developed has been seen to be its ability to communicate across cultural barriers. What I would suggest, however, is that it is the combination in this show of visual elements that are general—and therefore at least ambiguous if not universal—with elements that are intensely specific and personal that moves its audiences to a personal individual response that is further informed by viewing position. Evidence of this assertion can be seen in the varying responses to the performance by critics and academics residing in different communities.

Looking first at the response of a *québécois* critic to the play's original production, it is clear that Lepage had a keen awareness of his Quebec audience and their preoccupations. Lorraine Camerlain in "O.K., on change!" expresses her delight in the presentation in the following way:

Assises au sol, deux petites filles jouent; et elles s'amusent follement. Elles recréent, à même leur jeu, avec de simples boîtes de chaussures, tout l'espace qu'elles connaissent: la rue Saint-Joseph, à Québec. Ainsi, enjouées, elles prêtent vie à des personnages—qu'elles caricaturent avec une excitation désarmante—endossent tous les rôles, inventent des conversations dont elles retirent un plaisir évident et communicatif. Par ce jeu, elles parlent avant tout d'elles-mêmes et de leur rapport avec le monde. La scène est ponctuée de "O.K., on change," qui marquent leurs changements de personnages (d'identité), et qui résument à eux seuls l'entreprise de la *Trilogie des dragons*. "O.K., on

change," c'est un jeu d'enfant . . . *La Trilogie* n'a jamais prétendu être une "étude" sur les immigrants chinois du Canada, sur la guerre ou sur la misère canadienne-française. Elle s'est proposée comme un parcours artistique, et j'aime son oeuvre en moi. Complice de ma propre (petite) histoire, je me suis *retrouvée* enrichie d'étrangeté et de langages nouveaux.

(Seated on the ground, two young girls are playing, and they are enjoying themselves tremendously. They recreate in their game, with simple shoe boxes, the only place they know: Saint-Joseph Street, in Quebec City. Then they playfully give life to their characters—which they exaggerate with disarming delight—taking on all the roles, inventing conversations from which they gain evident and expressive pleasure. Through this game they speak mostly about themselves and their relationship with the world. The scene is punctuated by the phrase, "Okay, let's change," which marks their changes of character (identity), and which summarizes the central intent of *The Dragons' Trilogy*. "Okay, let's change" is just a game . . . *The Trilogy* never claimed to be a study of the Chinese immigrants of Canada, of the war, or of French-Canadian poverty. It presented itself as an artistic journey, and I like the effect it had on me. Implicated through my own (minor) history, I *believed* I was in China, feeling more *québécois* than ever, enriched by strangeness and new tongues.)[8]

The childlike approach taken to the subject is cited as justification for not taking the implications of the ideas presented too seriously. Everyone in the audience knew the issues being discussed, therefore, it was not necessary to clarify the details that lay behind the metaphor; to do so would have been pedantic and tedious in the Quebec environment.

The response of an English-Canadian critic to this production reflects a view that is equally informed by the Canadian experience of careful multiculturalism. It is a view that is also appreciative, but for rather different reasons. Natalie Rewa, in her article entitled "Clichés of Ethnicity Subverted: Robert Lepage's *La Trilogie des dragons*," states:

This analysis of the six-hour version of the production examines how Lepage departs from traditional explorations of cultural communities. In a strikingly flexible playing space the production elicits

an intertextual discourse among the disparate texts connoting ethnic experience. Superimposed on a simple narrative exploring the lives of two *québécois* women is a metatext which questions the validity of narrow, highly individualized, artistic portrayals of multiculturalism . . . Lepage concentrates on presenting distinct cultural perspectives and modes of expression rather than crude conflict of cultures . . . The international reception of this production attests to his penetrating insights.[9]

Here Rewa refers to multiculturalism as "the crude conflict of cultures." The international reception of the work is seen as a sure sign of Lepage's "penetrating insights." What she demonstrates in these comments is a characteristic English-Canadian sense of relief at the vision of cultural harmony portrayed. The endless negotiations of the particular details of a daily multiculturalism lead to a quick embracing of any image of the mixing of cultures that appears a little more straightforward. This position very much reflects my own initial response to the show in Toronto. In a world of serious contemplation of cultural identity, a playful approach is a breath of fresh air.

Some strong reservations about the less-than-serious approach taken to identity in this show are, however, articulated by Jean-Luc Denis in his article entitled "Questions sur une démarche" ("Questions on an approach"). In this article, he expresses his disappointment in the show for replacement of the probing insight of earlier Repère productions with an accessible style that he feels has lost its critical edge. He saw *The Dragons' Trilogy* as being characteristic of a general movement in Quebec's theater toward the more conventional, traditional, or safe, a movement that he condemns:

La *Trilogie* avait un déplaisant arrière-goût de téléroman; j'y ai vu une volonté sursimplificatrice d' "accessibilité" qui la confinait dans le banal, et un manque de vision qui m'a attristé. J'espérais du groupe qui avait produit *Circulations* et dont était issu *Vinci* quelque chose de plus clairvoyant, de plus visionnaire qu'un simple divertissement de masse, qu'un produit de consommation—aussi éblouissant et alléchant l'emballage soit-il.

(*The Trilogy* had an unpleasant aftertaste of a soap opera; in it I saw a desire to oversimplify for the sake of "accessibility" that

confined the piece to banalities, and a lack of vision that saddened me. I had hoped the group that had created *Circulations* and *Vinci* would produce something more perceptive, more visionary than simple mass entertainment, a product of consumption—however dazzling and alluring the packaging.)[10]

Denis takes issue with *The Dragons' Trilogy* because, to his mind, it is merely a shallow synopsis of a well known progression of clichés:

La Trilogie riait gentiment des vieux clichés sur les Chinois véhiculés dans les années trente . . . pour les remplacer immédiatement par des clichés plus modernes, sans s'interroger sur la genèse des clichés ni mettre le spectateur en garde contre eux.

(*The Trilogy* makes gentle fun of the old clichés about the Chinese common in the thirties . . . only to replace them immediately with more modern clichés, without questioning the origins of these clichés and without giving the audience the means to guard against them.)[11]

In order to present a productive analysis of the changing images of racism, it is essential, as Denis suggests, not only to present prevailing attitudes but to provoke an audience to interrogate those clichés. I understood what Denis originally saw in the production only when it came to Glasgow and it seemed to speak with some authority about the Chinese community in Canada. By simplifying the issues involved, *The Dragons' Trilogy* does a disservice, not only to the community it uses for its imagery, but also to the audience it deceives with images of false harmony.

In contrast to the impassioned home grown responses to the piece, it is instructive to look at the view of one outsider to the issues discussed. Michael Ratcliffe in the *Observer* writes:

Acted in English, French, Chinese and Japanese, *The Dragons' Trilogy* compresses Canada's ethnic diversity into a story of two sisters. . . . It is . . . theater of symbols and images designed to project with some sharpness the experiences uniting humanity—war, exile, madness, adolescence, affection, art—rather than those dividing it. . . . Lepage, who directs, excels in presenting moments

of the past as simultaneously transient and eternal. It is a magical gift.[12]

Ratcliffe notes both the scope of Lepage's work and his surprising success at achieving many of his goals. What Ratcliffe possesses, however, is an emotional distance from the specific issues of identity being discussed and in that is freed from the more emotional response of those closer to it.

What becomes apparent looking at the responses to *The Dragons' Trilogy* across time and place is that this production allowed for a multi-layered interpretation, which depended very much on the reception environment of the audience. Dealing with a very specific and emotive subject in a metaphoric and poetic way, Lepage was able to speak to a variety of different audiences at different levels. What this series of responses also indicates is that, while Lepage's work might be equally popular in a variety of environments, this popularity may not arise from appreciation of the same elements.

Tectonic Plates

This production moved a step forward from *The Dragons' Trilogy* in terms of Lepage's practical experience of intercultural exchange. *Tectonic Plates* was designed from the outset as a developmental international project that would incorporate, over time, a number of artists representing different cultural perspectives. Through this production process, Lepage was confronted by artists whose working practices and world views were significantly different from his own. The result was a production that was less coherent than *The Dragons' Trilogy,* but one that demonstrated a real involvement with the cultural collaborative process, an involvement that in turn brought about an increased sense of engagement on the part of critics in the communities discussed.

The Creative Development of Tectonic Plates

Tectonic Plates was originally commissioned in 1987 by Michael Morris as part of Glasgow's celebration as European City of Culture for 1990. Lepage was given three years to develop a show that would be

incorporated into the city's celebratory cultural program. The scale of this project was enormous, involving six different productions in six different cities on both sides of the Atlantic. To summarize the process, *Tectonic Plates* received its world premiere in Toronto in June 1988, after just three weeks of rehearsal. It was then performed in Quebec City and Montreal in November 1989 and March 1990 respectively. In November 1990 it played in Glasgow, followed by a run in London in December of that year. The final incarnation of the show was performed at the National Arts Centre, in Ottawa in June 1991, in both a French and an English version. There were two attempts made to incorporate contributors from different "cultures" into the creative process. Michael Levine, the celebrated set designer from English Canada, was involved in the creation of the Toronto version of the show, and four actors from Scotland were involved in creating, recreating, and performing the piece from Glasgow to Ottawa.

The story of *Tectonic Plates* revolves around three characters whose lives it traces from the 1960s to the late 1980s. Madeleine is an art student who falls madly in love with her tutor Jacques, an art historian. Jacques, in turn, is in love with Antony, the deaf, mute librarian at the college. Madeleine, devastated by her unrequited love, decides to travel to Venice to commit suicide. This romantic vision of death is radically altered, however, when Madeleine arrives in Venice and witnesses the death of her newly acquired friend Constance. Twenty years later, Madeleine is herself an art historian and travels back to the college to see Jacques. She encounters Antony who has also lost touch with his old lover. The two are surprised to then recognize Jacques's voice on the radio. Jacques has moved to New York where he has become Jennifer, a late-night radio host. Antony goes to visit Jacques, but upon meeting him and discovering his new lifestyle realizes that the Jacques he knew is dead. Jacques then meets, and is asked out by, a young, naïve Alaskan tourist. Jacques accepts his invitation, but when the young man discovers Jacques is a man he is so shocked and dismayed by his mistake that he unwittingly strangles Jacques in an effort to silence him. The performance ends with an auction of Madeleine's paintings, each of which is a romantic image of the events of her life.

In the initial Toronto production, the three-foot pool that separated the stage's two acting spaces, as an essential part of Michael

Levine's design, was used quite literally as the Atlantic Ocean, the gulf that divides North America and Europe. In later productions, however, this watery pool was used more symbolically: as a Venetian canal; as a screen for shimmering romantic works of art; and as the well of the subconscious mind. *Tectonic Plates* is the story of romanticism; the romantic painters and musicians of the nineteenth century are rediscovered by twentieth-century characters who, themselves, live lives of romantic intensity.

In Toronto, *Tectonic Plates* was presented as a work-in-progress as part of the World Stage Festival. Lepage's decision to work with Michael Levine in this first stage of the production was seen as an exercise in bringing together the country's two theater traditions. The words of Celina Bell, *Montreal Daily News* theater critic, were indicative of the media response to the project: "The Quebec/Ontario co-production is considered a significant step in bridging the gap between French and English theater in Canada."[13] The play, as a result, was seen to have much greater cultural significance than might be expected from such a preliminary project.

The second stage of *Tectonic Plates* was to take place in Montreal at the Festival de Théâtre des Amériques in May 1989. However, at a press conference held with the organizers of the Festival who had co-produced the show with Théâtre Repère, Lepage announced that it was just not ready for public viewing. Describing the event, Stephen Godfrey said Lepage appeared "shaken and tired."[14] For everyone involved it was a shock, but Lepage was adamant that he would not open to the public a show in which he did not have confidence.

Lepage returned to Quebec City, his native town and Théâtre Repère's home base, to work on the next phase of *Tectonic Plates*. Lepage felt that the production would receive a more sensitive and intelligent response there, sheltered from the Montreal press and the pressure of being presented at another international festival. This also enabled Lepage and his co-workers at Théâtre Repère to return to their own creative approach; it gave the working process the time that it required to produce a show of comparable size and scope to *The Dragons' Trilogy*. As a result, almost a year and a half passed between the initial opening of *Tectonic Plates* in Toronto and the opening of its second incarnation at the Implanthéâtre in Quebec City on 19 November 1989. What took place in Quebec City was a

reclaiming of the process used by this company to create all of their previous shows. This piece, however, differed from the others in that it was being designed with the specific idea of cultural collaboration in mind. The themes and characters that emerged in this stage of the production, and in the subsequent production in Montreal, determined its structure, a structure that was later imposed on the Glasgow participants.

In October 1990, when Lepage and his company arrived in Glasgow to begin work on the production that would open at the Tramway Theatre the following month, the actors and director were already well acquainted, having met during a week-long series of workshops held in January of that year. When work began, however, the Scottish actors discovered that, while discussions were open, there was a strict creative framework within which they had to work to produce a performance. While Lepage reworked the entire show to incorporate the Scottish actors, their input into the thematic dialogue was limited by the structure that had already been created in the three earlier versions.

The first restriction the Scots had to deal with was the imposition of a Quebec vision of a Highland goddess. Already in the Quebec City version, Lepage had introduced the image of a bare-breasted, sword-wielding, kilt-clad woman, an image that, although admittedly naïve, Lepage wanted to include, and the Scottish actors had no choice but to accept it. While the research done in Glasgow during the rehearsal process actually unearthed material that justified the character, the actors were not unanimously supportive of the image. Emma Davie, one of the Scottish actors, describes her response to it: "The one scene I avoided talking about earlier when we were talking about Scottish identity was the scene with this mythological figure, this Skaddie creature. In Scotland that kind of grated with us a little bit. Although we like it theatrically we didn't know how it expressed our identity."[15] Lepage, however, felt that it was necessary to include the image: "Okay you're right it is a cliché [but] if we deny the impression people have of you then you are not honest."[16] From the beginning of the Glasgow rehearsal period, the Scottish actors had to accept an imposed vision of what constitutes "Scottishness."

The second challenge the Scottish actors had to face was that the central characters, those around whom the narrative was based, were

all Quebecers. The Scottish actors were forced to find characters who, on the one hand, expressed their identity and a sense of Scottishness, but on the other hand, fitted into the story lines already developed. Not surprisingly, differences of opinions regarding how the idea of national identity should be addressed in the theater quickly became apparent. While the Quebec actors were initially excited by the comparisons that could be made between Scotland and Quebec, in terms of their parallel bids for independence, they soon tired of this debate and wanted to get on with putting the show together using their own creative method. The Scots, on the other hand, were not so keen to abandon their attempts to define the nature of Scottishness and their own ideas of how that should be represented on stage. Susan Feldman, an English-Canadian radio journalist, was on hand for these discussions and describes the debate: "The Scottish actors continually voice their concerns that their identity as Scots get dealt with in *Tectonic Plates* . . . They are frustrated by their unsuccessful attempts to insert their own stories into the production . . . To the *Québécois* the Scots seem unduly obsessed with the question of identity."[17] Peter Mettler, the director of the film version of the show, who watched the Glasgow rehearsals, also comments on this:

> One thing I remember was that even though the Québécois started the association between the Scots, the obvious parallels between Scotland and Quebec, they in fact were not all that interested in it as a theme . . . whereas the Scots were really concerned about it and about the whole nationalist thing. . . . In the beginning for Théâtre Repère that was just one level of the subject matter, whereas for the Scots it was number one.[18]

In order to create a piece for performance, Lepage encouraged the Scottish actors to take up his more personal approach to the idea of nationalism, by speaking through the trials of individuals who are also Scots, rather than addressing the nationalist question directly. Emma Davie describes her response to this approach:

> What was interesting about the process was that it was a different way of looking at being a Scot. You looked at it through not looking at it. It was quite a revelation because I think that we are used to

looking at questions of identity face on and when we tried to look at them face on in the show they disappeared before our eyes. We couldn't get at it, we couldn't put our finger on it. There was a long, drawn-out series of scenes about potatoes and about the Highland clearances and things and somehow it just didn't come out so maybe the way that our identity comes out is in the things we brought to the show in other ways.[19]

The Scottish actors' insistence that issues of Scottish identity be addressed led to their being incorporated into the Glasgow production only in terms of the concerns of the individual characters created, characters who were peripheral to the main narrative. The developmental process stimulated a tremendous debate between the two groups about their differing ways of approaching national identity and how that should be addressed on stage; however, in the final production Lepage's approach took precedence.

Following a run of the show in London, which differed very little from the Glasgow production, *Tectonic Plates* traveled back to Canada to be performed in its final form at the National Arts Centre in Ottawa. The Ottawa production, which was performed in both an English and a French version, was seen very much as the final incarnation of the show and the culmination of over three years' work. It is interesting that in an environment where Lepage himself was involved in the cultural debate he opted for two different productions, indicating that he did not feel the show was adequate to speak to both audiences.

The Reception of *Tectonic Plates*

Again with this production I had a variety of responses that were dependent on the time and place of the performance. I first saw the initial presentation of the embryonic show at the World Stage Festival in Toronto in 1988. Like most embryonic productions, it looked very little like the final show in its fully developed form. Having recently attended *The Dragons' Trilogy* in the same city, I found this production a pale comparison. The series of improvisations based around the ideas of separation and reunion, cultural influences and interchanges, seemed heavy-handed and contrived compared with the lighter touch

of *The Dragons' Trilogy*. My second encounter with the show was in
Glasgow in 1990, the year before *The Dragons' Trilogy* arrived there.
By this time, Lepage was the subject of my research and I viewed his
work with a much more critical eye. While this production did not
offend me on national or cultural grounds, as the characters who fea-
tured were obviously French Canadian, neither did it inspire me as his
earlier work had. The show had developed significantly by this point
and the narrative structure built around Jacques, Madeleine, and
Antony had been constructed. The production, however, seemed to
take itself too seriously and aimed at a profundity it was not able to
achieve.

The third and final viewing of the production was in Ottawa,
where I traveled specifically to interview the company. For the first
time, during this viewing I found myself fascinated by the audience
response to the performance. As the performance itself was much the
same as it had been in Glasgow, a few months earlier, it was the reac-
tion of that particular audience that interested me. In Canada, the
engagement of the audience was largely with the French-Canadian char-
acters and the issues of language. In Britain, these characters were seen
as symbolic outsiders and the language debate was hardly recognized.
In a show, which expressed the differences between North Americans
and Europeans, it was fascinating to witness how these different audi-
ences responded to entirely different aspects of the production.

Looking at responses to the productions in Toronto, Glasgow,
and London can illustrate some of these differences. Greg Quill, writ-
ing in the *Toronto Star*, addresses many of my initial concerns with
the original Toronto production:

> Certainly, Lepage has a unique vision of the theater. *Tectonic Plates*
> isn't so much drama as a randomly shifting series of funny and
> painful metaphors that use language, visual imagery, mime and an
> abundance of mechanical and technological wizardry to illuminate
> the cultural and political differences between Europeans and North
> Americans as the continents on which they dwell drift imperceptibly
> but inevitably apart.
>
> If it all sounds too weighty for a mere two-hour drama, it is,
> though bright spots are many and the acting (particularly that of
> Richard Frechette, who accomplishes a heart-stopping impersonation

of a runny fried egg) generally intriguing. Still, *Tectonic Plates* is nothing less than a grand overview of civilization fragmenting. And that may be a tad too much to swallow at one sitting.[20]

Because of its presentation in a World Theatre Festival, the first explorations in Toronto also drew the attention of the London critic Irving Wardle:

A long-term project, *Tectonic Plates* is due to reach Glasgow in 1990. The Toronto version is very much the early phase of a work-in-progress: packed with ideas which nobody has yet had the time to organize. Spectators caged to the walls of the du Maurier Theatre Centre craned downwards to follow the action in and around a swimming pool on the stage floor, and upwards to a midnight-blue grand piano suspended above their heads. Chopin arrives to rattle off a geological prologue and then ascends to his instrument to supply a soothing background to an invertebrate succession of scenes (or "plates") in English, French and Spanish.

Some are theatrically brilliant, such as the sight of French immigrant party splashing through the pool and breaking into American clichés as soon as they reach the other side. Others, featuring schizophrenia, courtship and a waterlogged auction, seem to have got in simply as variations on the endless theme of separation.[21]

Both reviewers point out the fragmented nature of the show, but where Quill acknowledges the metaphoric structure of the piece, Wardle seems to look for some sort of narrative structure. These criticisms of the show's incompleteness, and particularly the heightened attention of the international press, caused Lepage to retreat to Quebec City for the next presentation of the show. There he was able to develop the piece in an environment that was sympathetic to his developmental creative process.

When the production finally reached Glasgow, it was a much more structured performance, both metaphorically and in terms of the narrative, and it was, therefore, ready to face the international critics. The reception of the Glasgow presentation by Scottish critics, not surprisingly, focused on the relationship between the Canadian and Scottish participants and looked at the incorporation of the Scottish

themes and characters. Alasdair Cameron writes in the London *Times*:

> In *Tectonic Plates*, Lepage explores the metaphorical and actual links which bind continents and their inhabitants together in a fascinating circular narrative. Some of his themes are astonishing and invigorating, such as the supernatural ties which unite Scotland's Celtic past and Canada's present. Lepage makes these ties flesh by incorporating Scottish actors into his Théâtre Repère company. As part of an international cast, these actors create Scottish characters, from the past and present, who are woven into Lepage's cyclical patterns. These link their diaspora of the clearances to a death in Venice, and the re-enactment of a pagan Celtic rite to an all-night cinema in Greenwich Village. The Scottish performers also bring to the piece some welcome reductivist humour which helps to guard against a tendency to over-solemnity.[22]

Another review of this presentation also demonstrates an appreciation of the show's somewhat dark yet whimsical sense of humor, an aspect of the production not mentioned by Canadian reviewers, as well as its metaphoric structure. John Peters in the London *Sunday Times* says:

> Lepage is an intellectual showman with an elegant streak of elitism, a bristling sense of humour tinged with self-mockery, and a breath-taking theatricality that is both playful and menacing. His stage images are hauntingly original: a deep pool of water, chairs, pianos, ancient swords acquire a sense of life like exploding metaphors. It is like thinking in dreams: the story is fractured like landmasses . . . The show has a touch of playful sadism, both physical and intellectual . . . Lepage is a structuralist intellectual in full display telling us that neither structuralism nor intelligence can heal the gaping wound which is life. I don't think he cares whether you agree or not, and there is something thrilling about his erudite, doomladen arrogance.[23]

The Scottish sense of humor matched well that of the Quebec company and the mingling of the approaches and the cultural affinities of

the two groups were appreciated by the critics in this context.

The London run of *Tectonic Plates* looked at the piece in the context of the international theater community and reflected a characteristically English desire for narrative and thematic coherence and erudition. A study of several reviews illustrates the rather more literal approach taken in London to the show's narrative and its well-intentioned (but naïve) universalist view of human nature. Charles Spencer writes in the London *Daily Telegraph*:

> The blunt fact is that *Tectonic Plates*, now at the National's Cottesloe Theatre, is pretentious. The great achievement of Lepage, the hotshot French Canadian director, writer and actor who has been likened to both Peter Brook and David (*Twin Peaks*) Lynch is that he somehow manages to make pretentiousness both absorbing and enjoyable. There may indeed be less than meets the eye but what does meet the eye is so strange and fascinating that the viewer is hypnotised into acceptance.[24]

Michael Billington in the Manchester *Guardian* describes the piece as follows:

> As an intellectual proposition, it strikes me as sentimental: the notion that we are all drifting fragments searching for some vanished wholeness, a supercontinent of the self. But, theatrically, the show is sustained by the sheer wit and resourcefulness of Lepage's imagery. . . . My feelings about the evening are, in fact, extremely equivocal . . . Scratch the hard, highly sophisticated shell and you discover a surprisingly soft centre.[25]

Claire Armitstead writes in the London *Financial Times*: "Supreme theatrical wizard he may be, a sage he is not."[26] All of these reviewers see Lepage's universalist notions of human nature as sentimental and, as a result, question his intellectual abilities. They situate Lepage's work in an international theatrical context and find his startling imagery unmatched by the ideas they represent. Only Michael Coveney writing in the London *Observer*, sees Lepage's work as worthy of the international status it has achieved:

> Already seen at the Tramway in Glasgow, director Robert Lepage's work, with a mixture of his own *québécois*, Montreal-based Théâtre Repère performers and Celtic actors, is the first genuinely reverberative international theater piece for the 1990s. Why? Because it proposes mergers, rediscoveries, interconnections and cross-cultural affinities endemic to the political changes beyond Berlin and the coalescent spirit of a united Europe. It does so in an entirely metaphorical, poetic and beguiling way. Lepage's unforgettable *Dragons' Trilogy* investigated ethnic roots and tramlines in his own Canadian melting pot; *Tectonic Plates* breaks down even more barriers of history and evolution, incorporating ideas of spiritualism and incarnation.[27]

This review recognizes both the aims of the project and the process of collaborative creation that it used to achieve those aims. This reviewer, like earlier Glasgow reviews, allows for engagement with the structural and metaphoric questions raised, and is able to overlook the somewhat weak narrative threads.

Lepage himself, looking back on the creative process of *Tectonic Plates*, is critical of its starting point. He admits to trying to please too many masters and, in the end, pleasing none:

> The problem with *Tectonic Plates* is we started out like that, we decided to do something universal because that was the demand, the people commissioning it, that's what they wanted. Then what we discovered was that we were wrong actually, what's universal is what goes on in your kitchen. If you take care of that then you're universal; people connect with it even if they're African or Asian.[28]

The conflict in the creation of *Tectonic Plates* arose when Lepage expanded his scope in terms of subject matter while, at the same time, he entered into his first truly international collaborative project. While critics uniformly commented on the failure to create a coherent vision to bind the story together, they noted the accumulation of influences allowed for a variety of means of connection with the piece. Again, the most positive reviews come from those critics who allowed themselves to engage in the developmental and collaborative nature of the creative process and who entered into the metaphoric structuralist debate presented. The reserve and disdain of the London critics, who gener-

ally stood outside the debates raised, contrasts the views of the critics more involved and, in fact, act as a contrast to their own more recent opinions.

The Seven Streams of the River Ota

By this point in Lepage's career he was an acknowledged international star with an enormous following across Europe and North America. As such, he had earned the right to demand certain concessions for his working process. Unlike previous pieces, which had their gestation period in the critically supportive environment of Quebec, *The Seven Streams of the River Ota* opened its first explorations at a major international theater festival in Britain under the full gaze of the international press. The rather insubstantial and disorganized nature of the preliminary piece presented at the Edinburgh Festival in 1994 took the British critics by surprise. Many stated outright, however, that it was due to an increased exposure of this director's work in the years between this production and the London presentation of *Tectonic Plates*. There were also a number of critics who were willing to give Lepage the benefit of considerable doubts. This public display of support by the critics resulted in an even greater engagement and personal involvement, based partly on a sense of relief, when the extended and developed version of the show returned to London two years later. What Lepage had achieved by this point was a new sympathetic critical environment which was willing to seriously engage in the debates which he instigated. While Lepage's theater had moved toward a more grounded and experiential model, the critical response to his work had moved toward a process-oriented contemplative debate; an expansion and reconsideration on both sides, which I argue has benefited both parties.

The Creative Development of *The Seven Streams of the River Ota*

With this production, Lepage returned to his interest in Eastern cultures and combined this with his new experiences and his new world-spanning vision. *The Dragons' Trilogy* begins with the words "I've never been to China"; *The Seven Streams of the River Ota* begins its story in Japan. Again the work was an evolutionary one that began as

a three-hour exploration and ended as a seven-hour epic journey to seven different times and places. In this show, the development is not chronological as in *The Dragons' Trilogy*. Ideas and images weave the characters together. Opening at the Edinburgh Festival in some disarray the show was not initially warmly received by audiences. A reworked version appeared in Manchester several weeks later. The show then arrived in October 1994 at the Riverside Studios in London, returned to Canada for further development, and returned to the National Theatre in London in its full seven-hour version two years later in September 1996.

In the first version of the show, Jana, a Czech-Jewish photographer, acts as the central narrative thread. In the longer version it is the more abstract union between East and West, male and female, which rises up out of the destruction of the Second World War that binds the characters together. The seven-hour version begins in Hiroshima with a victim of the bombing being photographed by an American Army officer. These two characters subsequently have a child, but the officer then returns to the United States and fathers another child who will be about the same age as the first. The remaining characters in this show weave in and out of the lives of these four over a period that stretches from the Second World War to the present day.

This performance addresses not only the American involvement in the Second World War and its aftermath, but also the concentration camps and the treatment of Jews, the effects of fatal illnesses such as leukemia and AIDS, and the alienation of life in large urban centers. But these themes are not new in Lepage's work, nor are his means of expressing them. Youlaki, from *The Dragons' Trilogy*, was a product of the union between a Geisha girl and an American soldier during the war. The alienation of the individual in New York was seen with Jennifer in *Tectonic Plates*.

The makeup of the company, as well as the themes and the construction of the spectacle, also show the creative path that Lepage has taken. An opera singer whose face looks familiar appears in the concentration camp scene. Reading the program, we learn that this singer is Rebecca Blankenship, who performed in Lepage's production of the opera *Erwartung*. The New York apartment scene reminds one rather too much of a scene from *Needles and Opium* in which Lepage, as the central figure in the story, has been jilted by his lover. The production

appears almost like Lepage's own creative steamer trunk adorned with stickers from the places he has traveled. His work is increasingly an expression of his own creative journey and as such is also a comment on the increasingly international nature of our society as a whole. While not all of the images and ideas presented in *The Seven Streams of the River Ota* are profound, this show has a ring of truth and experience about it that was lacking in his earlier intercultural work.

What differentiates this show from *The Dragons' Trilogy,* then, is the extent to which Lepage exposes elements of himself. Following *Needles and Opium,* an intensely personal show, aspects of Lepage's personality seem to be moving forward in his work. *Seven Streams* contains predominantly *québécois* characters on their own cultural journeys. In this show, there is a young man who travels from Quebec to Japan to study movement, a travelling theater company from Quebec presenting Georges Feydeau's *La Dame de chez Maxim* in Osaka, and a French-Canadian diplomatic couple based in Osaka. These characters seem to mimic people known to Lepage or members of the company. The diplomatic couple in particular have the ring of parodic truth about them. All this specificity of experience moves rather a long way from *The Dragons' Trilogy* and its generalized visual images and the projection of the Quebec experience onto the Chinese community in Canada. Perhaps this is a conscious effort on Lepage's part to answer his more literal-minded critics. Unfortunately, by becoming more specific in his approach to other cultures he has, in fact, created characters with a more limited appeal. Because these characters are literal, not metaphoric (with the exception of the Japanese woman deformed by the bomb), the result is that their resonance is not as great as that of those in the earlier piece. By challenging his audience less, he has also allowed it to dismiss his series of small but specific stories as insubstantial. The ability to project more onto these characters than they possess has disappeared, leaving the contrived nature of Lepage's narrative more exposed.

This show is not, of course, without insight. One profound point that Lepage does make in this show is one that stems from the idea of translation both from one language to another and from one medium to another. While Lepage has often used a number of languages in his performances to say the same thing, in this performance he questions whether or not it is actually possible to say the same thing in another

THE INTERCULTURAL EXPERIMENTS OF ROBERT LEPAGE

language or medium. As a woman tells an impassioned story in French to the audience, it is translated simultaneously into English by a man on a television screen. If the audience member is able to understand both languages, he or she quickly realizes that the translation is, at first, a bland paraphrase and later a complete misconstruction of what the woman is saying. If one is unable to understand French (or the French Canadian accent), and is, therefore, dependent on the English translator for information, that information is rendered useless by the fact that the rest of the audience is laughing at its inaccuracy. This playful scene conveys a complex message about the translatability of language and the power of language to render one an instant outsider. Also, because the presentation of the translation is on a television screen, a profound comment about our supposed understanding of other cultures through the intense mediation of the media is also made. It is a brilliant moment and one which promises that Lepage's insights in this area are by no means exhausted.[29]

The Seven Streams of the River Ota shows a slow movement toward a synthesis of the influences that Lepage has drawn together. It is once again overly ambitious in its themes and uses a soap opera-like plot that depends on the wildest of coincidences to draw the characters into one another's worlds. It is an attempt, perhaps, to reach a worldliness of content that his images have always attained. In this it is only occasionally successful and best when it is not conclusive or didactic.

The Reception of *The Seven Streams of the River Ota*

When I saw the three-hour production of *The Seven Streams of the River Ota* at the Riverside Studios in London in 1994, I had shifted positions once again. By then I was working full-time for a Canadian university with a base in East Sussex. Watching the initial explorations at the Riverside Studios in 1994, I found my most memorable response was one of disappointment. Having seen other first drafts of his pieces, I understood what to expect but still I found myself questioning the future of this piece. To my mind, the performance held nothing new: it was simply a reworking of previously used themes and images. It appeared to me to be a constructed image of creativity, which did not match well with the enormous tabloid-sized program printed in silver ink (including a huge pinup-sized picture of Lepage at its center) or the

£20 ticket price. This ostentatious display made me resent the seeming privilege of watching what amounted to an open rehearsal. In addition to my initial response of disappointment was the overwhelming desire to explain to my companion on that evening how wonderful Lepage's work usually was. My familiarity with his work, an apparent advantage before the performance, had suddenly become a liability.

While I have continued to follow Lepage's work with interest, I have most recently seen his work in the theater produced in, or traveling through, London. Despite reservations about the final presentation of *The Seven Streams,* I believe it drew together many of his ideas about Eastern cultures in a more personal and specific way and avoided the offenses of generalization and projection of experience of *The Dragons' Trilogy.* Owing to the broad and abstract nature of the themes presented, however, this production did not move me to the kind of engaged response elicited by *The Dragons' Trilogy.* While Lepage has moved closer to issues of interest to the London critics, I find that he has actually moved further away from the specific issues of identity that confront him personally. The show did, however, allow for a range of interpretations, which, along with an increased access to the developmental process, succeeded in drawing even the disdainful London critics into this production.

The disappointment I felt at the Riverside Studios is reflected throughout the reviews of this early version of the production. What is interesting is the extent to which these reviews also articulate a personal connection with the show as a result of an ongoing relationship with the director's work. Jane Edwardes of *Time Out* says:

> Many of us had glum faces in Edinburgh when this first opened, wondering if our hero had lost his way. Robert Lepage is planning to produce seven one-hour shows to match the streams of the title. It was the first two that he opened in Edinburgh in some considerable disarray; but I can report that after many weeks of work the first part at least looks as though it knows which way it is flowing. . . . There is still much work to be done, but the journey now looks like one that is well worth making.[30]

This writer's comments reflect a general sense of excitement at being involved in the creative process, which is also reflected in Kate Bassett's

review in *The Times*: "When it is finished, Robert Lepage's latest original—quietly, dazzlingly original—theater piece will be a seven-hour seven-part affair. At present it's a three-hour trilogy. The creative process is fascinating, going on under public gaze as his Quebec-based company, Ex Machina, tours internationally."[31]

That there is no need to trace the reviewer's journey of reception onto Lepage's journey of creation is also evident in Michael Coveney's review in *The Observer*:

Robert Lepage's *The Seven Streams of the River Ota* was presented at the Edinburgh Festival, the first sighting of a major work in progress. I was intrigued but slightly disappointed. An improved version surfaced in Manchester last weekend en route to the Riverside Studios in London: a profound, chemical transformation has occurred since that rickety premiere in Edinburgh.[32]

These reviews show a remarkable sense of engagement on the part of the London critics, reviewers who are well known for their emotional reserve. In a sense each one is going out on a limb to show support of Lepage's creative process, despite reservations about this initial production.

When the seven-hour version of the show appeared in London in 1996, the critics moved another step toward the emotive and the personal in their responses. The gamble to support Lepage's work had paid off for those who stood by him, and for those who did not, it was time to admit their error. Charles Spencer writes in the *Daily Telegraph* of the 1996 London appearance of the show:

Robert Lepage's reputation has taken something of a bashing recently. I was among those who found the first version of this show, premiered in 1994 at the Edinburgh Festival, incoherent and self-indulgent. Then this year, again at the Festival, Lepage had to cancel his one-man show *Elsinore* because of technical problems. He was beginning to look like an over-feted whizkid who was finding the transition into mature middle-age traumatic. But the amazing production at the National's Lyttelton Theatre, radically revised and extended over the past two years, lays such doubts to rest.[33]

This almost confessional approach shows the ongoing relationship engaged by Lepage's developmental work. The need to chart the progress of Lepage's reputation shows the reviewer's concern for presenting this artist's work in its own context.

What these reviews also show is an engagement in the metaphoric and structural debates Lepage raises, debates that these reviewers had hitherto avoided. Lepage's theater acts as a catalyst for discussion. In *The Seven Streams of the River Ota* he again raises issues that go far beyond the performance itself. Ian Shuttleworth writes in the *Financial Times*:

> Around half of *The Seven Streams of the River Ota* was seen in the UK two years ago as a work in progress, devised by Lepage and his nine actors. It now emerges as both more calmly contemplative and more diffuse than at first suggested. The latter point is a mixed blessing: on the one hand, the knot which binds every character is no longer as constricting as in the earlier version; on the other, the original vision of the piece as inspecting the 20th century through the odyssey of one woman had been abandoned, and with it a fair degree of focus.[34]

Shuttleworth's analysis of the progressive process leads him to consider the nature of narrative structure and its dramatic effect. Robert Butler in the *Independent* on Sunday compared this work to a post-modern novel: "In range and ambition, *Seven Streams* rivals a fat novel, a fractured, multi-layered one, that presents a composite story from a number of angles."[35]

Once these critics take up Lepage's structrualist perspective, the scope of the debates provoked by his work is extremely wide-reaching. Michael Billington discusses the state of world theater in his review in *The Guardian*:

> Theatre seems to be going in two directions: either to short, intense experiences like Pinter's *Ashes to Ashes* or towards vast epics like Robert Lepage's *The Seven Streams of the River Ota* which ran close to eight hours at the Lyttelton on Saturday. I should say at once that it is far more coherent than the workshop version we saw at Edinburgh two years ago. It has many passages of striking visual beauty and

intelligence. Yet at the end I was left with the nagging feeling that the show's epic form is not wholly justified by its actual content.[36]

Billington fails to realize that Lepage's piece has achieved his own contemplation of the epic form and its appropriateness in the theater. Billington's conclusion, "The show's ideas may not sustain its epic length, but the journey itself has many and varied rewards,"[37] does show an appreciation of the nature of Lepage's contemplative adventures.

What Lepage aims to do with his theater is to create a theatrical dialogue which does not stop at the footlights. As Jean St.-Hilaire points out, reviewing an early version of *Tectonic Plates*:

Il renoue avec des thèmes explorés antérieurement . . . avec un désir ardent de préciser son rapport au monde et celui du théâtre au monde.

(He rejoins themes explored before . . . with an ardent desire to make his relationship with the world and that of the theater with the world more precise.)[38]

That is an ambitious aim, but as Paul Taylor states in the *Independent*: "Lack of ambition is not—prima facie, at least—a charge you could easily level against"[39] Robert Lepage. Fundamentally, what responses to this production illustrate is a rapprochement between the theater artist and his critics. Lepage's work has taken on an experientially-based, specific nature, which is a development from his earlier work. He has, at the same time, forced a change in the response to his work, which has resulted in reviews that are increasingly personal and yet wide reaching in their scope, mirroring Lepage's own theater. With his voracious appetite for self-discovery, Lepage has pushed his audience in the same direction, forcing audiences and critics to probe more deeply into their own world views to make more precise their own relationship with the world and with the theater.

Conclusions

Lepage's work dealing with other cultures has shown a slow movement toward greater understanding and acceptance of the complexity

of the issues he is addressing. Beginning with *The Dragons' Trilogy* and its naïve but playful approach to the Chinese community in Canada, and ending with *The Seven Streams of the River Ota* and its depiction of French Canadian characters travelling to foreign lands, Lepage's productions have examined the lives and concerns of individuals. While attempting to present his view of a universal human spirit has at times led him to generalize wildly in the face of a complex human reality, his unique imagery has consistently drawn attention and engagement from his audiences. The striking metaphoric pictures he creates work best when he resists the temptation to explain them. In some ways, this was the success of *The Dragons' Trilogy*. The ability of a wide range of audiences to interpret these images according to their own experiences and environment contributed significantly to its success. *Tectonic Plates* floundered in its attempts to be universal precisely because it set out with this as its aim. *The Seven Streams of the River Ota* moved away from generalization, but continued to try to address extremely broad issues. While the comments this show makes about the holocaust or AIDS might be somewhat vague, specific points about issues close to the director's heart, such as ideas about translation and representation through language and the media, are made clearly and poignantly.[40]

Lepage's work has not stopped, of course, and it is interesting to look at the direction his creative journey has taken. He has returned once again to Quebec City, where he has built, with significant government support, a theater workshop called La Caserne. Here he will host international artists and develop significant co-productions with international theaters. Following his great world travels, it appears that Lepage has returned home to settle and act as host: "Artists grow not only by touring overseas, but by working with other artists. That's why we developed the Caserne. I wanted a place where I could host those artists who had hosted me in the past."[41] As host, Lepage can return not only to a position of artistic security, but to one that he can combine with greater knowledge and understanding of the collaborative process. Lepage stresses that he will continue to travel and work abroad: "It's a base, but it's not an anchor. I'm still mobile. Artistic collaboration is all about give-and-take. The work isn't complete without it."[42] His journey, then, is not at an end, and neither do I expect is mine in relationship to his work.

What then comes out of these parallel journeys, in addition to a series of snapshots, is hopefully a greater understanding of this director's working process and the effects of that process on the accepted approaches to spectatorship and criticism. Lepage's work has forced me to revise the way I approach criticism of his work. A greater understanding of his process may not necessarily increase one's enjoyment of Lepage's pieces, but it may increase one's ability to engage in them. And that, ultimately, is what is rewarding about his theater, that it invites engagement not judgement, participation not pronouncement.

What Lepage creates is an alchemy of interaction between his actors and their audiences. To understand the phenomenon that is Robert Lepage's theater, it is essential to look at the intensely personal relationship that Lepage creates between actor and audience. His own self-reflexive, self-mocking style brings out the same in others. Charles Spencer points out the results of this in relation to the behavior of one of his fellow reviewers of *Tectonic Plates*: "One critic, in a reckless display of exhibitionist erudition, managed to compare it to Wagner, Jung and Plato's *Symposium* in the course of a single sentence, which perhaps says more about him than it does about the show itself."[43] I suggest that it is not the universal nature of the images that are presented on the stage that produces the magic of Lepage's theater, but the self-referential, probing dialogue, which he instigates, that draws audiences into his spell. As a master communicator, his medium, the theatrical experience, will always be his primary message. As subject, however, Lepage perhaps has hit on the only truly universal human trait: we all enjoy the deeply intimate pleasures of self-analysis and self-discovery.

Notes

1. Robert Lepage, taken from an interview with the author conducted at the National Theatre in London, 30 May 1992. An abridged version of this conversation is published in *New Theatre Quarterly* 33 (Feb 1993): 31–36.
2. Lorraine Côté, "Points de repère," *Cahiers de Théâtre Jeu* 45, no. 4 (1987): 180.
3. Ibid., 182.
4. Lepage, Ibid., 184–85.
5. Marie Michaud, Ibid., 186.

6. Diane Pavlovic, "Reconstitution de 'la trilogie,'" *Jeu* 45, no. 4 (1987): 45.

7. Lorraine Camerlain, "O.K., on change!" *Jeu* 45, no. 4 (1987): 87.

8. Ibid., 83, 97.

9. Natalie Rewa, "Clichés of Ethnicity Subverted: Robert Lepage's *La Trilogie des Dragons, Theatre History in Canada* 11, no. 2 (fall 1990): 148, 159–60.

10. Jean-Luc Denis, "Questions sur une démarche," *Jeu* 45, no. 4 (1987): 159.

11. *Ibid.*, 160.

12. Michael Ratcliffe, "The Magical Sandpit," *Observer* (2 Aug 1987).

13. Celina Bell, "Hit Play Plans to Keep Moving," *Montreal Daily News* (7 June 1988): 23.

14. Stephen Godfrey "Beds, Bells and the NAC," *The Globe and Mail* (Saturday, 4 November 1989): C1.

15. Emma Davie interviewed by the author, National Arts Centre, Ottawa (12 July 1991).

16. Robert Lepage interviewed by the author at the National Arts Centre, Ottawa (11 July 1991).

17. Susan Feldman, "When Cultures Collide," *Theatrum* 24 (June-Aug 1991): 11, 12.

18. Peter Mettler interviewed by the author, Toronto (15 Aug 1991).

19. Davie interview, 1991.

20. Greg Quill, "Fragmenting Civilization Too Heavy for One Sitting," *Toronto Star* (6 June 1988).

21. Irving Wardle, "Chopin, Geology and Not Too Much to Connect Them," *The Times* (18 July 1988): 16.

22. Alasdair Cameron, "*Tectonic Plates*," *The Times* (28 Nov 1990).

23. John Peters, "Reflecting Our Split Lives," *The Sunday Times* (2 Dec 1990).

24. Charles Spencer, *Daily Telegraph* (10 Dec 1990).

25. Michael Billington, *Guardian* (6 Dec 1990).

26. Claire Armitstead, *Financial Times* (7 Dec 1990).

27. Michael Coveney, *Observer* (9 Dec 1990).

28. Robert Lepage interviewed by the author at the National Theatre, London (30 May 1992).

29. It should be pointed out that it is this very incident that Lepage has used as the basis of his recent feature film, *Nô*.

 Nô's story concerns a flighty Montreal actress named Sophie (Anne-Marie Cadieux) who is stuck playing a maid in a classical French farce staged in the Canadian pavilion at the 1970 Expo in Osaka, Japan. As she tries to terminate an affair with an actor, Sophie gets tangled up in her own offstage farce—over sushi with a starstruck Canadian diplomat and his snobbish wife. Meanwhile as Sophie frets over an unplanned pregnancy, the comedy flips between Osaka and a hilarious

subplot in Montreal, where Sophie's boyfriend, Michel (Alexis Martin), is trying to plant a bomb with a bungling group of FLQ terrorists (Brian J. Johnson, "A festival zeros in on Quebec: Robert Lepage re-examines the October Crisis in his new feature," *Maclean's* 7 [Sept. 1998]: 52–53).

30. Jane Edwardes, "The Seven Streams of the River Ota," *Time Out* (2 Nov 1994).

31. Kate Bassett, *The Times* (25 Oct 1994).

32. Michael Coveney, *Observer* (13 Oct 1994).

33. Charles Spencer, *Daily Telegraph* (23 Sept 1996).

34. Ian Shuttleworth, *Financial Times* (24 Sept 1996).

35. Robert Butler, *Independent* (29 Sept 1996).

36. Michael Billington, *Guardian* (24 Sept 1996).

37. Ibid.

38. Jean St-Hilaire, "Les Plaques Tectoniques à l'Implanthéâtre: Quatre toute petites heures de transports poétiques," *Le Soleil* (23 Nov 1989): D1.

39. Paul Taylor, *Independent* (23 Sept 1996).

40. Lepage's decision to make *No* a feature-length film, which extends and expands these themes in another medium, indicates how close these issues are to his heart and to the center of his artistic explorations. Brian J. Johnson in Maclean's writes, "For Lepage, who spends his life touring the globe with audacious productions of opera and theater, *No* marks a homecoming of sorts" (Brian J. Johnson, "A Festival Zeros in on Quebec: Robert Lepage Re-examines the October Crisis in His New Feature," *Maclean's* 7 [Sept. 1998]: 52–53).

41. Robert Lepage quoted in "The World at his Feet" by André Ducharme, *Enroute Magazine* (March 1998): 46.

42. Ibid.

43. Charles Spencer, *Daily Telegraph* (10 Dec 1990).

The Staged Body in Lepage's Musical Productions[1]

Piet Defraeye

LEPAGE'S *MISE-EN-SCÈNE* has often been called filmic. While it is not always clear what is meant by this categorization, the reference is, among others, to the visual spectacle that unfolds itself on the stage. It is a spectacle that creates a particular tension between, on the one hand, the immediacy of the presentation, its live character, and its stunning visual seamlessness, on the other hand. The effect is one of transformation of space(s), common objects, and actors' bodies, hence the term "object theater." This essay focuses on some of the physical aspects of Lepage's *mise-en-scène,* more particularly, it offers an analysis of the theater director's use of the body on the stage.

The body in performance is a widely discussed topic in contemporary performance criticism, and especially in postmodern theory. My interest in Lepage's use of the body on the stage comes from an observation of a certain paradox in his stagecraft, which confirms that theater has an anachronistic quality in our virtually experienced techno-world. The relative old-fashionedness of theater is undoubtedly also its strength. Lepage's productions often display technological bravura, while the stage dynamics and the relationship between stage and audience are based on established conventions. Despite its high tech, multimedia quality, his theater remains "a concretely physical space where temporal and spatial perceptions are shaped by what comes physically into the space."[2] One of the most remarkable strategies of Lepage's exploitation of theatrical physicality is the way he uses and places the performed body in the performance space. Johannes Birringer's general observations are applicable to Lepage's stagecraft:

"the self-evidence of this space, and of the mechanics of the live body of the performer, is precisely what the theater can defer and speculate on by making us apprehend its relationship to the not-seen and not-heard, to the out-of-place and the forgotten." Lepage's staged body, through its interaction with itself, its surrounding space, and its audience, becomes, what Amelia Jones calls, an "embodied subject,"[3] in which interior motifs and exterior potential are in constant dialogue and rivalry for interpretation and obfuscation. The body on Lepage's stage, in other words, wants to be a locus that hides and reveals "all of its apparent racial, sexual, gender, class and other apparent or unconscious identifications."

The hermeneutic process in western theater has traditionally been dominated by words. For the purpose of this study, its focus is on a genre in which the word becomes secondary to a more prevalent semiotic system, that of music. Lepage's experimentation with non-verbal dominated theater is well known. Apart from his interest in Oriental theater, he has also directed a number of musical performances; among them are operas like *Noises, Sounds and Sweet Airs* by Michael Nyman (1994), Béla Bartwell *Bluebeard*, and Arnold Schoenberg's *Erwartung* in 1992. He also did the *mise-en-scène* for Peter Gabriel's *Secret World Tour* in 1993. I will refer primarily to the much-acclaimed Canadian Opera Company production of *Erwartung* and *Bluebeard*[4] and to Gabriel's *Secret World Tour*.

Research on Lepage's productions is a challenging enterprise, because the productions tend to change during the various *reprises* and, moreover, unlike Robert Wilson's or Peter Brook's work, they are not well documented on film or video. The Peter Gabriel video, which is commercially available, is a notable exception.[5] For my research on Lepage's opera, I spent several days in the archives of the Canadian Opera Company where my primary sources were two rather poor quality video tapings of the 1992 and 1995 Canadian Opera runs, respectively, and the promptbook for each of these productions (which, for all practical purposes, were almost identical, apart from some technical solutions to specific problems). Isolde Pleasants-Faulkner, who stage managed the double bill *Bluebeard-Erwartung* kept meticulous notations in the promptbooks. They consist of the score with the corresponding stage plan, and read like a colorful geometry of signs and signals that create presence for sound and body, light

and darkness, distance and proximity. Her records also document the technical challenges that accompany any Lepage production. In *Bluebeard*, for instance, there are seven different categories of technical cues, all indicated with different colors (Light, Sound, Flie, Smoke, Slide, Track, Water) that jump out from the page.

This argument is also based on my own perception of Lepage's interaction with text, bodies, and the stage. Some years ago, I had the opportunity to work with Robert Lepage as an actor in a university production of *Macbeth*.[6] It was a particularly illuminating experience, one that allowed me a first-hand reading into a wonderfully creative mind. One of the things that became very clear during the rehearsals is how Lepage's focus on the theater is driven by visuals. I am, of course, not the first one to isolate this aspect. It became increasingly clear, however, that these fantastical visual scapes are strongly linked with soundscapes that bring about certain rhythms, which in turn affect the physical composure of Lepage's bodies on the stage. At the beginning of a rehearsal, or during a break, Lepage would play one or another CD that seemed to connect with the kind of imagery that would grow on the stage. In a revealing comment on his filmmaking pursuit, he points out that, despite the imagistic forcefulness of film, it is "actually much more the sound that does the work. There are images of course. But the soul of the images are the sounds and oddly enough a lot of my work is musical but come [*sic*] out as very visual pieces."[7] This statement also reflects another characteristic that brings about a certain visual and auditory bias. During rehearsals of *Macbeth*, the traditional preoccupation with textual analysis, which has been an unavoidable starting place for most stagings of Shakespeare, virtually disappeared. There was, instead, what appeared to be a certain nonchalance with the text, with the words in the script. We have to qualify this immediately because, of course, Robert Lepage is interested in the lines of a playscript and their meaning, but this interest is mostly in function of their visual impact *and* in function of their sound: which means their melody and rhythm. He is interested in the physicality of language as it becomes a presence on the stage.

Lepage's appreciation of language as a visual force is also reflected in his observations about the difference between Anglophone and Francophone theater dynamics. The former is geared toward an

audience, a term that underlines the cognitive and auditory quality of the interaction between stage and auditorium, while in Francophone theater, according to the Quebec director, the prevalence of the term *public* or *spectateurs* is indicative of a predominant focus on the visual or spectacular aspect of this interaction.[8] His approach comes with a decisively visual predisposition in which *the word*, while retaining its cognitive strength, is transformed into a visual and often physical presence on the stage.

When commenting on the physical demands on his theater actors, Lepage refers to the art of theater as "le sport du théâtre."[9] His conceptualization of Peter Gabriel's *Secret World Tour* exists very much in the sphere of live sports, both in terms of its performers/athletes as well as its audience involvement. In contrast to an opera like *Erwartung*, the essential stage dynamic here is exterior rather than interior. One of the main objects on the stage underscores this exteriorization: a huge revolving projection screen on which the audience watch not only all kinds of video animation, but, also, a hyperbolic picture of certain parts of the stage and stage objects, and macro images of parts of Peter Gabriel's face that are transmitted from a micro camera attached to his head as an entomotomic antenna.

The stage itself is part of this reductionist exteriorization: a huge circle on one end and a square at the other end, connected with a long and narrow walkway, with a built-in conveyor belt. The implied symbolism revolves around masculinity and urban cultures (the square), femininity and rural, organic values (the circle), and the need for communication and transition (the walkway).

Referring to the staging of rock-music, Peter Gabriel uses the term "visual intelligence."[10] There are many visuals in Gabriel's *Secret World Tour*, and the whole show is intelligently put together. Gabriel and Lepage went through the list of songs and started drawing up a kind of geography of the show, by putting different songs in different categories and places.[11] The result is a stunning cauldron of technical wizardry and trickery. Most of these effects serve to illustrate the lyrics of Gabriel's songs, like belts of steam coming out from the stage during the song "Steam," and a tree popping up in "Shaking the Tree." They impress and entertain the audience not because of what they add to the pseudo-poetic lyrics of the songs, but because they underscore the rhythm of the music, and also, more important, because they defy

82

conventional staging, and bring the familiar effect and ambiance of the video-clip live on the stage either through involving technology or through *trompe-l'oeil* effects.

In the song "Secret World," for example, Gabriel, clad in a magician's coat, drags an enormous suitcase onto the walkway, through which the entire band, including his co-singer Paula Cole, subsequently disappear. The scene does not even imply a farewell *à la Prospero* of the magician/singer and his stagehands, since, barely a song later, they are back on stage for the finale. The whole episode does not go beyond the impression of clever trickery, a technique that, in Lepage's own words, is essential in his stagecraft: "theater arts revolve around trickery."[12] The result is a performance that does not go beyond a "static depiction"[13] of body, in which there is hardly any dialogue, dialectic or otherwise, between interior and exterior. The staged body in *Secret World Tour* remains, in other words, a predominantly exterior performance. The micro camera attached to Gabriel's head never manages to penetrate any protecting layer, there is no revelation; at the very most, as one reviewer pointed out, we get a good "shot of his [dental] fillings."[14]

There is, perhaps, one notable exception. The show opens with the song "Come Talk to Me" with Peter Gabriel singing from a seventies-era red telephone booth into the receiver. While the micro-camera projections on the screen are mostly part of a clichéd convention of rock-music concerts that need enlargement of the diminutive stage for its huge audience,[15] the snapshots of Gabriel's confined head provide an intimate reading of an inner drama. As the song develops its appeal for the need for communication, Gabriel clasps the square windows of the booth, and finally emerges, pulling and stretching the black phone cord onto the twenty yard-long walkway, desperately reaching for a hunched figure who stands in the dim light of the opposing circular stage. The figure turns out to be Paula Cole, her innocent beauty complemented by her celestial caterwaul. Within the first few minutes of *Secret World Tour*, a multi-layered image develops of isolated bodies struggling with desire; the phone cable becomes an umbilical cord that both releases and ties down, stretching self, and body, to their very limits.

Lepage's stagecraft presents "the actor's body as language as well as object, and thus it becomes part of an ensemble of scenic metaphors."[16] In order to understand the phenomenology of the body on Lepage's

stage, it is useful to reflect on the significance of Lepage's artistic interest in the genre of opera. Robert Lepage is naturally attracted to the genre because of the freedom it provides, the freedom from a certain naturalism. "The thing I love about opera is that it is so theatrical. In real life people don't sing,"[17] he once declared in an interview. The alleged affectation and contrived convention of the operatic genre where characters sing their way through some sort of narrative is for Lepage an opportunity for indulgent theatricality, unconstrained from the tyrannical demands of realistic representation, as it is exacerbated in Hollywood's popular culture. "The convention of falseness makes for a theatrical truth,"[18] he quips in another interview. It is also not surprising that Lepage forcefully opted to have both *Bluebeard* and *Erwartung* produced in the original Magyar (Hungarian) and German, respectively, thus reducing the language even further to sequences of vowels and consonants, diphthongal slides, guttural throat sounds, and glottic contractions and modulations.

The semiotics of music are clearly less codified than those of language, and it is no coincidence that Lepage's theatrical imagination finds in the operatic score a natural ally with which to mount a visual and auditory play with endless possibilities. It is also an art form that is paradoxically very much dependent on a staged realization. We can only imagine an obsessive opera fanatic as a regular reader of operabooks, scores with their librettos. Any opera cries out for a body, and more specifically a singing body: the "complex music of opera is brought to life, literally incarnated, in singing bodies, bodies singing words and acting out their stories on stage."[19] The words and sounds of opera demand, in other words, a corporeal realization, which is Lepage's specialty. His choice of Schoenberg's early composition as his experimental exposure to opera may well be a good one. It is a compact work, the C. O. C. performances took between thirty and thirty-two minutes, and, with its chromatic tonality and its myriad variations and transpositions of chords that are in constant rotation, the opera presents itself as a musical stream of consciousness that leaves lots of room for interpretation. *Erwartung* has been described by Vassily Kandinsky as "acts of the mind," and Lepage complements this appreciation with his strongly physically anchored 1992 production.

Although the opera has a fascinating and haunting libretto, written by Dr. Marie Pappenheim, its narrative yields to the gyrations of

the music. The story is first and foremost Schoenberg's chromatic composition. Theodor Adorno, in his *Philosophy of Modern Music* has stressed the cognitive character of Schoenberg's scores as a kind of revolt against the decorative function of music. The twelve-tone compositions function as a kind of rebellion, "the liberation of expression from the consistency of language,"[20] and at the same time a return. "The human being who surrenders himself to tears and to a music which no longer resembles him in any way permits that current of which he is not part and which lies behind the dam restraining the world of phenomena to flow back into itself."[21]

What Robert Lepage does in his *mise-en-scène* of the opera is complete that return, after the liberation, to the world of phenomena. It is important to note that the liberation is at least twofold: a freedom from naturalism that is brought about by the operatic convention, but also a radical move away from Schoenberg's detailed stage directions that accompany the libretto. The composer calls for a set with moonlit roads and fields, lots of trees, and a house with a stone balcony whose windows are covered by dark shutters none of which we get to see in Lepage's production designed by Michael Levine. The director's greatest departure from Schoenberg's libretto is the addition of three personages and the establishment of a different locus.[22]

The production opens with a projection of a wall on a white scrim, on which, almost like graffiti, we can read Schoenberg's handwritten signature and title of his composition. It confirms the opera as a form of *écriture* or, in Adorno's words, a form of knowledge, which is about to be materialized. The projection of Schoenberg's handwriting recurs several times throughout the monodrama, often enough to underline or make explicit the filmic quality of the *mise-en-scène*.

Through the scrim, the stage becomes visible and we see another wall, an imposing perspective of a receding brick wall. This opening moment offers a perceptive blending of two mediums. Filmic projection and stage reflect one another. The projection fades out and we see a woman sitting on stage, in front of the wall, kneeling, upper stage left. She is bundled in a white straightjacket with her hands tied behind her back, and the stage is silent as a man in a white labcoat walks from upper stage right to upper stage left, sits down in a desk chair, flips open a note pad, and grabs a pencil. A moon slowly rises stage center and moves stage right. The whole sequence takes place in complete

silence and goes on for ninety mesmerizing seconds, finally broken by
the steadfast opening gasp of a clarinet that hauls in the rest of the
orchestra. It is arguably the longest pause in operatic production; a
pause before its beginning, a silence that creates the space that is to be
filled by sounds, and a silence that creates the sound that is to become
the prime mover of the bodies on the stage. Lepage's composition rein-
forces *Erwartung*'s cognitive point of origin, an intellectual *écriture*,
and its physical point of realization in his representation of the individ-
ual as a desiring body. The medicalization of this desiring body within
a pathological environment has to do both with the historic origin of the
opera with the emerging theories of the subconscious in the early twenti-
eth century and with the fact that opera itself is dependent not only on
its realization in a body on the stage, but also the, often emphatic,
proclamation of that body as a suffering presence. Linda and Michael
Hutcheon point out this aspect in their study of opera and disease: "Of
all the art forms, perhaps only opera is so thoroughly dependent on suf-
fering in general as a narrative and emotional staple. The *body*, the
singing body, gives voice to the drama of the suffering *person*."[23]
Lepage has given multiple realizations of the Woman's suffering in his
addition of three bodies to the singing one.

As Schoenberg takes risks in his operatic score, so does Lepage
take great risks with his actors' bodies, a risk which is exacerbated by
the immediacy of live performance. It is also a risk that demands a spe-
cial sort of stage manager. Isolde Pleasants-Faulkner, the stage manager
for the C. O. C.'s double bill, makes a stoic note in her promptbook,
referring to an early cue when Rebecca Blankenship is on her own to
untie her hands: "straight jacket sleeves released (if lucky)."[24]
Something can always go wrong and often does.[25] A particularly chal-
lenging moment happens in the beginning of *Bluebeard*, after
Bluebeard has aroused Judith's desire to enter his castle to the extent
that she cannot wait any longer. It is a moment of intense curiosity and
mutual sexual longing. Both are on the apron, or the very front, of the
stage. In what amounts to a cinematic cut, Lepage gives his two
singers/actors seventeen seconds to run a considerable distance from the
front of the stage, behind the set, to the upstage entrance gate to
Bluebeard's castle where Victor Braun, who sings the role of Bluebeard,
has to gather his baritone voice immediately to "let the door be shut
and bolted."[26]

Having a character appear at one place and then the next moment at a completely different spot just on cue for the music is the kind of stuff that we see on TV channels like Much Music. The human body, in these music videos, often does all kinds of fantastic things that seem to defy the possibilities of ordinary human physics. Perhaps, unlike any other art form, the ever-growing music video genre presents a truly postmodern body: fragmented and eclectic, composed and deconstructed, unconforming and yet harmless. We have become used to it, because we vaguely understand the tricks: it has to do with money, beautiful bodies, skilful cameramen, and wizardly techies with PowerMacs in rented studios.

Lepage likes to use beautiful bodies too; he usually has at his disposal considerable sums of money, a handful of highly qualified technicians, and a bagful of tricks, and with all of this, he does live theater. His stage compositions may not be more beautiful or awesome than the kind we see in music videos, but they are more involving and more embroiling, usually more resonant, and also more important. While we recognize the filmic quality, and, perhaps because of our conditioning, embrace the visuals of his productions, we are mesmerized by the live quality of these compositions.

In his discussion of the European tour of *Hiroshima* (1996), Reinhard Kager refers to Lepage's dramaturgy as "Theaterfilm": "it has neither to do with traditional theater nor with conventional film, but filmic techniques such as reverse scenes and scene cuts that are used theatrically so the spontaneity of the stage is preserved."[27] It is an unfortunate choice of words. As in most of Lepage's other stagings, there is very little spontaneity in his operatic work in the way the actors allow their bodies to blend in with the score, and become extensions of the music. When the two dancers/acrobats Noam Markus and Sue Johnson, after a love scene in a metal hospital bed, lift the bed and fold it from underneath themselves away from the stage, purely relying on muscular power and careful maintaining of balance, we can hardly speak of spontaneous moves. Again, in its slow-move quality, and its extremely challenging physics and calisthenics, the scene comes across as something to be seen on film. Similarly, in a later scene, the lover and his mistress, both completely nude, slowly emerge from an opening in the wall, onto the bed, writhing underneath the sheets, while the Woman/soprano laments

her vision of an unfaithful lover. The two lovers roll over each other while holding onto the bed so that it too revolves upstage, whereupon Markus turns over and rolls diagonally stage center in front of the Woman.

The interactions between bodies and water, both in *Erwartung* and *Bluebeard* have a similar filmic effect, produced live on the stage. When, at the end of Bartn/soprano laments her vision of an unfaithful lover. The two lovers roll over each other while holding onto the bed so that it too revolves upstage, whereupon Markus turns oage, their bodies, hair, faces and costumes dripping with blood-dyed water. It is an arresting moment. "Living, breathing. They live here!"[28] Judith exclaims, complementing her shock with the spectator's astonishment. Living and breathing creatures, submerged in water, now strutting across the stage: they become re-invented bodies, coinciding with Bluebeard's project of appropriation and conquest. Biology and physics have seemingly been overcome for a brief period.[29]

A similar effect happens at the end of *Erwartung*, when the Woman's lover, now dead, rolls diagonally across the raked stage to downstage right, into a puddle of water. When the nude body of Noam Markus slowly and completely submerges into the water, the theme of physical absence acquires a body on the stage in the literal disappearance and erasure of his perfectly proportioned body. "What am I to do here alone? In my unending life . . . This colourless, boundless dream . . . ,"[30] the Woman commiserates. For her, as well as for the audience, what is left remains an empty space, moments before occupied by a living body.

One of the most exquisite moments of *Erwartung* is found in scenes two and three, when the Woman sings about a "tree-trunk" and a "crawling shadow." In a striking surrealist composition, Lepage arranges three bodies in a vertical line, on a horizontal plane, alongside the wall. The psychiatrist, after a somersault roll in his chair, is in a horizontal position, propping himself up with his elbows, with his legs against the wall;[31] the lover crawls out of the wall, feet first and then turns and crawls toward the floor, head down;[32] while the Woman, in an operatic *tour de force*, sings her lines while lying on her side, feet against the wall, thus completing the formation. Robert Thomson's lighting adds to the effect through the technique of *chiaroscuro*, creating isolated human beings, suspended in a fragile visionary nightmare.

88

Gravity is being defied here. It is the music that takes over and makes these bodies' immediacy even more present, while at the same time providing them with an energy that seems to supersede their physical limitations. The overall effect is one of physical presence, which coincides with the motif of the Woman's lament for her lover, and also with the opera's main theme: the Woman's maddening desire for bodily presence.

Lepage's radical dramaturgy is not so much located in his challenge of what could be called "the irreducible and uncompoundable reality"[33] of the human body on the theatrical stage, Lepage's "architecturalization of the human body,"[34] but rather in the forcefulness with which he requires that body to be present and the spectator to engage with it. Johannes Birringer's assertion that "it becomes increasingly disingenuous to claim that directors/stage designers like Wilson have changed the way we see images and experience space-time, light, color, volume and movement in the theater,"[35] also applies to Robert Lepage's stagecraft. Our viewing and auditory sensibilities have been well trained through network and cable TV, cinema, MTV, video, TV advertising, and, more recently, moving images on the internet. We have come to expect this kind of choreography and are experts at reading it. In fact, we have changed the way contemporary directors and stage designers think about visualization and, what can be called, the "architecture of perception."[36] Ironically, Lepage himself acknowledges the expertise of an important audience contingent, while commenting on the operatic genre: "Teenagers, brought up on a diet of MTV and pop videos, are already fully literate in the convention of telling stories through music and visual images."[37]

While Lepage's staging of *Bluebeard* can be classified as a clever and stunning illustration of the story of the four brides and seven doors, in *Erwartung* we go beyond this narrative visualization. Lepage manages to turn an inner reality, the neurosis of a lonely and disturbed woman, into an outside reality by exploiting what is both our expertise and our expectation, our gaze on the simulated body, and turns the theme of presence and absence into a fascinating struggle of human bodies with themselves and their physical and emotional limitations. As one reviewer of the double bill commented, it is "with *Erwartung* that Lepage decisively enlarges his emotional range."[38] His use of the body in this production, brings about what can effectively be called an

artistic symbiosis between mediums and themes. Theodor Adorno pointed out the polarized system of expression in Schoenberg's *Erwartung:* on the one hand, we hear "gestures of shock resembling bodily convulsions" and on the other hand, the music moves "toward a crystalline standstill of a human being whom anxiety causes to freeze in her tracks."[39] Lepage, in his *mise-en-scène*, with the assistance of first-rate performers, makes us also see this polarization in the human body itself. In doing so, Lepage reconfirms an old law of the stage that sees the presence of the performing body "as the primary condition for a shared experience of the social relations of theater."[40]

In his polemic on postmodern theater, Birringer admonishes us "to give more attention to those postmodern performances that do not let multimedia apparatus represent itself to itself, but react against that *mise en abîme* by foregrounding, and experimenting with, the transformable theatricality of body and voice in real space-time."[41] There are various occasions in Lepage's *oeuvre* where these conditions are clearly not achieved. On the other hand, in his *mise-en-scène* of Schoenberg's *Erwartung,* the transformation of the performed space, through an intense dialogue between this space and its occupying bodies, objects, and sounds, achieves an intensity in the experience of presence rarely achieved on the stage.

Notes

1. I would like to thank Alex Hachey, Blaine Herrmann, Birthe Joergensen, Judy Kennedy, Bruce McMullen, Isolde Pleasants-Faulkner, and Muriel Smith for their help and assistance. Research was made possible with a grant from the Research Fund of St. Thomas University, Fredericton, New Brunswick.
2. Johannes Birringer, *Théâtre, Theory, Postmodernism* (Bloomington: Indiana University Press, 1993), 31. The subsequent citation is from the same page.
3. Amelia Jones, *Body Art/Performing the Subject* (Minneapolis: University of Minnesota Press, 1998), 3. The subsequent citation is from p. 13.
4. Béla Barts: *Bluebeard's Castle* and Arnold Schoenberg, *Erwartung.* Produced by Canadian Opera Company (Toronto, 1993 and 1995). Subsequent references to the producing company: C. O. C.
5. Peter Gabriel, *Secret World Live* (video) (Los Angeles: Geffen Home Videos, 1994). The show was conceptualized by Robert Lepage and directed by François Girard.

6. William Shakespeare, *Macbeth*. Directed by Robert Lepage. Toronto: Hart House (Graduate Center for Study of Drama, University of Toronto), 1992.

7. Quoted by Bianca Nero, "Sounding out Robert Lepage; Stage Director, Actor, Writer," *The Financial Post* (London), 29 October 1994, S5.

8. "Qu'on dise *audience* ou spectateurs, on ne parle pas non plus de la même chose. Alors que les francophones et les Italiens viennent voir un spectacle, on sent très fortement chez les Britanniques et, par extension, chez tous les anglophones, cette notion du verbe, de la voix et du son dans le théâtre. Les publics anglophones viennent vraiment nous écouter. On cherche à sacraliser le langage, à trouver le langage qui se cache dans le langage." (Robert Lepage in Rémy Charest, *Robert Lepage: Quelques zones de liberté* [Quebec: L'Instant même, 1995], 67.)

9. Quoted in Charest, 99.

10. Quoted in Mick St. Michael, *Peter Gabriel in His Own Words* (London: Omnibus, 1994), 57.

11. See Richard Harrington, "The Secret Tour," *Washington Post* (20 June 1993), G3.

12. Quoted in Charest, 173.

13. Jones, 5.

14. Joseph Gallivan, "Oh, and the Songs Were Good, too," *The Independent* (London), (3 June 1997), 17.

15. There is a distinct difference in the use of cameras and projection screens between *Secret World Tour* and other Lepage productions. For a discussion of the effects in *Elsinore* see Marta Dvorak, "Représentations récentes des *Sept branches de la rivière Ota* et d'*Elseneur de Robert Lepage*," *Nouveaux Regards sur le théâtre québécois* (Montréal: XYZ, 1997), 147–49. See also Christopher Winsor, "Robert Lepage: Beyond the Spotlight," *Shift* (Summer 1994), 31.

16. Dvorak, 145. (My translation.)

17. Quoted in Lyn Gardner, "Tournez Lepage," *The Guardian* (London), (15 August 1993), S7.

18. Quoted in Clare Bayley, "Edinburgh Festival Day 12," *The Independent* (London), (27 August 1993), 14.

19. Linda Hutcheon and Michael Hutcheon, *Opera: Desire, Disease, Death* (Lincoln: University of Nebraska Press, 1996), 10.

20. Theodor Adorno, *Philosophy of Modern Music* (London: Sheed & Ward, 1973), 128.

21. Adorno, 129.

22. While several reviewers have suggested Lepage's psychiatric setting to be a pioneer choice, it has been done at least once before. Teatro La Fenice's 1987 production of *Erwartung* (in a triple bill with Puccini's *Il tabarro* and Manuel de Falla's *La vida breve*) in Venice turns the forest into "a

lunatic asylum" (Alessandro Camuto, "Venice," *Opera* (September 1987), 1069).

23. L. & M. Hutcheon, 12.
24. Isolde Pleasants-Faulkner, Promptbook for *Bluebeard/Erwartung* (C. O. C., 1993), 8a. In an interview, the stage manager adds: Rebecca Blankenship "had one hell of a time with those sleeves. . . . And there were a couple of occasions in performance where the sleeves didn't release, and she would just get her body out, and she managed every time. . . . She's a real trooper! She just did it" (Interview with Isolde Pleasants-Faulkner, 2 May 1998).
25. The stage manager's show reports of the various performances of the 1993 and 1994-95 productions mention several minor incidents that have to do with the complex and unforeseeable aspects of the *mise-en-scène*. The presence of water in both operas and the necessity for actors to be fully submerged in it was obviously one of the greatest challenges. Other challenges include Judith's pearls, the use of smoke, which affected Victor Braun's vocal cords in *Bluebeard*, the protruding tree branch, and the travelling moon in *Erwartung*.
26. The promptbook underlines the technical challenge of this quick change of location. "ASM >runs' u/s w[ith]/B[lue]B[eard] + J[udith]BB leads. ASM spreads J's train on stairs in prep[aration] for ent[rance] (Isolde Pleasants-Faulkner, Promptbook: 9b). The stage manager recalls that, depending on the venue, this was often a "really scary" disposition to be in, since the distance to be covered could be considerable, especially for the Hummingbird Center performances in Toronto. "There would be a take-down of the lights just as they hit the corner. My assistant would grab their hands and they would literally run along a taped runway around the set and get up into position, and there were a couple of intermediary cues . . . to join together with the music" (Interview).
27. Reinhard Kager, "Grauen im Spiegel der Schönheit," *Opern Welt* 8.54 (August 1996). (My translation.)
28. "Élnek, élnek, itten élnek." (*Bluebeard's Castle* [London: Decca Sound Brochure], 24.)
29. From the previously mentioned interview, Isolde Pleasants-Faulkner recalls:

> "We had two people off-stage, my two assistants," and the three brides. Two could get into the pool at the same time and on a touch of the shoulder, the first in the line-up then would [get ready]. . . . They'd get into the water. They'd gather up their dresses; and this was the hardest thing. They had to gather their dresses between their legs because they didn't have an awful lot of depth, and they had to crunch down and push off without their dresses sort of floating up. . . . There was a step on the on-stage side, so they would slowly come up, and

92

release their dresses behind and take the step up . . . and start moving
. . . . Gathering the dresses was the hardest part, because they would
fill with air . . . they were quite a very heavy silk and once it got wet,
[they] became heavier; but also, if air got under it, [the silk] would
bubble up. . . . The problem of not hearing any of the music cues, when
submerged in water was solved with a code: We had a lead pipe that
one of my assistants would knock at a musical point, we worked it out
in terms of timing, swimming time and rising time, and all of that.
When they were actually under the water, they would get a knock and
that would be their go to start their movement."

30. "Was soll ich hier allein tun? In diesem endlosen Leben . . . In diesem
 Traum ohne Grenzen und Farben . . . " (*Erwartung* [Vienna: Universal
 Edition, 1996], 23).
31. Isolde Pleasants-Faulkner recalls the particular challenge of this scene,
 which required a high degree of coaching of the acrobat/actor Mark
 Johnson by Robert Lepage: "it was a series of steps for [Johnson] to physi-
 cally be able to do that move. . . . When we first started working on that
 particular move, the chair went through a number of changes as well to
 accommodate what he was doing, and to try and avoid bruises and that
 kind of thing" (Interview).
32. Noam Markus had to perform a sort of mountaineering, but in reverse
 and upside down. "He had a special strap off-stage, and he had a person
 there to assist him, after the flap was opened, to get into the initial posi-
 tion. . . . It was a real tough move for Noam, because it was fast"
 (Interview).
33. Michael Sidnell in an unpublished essay, "Fronteras Teatrales."
34. Johannes Birringer uses this term in reference to a postmodern aesthetic
 that works, plays, and flirts with a model body that, through various per-
 formative simulations, becomes a automatized form that transcends tradi-
 tional limitations and categories of the body in performance (see Birringer,
 177–81, 205–16).
35. Birringer, 174.
36. Birringer, 175.
37. Quoted in Bayley, 14.
38. Raymond Monelle and Paul Taylor, "Edinburgh: The Best of Two
 Minds," *The Independent* (London), (31 August 1993), 10.
39. Adorno, 42.
40. Birringer, 177.
41. Birringer, 180.

Robert Lepage's Cinema of Time and Space

Henry A. Garrity

HAILED BY MANY reviewers as innovative contributions to the Canadian cinematic canon, Robert Lepage's two feature films *Le Confessional* and *Polygraphe* deal with multiple readings and interpretations of truth. With similar paradigms of texts within texts, both films use temporal and spatial narrative structures. Spanning time and space, Lepage's mobile camera juxtaposes the "here and now" with the "there and then" as might a theater director moving by alternate lighting between multiple sets.

When *Le Confessional* appeared in 1994, the popular press acknowledged its inspiration in Alfred Hitchcock's 1953 suspense thriller *I Confess*, both set in Quebec City. Hitchcock tells the story of a priest who hears the confession of a murderer. Silenced by the seal of confession and unable to reveal the murderer's identity, the priest becomes the prime suspect, is arrested, and tried. Lepage's scenario tells a story chronologically parallel to Hitchcock's, representing, on one level, an homage to the master filmmaker and, on another, a commentary on the sociopolitical evolution of modern Quebec society in its perpetual search for identity.[1]

Yet, few reviewers go beyond commenting on Lepage's clever interplay between the two scenarios while some denigrate his effort as over-complicated narration. About Lepage's assimilation of *I Confess*, virtually none of the contemporary reviewers suggests that the exercise consists of anything more than a tour de force. An exception, Christophe Brynix writes: "[Lepage] mélange à la fois le présent, le passé, la fiction et la fabrication de la fiction, et crée des lieux presque

95

magiques entre ses quatre histoires" ([Lepage] mixes the present, the past, fiction and the fiction of a fiction creating almost magical spaces among his four stories). The following analysis posits, however, that on a third level, *Le Confessional*'s search for personal identity, a metaphor for Quebec's quest for national identity, represents no less than a metatext, an alternative scenario of *I Confess*.

Fundamental to an understanding of how Lepage integrates Hitchcock's film are the time/space codes. In Hitchcock's text, they take the form of flashbacks. Technically similar, each of *I Confess*'s evocations of past time begins with the camera's panning into a dissolve and ends the reverse way returning to the diegetic present of 1952. What links them to classical flashback montage is that they are memories recollected voluntarily by a diegetic character.

Hitchcock's editing is a recognizable staple of Hollywood's most traditional fare, never straying from innumerable models of classic montage. For instance, Michael Curtiz's *Casablanca* features flashbacks to a past time (June 1940) and a past space (Paris) to explain why the two protagonists, now in the diegetic present of Casablanca, became separated. As in *I Confess*, the past time of *Casablanca*'s flashbacks is expository, providing a vehicle for a past truth to be known in the present. A diegetic speaker, like the interviewed Louis in *Interview with a Vampire*, who controls the reconstruction and understanding of the past may introduce these types of flashback. Another example of flashback can suggest the uncertain truth of the past, as in *Hiroshima mon amour* where the image evoked may reveal more truth than the accompanying voice-over. In yet another example, the past may be awakened involuntarily by an external event, in such cases as Gregory Peck's dream sequence in another Hitchcock standard, *Spellbound*.

Eschewing Hitchcock's flashback editing, *Le Confessional* narrates past time with space through parallel cuts and tracking shots. At times reminiscent of *Citizen Kane*, Lepage's temporal transitions recall the time/space puzzles and multi-layered narrativity in Alain Renais's *L'Année dernière à Marienbad*. Paternal identification, the objective of Lepage's suspense film, is achieved by temporal spatial camera codes complicated by repeated fictional and historical allusions to Hitchcock's film.

Real time/space juxtapositions of films like *I Confess* and *Casablanca* are extended to a three-tiered narrative in *Le Confessional*.

In addition to the past 1952/present 1989 polarities, Lepage incorporates the fictional past of the Hitchcock film. Unlike Hitchcock's or Curtiz's flashbacks based on voluntary recall, Lepage uses space as a vehicle for involuntary travel back and forth between the various pasts and present.

Le Confessional begins and ends with shots of the Pont de Québec that spans the St. Lawrence River a few miles upstream from Quebec City. The opening shot introduces the extradiegetic narrator who comments thus: "Le passé porte le présent comme un enfant sur ses épaules" (The past carries the present like a child on its shoulders). The literal meaning will be made clear in the final shot where Pierre, the film's principal character, carries his nephew on his shoulders across the bridge. But, although confirmed by the voice-over as a spatial/temporal link, the bridge is also used as an index of spatial separateness, joining otherwise unconnected places.

The use of objects like the bridge as time vehicles has cinematic precedents. In his *Le Sang d'un poète, Orphée,* and *Testament d'Orphée,* Jean Cocteau employs a mirror to connect spaces and enter a time zone unmeasured by hours and minutes. Lepage's time bridge is also reminiscent of Marcel Carné's flashbacks in *Le jour se lève,* which emanate from within a closed room where objects such as a stuffed bear and an armoire give the diegetic character the power to revisit past time. As such, Carné's are magical objects with which Cocteau would have felt comfortable.

Lepage's time/space bridges are multiple. *Le Confessional* has bipolar diegetic pasts set in 1952. One past is defined by the birth of the narrator and the other by Alfred Hitchcock's filming of *I Confess.* These two poles create real and fictional diegesis paralleling each other while being mirrored also by the extra-diegetic film text of *I Confess.* The seal of confession is one such mirror. In both films, the past involves a search for truth and a solution of a mystery—the naming of Marc's father in *Le Confessional;* and the naming of the real murderer in Hitchcock's *I Confess.* In the first, we learn the truth only obliquely in the final sequences. In the second, because we know the identity of murderer from the beginning, the suspense lies in how he will be unmasked and the falsely accused priest exonerated.

But confessed sins represent only half of the priestly dilemmas in both films. Hitchcock's priest is unwilling to demonstrate his innocence

because to do so would compromise a now-married woman he loved before he took holy orders. Lepage's priest too suffers the angst of secrecy imposed by the confessional when he learns who fathered Pierre's brother Marc. Like Hitchcock's priest, he is a suspect, but unlike him, with no intervention to save his reputation, he is defrocked. As in *I Confess,* the priest's situation is complicated by another motive because to defend himself Lepage's priest must admit his homosexuality.

Le Confessional's 1989 present is haunted by a more recent past time and space, the Orient—Japan and China. Pierre, a student of art, has newly returned from China to bury his father and search for his brother Marc. In an ironic and cyclical structure, Marc will be led back to the Orient—to Japan and death. Lepage synchronizes China and Quebec space and time through television. Repeatedly, television news footage and voice-overs describing the 1989 Tienanmen events intrude upon Quebec scenes. A second and ironic use of intrusive television fusing the Hitchcock past and an oriental present occurs when Pierre in Quebec, watching a video of *I Confess,* learns of Marc's death in Japan. These video intrusions correspond broadly to "bracketing syntagmas" described in Peter Wollen's analysis of *Citizen Kane*[2] (58–59) wherein Welles uses fictional documentary footage creating the illusion of historical truth. Their value in *Le Confessional* is to synthesize the there and the here, paralleling the manner in which the persistence of memory synthesizes the family's then and now.

Past time in *Le Confessional* is divided into specific/identified and non-specific/unidentified events. The former become the object of the diegesis, the quest, Pierre's search for the identity of Marc's father. Non-specific/unidentified events, like the fates of Greek mythology, lurk and threaten because they are unknown and unnamed. Moreover, they represent a persistence of memory, heredity neither sibling can avoid.

Marc's present is informed by the forgotten past of family photo album in which he hopes to find clues to his identity. Likewise, an unidentified past intrudes when Pierre attempts to create a new space for himself in his dead father's apartment. He finds he is unable to paint over the outlines of family pictures that once covered the walls and to which he refers as "les négligences de mon père" (my father's neglect). The painting of walls is yet another intertextual reference to

I Confess. Pierre's activity recalls the priest, played by Montgomery Clift, who repaints the living room of the parish house. When visited by homicide detectives, he comments in a play on words that he is trying to cover up the grime (crime), a parallel to the neglect of Pierre's father.

Unlike Hitchcock's flashbacks/recollected pasts, Lepage's temporal transitions are, first, unconnected to voluntary memory and, second, characterized by tracking shots. At his father's funeral, Pierre surveys the church, empty because nearly all the other possible mourners except Marc are already dead. However, tracking down the center aisle, the camera transitions to 1952 and begins to find members of the parish attending Sunday mass and ends its movement at the door of the confessional.

Likewise, as Pierre, seated on the floor of his father's house in 1989, looks at the family photo album, the camera transitions to 1952, tracking his mother as she enters the room and as Pierre dissolves from the frame. Once again, Lepage's technique differs from similar and recent examples such as John Sayles's *Lone Star*, which also uses tracking shots to transition to the past because, unlike *Le Confessional*, Sayles's past is always voluntarily recalled.

Le Confessional's textual transitions to and from the past of *I Confess* are accomplished through fades—to and from color (present) and black and white (past film fiction). Recreating the filming of a scene from *I Confess*, *Le Confessional*'s actors and director of the historical diegesis set up in color. When the filming begins, the color fades to black and white as the diegetic actor becomes Montgomery Clift in the fiction of Hitchcock's movie.

All Lepage's temporal transitions have their relation to space in common. As the separated spaces suggest in the opening bridge shot, *Le Confessional* constructs visual compartmentalization. The compartment of the confessional itself lends the film its name and links it to Hitchcock. The confessional is the logos of guilt with which, though confessed, one must live. In closets called confessionals, Marc's ex-girlfriend, and mother of his child, works as a nude dancer. The father's apartment represents the inescapable, the persistence of memory, indexed by the blank discolored squares on the walls where once there were photos. Surrounded by the bourgeois modesty of the apartment, this place of incest is juxtaposed to the logos of prostitution represented

by the opulent apartment of Marc's lover and possible father, the defrocked priest. Another such space is the gay baths called the Hippocampe, where nightly assignations take place in cubicles. Finally, it is within closed cars that Marc learns his parentage, and where his father recounts his family's story to Alfred Hitchcock.

To confirm visually the compartmentalization of spaces, Lepage uses the grid pattern. This geometry made from overhead shots of the cubicles in the Hippocampe repeat the grid separating priest and confessor. The grid is again a focus during the game of chess organized by Marc's lover. In Japan, as Marc sits in his geometrically decorated bedroom, he gazes at the frame of a television screen on which a checkers match is being played, reminding us of an earlier chess game between Pierre and the defrocked priest. The grid itself can be reduced to its individual cells or frames: the frame of the motion picture screen that projects a diegesis limited to what the director chooses to put into the frame; and the frame of the movie within the movie.

Compartments abound: the enclosure of the Chateau Frontenac courtyard where outdoor scenes are filmed. The blood of Pierre's mother miscarriage is contained in her bathtub just like the blood of Marc's suicide in the Japanese bath. The square of the Hippocampe matchbook brings Pierre into Marc's world where, in the isolation of the steam bath, Marc underscores their separate spaces insisting that this space is not "ta place" (your place) just as the church is not "sa place" (his place).

As a consequence, it appears as though physical, cinematic space contains all time within it, making voluntary, recollected pasts like those of *I Confess* or *Casablanca* unnecessary. Unlike the flashbacks of *I Confess,* Lepage's past reappears spontaneously and involuntarily because time, independent of memory, emanates from spaces. However, the very hypothesis of an involuntary past independent of human memory of it raises perplexing diegetic questions. The recollected past of traditional flashbacks always has an author. In *Le Confessional,* Pierre cannot be the author of this past. He had not yet been born.

Such involuntary and uncontrollable time/space transitions have resonances in the montage of Alain Renais's *L'Année dernière à Marienbad.* Like the traditional flashback technique represented by *I Confess,* the narrator of Renais's film conjures up a variety of recollected

pasts, in an attempt to flesh out the biographical/historical enigmas of plot and character. As in *I Confess*, these flashbacks purport to explain character motivation. On the other hand, Gilles Deleuze shows succinctly how *Marienbad* departs from the traditional when he says that "we can no longer distinguish between what is flashback and what is not."[3]

Renais's film, like *Le Confessional*, raises two problems of narrative truth: contradiction and conflict. The lack of temporal clarity generates a psychic time in which a variety of options are possible. One lies in the narrator's voice-overs that propose different and contrasting images in the visual text. For example, the voice-over ascribes a multiplicity of gardens to one locale, and, alternatively, contrasting visual representations of the same garden. The repetitious and hypnotic voice-over describes empty corridors, while we sometimes see them crowded with hotel guests. When woman A, dressed in white, turns 180 degrees, she is dressed in black while the narrator assures us that: "Vous êtes toujours la même" (You are still the same). The visual and narrative contradict each other and suggest a variable truth.

Another example important to the discussion of *Le Confessional* occurs toward the end of the film as the narrator attempts to recreate the events of one year earlier. The visual refuses to correspond to the narrator's description causing the narrator to lose patience and to insist upon his version of truth. He repeats "Vous êtes retournée vers le lit" (You went back to the bed)" while woman A on screen resists the narrator's commands and moves away from the bed. These conflicts appear to suggest alternative diegeses, possible pasts, real or fictional, that were never resolved.

The problematic visuals and narratives in *Marienbad* raise two issues that become central to the meaning of *Le Confessional*. The first asks who is remembering; the second questions the nature of the recollected past. The one addresses the question of authorship, the other of narrative truth. *Marienbad*'s inability to synchronize images and voice-overs, makes us wonder if we are seeing his, her, or a third party's recollections. Does past time resist, as I suggested is the case in *Le Confessional*, because it is not a voluntary recollection?

Edward Branigan's observations on the nature of the flashback underscore the problem. He calls an involuntary or unauthored flashback "objective in the sense that it has not been inaugurated by a

101

character . . . the past is simply made present."[4] Branigan's analysis of *Citizen Kane*'s flashbacks has resonance in our discussion because, as he comments, "it might have made no difference if the past had been evoked by a character . . . because what we see in a subjective flashback is often stubbornly independent of the character's recollection."[5] Branigan's logic evolves to a later question when, during an analysis of Boorman's *Point Blank,* he questions whether such sequences can even be called flashbacks.[6]

The core question of narrator and memory in *Le Confessional* arises from the biographical fact that Pierre and Marc cannot be remembering in 1989 the events of 1952—which begs the question of what we are seeing in the time/space transitions. For one thing, if these are not the narrator's memories, are they really flashbacks, as Branigan posits? Indeed none of the participants in the diegetic present can be the voluntary author of the 1952 past. None except the defrocked priest would know what had been said in confession, the seal of which is reflected in the title of both Hitchcock's and Lepage's screenplays.

Paul Ricoeur's work entitled *Time and Narrative* suggests an alternative key to the question. Starting from a discussion of documentary reconstitution of past time, he suggests that reenactment of the past [history] "does not consist of reliving what happened. Rethinking [the past] contains the critical moment that requires us to detour by way of the historical imagination."[7] If we were to apply this paradigm, the unauthored recollections of *Le Confessional* would represent an imagined, and not a historically faithful reconstruction of the past. This alternative, while offering a solution to the puzzle of the flashback, has the disadvantage of clouding the resolution of the plot.

If the visual tensions in *L'Année dernière à Marienbad* can represent alternative narratives (one of the narrator, the second of his respondent), perhaps the explanation of *Le Confessional*'s flashback can be understood in the same way. On this point, an observation by Raymond Durgnat in *The Strange Case of Alfred Hitchcock* is intriguing. Discussing the passivity of Hitchcock's priest (*I Confess*) in the face of public opprobrium, Durgnat posits that the priest is not the author of his own salvation. Rather, it is the confession of the murderer's wife that saves the priest's reputation and, quite probably, avoids his being defrocked. Durgnat explains:

A more ruthless treatment might have concluded with the priest aware that, spiritually, the jeering crowd is right about him. But he has to go about his priestly duties, confronting the complacent, sympathetic, almost patronizing murderer every day, thus being confronted, in a sharp, personal form with affable, suffering, evil whose omnipresence must be more familiar to any priest.

Or alternatively "the priest might finally connive in some dishonorable trick which brings the murderer to book, clears his own name, and brings on him the congratulations of his parishioners . . ."[8]

Le Confessional may mask a more profound, narrative undertaking and represent an alternative diegesis, a second filming of *I Confess*. *Le Confessional* can certainly be seen as the "more ruthless treatment" that Durgnat might have wished. Lepage's not-so-lucky priest becomes an outcast, first from his church, then from society, remaining always outside the pale, unlike his counterpart in Hitchcock's film. To borrow André Bazin's interpretation, the self-contained Jansenistic priest of *I Confess* who escapes punishment despite his own inaction is transformed by Lepage into one who suffers humiliation and degradation, never succeeding in rehabilitating himself with his church or parishioners.[9]

Lepage's 1996 *Polygraphe* bears a striking resemblance to *Le Confessional* because it centers on multiple readings of a text: apparent coincidences, multiple voices, and stories told by strangers whose meeting seems to underscore their similarities rather than their differences. The voices recount identical presents employing dissimilar metaphors. Like its predecessor, *Polygraphe* is a whodunit. It resolves to uncover the murderer of Marie Claire, whose lover François, a suspect, is subjected to a polygraph test during the opening sequence of the film. However, when the polygraph itself proves inconclusive, his guilt or innocence remains undetermined until the final sequences, as in *Le Confessional*.

A present/past in *Polygraphe* is doubled by a binary, ignorance/knowledge. As in *Le Confessional*, the solution to a crime is the object of the quest and, also like its predecessor, *Polygraphe*'s real diegesis is mirrored by a fictional one, once again a film within a film. Just as *Le Confessional* incorporates a movie text (*I Confess*), so the crime of *Polygraphe*'s diegetic past comes into the present as the subject of a

movie. Based on the actual diegetic event, *Polygraphe*'s crime scene, a burnt-out apartment, is reconstructed faithfully as a set for a docudrama. However faithfully reproduced physically, the docudrama's plot proves misleading, placing the blame on the police rather than on the real killer. The cinematic script within a script thus suggests yet another written version—a polygraph—of a possible truth.

Polygraphe is also a film about history, personal and political. The prime suspect, François, is a doctoral student in history whose thesis on the individual identity of political exiles mirrors the story of Christoph, a German pathologist, who flees East Germany to find political asylum in Quebec. Where in *Le Confessional* Pierre is unable to paint over the traces of his family's past, François covers his walls with the year-by-year historical facts of post-war German history. In *Polygraphe*, the walls deliberately recall a specified/voluntary past while in *Le Confessional*, as we have seen, the discolored outlines of an unspecified past evoke it involuntarily.

Another model of *Polygraphe*'s spatial mirroring is revealed in crosscutting between François's classroom and Christoph's surgical theater. In the one, François defends his dissertation; in the other, the pathologist performs a postmortem. The metaphor of the wall is used in both. François explains how the Berlin wall impeded the flow of humanity from one side to the other, thus causing the collapse of the formerly healthy political entity. In the surgical theater, the pathologist reveals how the dead man's blocked artery created a wall impeding the flow of blood from one side of the heart to the other, thus causing the collapse of the once healthy physical entity.

As in *Le Confessional*, this parallel montage is complicated by the intrusion of the third space, Berlin. In flashbacks relating to the pathologist's escape from East Germany, we see the details of the process, a series of lies told to his wife and to the political authorities, reminding us of the film's opening sequence and the polygraph test which purports to detect deception. As if to create a metaphor of lies, Lepage's escaping pathologist hides a set of Russian dolls in his baggage to which there are two subsequent allusions: like a space within a space. The first is that the dolls hide one truth inside another, the second that they hide one mystery within another.

Both films juxtapose accelerated motion with real time. *Le Confessional*'s use of acceleration occurs when Marc receives a gift of

frozen salmon. Left to thaw in a motel sink, the accelerated de-icing of the fish signals the passage of time. In Lepage's two films, time thus appears to have its own determinative purposes. If the salmon had not thawed before Marc left the motel, he would not have decided to feed them to the fish in the aquarium, would not have been arrested by the police, would not have been forced to telephone his lover to provide him bail, would not have been reunited with him, gone to Japan, learned of his parentage and died. The aquarium of cannibalizing fish repeats the metaphor of the Hippocampe's reception area fish bowl. The denizens of this house of male assignation operate in an equally circumscribed area as they circulate in search of their own kind like the fish-eating fish of the aquarium.

Polygraphe's more liberal use of variable film speeds includes both acceleration and slow motion. As François and his friend Lucie talk in real time in a restaurant kitchen, the waiters move about at accelerated speed. After learning that Lucie has a part in the movie re-enactment of Marie Claire's murder, François's dread is indexed through slow motion movements in the room full of real-time activity. In a third scene, as François stares at a fire-devastated apartment building, an acceleration refurbishes the ruin as a movie set for the shooting of the docudrama depicting Marie Claire's murder.

Like the visual juxtaposition of times, real and accelerated, present versus past, the film-within-the-film fictional reenactment of Marie Claire's murder evokes the image of the title's polygraph. Aside from the meaning of lie detector, the polygraph represents multiple writings, as the reenactment of the docudrama is the fictional director's version of events. A second version is created by the lies told by the police who continually pursue François even though we learn that they always knew he was innocent. *Le Confessional* and *Polygraphe* hide their revelations until the final sequence when, like *Le Confessional*'s father, *Polygraphe*'s killer re-enacts her deed, albeit metaphorically through suicide, setting fire to herself in François's vacant apartment just as she had immolated his lover, her sister, Marie Claire.

What distinguishes *Polygraphe* from *Le Confessional*'s space/time narrative is the latter's selective flashbacks. Unlike *Le Confessional*, *Polygraphe* has no unauthored flashbacks, only the docudrama's fiction and erroneous re-enactment of the crime. Despite evocations of the past, we cannot know François's relationship with Marie Claire

because the camera does not adopt his point of view. Moreover, he says he cannot recall the past and acknowledges throughout that he is unsure what part he might have played in Marie Claire's death.

Yet *Polygraphe*'s epilogue seems to suggest that, like *Le Confessional*, the past is always present. Set five years after the revelation of the murder's identity, the epilogue juxtaposes, for the second time, mirrored present times by crosscutting between François and the pathologist. In one space, François lectures his students on the demolition of the Berlin wall. Having lost the initial euphoria caused by reunification, East Germans are now nostalgic for the past, he says. In another space, the self-exiled German Christoph passes through airport security at Montreal in search of his past life in Berlin.

In Lepage's films, the crossing of space, like the crossing of time, puts all events in the here and now. The there and then are absorbed as an integral part of the present experience, even extending to the secondary characters. Like *Polygraphe*'s Christoph, a participant in present and historical movement between spaces, *Le Confessional*'s priest transitions from the ecclesiastic to the secular where, as a diplomat, he crosses spaces. Defrocked and embracing his nature once hidden by priest's robes, his nature has become visible.

Le Confessional can be read as more than a film that integrates elements of Hitchcock's *I Confess*. It is an alternative version of the screen play—what it might have been had Hitchcock lived to retell it in 1989, or might have filmed it in 1952 without the censorship of Hollywood's Hayes Office, or might have filmed it, had he been a Quebec filmmaker of the 1990s. Lepage's fictional Hitchcock denies the suspense of *Le Confessional*'s plot, calling it instead a Greek tragedy. But *Le Confessional*, avenges itself by creating a metatext as suspenseful as its inspiration. *Polygraphe* represents a mystery of confused texts, multiple and confused interpretations of lives and events like the intersecting lines of the polygraph. Reading his own life, François comes to an understanding of his relationship only through the palimpsest of the polygraph. In this way, *Polygraphe* can also be read as a metatext of and sequel to *Le Confessional* deriving its meaning from multiple inscriptions, each hidden within the other. In any case, both works confirm a style and invite even closer aesthetic and political readings of Lepage's contributions to modern Quebec filmmaking.

Notes

1. Bruce Kirkland, *Toronto Sun* http://www.torontosun.com/, 24 December 1995.
2. Peter Wollen, *Readings and Writings* (London: Verso Editions, 1982), 5859.
3. Gilles Deleuze, "Cinema2", *The Time-image*. Trans. Hugh Tomlinson and Robert Galeta (Minneapolis: University of Minnesota Press, 1989), 122.
4. Edward Branigan, *Narrative Comprehension and Film* (London: Routledge, 1992), 173.
5. Branigan, 173.
6. Branigan, 176.
7. Paul Ricoeur, *Time and Narration*, vol. 3, trans. Kathleen Barnty and David Pellauer (Chicago: University of Chicago Press, 1988), 144-54.
8. Raymond Durgnat, *The Strange Case of Alfred Hitchcock* (Cambridge: MIT Press, 1974), 232-33.
9. André Bazin, "Hitchcock versus Hitchcock," in *Focus on Hitchcock*, ed. Albert J. Lavelly (Englewood Cliffs: Prentice Hall, 1972), 60-69.

Transnationalism, Orientalism, and Cultural Tourism: *La Trilogie des dragons* and *The Seven Streams of the River Ota*

Jennifer Harvie

ROBERT LEPAGE'S PERFORMANCE work[1] demonstrates a consistent inter-
est in the experiences of traveling and of contact between cultures. *La
Trilogie des dragons*,[2] set primarily in three Chinatowns across Canada
(in Quebec, Toronto, and Vancouver), explores the changing cultural
relationships between, in particular, Chinese immigrants and *québécois*
over time. *The Seven Streams of the River Ota*,[3] Lepage's recent epic
production and his first as artistic director of Ex Machina, traverses
Asia, Europe, and North America, exploring interpersonal relationships
spanning all three continents. "My shows," Lepage has said in inter-
view, "are usually about traveling, about culture clustering, and things
like that" (Hunt 115). And like the narrative contexts of his shows,
Lepage's contexts of production have spread from his home town of
Quebec to encompass other parts of Canada (including Ottawa,
Toronto, and Vancouver), parts of Europe (including Glasgow,
London, and Stockholm), and parts of Asia (including Hong Kong and
Osaka).

At first glance, Lepage's continuing depiction—and practice—of
travel and intercultural encounter might be seen as a transnational
utopia, a world view where communication across cultural borders is
not only possible, it is practicable. Not to mention, in Lepage's produc-
tions, it is often romantically fulfilling. This perspective on Lepage's
work is widely shared: for Michael Coveney, writing in the *Observer*,
the work "forges links between cultures and contact between peoples";
and Denis Salter, in *Theater*, describes Lepage's and Théâtre Repère's
work as "committed to theater as a form of cross-cultural understanding"

109

(64). Of course, this transnationally utopian world view has its attractions. It is optimistic about cross-cultural understanding and communication. It is forward-looking, heralding an apparently border-free future "promising of opportunities" (Hannerz 5). But what of some of the critical problems it raises? What, for instance, of the borders—both cultural and economic—it seems to cross so effortlessly? What happens to cultural difference when its defining borders are imagined to have vanished? As critic Michael Billington put it in the context of reviewing Lepage's work, how do you "reconcile a separate cultural identity with universal brotherhood"? And what of the pasts from which this future-oriented transnational utopia seems so readily to move? (Billington 1649-50). How are their legacies—including particular histories of deprivation, violence, and trauma—so easily set aside? What new futures—created in who's imagining—are sought and constructed? Is cross-cultural communication as easy or as simple as this first glance at Lepage's performance work apparently makes it look?

As Edward Said's book *Orientalism* persuasively demonstrated, Orientalism's strategies for "put[ting] the Westerner in a whole series of possible relationships with the Orient without ever losing him the upper hand" (Said 7) are too insidious and pervasive to assume that any Western representation of Eastern cultures is without prejudice, no matter how good—or transnationally utopian—its intentions. But how do we prevent Western representations of Eastern cultures from becoming banal, superficial, commodified, demonized, aestheticized, romanticized, or archetypal instead of actual? In endeavoring to represent and enact transnational communication, we must pay careful attention to both how these representations and enactments are performed and what effects they produce.

This essay examines two of Lepage's most epic performance pieces, *La Trilogie des dragons* and *The Seven Streams of the River Ota*; it explores the changing approaches of his dramaturgy to these important issues of communication across cultures, particularly across Eastern and Western cultures.[4] It explores these issues through these two plays in particular for several reasons: both plays range over vast expanses of time and space, thus lending themselves to analysis of cultural identities produced in and changed by specific times and places. Both deal in particular with parts of East Asia, its peoples, and their significations for Westerners, primarily for *québécois*. Both plays, thus,

engage the complex and long-standing power asymmetries between East and West, produced through Orientalism—in particular, discursive and other violences committed against the East. They also furnish the critic with material to examine how Lepage himself uses and constructs the Orient. Both have toured internationally and so can be analyzed for their differing relationships to—and not simply depictions of—different peoples and audiences. Their different critical receptions in different contexts of production can also be considered. Finally, the progression from *La Trilogie des dragons* to *The Seven Streams of the River Ota* demonstrates his changing tactics by addressing cultural differences, movements, and encounters in changing global circumstances.

This essay focuses on Lepage's engagement with the Orient. It suggests that in both plays Lepage adopts perspectives that are external to the Orient, perspectives that are at least partially removed from claiming an appropriative knowledge of the East. It suggests that *La Trilogie*'s Oriental (and potentially Orientalist) perspective is more apparent than real, that the play's focus is more strongly on *québécois* identity than on Oriental culture, and that it engages nevertheless with Orientalist East/West binary constructions in ways that are productively disruptive. *Ota*'s tourist gaze, it suggests, is more problematic, going only so far in problematizing the power dynamics of its own and its audiences' perspective on the Orient and succumbing to certain retrograde Orientalist fantasies. Both plays provide telling examples of the potentials and limits of dramaturgical practices that aspire to transnational connections.

La Trilogie des dragons

Je ne suis jamais allée en Chine
Quand j'étais petite, il y avait des maisons ici
C'était le quartier chinois
Aujourd'hui, c'est un stationnement
Plus tard, ça va peut-être devenir un parc, une gare, ou un cimetière
Si tu grattes le sol avec tes ongles
tu vas trouver de l'eau et de l'huile à moteur
Si tu creuses encore
tu vas sûrement trouver des morceaux de porcelaine

111

du jade
et les fondations des maisons des Chinois qui vivaient ici
et si tu creuses encore plus loin
tu vas te retrouver en Chine.[5]

Although *La Trilogie des dragons* is unpublished, Diane Pavlovic's "Reconstitution de *la Trilogie*," in a special issue of *Cahiers du théâtre jeu* dedicated to *La Trilogie*, describes the show in detail.[6] I will not, therefore, provide extensive summary or description of the show, but will indicate, instead, a few of its features central to my analysis.

La Trilogie des dragons is performed on a rectangular expanse of carefully raked sand that represents, over its three parts, the Chinatowns of Quebec City from 1910–1935, Toronto from 1940–1955, and Vancouver in 1985. Its central characters, Jeanne and Françoise, are introduced as childhood friends, living near or within—but culturally separate from—Quebec's Chinatown. Playing in the sand, they create their neighborhood in miniature, with shoe boxes representing people's houses and work premises, and they conjure their neighbors, including the Chinese laundry man, Wong, and the English shoe salesman, Crawford.

The second part follows an adult Jeanne to Toronto, where she lives with her husband, Wong's son Lee, and her daughter, Stella. Her betrothal to Lee was the outcome of her father's losing hand in a high stakes poker game versus Wong. Her daughter is the progeny of another relationship. After Stella contracts meningitis and suffers permanent brain damage, Jeanne commits her to a hospital in Quebec. Returning to Toronto, suffering from cancer, Jeanne hangs herself. Françoise, meanwhile, having traveled to Europe during the Second World War, has returned to Quebec City and is pregnant.

The third part focuses on Françoise's adult son, Pierre, a Vancouver-based artist. He forms a relationship with Yukali, who is also an artist and the daughter of a Madame Butterfly-like Geisha and an American naval officer. Crawford, now an old man, crashes in the Pacific while flying to his childhood home, Hong Kong. And the play concludes where it began, in the Quebec City parking lot of an ambiguous past/present/future.

This précis is necessarily brief and neglects many strands of plot, not to mention many nuances of significance created through the

means for which Lepage is most famous: multiple, simultaneous images and actions; evocative lighting; verbal, visual, physical, and aural resonances and echoes; casting (including the effects of single actors playing several roles); and so on. But it does convey the play's focus on Chinatowns and its encounters with people from outside Quebec (including the Englishman Crawford and the Japanese Yukali). I want to highlight these features because they are at the center of some of the strongest criticisms of the play in general, and my critique of Lepage's work here: its handling of cultures foreign to its own, particularly Eastern cultures.

The central criticism made of the handling of other cultures in the play is that it is relentlessly clichéd, so that, instead of productively exploring other cultures, it reinforces diminishing and often naïve perceptions of them. The Englishman Crawford exhibits "typically English" behavior; chief amongst his characteristics are politeness and reserve, and dotting his dialogue are phrases like "By George" (Pavlovic, "Reconstitution," 49). He is also made to bear the burden of a large portion of British colonial history—having lived in Hong Kong, the U.K., and Canada—not to mention, according to a *Financial Times* review, a kind of villainous arrogance crudely associated with the Occidental colonizer: "The Brit (one Crawford—a Scot?) is portrayed in the crude and uncomprehending colours one associates with nineteenth century Japanese depictions of western devils and is satisfyingly killed off, for being a success, in a plane crash" (Hoyle). This reviewer's criticism is hyperbolic but suggestive, and is certainly corroborated by further critical concern about the play's handling of Chinese characters.

Another British reviewer describes these characters as "inscrutable and even sinister owners of laundries, opium dens and gambling saloons," and proposes, "surely there is more to the Chinese than can be learned from antiquated pulp fiction" (King). In response to this criticism, one could argue that since the plural "owners" cited here can only be based on one such character—Wong—this criticism should in fairness be confined only to that part in which he appears, the first. On the other hand, the kinds of specious East-West binary oppositions conjured with Wong's depiction can also be seen elsewhere, and later, in the play. The pilot flying to Hong Kong from Vancouver, for instance, describes his places of destination and departure thus: "Hong Kong, la

noire, la mystérieuse!, de l'autre côté du miroir de l'océan, se mesure à son reflet, Vancouver, la blanche, la limpide . . ."[7] And while the play's initial stereotypes may be contextualized as culturally specific to early-twentieth-century Quebec, subsequent clichéd depictions make less "sense" and do not, for Jean-Luc Denis writing in *Jeu*, propose any particular critique of racist stereotyping nor problematize it for the spectator: " . . . *la Trilogie* riait gentiment des vieux clichés sur les Chinois véhiculés dans les années trente . . . pour les remplacer immédiatement par les clichés plus modernes, sans s'interroger sur la gènese des clichés ni mettre les spectateurs en garde contre eux . . ."[8]

The strongest response to these charges of clichéd, Orientalist representation is that, rather than betraying the racism of the production, they portray the racism of its main characters, problematizing it by highlighting its naïveté, crudity, and extent, and emphasizing its change over time. Throughout the performance, the central perspective proffered is that of the *québécois* characters. "Le spectacle ne prétend pas parler de la Chine vraie. Le 'Je ne suis jamais allée en Chine' initial fait appel à une autre Chine, imaginée, à une 'image' de la Chine."[9] And significantly, this is a China imagined, at least initially, by two young, naïve girls who conjure, or produce, their neighbors as caricatures—"Les deux enfants inventent tout innocemment un Anglais, naturellement un peu caricatural. . . ."[10]—caricatures informed by the girls' prejudices and fantasies: "Le Dragon vert [the first part of the play] nous offert une *image* des Orientaux, image biasée par les préjugés et magnifiée par les fantasmes."[11] This image of China is filtered not only through youth but through time. In interview, Lepage has defended *La Trilogie* against charges of clichéd representation by arguing that it portrays both an evolving historical perspective and developing East/West intimacies.

> The first part gives us a very clichéd vision of what the Chinese are, but that's the vision we have of the past. I wasn't there in 1925, but what our parents transmitted to us in Quebec City was that vision, that's how they told the story. The second section is a bit more accurate, but still we weren't close friends with the Japanese during the Second World War. We saw documentaries about the war, but we can't really know what motivated them, although it's much closer.

> But the Japanese girl in the art gallery in the last section we know
> very well: she's not a cliché, she exists. ("Collaboration," 34)

"Knowing" about other cultures is perhaps more complicated than
Lepage acknowledges here, but the point I would like to take from
Lepage's argument in this context is its emphasis on the effort of the play
to articulate change over time. Finally, Pavlovic describes how the pro-
logue's description of digging to China provoked "rires complices des
spectateurs."[12] Not only was the play's Orientalist perspective recog-
nized by its Quebec audience, it was recognized as shared, recognized,
in Lorraine Camerlain's words, as "la mentalité québécoise, empreinte
de xénophobie."[13] What the play does not perhaps adequately
address—for itself or its audience—is how to redress this xenophobia. If
we conceive *the imagination as a social practice* (Appadurai 5), we
must be careful not to abjure responsibility for what we imaginatively
produce.

On the other hand, one could argue that the apparent focus of the
play on the Orient is just that—apparent—and that its handling of
non-*québécois* characters is secondary in importance to the play's
more thoroughgoing focus: the Quebecers themselves. Lepage and col-
laborator Marie Gignac (who played Françoise) are frank about the
production's use of China as a vehicle through which to explore them-
selves and their own culture.

> *Gignac*: . . . in the *Trilogie*, we were talking about ourselves through
> our vision of China.
> *Lepage*: It was a pretext for us. We said, we're going to do a show
> about the Chinatowns. But we knew what really concerned us was
> the people we knew, our families, our intimates. . . . We're very
> interested in the Chinese, Chinatowns, and all of that. But while we
> are searching and digging to find answers about that, most of the
> answers that come back to us are about ourselves, about how we
> are, how we look.[14]

Certainly, for several of the critics writing in *Jeu*, if not for those
writing in the British press, this focus was apparent and appreciable.
Camerlain, for instance, highlights the comedy of Wong's and
Crawford's first encounter where the two characters struggle to com-

municate in English (87–88). For Camerlain, this is a scenario that would appeal to a primarily francophone *québécois* audience sympathetic to the confusion that can arise when communicating in English. Furthermore, with Wong's "The store is burn" being transfigured by Crawford into "A star is born?", the characters' confusion attests, for Camerlain, to the potential productivity of that confusion, presaging the significance that stars (including Stella) will take on as the play progresses and displacing the destruction of burning with the creativity of birth (Camerlain 88). This cultural and linguistic focus on Quebec is characteristic not only of the play's first two stages of production, but even of its third, longest, version, which toured most extensively and was the one reviewed by the British newspaper critics quoted above. In this six-hour version, observes Pavlovic, "une grande partie des scènes ajoutées réintroduisent la ville de Québec et accentuent, ailleurs, l'usage du français (Sœur Marie à Toronto, Maureen à Vancouver) . . . même là où s'y 'attend' le moins."[15] The production is trilingual, its settings traverse Canada, its characters come from around the world. But its primary perspective and focus are *québécois*, both perhaps more recognizable to the *québécois* critics than to the British critics who were most vehement in their condemnation of what they saw as the play's racist perspective and focus on the Orient.

Perhaps a useful point of comparison to *La Trilogie*'s Oriental portrayal is its representations of the Second World War. These register moderately less criticism than *La Trilogie*'s depiction of other cultures. Denis writes, "*La Trilogie* jetait un regard compassé sur la guerre et ses victimes . . . sans interroger la nature de la guerre (ou de la violence microsociale), sa signification actuelle, son procès, la question de responsabilité."[16] He admires the impact—"frappante et originale"[17]—of its portrayal of the war's destruction, described by other critics thus: "Music underscores all the action and not a single word about the war is ever uttered" (Rewa 155); "pairs of shoes are mutilated and the sand churned by uniformed figures in ice skates" (Curtis 1411). But Denis, as noted in the above citation, questions its critical effects.

La Trilogie's representation of the war is typically polyvalent. While the soldiers skate over the shoes, other stage action depicts Stella's affliction with meningitis and the geisha's desertion by her American lover. Even the "attack" on the shoes has multiple significations:

the destruction of what they metonymically represent—their wearers; the ironic preservation of the Nazis' victims' shoes and eyeglasses, iconically familiar to a post-war audience from museums and photographs; and even—an ocean away from the "front"—the experience of devastation felt by Jeanne in her immediate environment, the shoe store where she works in Toronto. *La Trilogie*'s strategy in representing the war is to link its vast scale of devastation to tragedies that are local and fictional—Jeanne's and Stella's—and even mythic—the geisha's, with its obvious reference to Madame Butterfly. It may not fulfill what Denis seeks: an interrogation or explanation of the causes of, and the responsibilities for, the war. But it does—perhaps more humbly—convey the extent and specific local experiences of wartime devastation. Its purview is, again, more local than global. Criticisms of the scope of its commentary, if not incorrect, are perhaps misplaced.

La Trilogie's *québécois* perspective and focus are conveyed further through its handling of both narrative and scenic space and time. While the play's narrative movement may be from Western/Occidental culture toward Eastern/Oriental culture, its geographical movement is the reverse: from Quebec westward to Vancouver and Hong Kong. The binary oppositions Oriental/Occidental and Eastern/Western, which are usually comfortably complementary, are here confounded. Further, "the West," which is so often conveniently but rather arbitrarily homogenized, is portrayed as heterogeneous, encompassing the disparate cities and cultures of Quebec, Toronto, and Vancouver, not to mention the "Trojan-horse" pockets of "Eastern" Chinatowns. Notably, Crawford's plane, destined finally for the "real" East, Hong Kong, of course crashes and never reaches its destination. The Orient is never realized in the play; it remains a complex fantasy viewed from the West.

The complexity of this narrative perspective is reinforced through the play's scenic perspective. At least one British reviewer saw the set as thoroughly Canadian, with "the vast expanse of Canada evoked by the bed of sand on which the action takes place" (King); but even the set holds multiple perspectives. The spatial organization of the two bands of audience seating facing one another over the stretch of sand permits at least two major performance configurations, both of which may be used independently or in tandem: promenade, when the action is on the sand between the spectators; and proscenium-like, when the

action takes place on the ends of the sand pit. The flexibility of this playing area, combined with the frequent simultaneous staging of multiple, disparate but complementary scenes and scenes that are ambiguously actual and/or memory, dream, or fantasy, conveys a sense of overlapping multiple spaces, times, and even qualities of time. This scenic multidimensionality is enhanced, if only through metaphor, through the play's references to temporal and physical digging. Scenically, the perspective is both specifically located in Quebec and Canada, metonymically represented by the stretch of sand, and distributed over a complex range of times and places layered like palimpsests atop the other.

The divergent critical responses to this play are instructive. British critics seemed to take the play's apparent focus on the Orient at face value and to criticize the play as Orientalist on that basis. *Québécois* critics seemed more prepared to recognize the play's perspective as *québécois* and to acknowledge the play's racist representations as self-conscious and, indeed, self-critical. Of course, as the play illustrates, the categories "Oriental" and "*québécois*" are not necessarily entirely mutually exclusive. The cultural complexities of migrations, nationalisms, and their intersections are depicted by the play, but, are only rather thinly examined. How do this show's strategies and effects compare with those of *The Seven Streams of the River Ota* produced almost a decade later?

The Seven Streams of the River Ota

> *The Seven Streams of the River Ota* is about people from different parts of the world who came to Hiroshima and found themselves confronted with their own devastation and their own enlightenment ("Jana" in Lepage and Ex Machina, *The Seven Streams of the River Ota*, 1).[18]

> What is "Hiroshima"? No longer just the name of a place but of a place in time—6 August 1945—"Hiroshima" is now the name of a story. That story has belonged to the world for almost half a century. Yet, since what happened at Hiroshima happened to the Japanese, it is, in the first "place," their story. . . . (Treat 233)

Both *La Trilogie* and *Ota* are epic, in the geographical, temporal, and even emotional scale of their narratives and the length of their actual running times. There are, nevertheless, important differences between each play's scope and its resulting emphases. The narrative settings of *La Trilogie* are confined principally to Canada and are contained by the prologue's claim, tenable not only at the outset of the play but throughout, "Je ne suis jamais allée en Chine." *Ota*'s narrative settings, on the other hand, might be understood as cosmopolitan, beginning in Hiroshima, and visiting New York, Amsterdam, Terezin, Osaka, and, briefly, Hong Kong. Thus, while a predominantly Western narrative perspective is shared by the two plays, its contextualization constructs it differently in each, as domestic in *La Trilogie* and cosmopolitan in *Ota*. Similarly, while *La Trilogie*'s action spans much of this "post-traumatic century" (Felman 1), the only widespread trauma it really touches on is the Holocaust, and most of its traumas are personal and even domestic. *Ota*, on the other hand, concerns itself with "the Nazi persecution of the Jews, the nuclear bomb and AIDS," described by Lepage—rather self-importantly and certainly idiosyncratically—as "the three holocausts of this century" (Fricker). Admittedly, these, too, are often explored through personal and again domestic examples, but their accumulation and mutual contextualization tends to make them seem somewhat iconic, even generic.

Exploring Eastern cultures, *Ota* could, again, like *La Trilogie*, be accused of Orientalism and cultural tourism, particularly given that it ventures beyond *La Trilogie* "into" non-western cultures and spaces and multiple world traumas. However, as we might see *La Trilogie*'s clichés as a feature rather than a flaw of its narrative, the same may be said of *Ota*'s tourist gaze, a gaze expressly looking in, not claiming insider status. In early versions of *Ota*, Jana acted as a central narrative vehicle. But subsequent versions disperse her role as participant in and witness to events amongst many other characters, several of whom, as in *La Trilogie*, are *québécois* (e.g. Patricia, Walter, Sophie, and Pierre) and are evidently—to themselves and to the audience—tourists and observers. Even in the Amsterdam café scene, where Ada is an "insider" in her own city, she is surrounded—and almost talked over—by numerous tourists. Although Hanako and Pierre might grow closer to one another, the audience does not forget his position as observer as it watches him carefully mimic her movements for his *butoh* performance.

Neither can the audience forget its own position as observer. In this scene, it shares complicity in making Hanako, blind and apparently unaware, the object of its scrutiny. And earlier, at the end of Part 4, The Mirror, Jana's memory of Terezin observed through the panels/mirrors ends with the stage direction, "Blackout upstage; the lights switch so that the audience can see its own reflection in the downstage mirrors" (57). Instead of criticizing the play for maintaining an Orientalizing distance from its material, we might see it as emphasizing the necessary distance of its perspectives on what it portrays, a distance which is respectful of differences and is shared not only by its characters but by its audience as well.

This distance is shared by the audience partly through identification with *Ota*'s tourist and observer characters, but also through the play's scenic organization, which again emphasizes the position of the audience as onlookers, and the metatheatrical emphasis of the play, which highlights the processes of representation and spectatorship. Scenically, the *Ota* set is designed for face-on viewing like a snapshot or a postcard. The central structure that begins as Nozomi's house takes on other guises, but sustained throughout the performance are the structure's flat panels and their frames, which face the audience and frequently act, quite literally, as picture frames, or mirrors, as we have seen above. Although these frames have depth (as when lighting and mirrors behind the screens create the effect of infinite depth in the Terezin scene), the picture frame quality remains as the set's "details can't be seen in side seats" (de Jongh).

Representation—and particularly theatrical performance and translation—is the work of the play, but, also, perhaps, the subject of its critique. The set is built to be looked at like a picture, not a "reality." Its construction as frame acts to acknowledge its mediation of the play and its events, and this metatheatricality is picked up in numerous other details of the performance. In Part 5, Words, Sophie and François-Xavier perform in a Feydeau farce. Later, a naturalistic domestic dispute metamorphoses back into a farce, complete with canned laughter and false exits. Live and surtitled translation operate both naturalistically within the narrative (as when Hanako translates the farce from French into Japanese) and extra-diegetically (as when another translator translates Hanako and Sophie's conversation). But even this separation collapses as Hanako corrects the live translation of

her otherwise apparently naturalistic dialogue (98). Repeatedly, throughout *Ota*, the representational mediation of events is highlighted: in Patricia's heinous interview with Jana ("heinous" mostly because of the effects of its mediation through composition and editing); even in Jana's memory of Terezin, which is mediated through the panels/mirrors.

Ota's preoccupation with representation and representational media is, I think, indisputable. A list of media and forms of representation used in the play would have to include photography, live and recorded video projection, film projection, voice-over, surtitles, opera, *Noh*, *butoh*, puppetry, and many others. What may be disputable, however, is the degree to which this preoccupation with, and proliferation of, representational media and forms develop to form a critique of representational and spectatorial practices and effects. The Mirror's audience-reflecting ending, for instance, may certainly act to critique the complicity and responsibility of the audience's watching, coming, as it does, at the end of both Jana's literal reflection on her experiences at Terezin, and Sarah's singing of the finale from *Madame Butterfly* whereupon, "at the music's climactic point, [she] stabs herself" (57). But it might also be read as effect rather than—or, at least, more than—critique. Indeed, this is how James Frieze reads the play's inclusion of *Madame Butterfly* in his *Journal of Dramatic Theory and Criticism* review.

> Is Butterfly deployed ironically, or merely for her inter-cultural, hyper-theatrical flavor? In practice, the question is somewhat moot, the hyper-theatricality overwhelming the irony. Like a stadium rock concert, the play is so driven by aesthetic set-pieces, by the hyper-life of theatricality, that it provokes an intense but strangely vacuous experience. (137)

Elements that we might be tempted to read as critically metatheatrical instead, Frieze suggests, may be decadently hyper-theatrical. And instead of turning a critical eye on the dramatic practices and apparatus, which produce naturalistic effects and potentially naturalize Orientalist fantasies, these elements might work to compound, or to naturalize further, those effects. Lepage's integration of opera and operatic elements into plays like *Ota*, for instance, seems designed at

least partly to gain access to the extreme emotional expression of opera while, nevertheless, containing it within naturalistic performance. "The other thing that opera has is emotion," Lepage attests.

"In theatre you spend weeks of rehearsal trying to make it surface, but in opera it's there immediately in the music. . . . Opera allows you to tap into universal human themes. I'm intrigued to see how I can bring that dimension to my other work from now on" (Gardner).

Ota's metatheatricality highlights the practices of representation, but its critique of those practices is disappointingly limited.

To return briefly to *Ota*'s tourist gaze: this gaze, too, importantly acknowledges the limits, and even potentially the biases, of its understanding of other cultures. But its critique is also significantly circumscribed. "The logic of tourism," writes John Frow, "is that of a relentless extension of commodity relations between center and periphery, First and Third Worlds, developed and underdeveloped regions, metropolis and countryside," and, I would add, West and East (151; in Gilbert and Tompkins 287). *Ota* acknowledges, for instance, Pierre's ignorance about the relative values and costs of space and accommodation in different places and cultures, but does little else to explore the potential exploitations of tourism's consumerism. Further, the play fails to develop a critique of the particular "snapshots" of Japanese culture that it constructs—or even fetishizes. These are, predominantly, of a fantasized, aestheticized past. While *Ota* does acknowledge the postmodernity of Japan's technological present, primarily in the context of the Osaka train station scenes, it nevertheless sublimates this present through a nostalgic focus trained more consistently on various traditions: the artistic traditions of *Noh* and *bunraku*, for instance, and the ceremonial traditions around dress, marriage, and death. *Ota*'s depiction of Japan seems dangerously close to what David Morley and Kevin Robins have described as Far Orientalism:

> Far Orientalism . . . has been seduced by the elaborate and arcane rituals of Japanese culture; this Orientalism has been one in which Japan functions as a locus of self-estrangement and cultural transcendence. . . . In contact with this refined exoticism, the world-weary Westerner has indulged in unashamed aestheticism, eroticization and idealisation. (162–63)

122

Bearing a remarkable similarity to Morley and Robins's "world-weary Westerner" is, of course, Pierre, who learns and practises *butoh*, sleeps with both David and, it is implied, David's mother, Hanako, and literally puts on the mantle of the Orient, the kimono (146–47). Indulging in an "aesthetic *Japonisme*" (Morley and Robins 147), *Ota* perpetuates these Far Orientalist aesthetic, erotic, and idealizing fantasies of Japan. And focusing on Japan's past, *Ota* produces Japan more as a vehicle for Western nostalgia than as a place with a self-determining present and future.

Like *La Trilogie*, *Ota* adopts a distance in its perspective on Oriental culture, a distance that goes some way toward acknowledging Japan's cultural difference and inhibiting the Orientalist arrogance of claiming to know, and to speak from the position of, the other. The critical effects of this distance are most acutely realized through the play's metatheatricality, its foregrounding of representational practices' mediation, and construction of their subjects. These effects are, however, sadly underdeveloped because the play fails to produce a thoroughgoing critique of representational practices, instead producing—and to some degree fetishizing—a vision of Japan which is typically Orientalist in its recidivist exoticism.

Orientalism's effects are often insensitive, and sometimes more grossly abusive, but they are never totalizing. *La Trilogie des dragons*, and *The Seven Streams of the River Ota* exhibit features of Orientalism: its tendency to portray the East as either a demonized (Wong) or idealized (Hanako) complement to the West; its tendency to use the East, in other words, as a vehicle for Western fantasies, denying the East's own autonomy and self-determination. But they also work to critique, and even to intervene in, Orientalism's discursive and performative practices of oppression: *La Trilogie* by historicizing Western racial prejudice and disrupting the conventional synonymy of East/West and Oriental/Occidental, and *Ota* by diegetically accentuating the outsider status of the tourist and metatheatrically emphasizing the ways in which representations are culturally produced instead of naturally given. Both plays also exhibit both constructive and restricting features of transnationalism. Optimistically, they demonstrate and promote cross-cultural understanding. More dubiously, they are somewhat insensitive to the (tourist) class privilege of transnationalism as it is often currently configured. They are also given to fantasizing about a universal culture,

neglecting differences (of power, centrally) between cultures. Imagining the potentials of transnational communication, both plays betray some of the arrogance of their endeavors, but they work also to critique and intervene in that arrogance and productively to explore transnational connections.

Notes

1. Of course, Lepage always works with co-creators, even on his solo shows. "His" work is very rarely his alone, and writing of it as such potentially reinforces notions of the genius artist working outside or above social and material relations. Most often, therefore, when I write of Lepage's work here, I mean to refer to the work of Lepage and his collaborators.
2. The first version of *La Trilogie* was produced in 1985; its full six-part version was first produced in 1987. Titles of plays are given in the (main) language of their first productions.
3. The first version of *Ota* was produced in 1994; its eight-hour version was first produced in 1996.
4. This essay explores the challenges put to transnationalism by Orientalism. Another paper, co-authored with Erin Hurley, "States of Play: Transnationalism and Performance," also examines transnationalism's cultural effects but focuses on their effects for individual and community identity more broadly. It cites its analysis in the performance work of the Cirque du Soleil and Ex Machina. See Harvie and Hurley, "States of Play."
5. I have never been to China/When I was small, there were houses here/This was Chinatown/Today, it's a parking lot/Later, it might perhaps become a park, a station, or a cemetery/If you scratch the ground with your nails/you'll find water and motor oil/If you dig further/you will surely find pieces of porcelain and/jade/and the foundations of the houses of the Chinese who used to live here/and if you dig further still/you'll find yourself in China.

 This is the first half of the prologue to *La Trilogie*. The prologue is reprinted in *Cahiers du théâtre jeu* 45 (1987), 38. All translations are those of the author unless otherwise noted. Rewa provides an alternative English translation (153–54).
6. See also Hunt's summary, 112–14.
7. "Hong Kong, the black, the mysterious! On the other side of the ocean's mirror, measuring itself in Hong Kong's reflection, Vancouver, the white, the limpid . . ." (Pavlovic, "Reconstitution," 7).
8. ". . . *la Trilogie* gently pokes fun at some of the old clichés about the Chinese current in the '30s . . . only to replace them immediately with

more modern clichés, without interrogating the genesis of the clichés or alerting the spectator to them" (Denis 160).

9. "The show doesn't claim to speak about the real China. The opening 'I have never been to China' summons another China, an imagined China, an 'image' of China" (Camerlain 89–90).

10. "Completely innocently, the two children invent an Englishman, naturally a little caricatured" (Vaïs 101).

11. "The Green Dragon offers us an *image* of the Orientals, an image biased by prejudices and magnified by fantasies" (Pavlovic, "Reconstitution," 55). See also Pavlovic, "Le Sable," 121.

12. "[T]he spectators' knowing laughter" ("Reconstitution" 44).

13. "[T]he Québécois mentality, tinged with xenophobia" (87).

14. In Hunt 116–17. Lepage makes a similar point in Charest 35–36.

15. "[A] large portion of the added scenes reintroduce Quebec City and accentuate, elsewhere, the use of French (Sister Marie in Toronto, Maureen in Vancouver) . . . even where one would least 'expect' it" ("Le Sable" 122).

16. "*Trilogie* cast a formal look at the war and its victims . . . without interrogating the nature or processes of war (or of microsocial violence), its current meaning, or the question of responsibility" (160).

17. "[S]triking and original" (160).

18. In all subsequent references to this play text, page references will appear in brackets in the body of the text.

The Geometry of Miracles:
Witnessing Chaos
Michael J. Hood

La Caserne Dalhousie, a converted firehouse, sits below Quebec's Old City Wall, with the Musée de la Civilisation on one side and the industrial wasteland of the city's port on the other. The building, like its location, marks a point of cultural and artistic convergence. At one side is a copper-domed bell tower and a graceful wall of Victorian yellow brick, to the other is a box of polished black granite, impersonal, questioning, mysterious, a monolith that might be seen in other circumstances as either gnawing away the elegance of the building's past or somehow growing out of it, like some uncontrollable silicate cancer. Yet here, perhaps because it is the home of Robert Lepage and his company, Ex Machina, the collision of form, time, and function works, not only belonging in its place, but also promising wonders within.

Robert Lepage is without question the most celebrated of Canada's contemporary theater artists. With the possible exception of Michel Tremblay, who for an earlier generation represented Quebec's theater to the world, he is the voice, the style, and the direction of the theater and, increasingly, the film of Quebec. Noted as performer, as playwright, as director, and as filmmaker, Lepage has taken the world by storm with his signature productions of cultures in collision. Beginning with *The Dragons' Trilogy* and continuing through *Tectonic Plates*, and *Seven Streams of the River Ota*, he has repeatedly examined the interactions and intersections of peoples of different lands, different continents, even different times, with the lens of an artist/philosopher of amazing technical skill and an even greater

127

understanding of human nature and of human need. In each of these examples he seems always to find the point at which cultures not only converge, but complement each other, each drawing strength from the other.

Now, with a young multinational company, he is preparing a new piece, *The Geometry of Miracles*, which has as its central convergence the connection between Georgei Gurdjieff and Frank Lloyd Wright. Each of these two "remarkable men," one a Russian adventurer-cum-mystic/scientist-philosopher, and the other an American architect of lasting international fame and influence, represents a point of convergence between science and spirit; as a pair, they represent the collision between European and American culture during a time of great change. Each man brought with him revolutionary ideas and, while Wright is the far better known, both have influenced the way we view the world and our place in it.

My copy of Rémy Charest's collection of interviews with Robert Lepage, *Connecting Flights*, has the following inscription from its subject, "To a witness of our chaos . . ." Mr. Lepage's kind and generous invitation and the support of the University of Alaska–Anchorage and its program in Canadian Studies made it possible for me to attend and to "witness" the final private and then the public rehearsals of *The Geometry of Miracles* in Quebec City. This essay is in essence a message from the fertile "chaos" that is Robert Lepage's imagination in process. It takes as its study the third stage of a piece that will have at least four stages of creation. It cannot comment on or describe a completed piece of art. All this by way of saying that I will describe a play that, as of this writing, will not be seen again in its current form, that has never been seen in anything but rehearsal, and that may take a new direction tomorrow morning, next week, next month, or next year.

While there has been a great deal of writing centering on reactions to Lepage's work, ranging from rapturous praise for his command of image to great distrust of his use of technology, there has been little that focuses on his process. There has been some discussion of the Repère Cycles and the acknowledged contribution of Alain Knapp, Jacques Lessard, and the Halprins, but nothing from within the process as currently practiced. There are questions that beg to be answered. How does he choose the subjects for his projects? How are rehearsals

conducted? How much real collaboration occurs? Where do the visual metaphors so central to the work originate? How are they developed in rehearsal? When, if ever, is the play finished? Finally, how large a role does technology play in *The Geometry of Miracles*?

In a phone interview, Lepage explained that work on the show began with a series of coincidences:

> My interest in Frank Lloyd Wright was, of course, the whole idea of organic architecture because I have the ambition of trying to develop a kind of organic way of writing and constructing and developing stories. . . . And the way . . . the company's been working in the past years, we've always referred to our way of working as a kind of organic way of working. And it's only by chance that we were visiting close to Chicago, visiting the old part, that we actually ¨. . . came across this expression of organic architecture. And I said, "Oh, what is this about?" And then when I tried to be more interested in his work process and his philosophy of architecture, then I said, "Oh, you know, there's so many connections, and there's so many—so this would be great for our company to actually . . . just explore that theme of organic architecture."
>
> And as I started to do that, one day I—really by chance I was going—flipping through a book about the 1930s. Of course, Frank Lloyd Wright's work spreads on such a long period of time that it's difficult to do actually something about his life because then, you know, you would have to do a really, really, really long show. So we were trying to—we were looking for a period that would be—that was more exciting. And of course the thirties was a very interesting time in Frank Lloyd Wright's career because it was just after the crash of '29, the Wall Street crash, and he didn't have any commissions during these ten years that were— . . . there were some commissions, but they weren't very, very, very important commissions, there was no work for his group, for his fellowship. So it was actually a fantastic time for him because he could explore, he could do, he had a lot of time to develop new ideas and explore and do stuff. And so we started to focus more on the thirties.
>
> And by chance in a book about Frank Lloyd Wright in the thirties, I came onto this photograph of Gurdjieff, and I wondered what is the relationship of Gurdjieff with Frank Lloyd Wright, and that's when I

got into the whole story of . . . how he met his wife and how his wife was a disciple of Gurdjieff before she met Frank Lloyd Wright and how Gurdjieff actually in the thirties visited the fellowship and actually made them do all these strange movements and sacred dances and harmonic chants—chanting and stuff. So all of that was really very inspiring because I had been very intrigued by Gurdjieff's work before in the Peter Brook film, *Meetings with Remarkable Men*. And it happened that the day where I found this photograph of Gurdjieff in that book about Frank Lloyd Wright, I was meeting Peter Brook that morning, I was having breakfast with him. And I—and he was asking me, "What are you doing? What are you working on these days?" And I explained to him . . . this Frank Lloyd Wright project and all that. And I said, "It's so strange that I'm meeting you this morning because I bumped into this photograph, I came across this photograph of Gurdjieff." And he said, "Well, yes, of course, Frank Lloyd Wright and Gurdjieff both had a great influence on each other."

And so that kind of gave me . . . that amazing coincidence, that kind of a benediction of Peter Brook, kind of gave me this kind of, how can I say, push towards this idea of trying to find out what are the connections between these two men, these two characters that are—you know, that were larger than life and because both of them were, of course, very much into geometry and mathematics, whether it was for the soul or a building . . . for the material or immaterial world. Both were, I think, great explorers of the geometries of these respective miracles. . . . So that's how the whole thing kind of—we had—some of us were more interested in the Gurdjieff things, and others of us were more interested in architecture and in Frank Lloyd Wright, so the group we have now is very much documented on both subjects. (Lepage, telephone interview, 17 July 1997).

A combination of curiosity, knowledge, coincidence, and convergence, then, has informed Lepage's choice of subject. But how has the subject been approached? Marie Gignac, one of Lepage's favorite co-creators, and an unforgettable presence in *The Dragons' Trilogy*, *Tectonic Plates*, and *The Seven Streams of the River Ota*, though not a member of *The Geometry of Miracles* team, offers insight into the process of collective creation as it is currently practiced at La Caserne:

I think that the part of creation that he asks of the interpreters is, I should say, almost as large as what he asks in the creation itself. So it's the same type of work, it's the same way of working. . . . Maybe—the image—I always used to talk about this—is the image of the pyramid . . . So when you create a new piece of work, you start by—it's like if you start from the base of the pyramid, so you . . . have to research . . . you have to collect lots of information about what you are going to talk about. You do lots of improvisation, of research, of explorations about your topics and things like that, and characters. And so this is your material that you start from to get to the actual play that's going to be shown on stage, which is the top of the pyramid. So your work is to collect and take all this and to, how could I say, to get it . . . smaller and smaller and smaller and to get to this last small triangle that's the top of the pyramid that's going to be the show that you're going to stage and show to the people. (Gignac, telephone interview, 13 January 1998)

In the case of her last production with Lepage, *The Seven Streams of the River Ota*, the first meetings began with only the notion that it was going to be a seven-hour show in seven parts.

So we were going to have seven . . . small stories that would ideally be linked together in order to be a big saga or a big story. So basically we started with this number, the number seven, and of course Robert always comes with many, many ideas that can be formal or that can be ideas of structure like that and also with some topics. . . . We knew also that this was going to—the starting point of this was the bombing of Hiroshima— . . . as a kind of turning point in the twentieth century, political and spiritual and ecological and everything. . . . So we knew that those seven small stories that we had to create were all going to be linked in some way with this bombing in Hiroshima, with this event. And then Robert had . . . numbers of other ideas that he took here and there in his travelings and his readings. And he wanted first that all the seven stories, that every story, each story had to do with a city or a country. So from the beginning we had . . . New York, Paris, Stockholm, Montreal, Hiroshima itself. And we had Peking, also, I think. I can't even remember. And Prague.

So what happens first is that . . . we—this is very concrete. We hang to the wall seven big papers, and then we put a title on each paper. In that case the title was then the name of those seven different cities that we were going to work on. And then we do a kind of brainstorming, and on every big paper, on the seven big papers we just brainstormed and found ideas, which again can be formal or can be more on the intellectual or concrete side, and we put all those ideas on every paper. And then we started to explore everything. . . . by improvisation, we buy books, we read, we talk; everybody . . . tells the stories of what everything invokes for them, all these ideas. So that's it, that's the way it starts. (Gignac)

Lepage makes clear that, while he retains much of the creative process that he learned with Repère, he has abandoned a formal reliance on that system and adopted a more free-flowing style.

People [the performers] are starting to be used to—they are getting used to the way we work, so it goes faster. We don't spend a lot of time . . . evaluating what we're doing. We just trust that it's growing. [It's] very collective, very, very much collective. Of course, the signature, the style, the directorial style and the aesthetic, the way it's singular or wrapped or linked and whatever or tied up is my thing. . . . It's my thing or my style or my signature, but the development of the story line and the characters and all that is very, very collective, more than ever, I'd say. (Lepage, telephone interview)

Company work on the *Geometry of Miracles* began with a group of five actors working for three weeks in February 1997. The three-part structure that emerged from that first workshop then drove a second stage in July of the same year, involving ten performers and five weeks of work, including two "public" rehearsals. Lepage and the company began with a house, then the rooms of a house, then the things associated with those rooms. The company included several dancers and much work went into learning and incorporating Gurdjieff's "sacred dances." As late as last 16 July 1998, the play was primarily about Frank Lloyd Wright, though he never appeared as an individual character. At the time, Lepage believed the play would also focus on the changing role of the United States, both internal and external,

during the time just preceding, during, and following the Second World War.

> The first part is set in the thirties; the second part is set in a prison during the war, the Second World War; and the third part is set in Paris in 1948. So that's . . . how—so we have an idea of what America was before the war and what it became after the war, what happened to artists and intellectuals and architects, because of course there's a bit of criticism in that in the sense that the United States seemed to be, if we—if one is interested in the artistic milieu before the Second World War, how the United States was this amazing place where people from all over the world just went and expressed themselves and where communism and whatever other crazy idea, . . . popular in those days actually could be expressed or be experimented. And suddenly the Second World War forces the United States to become . . . the global cops . . . to actually protect the world and to regulate the world military. So of course the United States has become a place that's a bit more—is less free than it was and certainly artistically controlled. And so it's a comment on that, too, . . . on what America has become after the war. . . . You know, it was a great period, the thirties . . . all these amazing people who just experimented with everything because they were free. And the people who experimented in the United States after the Second World War were a lot of artists who were in reaction to the system. So that also is a comment. (Telephone interview)

Fascinating. America's emergence not only as the savior of a free humanity, but as the most powerful country ever known: the United States taking up the baton and whistle of policeman and defender of that freedom. In accepting that task, America would no longer serve as a refuge for *les refusés du monde* and would instead play a role defined by suspicion, exclusion, and repression. The intellectual ferment, economic depression, and cinematic froth of the 1930s, interrupted by the exigencies of war on a global scale, replaced with the Cold War, the McCarthyism, and the narrow-minded comfort of Eisenhower's 1950s. Here were themes worth pursuing.

These themes were interesting, relevant, intriguing, but, as of now, no longer central to this version of the play. These ideas and the

three-part structure that accompanied them did not survive the July rehearsal process. After five weeks of work and two well-received public trials, the play "took a different direction" (Lepage, in rehearsal).

Now, in March 1998, following an additional five weeks of rigorous exploration and improvisation, the play still has to do with the convergence of Gurdjieff and Wright, but is now told through the eyes of Wright's third and last wife, Olgivanna. In addition, the character of Wright, earlier "played" by no one, is now played by Marie Brassard, one of Lepage's long-time collaborators, who also plays Olgivanna in her later years.

Olgivanna Lazovich Hinzenberg Wright, a native Montenegrin, was a disciple of Gurdjieff at Fontainebleau, and studied with him for seven years. After leaving France for the United States, and after a divorce, she met the then-married and much older Wright at a performance of *Les Ballets Russes* in Chicago in 1924. With him, she withstood the scandal of a very public affair, married him in 1928, and remained with him through the remainder of his life. Olgivanna is given credit for inventing the Taliesin Fellowship, the system of group apprenticeship that, from that point on, kept Wright supplied with an income and with ready hands for all sorts of necessary work, both professional and personal. As the play stands now, Olgivanna, for whom a gypsy fortune-teller has prophesied a life defined by successive shapes: "a circle, a square, two lines, a spiral, a triangle," goes to Gurdjieff on a quest for personal immortality. Her search leads her to America, to Wright, and in Wright as affected by her and, in part, through her earlier connection to Gurdjieff and his teaching, to a kind of immortality for both men.

While the action of the play is seen through her eyes, its scale remains global and beyond. Our attention is focused on the three major characters, but along the way, almost incidentally, we are parties to the Russian Revolution; the Wall Street crash of 1929; the manic force of American capitalism as represented by Herbert "Hib" Johnson; the birth of the Taliesin Fellowship; the death of Lenin; the sacrifice of art (as personified by Meyerhold); the horror that was Stalin; World War II; the witch hunts of the 1950s; the nature of the cosmos; the triumph of Wright's "organic" architecture; the nature of the creative process; the quest for immortality; and last, but certainly not least, the "geometry" of miracles.

134

It is in geometry that Gurdjieff and Wright meet most eloquently, in Wright's command of form and in Gurdjieff's understanding of the nature of the miraculous. There is a certain organic and mathematical inevitability to the three major characters being given new life by Lepage. Here are Gurdjieff, the magician/philosopher/charlatan, Wright, the spendthrift/philanderer/master builder, and Olgivanna, the lost soul of a civilization torn between the factional shouting of Europe in decline and an America not quite having found its voice. Happily, here to enliven them is a magician of the stage, a consummate technician, and a native Quebecer, and as such, as much by heritage a citizen of Europe as perhaps any North American can be.

The Process

Lepage has contrasted his approach to the creative task with the traditional model.

> Most of the time, a theatrical production is constructed in the following order: writing, rehearsal, performance and, sometimes, translation. I've noticed over time that in our creations, the process is, in a sense, reversed: the real writing happens at the end. Our creative work begins with a huge brainstorming and a collective drawing session where ideas are grouped together. Then, we discuss ideas that have been singled out, which leads us to improvisation. Then there's the phase of structuring the improvisations, which we rehearse, and eventually perform publicly. These performances, rather than being the culmination of the process, are really further rehearsals for us, since the show is not written down or fixed. Because we perform our plays in a number of countries, the translation is done at about this stage. . . . To my mind, the text for a show can't be written down until all these stages have taken place, when all the performances are over. It's only at this point that the shape and the subject matter have stopped evolving. If you look at this process in cyclical terms, the cycles in which I work are out of step with the conventional sequence. Simply put, the starting point for most creations becomes, for me, their final point (qtd. in Charest, *Robert Lepage: Connecting Flights*, 177–78).

135

In *The Geometry of Miracles*, Lepage is working with a young company, many of whom have not worked in this manner before. Several of the performers are dancers, one is an architect, and the dramaturg is an opera singer. They hail from at least five different countries, including Great Britain and Croatia, and, one suspects, from at least five frames of creative reference. One has worked with Ariane Mnouchkine, two others with Gilles Maheu at *Carbone 14* in Montreal. The company has been introduced to Gurdjieff's "sacred dances," harmonic chants, and to at least one of Usovolod Meyerhold's exercises in biomechanics. Cast and crew have a library of materials at their disposal, books and videos on Wright, Gurdjieff, history and culture, and each company member is truly a co-creator. Performers share ideas and discoveries easily and often, time is taken for discussion, more often of structure and approach than of specific details of dialogue or action.

One of the great changes in Lepage's process came with the opening of La Caserne and the theatrical arm of his creative work, Ex Machina. Instead of leading the nomadic rehearsal experience that had characterized his earlier work, Lepage now has a home for his explorations, complete with studios stocked full of the technologies that so often support his imagination. In addition to the machinery itself, during the rehearsal process, technical and design artists hover everywhere, at the ready, full participants, and fully capable of working magic in service of Lepage's vision at any moment. Among them there is a palpable sense of personal responsibility. They respond to requests from director and/or actors, but are also constantly bringing contributions. Sound, lights, props, costume pieces, or at least facsimiles, appear as if by magic. The need is noticed before it can or has to be legitimized by the director. New resources are found and incorporated as a matter of course and looked-for opportunity. New scenes are explored, then commented on by everyone. Lepage may pose the question, but it is normal for him to invite answers. He does not impose himself too early and, when he does, it is in the spirit of "let's try this," not "do this for me."

He characterizes his role as that of a facilitator:

> Because at one point in this way of working we all have to admit that the subject matter and the resource that we've chosen and the stories that come out of that resource are more infinite than we are.

Because everything is larger than us, we have to have a sense of humility and we have to let the story tell itself, appear by itself.

The play takes on its own life, "starts to move," and Lepage then tries to tell his actors "where they should look or what they should be attentive to, in order to understand who and what this show is. . . . I have to keep them well informed of the beast that is starting to appear and what he looks like" (Lepage, interview by Alison McAlpine, 140–41).

Now, in the last rehearsal cycle before its 16 April 1998 opening at the Du Maurier World Stage in Toronto, the "beast" that is *The Geometry of Miracles* is beginning to emerge.

A Rehearsal Day: 11 March 1998

Strategy: 10:00 a.m.

The company is gathered in a rehearsal room receiving a few notes from the previous night's public rehearsal. The evening had its share of gaffes, lost props, dropped lines, technical miscues, but all are understandable given the pace and complexity of the work. There were also a number of clearly stunning moments, moments that drew gasps from the full house. Most of the problems were undetectable to a new audience, and most of the public response to the piece was good, but Lepage and actors agree they need to find ways to deepen the work. In particular there is the feeling that Olgivanna is "too much of a housewife" in act two. The observation is made that she is the point where Wright and Gurdjieff converge, and that her role as the instigator of the Taliesin fellowship needs to be made much clearer. In addition, there are a number of scenes that have been identified as parts of the structure of the play but that have not been dealt with or, at least, have not been dealt with in this stage of the work.

To one of the players, the play as it now stands seems like a series of still photographs, displayed in more or less chronological order. Everyone agrees that they need to bring more depth to the characters and to the work in general. Out of the discussion, which is far ranging and lengthy, comes the idea that they have been perhaps too much the slaves of time and have not experimented with time as it is served by

137

memory. "Why do we have to move only one direction?" The play's
major action begins in Olgivanna's memory, brought on by the connec-
tion of the beginnings of the vision problems which will eventually
blind her, and the memory of reading to her blind father in the
Montenegro of her childhood. As it currently stands, the action then
flows forward, like a family album, though it moves all around the
globe. The discussion covers cinematic concepts of time, the idea of
having characters from the past encountering the future. Is hypnotism a
way into a different approach to time? Gurdjieff at one time supported
himself as a professional hypnotist. Wright is quoted as having replied
to the comment that he had hypnotized his clients "Yes, I do. I hypno-
tize them with the truth. There is nothing so hypnotic as the truth."
Someone mentions the spiral-figured disk we associate with old-time
mesmerists. The question is posed, "Can we change our direction and
move backward and forward through time? Can we take the hypno-
tist's subject not into *past* life regression, but into *future* life projec-
tion?" A player mentions his theory (I have not proved it yet), that time
is always simultaneous with itself, just stacked. The company will per-
form the piece for the public again the next evening, yet they suggest
and discuss major structural changes, not just details.

At least one company member is feeling the pressure of an upcom-
ing world premiere in Toronto in April, and wants to end the discus-
sion and get to the work. Lepage, a bit impatiently, admits that he too
is concerned with approaching deadlines, but takes the time to explain
that this kind of thinking "sucks the creativity" out of him. "We're all
worried about time, but we are not losing time. All this (the discussion,
the new ideas) has value. There's no sense in 'jamming' new scenes into
the play." This last is delivered perhaps on the edge of exasperation
but without any rancor, the player accepts Lepage's position and the
discussion moves forward.

In addition to the question of Olgivanna's role and the manipula-
tion of time, there are also questions raised about Gurdjieff's charac-
ter. Is he currently seen as a charlatan, or simply a stage magician?
How can the company bring his philosophical and mystical qualities
to the fore?

One is struck also by the incredibly rich preparation this company
has undertaken. Because they invent all that they do, and much of

what they say, their sense of the reality of their characters must be extremely secure. At any moment they may find themselves involved in an improvisation that absolutely demands their total commitment and a depth of knowledge seldom otherwise encountered. The group is extremely literate. While there are sometimes difficulties occasioned by language differences, it is clear that they have done their homework. All of them have read all the resource material and where one may have a memory failure someone else will take up the torch and the discussion goes on. While some are more talkative than others, and while there is plenty of time for humor, even silliness, all remain focused on possibility.

Marie Gignac, while admitting the frustration that sometimes accompanies the work, especially the fact of Lepage's always being at the center, suggests that the success that has accompanied their collaborations has been ample compensation and, further:

> It's the most interesting thing that happened to me in all my professional life. And also I do things with him that I would never have done with other people. . . . I sometimes imagine my life if I would have . . . led a regular career of an actress in Quebec City. . . . And, my God, it's so boring . . . [and] . . . he opened the world to me because I started to travel and I started to perform in other languages and to explore other cultures and other ways of working, and I started to be a writer as well . . . because you do everything when you work with him. You do—you direct sometime, you write, you study. . . . You have the right to your opinion and . . . you can express yourself entirely. And people—. . . usually the people that work with him are very interesting people, so I've met wonderful people that became lifetime friends now. (Gignac)

The remainder of the "comeback" session is given over to the "two lines" sequence, a sequence not included in the first public rehearsal. In this sequence Lepage has to introduce Meyerhold, portray the death of Lenin and the rise of Stalin, show Meyerhold falling a victim to the purges, then the conference visit of Frank Lloyd Wright and Olgivanna Wright to Moscow.

Two Lines: 11 March 1998

Afternoon and Evening

In rehearsal that afternoon, the sequence begins with a prison scene. During World War II, John Howe (Jean-Francois Blanchard), one of Wright's most talented apprentices, has been imprisoned for his objection to the draft. Olgivanna comes to visit him and a long dialogue is invented that provides the players the opportunity to illuminate Olgivanna's central role in the fellowship and her connections to Gurdjieff's methods of teaching. It also provides an opportunity for a criticism of the fellowship, noting in an extremely personal way the exploitation of the talented young men who came to study with Wright. The scene is played across a drafting table, with a prison guard hovering in the background. At its end Gurdjieff enters, calls his disciples to the stage and teaches them a sacred dance, the "March of the Herons." As the dance is played, Wright fellow Wes Peters and Olgivanna's daughter, Svetlana, now his wife, enter and move to the drafting table that, by virtue of their actions, is transformed into a car. Catherine Tardif, as Svetlana, sits at the drafting table while Anthony Howell, as Wes Peters, raises its drawing surface as though it were the hood of the automobile. He steps away from the car and as he moves away, she "drives" forward. Gurdjieff's disciples, still engaged in their dance, now move across the stage and overwhelm the car, suddenly having become the water of the river into which Svetlana Peters accidentally drove to her death. In a moment of dazzling simplicity and lingering sadness, Catherine/Svetlana is thrown over the hood of the car in slow motion and in opposition to the movement of the dancers who are rolling over and around the drafting table/car. She rolls forward, ending at Wes's feet at the far edge of the stage, almost touching but untouchable. The moment is heartbreaking.

A following scene is set on a westbound train in 1970, with Wesley Peters's announcement to Olgivanna of his upcoming marriage to Stalin's daughter, whose name, coincidentally, was also Svetlana. The train sequence has earlier been envisioned as taking place in Russia during the 1930s, a scene that recounted Wright's trip to address an architectural conference in Moscow. Now their discussion of time and place leads to a new approach. Where it had been planned

for Marie Brassard to play Wright on the train to Moscow, she now appears as the older Olgivanna, accompanied by Anthony Howell playing Wes Peters, and traveling from Chicago to Phoenix. The focus moves from them at far stage right to stage left by virtue of the arrival of Thaddeus Phillips as a Southern Pacific conductor who, as he moves across the stage, through adjoining "compartments" changes by turns into a Nazi conductor, a Czech customs agent and, finally, a Soviet border guard ending his journey at the other end of the stage, where actor Kevin McCoy plays Wright while Thea Alagic plays the younger Olgivanna. The play moves thirty years into the past, seamlessly, in less than two minutes.

In another part of the Russian sequence, Lenin (Rodrigues Proteau) lies in state on the drafting table, is embalmed there, and then is placed across the base of the table. With the addition of a light that shines from below its drawing surface, the table becomes the mausoleum in Red Square where, in reality, Lenin's body still lies. The table turns, the top is raised and Stalin emerges above and behind it, now on the Red Square reviewing stand so familiar to us all from television news reports. There he oversees the execution of Meyerhold, whom he had greeted warmly only minutes before. Ironically, the execution carries overtones from Meyerhold's "Stringing the Bow," earlier identified, as was Meyerhold in life, with the Russian Revolution.

All of this is explored in the day's rehearsal. The company remains present in the room throughout the session, even in lengthy scenes that do not involve them. The scene is played, without interruption or direction, then there is brief commentary. It may be repeated or the company may move on to a new scene. Lepage sits in the front row, six feet from the edge of the sandbox that makes his stage. He interrupts infrequently at this point and mainly when the actors are in the wrong place or have forgotten to do something. He speaks softly, but all are made quickly aware that he is speaking by the silence that falls around him. His criticisms can be to the point, but are not brusque or cruel. He does not spend a great deal of time analyzing the improvisations. He is painting on a giant canvas, and details can wait. He says to Thaddeus Phillips who, as the train conductor, has just introduced new dialogue in four languages and four separate characters: "Try it like that, and we'll fix it later" (Lepage, in rehearsal). He does not use the word "fix" to mean, "correct." Instead he uses it in the sense of "finish." And "later"

141

may be much, much later. The scene is going in the right direction and the actor is expected to keep it going in that direction and to keep it *growing* as well.

Spirals 7:00 p.m.

Lascaux-Guggenheim

Now the rehearsal shifts to new tasks. It has been decided to include two new scenes. The first is set in Lascaux, amid the glory of Paleolithic cave painting, and the second in the Guggenheim Museum in New York City, the Wright-designed temple to modern art. There is very little discussion. Quickly a scene is improvised, a guided tour to Lascaux for Gurdjieff, Olgivanna, and other disciples. The scene touches on the impulse to art and the organic nature of caves as living spaces. There is some discussion of incorporating the spiral hypnotism motif discussed earlier in the day, and an attempt at finding whether the "future-life projection" will work. The second scene is brand new. How can the Guggenheim be represented, at the time of its opening just after Wright's death? How can its connection to modern art be represented as well? In conscious evocation of Jackson Pollock, several of the players throw paint (water) against the upstage screen. At first they use paint cans, then clear jars, then clear jars in which have been placed pieces of colored gel. The painters become wilder and wilder. Throwing paint from brushes, from their hands, dipping their hair in the jars and whipping the paint toward the screen. In a dizzying sequence of ideas, Kevin McCoy suggests that the spiral shape can be made manifest with an actor suspended, spinning, circus-like on a standing rope. Further, it is suggested that he carry a paintbrush; he is a commercial painter, painting the walls of the Guggenheim as he spins in mid-air. Immediately the proper rope is produced and hung from the grid above the stage. McCoy climbs the rope, places his hand in the loop, and after some small adjustments are made, suddenly takes flight, a celestial vision, graceful and majestic, totally unlooked-for and totally right, spinning in mid-air. The company "oohs" and "aahs" like excited children, totally engaged with their fellow-creator and

totally supportive of his work. A place, a time, an era in American art and architecture are given shape and life in an hour's rehearsal. The rehearsal ends at 10:45 P.M. The company has been at work since 10:00 that morning, with two one-hour breaks. They have been accompanied and supported through that entire time by the production crew. Costume pieces, props, adjustments to props, rigging, and lighting have been provided, altered, corrected, or replaced, and approximately forty-five minutes worth of material has been invented, played, and incorporated into the piece.

Beelzebub

Gurdjieff's life-long quest was to find the meaning and purpose for human existence. The morning's comeback session raised the concern that Gurdjieff as represented in the current version of the play does not have the gravity necessary to the role. There is a chance that he will be seen only as some kind of a charlatan, a magician performing parlor tricks. Previously in rehearsal his final appearance has been in a desert scene in which immortality, the nature of miracles, and the connections between the visible and invisible world have been explained. The earlier improvisation, however, a campfire-side counting game with Wright's apprentices, unintentionally gave the impression of an avuncular blowhard telling tales. Now, Rodrigues Proteau appears, not as Gurdjieff, but as Beelzebub, a reference to one of his most popular books, *Beelzebub's Tales*. In this iteration he is a horned satyr, on stilts, who appears to Wright and to Wright alone, and who creates first fire with a wave of his hand across the sand and then a tent from nowhere with only his voice. "Geometry," he says, "is the relation of a unit of one number of dimensions to a unit of a larger number of dimensions: a dot to a line, a line to a plane, a plane to a solid, a solid, a three-dimensional object to an object of four dimensions," and miracles "do not break the rules of the cosmos, they simply follow those of a different cosmos," unperceived and unknowable. The transformed scene now works. Beelzebub brings the mystery and the power of truths beyond our knowing and beyond our control. He embodies for characters and audience alike the very concepts he explains.

Metaphors and Magic

Lepage is rightly famous for his use of visual metaphor. *The Geometry of Miracles* is filled with inventive and meaningful examples of his ability to make the most prosaic of objects into symbols of startling clarity.

The drafting table, side to us, top angled to form a vertical drafting surface, becomes, simply because the actress turns to it in her chair, a grand piano, lid up. She plays, we believe. At another point it serves as a dining table, upon which Wright's apprentices assemble from the dinner service a model of Wright's masterpiece of industrial design, the Johnson's Wax Building. It becomes as well the earlier-mentioned automobile, catafalque, reviewing stand, mausoleum, and firing squad wall. In a particularly beautiful moment, the ink from one of Wright's drawings, running off the paper on the drafting board, is in the rain that accompanies his funeral, takes us from the tangibility of being to nothingness in a matter of seconds. The finality is startling. The connection between the fleeting nature of the creative impulse, its products, and life itself is reinforced and given immense power.

In a surprising transformation, the coffin used immediately before for Wright's funeral becomes a platform for the figure of a Russian dancer, *après* Nijinski, who rises from behind it to perform the controversial "Afternoon of a Faun," which scandalizes much of its Chicago audience. Later it becomes a bed, a sarcophagus, and a mummy case. Again we accept the visual shorthand that makes one thing into many. And the accumulated weight of those many meanings, a kind of visual anaphor, grants meaning beyond any topical sense to each subsequent use.

In *The Geometry of Miracles*, like *The Dragons' Trilogy*, the playing area is covered in sand, this time in a raised box. The sand becomes a place to hide things, chairs, a tent, fire, and a connection to the earth, bread, fields, most appropriately the desert of Wright's Arizona and of Gurdjieff's Middle East. The play begins with eight figures upstage playing in the sand, making small mounds in front of themselves, in a kind of ritual act of commencement, and then, *magically*, in an early scene, as Rodrigues Proteau stands before those small mounds of earth, they are transformed into the mountains separating Georgia from

Mother Russia, the track that Gurdjieff follows as he escapes the Revolution.

Throughout the play, Lepage has incorporated dance as a vehicle for meaning. Early on, a Russian folk dance is transformed into the brutal conflict that accompanied the Bolshevik Revolution and drove many people, including Gurdjieff and Olgivanna, from their homelands. Meyerhold's "Stringing the Bow," while not a dance *per se*, performs the same function as its performance represents Bolshevik art and the masses. Gurdjieff's sacred dances are everywhere. They appear as part of his teaching, as rites of passage, as the river waters earlier described, and in one moment as the dervish dance of Johnson's "spinning secretaries." Dance is also incorporated in an evocation of *Les Ballets Russes*' performance of "Afternoon of a Faun." In this instance, the choreography, developed and danced by Daniel Belanger and Catherine Tardif, is a conscious attempt to evoke Cubism, and produces a wonderfully "arty" exercise in two-dimensional movement.

In yet another dance style, Herbert Johnson, portrayed here with élan and wit by Thaddeus Phillips, is a tap dancer. The sound and the speed of his feet sets a brash American counterpoint to the more lyrical and extended Gurdjieff movements and music. His rhythm is the rhythm of American Industry, quick, impersonal, unremitting. There is no commentary. It simply is.

Finally, following Olgivanna's death, in a gay discotheque decorated in an Egyptian theme, with a rap DJ wearing a pharaonic hood and dancing suspiciously like Steve Martin doing King Tut, Lepage stages a joyous *rapprochement*. An uncomfortable Wes Peters, still in mourning for Olgivanna, is coaxed to the dance floor where he shares the now familiar movements of Gurdjieff's sacred dance with a new world, post Wright/post Gurdjieff. It is a moment that is at once unsettling and somehow a perfect indication that the ideas of these two remarkable men are and will remain fresh, available, and challenging.

Dance, then, becomes much more than a diverting or even spectacular aspect of the play (though it achieves both). Instead, through the repetition of some forms and through the juxtaposition of others presenting differences in style, in time, and, certainly, metaphorical content, Lepage brings wit, understanding, and depth to his work.

Technology, or Life after Elsinore

In the course of the past several years, notably with his production of *Elsinore,* it has become almost fashionable to dismiss Lepage's stage-craft as somehow suspect, as non-theatrical. There have even been sug-gestions that he ought to leave the theater for film, since that is so clearly where his heart lies. In the eyes of some, technology obscures rather than reveals meaning. Like the polished granite that has attached itself to the old firehouse on Rue Dalhousie, technology and the tricks it can perform seem to some to devour the better substance of the the-ater, leaving only the skeletal remains of what once was.

According to Shirley Mathews:

> this is the next incarnation of new Vaudeville—those precision enter-tainers who brought back juggling, physical stagecraft and magic in a new form—looking to go legit by tackling a serious project. "Elsinore" is what happens when the Big Budget movie mentality hits the theater—it's all about special effects, spoon feeding and making the audience say, "Ahhh." (F4)

Although less categorical, David Lampe-Wilson is of a like mind:

> What do you call a production of "Hamlet" that puts more trust in its set designer than in its playwright—You call it "Elsinore," or you might call it "El Snore." . . . maybe we are seeing what Hamlet recalls at the moment of his death. Or maybe not. It really doesn't matter: Lepage just wants to dazzle us with kaleidoscopic fragments, not win us over with coherent thought. . . . The play's music, video, film, slides, fog, and twirling sets obscure the sense of the words. . . . Lepage could be either a theater genius or a sideshow charlatan.

And he could be creating nothing more than, "self-indulgent, preten-tious twaddle" (*The Hour*, C7).

It can probably be argued that this feeling comes chiefly to the fore when, as in *Elsinore,* Lepage is working on classical pieces, pieces where the critic is most likely to have a pre-conceived notion of the intended meaning and, perhaps, a bias or two. Other critics, reviewing the same production, though in different performances, were more

positive in their response. Clive Barnes, writing for the *New York Post,* believes that:

> to an extent it is the visually arresting aspect of the drama that domi-
> nates the Canadian director Robert Lepage's *Reader's Digest* view of
> "Hamlet" as a one-man show . . . yet there is in the final count a great
> deal more in Lepage's phantasmagoric "Hamlet" than merely meets
> the eyes. The man is a master of the theater, a purveyor of miracles, an
> illusionist of style . . . what you take away with you from this dizzy
> sojourn in "Elsinore" is the memory of . . . Lepage's incredibly effec-
> tive, often simple devices that turn Shakespeare's play into a night-
> mare landscape of ingeniously persuasive validity. (63)

Jocelyn Clarke sees Lepage's *Elsinore* not as an end to theater but as a glimpse of where it might be going:

> While one critic described Elsinore as a "deadening *cul de sac*" in
> which live interactive theatre might "die"—and he was by no means
> alone in his view—many in the audience were astonished and
> enthralled by what took place on stage: what horrified the critic was
> exactly what excited the audience.
>
> In *Elsinore*—as in the rest of his work—Lepage embraces new
> technologies and alternative narrative idioms in order to represent
> them onstage and in a theatre, live and in the moment. Though theater
> as an art form already incorporates different forms and idioms—archi-
> tectural, textual, visual, physical—Lepage is one of the few directors in
> the world actively exploring what is possible with new media and
> technologies on stage.
>
> The audience gasps at moments of astonishing simplicity and
> beauty—because they recognize the visual and narrative idioms, and
> see and hear the text and the actor in new and exciting ways. (35)

Lepage, himself, has made an answer to his critics:

> I am accused of imprisoning myself in technology, but technology is a
> tool that allows me to explore things. We're dealing with an audience
> today that has a very sophisticated narrative vocabulary. I'm not say-
> ing that we have to become more cinematic or more televisual, but

147

we have to find a way to invite that audience into the theater. Film
was supposed to have killed the theater, but it liberated it. Every time
there is a technological revolution, it gives an artist reason to hope.
(*The Globe and Mail* [12 August 1997]: A14)

Now, without any indication that he is responding to criticism of his
reliance on technology, Lepage has made *The Geometry of Miracles*
extremely simple. Gone are the tilting walls or revolving rooms of
Elsinore and *Songe*. While film is used, it is used, as yet, far less than it
was in *Seven Streams* or *Tectonic Plates*. *The Geometry of Miracles*
makes its magic simply and eloquently. Actors making creative use of the
objects they have been given to work with realize most of the "effects"
here. A change of scene or mood or subject may occasion or be occa-
sioned by a change in business. There is "high-tech wizardry" to be sure,
but it is subdued, and serves, rather than intrudes upon, the human wiz-
ardry so often on display.

The stage sand hides cables, turntables, and gas lines. The grid
above the playing space, and the control mezzanine behind and above
the audience seating, contain the requisite mechanical and electronic
tools of the contemporary theater. There are projections of both light
and image, but in *The Geometry of Miracles*, Lepage has returned to
the relative simplicity of *The Dragons' Trilogy*. And in that simplicity
lies the possibility of awe. In *The Dragons' Trilogy,* more than anything
else, at least for this viewer, there was the sense that the actors were lit-
erally giving themselves to the rite within which they played. *Un don de
soi.* Nothing was held back. All was genuine. There was no pretense
and no hesitation. That this clarity and purity of purpose was couched
in and supported by staging that included a series of stunning visual
coups de théâtre only added to the fullness of the experience; the com-
bined effect of actor and staging was completely, though sometimes
inexplicably, overwhelming. *The Geometry of Miracles* holds that same
promise. This appears to be the judgement of no less than Peter Brook,
arguably the most honored *metteur en scène* in the world:

Robert Lepage and his collaborators have given themselves a task that
is as immense as it is deeply needed. They seek to create a theater
where the terrifying and incomprehensible reality of our time is insep-
arably linked to the insignificant details of our daily lives—details that

are so important to us, so trivial for others. For this, they are experimenting with a theatrical language where today's technology can both serve and sustain the humanity of a live performance. What a splendid task! What heroic ambition! (qtd. in Charest, *Robert Lepage: Connecting Flights*, 17).

Reaching Out to the Gods

In *Gurdjieff: Making a New World*, J. G. Bennett described Gurdjieff's manner of teaching:

> He never gave anything a finished form. He always gave only the beginnings of ideas, leaving it to his pupils to work them out. He never bothered about terminology and nomenclature, taking the first words that occurred to him and suiting them to his purpose. Sometimes in this way he made definitions that were extraordinarily exact, but there was also such an accumulation of examples that it was necessary to know the subject very well in order to understand what it was about.
>
> But the chief thing about his method was the fact that in giving his listeners and his pupils only the beginning of ideas, he seemed to be always waiting to see what they would make of them.
>
> One received more, another less, according to their power and training. The question was what each would make of it. (8–9)

Like Gurdjieff and Wright, Lepage asks a great deal of his disciples, both those onstage and those in the audience. He sees the theater as an art form that ought to be the ascendant province of metaphor. The earthbound, cause and effect horizontality of metonymy should be reserved for film. *The Geometry of Miracles,* perhaps more than any other of his collaborative pieces, has the potential fully to illustrate that vertical leap to which he aspires. Here are the most elemental mysteries of life, of physics, of geometry, of religion, brought into convergence with the most trivial of human concerns. We, the initiates, again, are asked to make the connection, to make the jump. We must participate, we must be informed. In the same sense that *Elsinore* is another look at *Hamlet,* but not *Hamlet,* so *The Geometry of Miracles* is another look at Frank Lloyd Wright, at Gurdjieff and, centrally, but

149

not necessarily sympathetically, at the catalyst of their convergence, Olgivanna Wright. Lepage is a storyteller, not a biographer. We see fragments, some of which contain tantalizing allusions to personalities and events that, at least for now, we never see illuminated. We must complete the task.

Along the way, from the beginning of rehearsals, through translation, public rehearsal and performances, to the writing of the script, Lepage asks a great deal of his audience. Contrary to Shirley Mathews's charge of "spoon feeding" quoted earlier in this essay, Lepage characteristically poses a great challenge to his audience. He poses questions of language, both visual and verbal; he poses questions of human relationships, societal and personal; he poses moral and ethical questions that require an enlightened and participating spectator. Not everyone hears or sees the dialogue they have been invited to enter. But the invitation is palpable and involving. Mystery established encourages exploration and, it is hoped, discovery.

In his work and in his manner of working Robert Lepage is an explorer. He explores the need we have for mystery and for the truth that only mystery can provide. He has returned to the work of the stage the elemental and deeply meaningful purpose of religious drama, the delivery of the mystery of human existence. We, the initiates to the rite, are offered the opportunity by its celebrants, to see the truth of who we are and what we might be, and, perhaps, our connection to things both physical and metaphysical. But if we are to understand the mystery, we must come to the cave having completed our preparation. The ultimate understandings are reserved for those who have studied, those who have sacrificed, and those who have made the choice to participate fully. It is one thing to be thrilled by tricks, by the undeniable genius of Ex Machina's technical expertise, to be "seduced," as Rémy Charest put it, "by a remarkable capacity for razzle-dazzle, magical tricks and acrobatic moves"(7). It is another thing to look beneath and beyond the magic to the possibility within.

Lepage may be a bit like Gurdjieff's miracle—perhaps he brings his rules from another cosmos. Perhaps he heralds a future that, far from drowning us all in its flood of high technology and predicted dehumanization, takes technology as the tool it ought to be, and uses it as a door to the simple unanticipated truth of other dimensions.

150

There is something otherworldly about Robert Lepage, something that speaks to his manner, not his appearance. He seems almost to be only an observer of the world around him, yet it is clear that the gift of a catalyzing vision belongs to him. He sits in rehearsal, softly, silently, watching, no, *expecting* what ought to follow and why it must. One gets the feeling that he looks at life in the same way, critically but not judgmentally. In his work people transcend suffering and loss, moving together, inexorably, like the continents in *Tectonic Plates*. Sometimes they converge in a gentle sharing, and at other times they collide violently, but when all is said and done we are left with the certainty that his characters are both happily and excusably human, here for just awhile, valuable and valueless, all at once.

Lepage, artist and engineer, himself as much a duality in the flesh as is La Caserne in brick and granite, is using the tools of technology to humanize. And to mystify. He delivers, with his twisting and turning walls and rooms, with dancing tables and fire from the sand, as well as with the simpler magic of shadow and light and of movement and music, that possibility that we might make a leap to understanding. His gift is not only to move our gaze upward, but also to invite us to look at mysteries within ourselves, mysteries whose depth is obscured by the curtain of inner distance, but that is also filled with light.

Response to the Criticism of *La Géométrie des miracles* at the Du Maurier[1]

After reading the responses of the critics, anglophone and francophone, to Lepage's opening at the World Stage, and in the context of my essay on *La Géométrie,* I can offer only a few comments. First, my piece was written as anything but a critique. It tried, specifically, to recount the experience of observing and taking part in the process of the company as it approached performance of a public rehearsal. It was quite purposely *uncritical.* I allowed myself the luxury of participation in the event, and was rewarded not only in terms of what I saw and experienced, but also in terms of those (extremely) minor moments where I was allowed to contribute to the piece. I did not need to judge the work. I accepted its being in flux and enjoyed my place in Lepage's and the company's "*chaos.*"

I have not spoken directly to Lepage since March at the Caserne, but he has contacted me through an assistant, and I know that a number of the criticisms leveled at the show in Toronto were taken as personal attacks. At the same time, he has made it clear that in his work "intelligent" criticism is given priority and often results in substantive change. I believe that critics can have an important place in Lepage's theater, but that they need to understand that their role has changed. They need to embrace a positive, formative, dare I say it, a creative capacity. Lepage invites us to a new criticism and to a new theater. Instead of picking over the lifeless corpse of a "finished" piece, we now participate in the birth of a work of art in process. Instead of a closed creative process, elite and remote, producing only copies of creative acts, we see art coming out of the closet, unashamed, courageous, challenging, flawed, perhaps, but alive.

I do not know what the performance at the Du Maurier was. I have only the words of the critics to help me understand what, from the rehearsals I saw, remained in the work. I can understand their comments about the "script." There were moments and stretches within the rehearsals that were awkward, both in diction and in performance. There were scenes and sequences that seemed to lack completion. There was the undeniable fact that often the performers were speaking a language not their own, and with accents that were not those of the characters they portrayed. There were scenes that seemed too short or were too long, and there was sometimes an uncertainty (on my part) of just what was the aim of the artists. In the months since, even Lepage has said on various occasions that the piece "was not ready to show in Toronto."

Yet somehow, despite all that, I wonder what I missed. What more was I to learn? What deeper insight was to be delivered? Was there something beyond the heightened understanding that we live in the center of a miracle, that the act of creation is, at any level, a leap that bridges dimensions? That the infinitesimally small and the infinitely large are one and the same reality? That questions of science and of art and faith are as necessary to us as is breath? That the answers to those questions are available if only we can find the perspective that makes them clear? That there is, finally, hope? And magic?

These are some of the things that I did learn, or better, perhaps, these are the things of which I was reminded.

The rehearsal that I saw was not polished. It was rough. It was in progress. And I am certain that *La Géométrie* is *still* in progress. Is it not possible that there remains more to this play than it can hold, and that its future will include many parings and focusings before the company arrives at its essence? Has there ever been any doubt of that?

Does it become an issue, then, only of whether we should pay to see unfinished work? Or, better, whether presenters should book unfinished work? The fact is that people *will* pay to see this work and that presenters *will* present it. It is the event itself that is worth the risk, as is the attendant possibility that with artists and companies such as Lepage and *La Géométrie*, audience members will learn, at last, to embrace the possibility and the gift of real participation in the creative act.

Note

The author asked for and received the opportunity to respond to the unusually hostile critical reaction at the premiere of *La Géométrie des miracles* at the Toronto World Stage Festival.

Adrift: Affective Dislocation in Robert Lepage's *Tectonic Plates*[1]

Shawn Huffman

> We were among the rumour of wells. In the palace of winds.
>
> Michael Ondaatje, *The English Patient*

Continents float on oceans of rock. Once grouped together as an undivided whole, underlying currents fragmented the initial mass and, over a period of time, conveyed the pieces away from each other. Water now lies between these continents, speaking to the separation that has formed them and to the drift that has distanced them. Montreal, New York, Venice: all cities surrounded by water, founded on islands, small continents. *Tectonic Plates* takes place in these cities and tells the story of drifting people and of the underlying currents that convey them to various places, forcing them to separate from the continents of people to which they were once joined and to carry out their individual quests. The forces that drive them are affective and sexual: Jacques/Jennifer, caught between the love of Antoine, a deaf librarian, and Madeline, an artist, leaves Montreal to come to an understanding of his/her sexual identity. Madeleine, heartbroken, goes to meet death in Venice: "I was eighteen, romantic. I thought the most romantic thing to do would be to die in Venice,"[2] she says. There she meets another character, Constance, who will die as she confronts her own sexual history, formed by an incestuous relationship with her father, a sailor. These individual story lines come together under the gaze of a psychiatrist,[3] who treats the main characters of the play: Madeleine, Jacques, and Constance's father. The therapist remains on stage throughout the play, acting as a centripetal device, a bridge between events, allowing us to

155

discern the various affective displacements that have occurred in the character's lives.

Drift is represented in the play primarily through two artistic signs, which operate according to a rhizomatic principle:[4] the music of Frédéric Chopin and a portrait of George Sand. The importance of these two signs becomes apparent when Madeleine attends a benefit art auction for a society whose aim is to prevent Venice from sinking into the ocean. There she meets a Welsh pianist and tells him the story behind a portrait of Sand that has just been auctioned. She explains that the portrait originally depicted Sand *and* Chopin. A shady art dealer cut the painting in two to realize a larger profit, and as Madeleine says, "Frédéric Chopin ended up at the Louvre in Paris while George Sand went on drifting from private collection to private collection." In addition to being an ironic commentary on institutionalized sexism, this quote reveals that the two signs function as icons of drift and indicate, as we shall see, passional "gaps" within the discursive chain. Furthermore, it is significant that the representation of Sand and Chopin's separation be mirrored in art. The notion of art reflecting life is in fact quite important for the vocabulary worked out in the play. Lepage seems to experiment with a form of *vanitas* most succinctly expressed by Shakespeare in *Hamlet*.[5] Yet the *vanitas* principle elaborated in *Tectonic Plates* does not reflect in straight lines, adopting instead the baroque image of the convex mirror, where certain paths of meaning intersect and others are cancelled out. The troubled reflection thus obtained is further underscored by the projection of the Sand's portrait onto a pool of water occupying center stage.[6] As Jubinville points out in his review of the play, the pool of water becomes a sort of *mise en abyme* of theater itself (1990: 7), metafictionally mirroring the processes of theatrical representation on stage. Moreover, it signals at the same time a space of disengagement with respect to the play's here and now frame of reference. More precisely, a representational doubling occurs, this doubling being clearly represented by the pool of water, a space which contains the passional and theatrical imaginary of drift within the play.

Passion has occupied a prominent place in theater theory since its emergence as catharsis in Aristotle's *Poetics*. The importance of this concept is underscored by Pavis, who enthusiastically states that "the history of theater could be articulated around the notion of catharsis"

(1980: 57 [my translation]), entire branches of reception theory in theater having indeed been developed in its wake. Yet, the study of emotion is not restricted to the manner in which imagination and theatrical illusion precipitate audience response. Passion has also been approached in terms of the production of meaning in theater. Artaud for example, in *The Theater and its Double*, situates affect within the actor. He explains that "[t]he gifted actor finds by instinct how to tap and radiate certain powers; . . . these powers . . . have their material trajectory by and *in the organs*" (1958: 134). In other words, the actor taps into his or her passion at a visceral level and, through rigorous training, comes to an awareness of his or her emotional forces. This training allows the actor to locate the paths that emotion must take in order to be exteriorized as the theatrical projection that Artaud identifies as the "double" in theater. It is through this double, this "perpetual spectre from which the affective powers radiate" (1954: 134) that the actor's emotion is converted into representation.

Although Artaud privileged the *actor* as the site where affective topography is converted into the three-dimensionality[7] we know as theater, a less programmatic vision would probably take into account the various sites of meaning production mobilized on stage. In addition to the actor, the dramatic text, the director, the stage space, the objects to be used and the staging approach[8] all add specific contours to the representation that eventually unfolds before the spectator. For example, as a member the of Théâtre Repère,[9] Robert Lepage participated in a staging technique based on a theory of creativity in architecture.[10] This theory was subsequently adapted by Jacques Lessard and was developed into the *Cycles Repère*. The cycles are a series of processes that are summarized by the name *Repère*: **RE** designates the REsource (the object), **P** the Partition (the "score"[11] in its musical sense), **E** the Evaluation, all of which lead to **RE** the REpresentation (the staging).[12] It is an approach by which the individual actors elaborate a representation using the cycles as a sort of sextant. To illustrate, Théâtre Repère's first creation, *Circulations*, used as resources an English language course on cassette and a road map of the United States. The expression "cartographic vision" thus seems appropriate in describing an exploratory sensibility in the early work of the Théâtre Repère. This sensibility continues to guide the subsequent work of Lepage,[13] the cycles precipitating a "mapping out" of meaning and instituting an exploratory perspective

which determines the processes of creation put into motion by the actors.

The challenge in critically understanding affect is to find a coherent approach that enables the spectator to follow the topography laid down in the representation occurring on stage. Artaud's theories, centered primarily on the physical and emotional dimensions of the actor, ultimately prove to be too narrow in scope to deal critically with a multifaceted approach to the representation of affect in theater. I believe that the semiotics of passion, which attempt to explain the representation of emotion through a linguistic and phenomenological approach, provides the most dependable framework in which to investigate the production of meaning.[14]

Characterized by Greimas and Fontanille as "narrative dysfunction," passion provides a fascinating glimpse into the *gaps* in doing, into the "spaces between" where action is suspended or transformed.[15] Greimas and Fontanille speak of this affective gap as:

> the operation by which the subject, now qualified for action, becomes able to *represent himself* in the process of doing—that is, to project a simulacrum of the . . . scene that characterizes the passion in question. With all modalizations in place, the imaginary path they open can be seen in terms of and in the form of the existential trajectory. This allows us to understand, among other things, why passion often appears in the narrative unfolding in terms of shying away from performance: once he has been manipulated or persuaded or made capable, the impassioned subject takes refuge, or finds himself carried into his imaginary, before renouncing action, or instead, rushing into it. (1993: 90–91)

Affect thus intervenes in the subject's "ontological" constitution by creating a "passional scene" which, according to Greimas and Fontanille, appears "as effects of localized disengagements by which the impassioned subject establishes scenes of his own 'imaginary' in the discursive chain" (1993: 29–30). The object of a semiotics of passion is to come to an understanding of how the passional scene interacts with and determines representation (action) as a whole. It is exactly this tension that is underscored by Lepage and the Théâtre Repère in *Tectonic Plates*. This article will focus then on the notion of drift and its repercussions on the

affective body in this play. These concepts will be treated not only descriptively, but also with a view to study their theoretical importance, especially in the light of a semiotics of passion. Before addressing these questions, a word about the "version" of the play to which I will be referring is necessary.

It is well known that Lepage does not publish his plays. They exist rather as ever-evolving "works in progress," which constantly circulate in the exploratory processes of the *Repère* technique. This dynamic approach is undeniably stimulating in terms of creativity. It poses, however, a number of uncertainties for the study of Lepagian theater. In some respects, and as Villeneuve points out, these uncertainties stem from the general ephemeral nature of the scenic text[16] and the ensuing *absence* of an object of analysis (1989: 23). However, the instability that Lepagian theater integrates into the scenic text further exacerbates this methodological challenge and thwarts the construction of a homogeneous critical object. In other words, the *Repère* technique gives rise to many versions of *Tectonic Plates*, none of which can be considered less valid than the others. It is for this reason, and for reasons of ulterior verification and accessibility, that I will be using Peter Mettler's 1992 film version of the play[17] as my primary source of reference. This "object" will be complimented by my own recollections of the play, by critical assessments and interviews.[18]

Adrift

When Madeleine goes to Venice to meet her death, she comes upon Constance, a drifter and heroin addict, overwhelmed in life by the repercussions of an incestuous relationship with her father. Art is the passageway into this passional drift, and perhaps into its understanding. In the film version of the play, life and art are in constant contact, enjoying a relationship that is virtually contiguous. The door, for example, into the attic room where Madeleine and Constance seek shelter in Venice and where they both take heroin, opens on a piano hinge. The floor is black, like the interior of a piano and the next shot pulls back to reveal that both characters have emerged out of Venice and onto the top of a grand piano—onto an island. Art, in the form of theater, has provided a hole into another world—a passage through which to drift.

Yet drift does not mean escape. Constance says, "It seems that anywhere you go there is always something that makes you face yourself." In the drug-induced drift that Constance experiences after Madeleine injects her with heroin, she is called to face her incestuous past with her father. This is conveyed once again through art, more precisely, through the ballet of *Swan Lake*: "I would have loved to dance the *Swan Lake*," says Constance, "dance the death of the swan." As we pass into the place where she will dance, in the presence of her father, we observe a series of walls, huge holes blasted through them, signposts of the violence that her father has perpetrated upon her.

The meeting with her father during the course of her drug-induced state introduces a structural drift into the play as well. An oneiric time and location frame is opened within the "real world" of the play, this new frame of reference corresponding to a passional scene. The reversals in this drug-induced drift are astonishing, conforming to the mirroring principle between life and art already observed with the portrait of Sand and the music of Chopin. In fact, a chasm occurs, the reality of the heroin world being reversed in the reality of the "real world" of the play, a reversal germane to the language of mirrors. In the heroin world, for example, Constance's father falls into the ocean while she remains on shore, calling to him not to leave her.

"Do you feel the rush of ocean to your heart?" asks Constance. At the level of "reality," however, outside of the drug-induced passional scene, it is Constance who has entered the ocean, it is she who is drowned, not her father. In terms of the enunciatory subject, we can see that the passional scene is not experienced as a separate event. The *vanitas* principle set up in Lepage's play instead suggests that the effects of the passional scene are mirrored in the "real world" through the body as point of transition. While Greimas and Fontanille unequivocally state that "the body becomes the center of reference of the entire passional staging" (1993: xxv), the model they present of the general economy of the theory (1993: 38) abstracts this body into discourse. Theater brings the somatic centering back into focus, for as Lepage illustrates, the body of the actor is the locus of enunciation in stage practice.

The pool of water embodies the representation of the passional scene as theater. It also represents the pain of separation; it is an ocean

that symbolizes the gap, the wound, that separates and divides continents. The projection of Sand's portrait onto the pool reinforces this meaning. Chopin is also introduced into this paradigm through the medium of dream. While the dream state itself already closely parallels Constance's drugged state, we are in addition told that, in his dream, Chopin is said to have seen himself drowned. The fatal potential of the wound thus represented by the pool of water is unequivocal and in two instances in the play, once involving Jacques as we shall see, and once involving Constance, blood and the water intermingle. In Constance's case, the mixing occurs as her father penetrates her. The scene occurs in the pool and is recounted by Constance's father to the psychiatrist. As blood is, to a large extent, composed of salt water, Constance's bleeding points to the ocean within, to the wound she carries *inside*. This emotional wounding can be expressed as the rift between Constance's desire to be in a state of conjunction with her father's (non-sexual) love and the betrayal of this configuration by her father. Incest prevents the accomplishment of this desire and provokes in Constance an obsessive return to the site of the affective breach. The betrayal of Constance by her father inscribes her within a passional "gap." This inscription is accompanied by a sort of "ontological" regression leading to her death. This occurs at the end of the scene. Constance's inert body floats in the water, the time frame catapults back to the real world of the play, and Madeleine finds Constance's body. The setting then telescopes out of the past and into the present, into the psychiatrist's office. Constance's father, in the pool, looks up, with a dawning awareness of the pain that he has inflicted on his daughter.

Jacques/Jennifer represents a case of multiple drift, all connected to affectivity and sexual identity. S/he is in-between—between male and female gender, and between Antoine and Madeleine. This in-between-ness extends even to mythological proportions as, in therapy, Jacques moves toward a mythical beginning in order to understand himself, to understand his in-between state. This mythical birth occurs in Scotland—there he sees Skadi, the goddess who gave her name to that country and who "could split continents in two with one blow of her sword." Each year she demands a human sacrifice, a young man, whom she takes with her to the Isle of Skye, where she teaches him to fight. It is only in the spilling of the blood of a young man that the earth can

become fertile. Skadi and Jacques battle in the water, she emasculates him and he falls to his knees, his blood tinting the water around him. As with Constance, the intermingling of blood and water points to a wound of separation inside. In Jacques' case however, this wound is also symptomatic of gender uncertainties. Some might object to my use of the word "wound" to describe the site of the gender uncertainties experienced by Jacques. I do not use the term to designate a "medical trauma" that the genetically sexed body undergoes in order to actualize a gendered subjectivity. My use of the term instead points to the uncertainty itself, the dislocation between biological sex and the specific gendered subjectivity felt by the subject.[19]

Jacques' mytho-identity drift is comparable in many respects to the drug world of Constance. Both episodes create a dream-like world within a world and both contain the "primitive scene" of a sexuo-identity wounding. However, important differences exist between the two. Jacques's return to his beginning does not immediately lead to his death as does Constance's return to the scene of her wounding. The difference seems to reside in the fact that Constance returns to a scene that has already occurred, while Jacques's return to a beginning is in itself a beginning. He must experience the drift that Constance had already endured prior to returning to its scene. Thus, he returns to the "real world" of the play as Jennifer McMann, and we next see him in a New York restaurant, in which hangs the portrait of George Sand.

Sign Language

Communication is not immune to drift either. The dispersal of meaning, from its emission to the chance that it will be intercepted and correctly decoded, is also a major issue in Lepage's play. Like the affective drift represented iconically through art, communicative drift is related through a series of sign languages. The first such instance occurs quite concretely with Antoine, who is deaf and who communicates using sign language. Yet, his interlocutors do not all speak his language, do not all correctly decode his signs, drifting instead in a space of "almost communication," in the wound left by faulty language. Antoine attempts to bridge this gap by holding the throat of the person with whom he is speaking, to better understand him or her through the vibrations created by the vocal cords. As Antoine says, "words vibrate," much like

the strings of a piano vibrate. The language of the earth is also included in this paradigm of communication, as Antoine prostrates himself to feel the vibrations of the earth, the shifting ground also being involved in *faulty* communication.

Sign language is also used in the drugged world where Constance meets with her father. It will be remembered that Constance casts herself as the dying swan in *Swan Lake*. We will also be reminded that, in French, "swan" is "*cygne*," a homonym of "*signe*," which means "sign." Constance then, as a ballerina, becomes a sign communicated through art. Her father also transmits signs, via semaphore; that is a marine convention whereby signs are communicated through flags, thereby permitting communication at a distance.

The use of semaphore underscores the affective rift that has occurred because of the incestuous aggression and the uncertainty of words as a reliable means of communication. Together, Constance and her father represent *Swan Lake* and the death of the swan, the death of the sign. The extraordinary conflation of body and language communicates the theatrical underpinnings of the representation of the passional scene in *Tectonic Plates*. Since the languages of theater are spoken primarily on the body of the actor, his or her corporeal and symbolic (in language) death marks the fragility of communication and the failure to bridge the gap that drift has caused.

Constance's death is in fact comparable to the transport experienced by the mystic subject who invests him/herself in a passional scene, the price for such an investment being the corporeal body. In the mystic subject, we are dealing with a case of extreme euphoric aesthesis, attained, explains Greimas, "when the subject's consciousness is about to dissolve into a world of excess" (1987: 52 [my translation]). The experience related in *Tectonic Plates*, however, describes a *dysphoric* experience accompanied by "ontological" regression. The death of the sign and of the subject occurs when the impassioned subject dissolves into the passional scene, and consequently, into death. Barthes describes a similar, if only temporary, dysphoric dissolution in *Fragments d'un discours amoureux*: "L'abîme n'est-il qu'un anéantissement opportun? Il ne me serait pas difficile de lire en lui non un repos, mais une *émotion*. Je masque mon deuil sous une fuite; je me dilue, je m'évanouis pour échapper à cette compacité, à cet engorgement, qui fait de moi un sujet *responsable*: je sors: c'est l'extase" (1977: 17).

The final sign language to be examined is that of the identity signs
emitted by Jacques/Jennifer. Kevin, an Alaskan boy in New York in
search of a mate on an Oprah[20] match-making special, does not suc-
cessfully decipher the signs of in-betweenness that Jacques/Jennifer
emits. He takes Jacques/Jennifer to be genetically female, a situation
that Jacques/Jennifer does not correct because s/he does not know
how to address the situation her/himself. An interesting exchange
between Kevin and Jacques/Jennifer succinctly characterizes the lat-
ter's situation:

KEVIN
Mais, vous savez, ce qui me frustre le plus, c'est le sexe.
JACQUES/JENNIFER
Ah bon?
KEVIN
Oui, pour vous, les Françaises [sic] c'est facile le sexe. Nous, les
Anglaises [sic], on n'a pas de sexe.
JACQUES/JENNIFER
C'est dommage!
KEVIN
Mais pourquoi vous dites "le café" et pas "la café" ou "la table" et
pas "le table" . . .
JACQUES/JENNIFER
Ah! Vous voulez dire le genre, pas le sexe! Gender! Yes, sometimes
gender can be very confusing.

When Kevin discovers the truth about Jacques' sexual identify, he is
outraged. A subway rumbles by, continents seem to shift, and another
drift occurs. Kevin takes Jacques/Jennifer by the throat, just as Antoine
does to understand the vibrations of words. Yet Kevin does not want to
understand; he silences his/her voice, strangling him/her against the
radio tower. It is a sacrifice that Skadi, perched on the tower behind
Jacques/Jennifer, accepts. She then blows madness into the head of
Kevin who flees. We next hear the music of Chopin and see the sky (the
Isle of Skye) through the cityscape. Like Constance, Jacques/Jennifer
returns to the scene of the sexuo-identity wound (the Isle of Skye). Like
Constance, s/he dies in the in-between space, in the drift space between
continents, in the wound, which is sexual in both cases.

Signposting Drift and a Semiotics of Passion

When the subject is invested in a passional scene, he or she is caught up in a process that André Green identifies as "primary narcissism," that is, a space where "[t]he representations of self are in fact object representations disguised as the Self through narcissistic investment" (1983: 140). Semiotics conceives of this place in terms of narrativity—not in the ontological terms of Green. This is not to say that Green's observations are not pertinent; it is however essential to remember that we are dealing in fictive paradigms and not in real subject configurations.

The passional scene is an intimate parallel world, represented throughout Lepage's play by drift and signs of drift. It is an instance where the subject becomes enfolded upon itself, drawn to the scene that has so marked its existence. Following Green and Greimas's thought, it can be observed that within the passional scenes worked out in Lepage's play, the impassioned subject represents *itself* as an object invested with subjectivity. It is a risky endeavor. In both the case of Constance and of Jacques/Jennifer, the passional scene (incest and mythic rebirth) spills over into the now reference in the play, taking over and eventually eliminating the lives of Jacques and Constance. This paralysis of action is significant. To characterize the passional element as drift introduces important gateways into the actional world, gateways that risk influencing action on several levels, especially through modal investments, that is, the impact of beliefs, possibility, and desire upon action. For example, the total and fatal identification that Constance and Jacques/Jennifer undergo with respect to their passional scene suspends action through death. Life in the real world context of the play is no longer possible because the narcissistic investments in the passional scene are too great. In this instance, actional paralysis occasioned by the passional scene institutes a modality of *not being able to do*. In this respect, drift can also imply a dysfunctional permanence. The case of Madeleine, however, offers another possibility.

For many years following the death of Constance and Jacques/Jennifer, Madeleine, an artist, was not able to paint, overwhelmed by her experience with these passional scenes. When finally she does bring herself to paint, she uses the passional scene to deal with her experiences instead of becoming paralyzed by them. It will be remembered that everything takes place in the office of a therapist. Everything is

165

recounted. The drift to which Madeleine was exposed affected her life—primarily her ability to represent. The paralysis of this ability in a painter is not to be underestimated. Furthermore, Madeleine is a key element in these passional paradigms because it is through her that these different drifts are bridged *affectively*, for while the therapist also acts a bridge, she, unlike Madeleine, remains sheltered from the emotional implications of having lived this drift and from the responsibility for their exteriorization through artistic representation. This sheltering is humorously reinforced by the therapist's glasses, which have no lenses. Thus she cannot really see, at least not in the same way as Madeleine. The artist's paintings map her affective relief onto the space of the canvas, the years of artistic inactivity representing her search to exteriorize her emotions. The contrast of this process of exteriorization with the fatal interiorizations of Jacques/Jennifer and Constance is telling. In *The Semiotics of Passions*, Greimas and Fontanille set up a progressive sequence of modes of existence composed of four terms:

virtualization ‡ actualization ‡ potentialization ‡ realization (1993: 90)

"Potentialization" is conceived of "in terms of an open door, within the narrative trajectory, opening on the imaginary and on the passional universe" (1993: 90). By way of illustration, Greimas and Fontanille examine Lafontaine's "La Laitière et le pot au lait," coming to the conclusion that Perette's imaginary speculations (occurring at the potentialization phase) lead to a failure of performance in the tale's "here and now" reference (1993: 91). This suspension of performance also occurs, as we have seen, in the case of Constance and Jacques/Jennifer, who both die in the drift of potentialization. Madeleine, however, because she is both witness to the experiences of Constance and Jacques/Jennifer and is charged with the mission to represent the emotional scenes through painting, can be seen as a metasubject, a subject of enunciation through whom the passional scene is artistically recalled as memory and not lived as experience. While both Constance and Jacques/Jennifer are presented as *impassioned* subjects, Madeleine is a passional subject, the impassioned subject experiencing passion firsthand and the passional subject describing it after the fact.[21] Madeleine's

capacity as a passional subject is revealed through a copy she executes of Delacroix's painting of Sand and Chopin. In her painting, she reunites the two, ending the drift symptomatic of the passional dysfunction inhabiting Constance and Jacques. Constance resurfaces in Madeleine's paintings as Ophelia. It seems appropriate that her death be preserved in an artistic sign which makes reference to theater and painting since Constance herself expressed her passional scene through art, more precisely *Swan Lake*. The most eloquent paintings are those she executes in memory of Jacques/Jennifer. They are a series of watercolors, entitled "J for Jennifer" depicting "sailors, ships and semaphore." This in-mixing of Constance and Jacques's passional scenes results from the years that Madeleine has harbored them. In her mind they are linked, and she captures them both within a state of drift. The water-based medium of the paint echoes this notion, evoking the ocean, capturing the essence of the terrible wound that speaks to the tear and the drift between continents, a wound best represented in the final analysis by Venice, Venice being the *wound-in-process*, the sinking into the gap of drift.

Conclusion

Tectonic Plates then charts drift in terms of people, the relationships they form, and their necessary link to what could be described as a sexual diaspora. Art is the major instrument through which drift is identified and tracked in this play. Visual art, music, and literature signpost the affective displacement and span, if only temporarily, the separateness that divides the characters. Furthermore, it is Greimassian semiotics that best provides a method by which to map the affective separations occurring throughout the play. By theorizing a passional scene, Greimas provides us with a key notion for the description of affect in the elaboration of subject configurations.

Notes

1. This article was first published, in a somewhat different form, in *Recherches Sémiotiques/Semiotic Inquiry* 17, no. 1–3: 193–210. I would like to thank the editors of *RS/SI* for their permission to reprint portions of the original article.

2. No published version of the play exists. I am thus unable provide page references for quotes taken from the play. The quotes that appear throughout this article have been transcribed from Peter Mettler's film version of the play.

3. Lepage has used the psychiatrist as a "story gatherer" before. In the initial section of *Vinci* for example, the character Philippe tells his problems to a psychiatrist (who remains invisible).

4. In *Rhizome*, Deleuze and Guattari state that the rhizome functions according to a "[p]rincipe de multiplicité: c'est seulement quand le multiple est effectivement traité comme substantif, multiplicité, qu'il n'a plus aucun rapport avec l'un comme sujet ou comme objet, comme réalité naturelle ou spirituelle, comme image et monde" (1976: 21). This multiplicity is at the core of the Repère technique and accounts for what some critics characterize as an alarming lack of structural unity in Lepage's work. The Repère technique organizes meaning in a different fashion, exploring its manifestations as they present themselves during the course of the creative process. It is also for this reason that Lepage often describes his plays as "works in progress," thus underscoring the exploratory nature of his rhizomatic technique.

5. " . . . the purpose of playing . . . is to hold as 'twere the mirror up to nature, to show virtue to her own feature, scorn her own image, and the very age and body of the time his form and pressure" (*Hamlet*, Act 3, Sc. 2).

6. Some find Lepage's use of water on the stage surprising. It should be pointed out that it is in fact a technique with a venerable history, especially favored during the baroque era. Beecher and Ciavolella report, for example, that one of Bernini's most celebrated spectacles "was the *Inundation of the Tiber* (1638) [a lost play], in which boats plied back and forth on a flooded stage" (1985: 6).

7. Ubersfeld, for example, stresses the importance of three dimensionality in theater (horizontality, verticality, and depth). For her it constitutes a distinguishing feature of the theater genre (1982: 139).

8. For a study on the way staging approaches can affect the fictional world created on stage, see Huffman (1996).

9. The Théâtre Repère is a theater collective located in Lévis, Quebec. It was founded in 1980 by Jacques Lessard, who remains the artistic director.

10. More precisely, it was a creative technique developed by Lawrence Halprin and set out in his book, *The RSVP Cycles: Creative Processes in the Human Environment* (1969).

11. Hunt translates *partition* by "participation" (1989: 104). While *partition* can have this meaning, and despite the felicitous conservation of the "p" in *Repère*, Hunt's translation causes one to lose sight of the different mappings that are constructed out of the resource. In the *repère* method, these mappings are construed as a score, that is, a multi-layered organization of meaning effects. Moreover, in the original RSVP cycles, from which the

repère method was developed, the acronym stands for Resources, *Scores*, Valuation, Performance (Halprin 1969: 2). Thus, while "participation" is more elegant than "score," for the sake of clarity I will retain the latter.

12. For an excellent history and explanation of the Théâtre Repère, see Irène Roy (1993). The second chapter (p. 31–42) treats the cycles in detail.

13. In an interview with Hunt, Lepage confides that before he decided to be an actor, he wanted to become a geography teacher (Hunt 1989: 110).

14. Although this is the first study to use the semiotics of passion, developed by Greimas and Fontanille, as a framework of analysis for Lepagian theater, it is not the first semiotic inquiry into his work. Roy uses Peircien semiotics to trace the production of meaning through the *Repère* cycles (1993).

15. These "spaces between" refer very specifically to the phase of potentialization, which is a stage in the pathemic realization of a subject. This phase is contextualized later on in the article.

16. It is generally accepted that the "scenic text" refers to the performance while the "dramatic text" designates the published version of a play. See Pavis (1996: 535–57) and Ubersfeld (1996: 34–35).

17. It hardly needs to be pointed out that major differences exist between the stage version and the film version. For example, the play *Tectonic Plates* was presented using a theater in the round, with the spectators on raised scaffolding surrounding the stage and looking down into it. In film, however, it is nearly impossible to obtain the same level of three dimensionality (IMAX perhaps?). Nevertheless, the themes present in the original stage version continue to resonate in the film. Thus, although Mettler's "integrationadaptation" alters the theatrical performance, it also documents it. Moreover, as change plays an integral role in the processes of dynamic (re)vision established by the Repère technique, Mettler's film can perhaps even be considered as one of the possible *theatrical* versions produced by this technique. In this respect I take issue with Belzil's biased review of Mettler's film. See Belzil (1993).

18. Some might object that my analysis is not of the *play Tectonic Plates*, but rather of the *film*. However, let it be remembered that the scenic text as an object of study is essentially absent. In this respect, the film, along with the other elements I have named, serve as various traces of the theatrical representation.

19. See Namaste (1994), for an examination of discursive strategies in the production of sexual identity.

20. Oprah Winfrey hosts an extremely popular American television show.

21. Anne Hénault makes a similar distinction in *Le pouvoir comme passion*. She uses the infinitive form of the verb *éprouver* to describe immediate emotion, reserving the past participle of the same verb, *éprouvé*, to refer to sentiments or feelings of the past (1994: 7).

Robert Lepage Interfaces with the World—On the Toronto Stage
Jane M. Koustas

"Rare is the play that is so innovative, so utterly different, it makes you feel as if you have just witnessed something extraordinary" (Matthew Fraser, *Globe and Mail* 1 March 1985).

IN THIS REVIEW of *Circulations*, Robert Lepage's first Toronto performance (Canadian Repertory theater, March 1985), Matthew Fraser recognized not only Lepage's tremendous talent, but his potential for transforming Canadian theater: extraordinary, innovative, different; Lepage's theater radically changed the way in which Canadians, particularly Torontonians, view and do theater. While the "stage genius" (John Bemrose, *Maclean's* 20 Nov. 1995) of "Canada's greatest dramatic innovator" (Bemrose) transformed English Canada's notion of performance, Lepage's work also altered theater practice. Instead of a text-based Quebec play in English translation put on by a local company,[1] as was the tradition, Lepage offered Toronto theater-goers "imagistic theater at its best" (Robert Crew, *Toronto Star* 19 May 1988), performed by a touring company and designed to appeal to "different audiences with different tastes and expectations" (Vit Wagner, *Toronto Star* 13 May 1988). Through the creations of this playwright, director, and actor, Quebec theater in English translation was replaced by international theater, which defied or circumvented translation and Quebec's "enfant terrible" (Gina Mallet, *Toronto Magazine*, May 1988) and his company became "theatrical globetrotters" (Christopher Winsor, *Globe and Mail* 2 Nov. 1996) while their Anglo counterparts remained at home. He "redefined Canadian theater around the world" (Sid Adilman, *Toronto Star* 4 Nov. 1995), particularly in Toronto. This paper will discuss

171

Lepage's theater, primarily as viewed and reviewed in Toronto, and will illustrate how Lepage brought a new way of viewing and doing theater to the Canadian theater scene: his work forced the Toronto audience to see beyond the traditional "two solitudes" and to appreciate theater that was international both in scope and in method. It is not within the compass of this paper to examine in detail the long history of Lepage's success in Toronto. Therefore, this study will focus primarily on his most successful Toronto production, *The Seven Streams of the River Ota* and will consider briefly earlier productions, namely *Circulations*, *The Dragons' Trilogy*, *Vinci*, *Tectonic Plates*, *Polygraph*, *Needles and Opium*, *Elsinore*, and his most recent work, the *Geometry of Miracles*.[2]

Quebec theater in translation has a relatively long history in Toronto. From Gratien Gélinas's success with *Tit-Coq* in 1951 to the public's enthusiastic reception of Michel Tremblay, and, more recently, the production of Daniel Danis's *Stones and Ashes*, Toronto theatergoers have showed considerable, though not necessarily consistent, interest in Quebec theater in translation. However, while Robert Lepage is in no way the first *québécois* playwright to enjoy the acclaim of the English-Canadian audience and critics, he is one of the few to do so in a theatrical climate that does not depend on translation. As one critic noted in his review of *Circulations*, Lepage and his company were "twisting the language of theater into bizarre and fascinating shapes" (Matthew Fraser, *Globe and Mail* 1 March 1985). Unlike that of his forerunners, Lepage's theater is not Quebec theater in English translation but international theater in a theatrical language that goes beyond translation, relying even on the confrontation of different languages and cultures. While other productions relied on the filter of translation, Lepage's work, for the most part, is presented in the "version originale" and not necessarily in French. Plays by Gratien Gélinas, Marcel Dubé, Michel Tremblay, René-Daniel Dubois, Daniel Danis and others were always produced in English, and not always in a good translation. Furthermore, the need to translate drew attention to the French origins of the plays and stamped them with the "made in Quebec" label. In short, up until the arrival of Robert Lepage,[3] *québécois* theater in Toronto was, for the most part, French-language theater in English translation. However, cultural and linguistic difference, the basis for translation, is either at the very center of Lepage's theater, and hence exploited and exploded, as in the *Dragons' Trilogy*, or circumvented entirely in plays like *Elsinore*, in

which the only real language is the *mise en scène*. In theater that relies on a plurality of idioms, notions of language and place of origin lose their traditional pertinence. Therefore, the Toronto audience could no longer interpret Lepage's theater as a lesson in *québécois* culture, as it had sometimes done for other *québécois* playwrights, and had to change its way of viewing theater in order to appreciate Lepage's imagistic, multimedia, multilingual, and multicultural productions.

It is important to recall that Lepage's productions are largely improvised and thus the text no longer has its traditional status. According to the playwright:

> The writing starts when you perform and it's a difficult thing to comprehend for a lot of people . . . because we're used to the traditional hierarchy of the author. . . . Everything is supposed to be freeze-wrapped and sealed and delivered to the audience. . . . I've always believed . . . that the writing starts the night that you start performing . . . and you end up writing things on the day after the closing of the show (McAlpine 134-35).

Furthermore, the bilingual actors switch effortlessly back and forth between French and English as they "decide for themselves what they should say" and "improvise and write their own text" (McAlpine 139) in the language of their choice. There is, therefore, no original source text, nor a translated target text. Lepage bypasses or deforms the filter of translation, thus destabilizing traditional notions of identity and translation: his work, in Toronto and elsewhere, is not Quebec theater in English translation but international theater that works on the interface and depends on the interference of languages and cultures and indeed owes its international success to its refusal to identify with one culture. Sherry Simon puts it this way: "Il y sans aucun doute un lien à faire entre la matière transnationale des pièces de Lepage et leur réussite internationale. Le jeu de références culturelles inscrit dans les pièces leur donne une mobilité certaine. Tous les publics peuvent se reconnaître dans le dialogue qui s'y ouvre entre le local et l'international" (161).

Another critic noted that Lepage "seems to have a god's-eye view of the world" (Stephan Godfrey, *Globe and Mail* 24 March 1990) perhaps, as some critics have argued, even at the expense of his own personal

québécois identity.[4] It is a theater of nonlinear translation, in the sense of the target and original text, and of a cultural non-identity in that it is instead *multi-identitaire* and nontextual.

It is important to note in this regard that multicultural does not mean here an arbitrary collage of international theatrical and social practices and languages. It is rather, as Patrice Pavis argues for the case of Peter Brook, Ariane Mnouchkine, and Eugenio Barba, a careful and deliberate sorting or sifting of signs and ideas comparable to the controlled passage of grains of sands in an hourglass. Pavis qualifies this as intercultural theater which requires spectators to position themselves at the interface, in the "between zone," in an effort not merely to understand the "foreign" culture, but to appreciate the interaction between the familiar and the foreign or, as is sometimes the case with Lepage, between two or more "foreign" cultural signs and languages. Pavis states, "pour comprendre la culture étrangère source, le spectateur ne doit pas se transplanter en elle, mais se situer par rapport à elle, assumer la distance temporelle, spatiale, comportememementale entre les deux" (289).[5]

Similarly, multi- or plurilingualism[6] in Lepage's theater is not an arbitrary combination of disparate languages, a mere nod to Canada or Quebec's multilingual, multicultural status, nor a simple political statement about the status of French and Francophones in a multi- or plurilingual nation. It is, instead, as Jeanne Bovet explains, an exploration of the power of language as a sound, as a determinant in the dynamics of relationships (who speaks what language when and to whom), and of personal identity:

> Nous avons découvert que les passages plurilingues n'étaient ni de simples reflets de la réalité cosmopolite actuelle, ni de pures expérimentations sonores, mais l'expression sonorisée d'une idéologie humaine authentique auquel aspirent les personnages.
> 1. l'acceptation de soi, figurée par l'importance croissante de la langue-identité
> 2. le nécessaire évincement de la langue, preuve audible des décalages culturels au profit des langues sensoriels du corps et de l'art, modes d'échanges universels.(2)

Like all other theater "languages," body movement, lighting, and costumes, which Lepage also transforms, the spoken language has a value and a function beyond its traditional, referential role: while characters are saying something (which may or not be comprehensible to the audience), the mere act of speaking (particularly in one language or another), and the sound generated, are in themselves significant. Again, according to Bovet:

> la parole a en fait subi exactement le même sort que les langues scéniques paraverbaux, à savoir que c'est sa dimension d'objet tangible, plutôt que sa dimension référentielle, qui est mise en évidence par les expérimenteurs *québécois* actuels. En d'autres mots: la parole n'est plus exploitée pour son traditionnel pouvoir dénotatif mais aussi, et quelquefois même exclusivement, pour ses effets connotatifs. (2)

Instead of a text "dénotatif et politisé," Lepage proposes language that is "connotatif et poétisable" (Bovet 1) hence the need not to translate: it is frequently the incomprehensibility of the spoken words, their sounds, their disorienting effect on the audience and their determining role in a power relationship that motivate the "text." Furthermore, the inaccessibility of language forces spectators to rely on the other languages of theater which Lepage uses so ingeniously. As Paul Thompson, director of Montreal's National Theater School, notes, "It is his picture-making ability that allows his plays to travel so well internationally. His work transcends the limitations of language" (quoted in *Maclean's*, John Bemrose, 23 May 1988, 53). Indeed, his trademark is his refusal to prioritize the text and his use of technology:

> Dans son entreprise de déréalisation symbolique de la parole, le Théâtre Repère semble donc avoir pris le parti d'une poétisation par la négative, visant à démontrer, non pas nécessairement l'inaptitude, mais toujours l'incomplétude des échanges linguistiques pour l'établissement d'une communication efficace. Bien que le plurilinguisme joue, on l'a vu, un rôle charnière dans l'élaboration de l'idéologie de la communication humaine, il ne confère pas pour autant à la parole un statut scénique privilégié: il n'est qu'une étape transitoire vers le langage universel du corps. Au pire, la parole s'avère obstacle, au mieux simple adjuvante a la communication authentique. (132)

175

Through Lepage's success, Toronto theater companies saw as well another way of doing theater. In the same way his productions break down, challenge, and transgress cultural and linguistic boundaries, Lepage's theater also defies geographical barriers. As one of Quebec's "theatrical globetrotters" (Winsor, *Globe and Mail* 2 Nov. 1996), Lepage and his touring company, Ex Machina, are on the international theater circuit so often that, as his producer Michel Bernatchez states, "He [Lepage] is dizzy from all the travel in the past four years. One show in Swedish, the next in Japanese" (quoted in Ray Conlogue, *Globe and Mail* 15 April 1995). English Canadian theater companies continue to use a more traditional formula, playing solely to home audiences. As Winsor notes in the above article, while Lepage's plays "tour the world to great acclaim, their Anglo counterparts are virtual stay-at-homes." Though the personal costs of world success and touring may be high, since Lepage needs time and space to create, the benefits of this new way of doing theater are obvious: Ray Conlogue identifies Lepage as "the sole Canadian theater director who has to juggle offers from Ingmar Bergman and Peter Gabriel or find time in his schedule for the Paris Opera" adding that "a surfeit of global success is not a common Canadian problem" (Conlogue, *Globe and Mail* 15 April 1995). Lepage intends to take his way of doing theater even further: having established headquarters in a renovated firehall, wired with the latest in video, computer, and satellite technology, he intends to create "what may be the world's first virtual theater" (Conlogue, *Globe and Mail* 15 April 1995): He will "rehearse" actors who may be thousands of miles away to create virtual plays that will have everybody live on stage at the same time but in different cities. He will thus "go global and stay at home at the same time" (Conlogue), showing more traditional companies yet another way to do theater.

Toronto theater goers got a taste of Lepage's "aural, visual poetry" (Matthew Fraser, *Globe and Mail* 1 March 1985) and multicultural, multilingual, and multimedia theater with the production of *Circulations* (Canadian Rep Theater, 22 February 1985). This production, like all his work, was inspired by a "concrete visual source" (Press kit, Ex Machina Archives), in this case a road map, rather than by an idea (the *Ressource* in *REssource Partition Evaluation REpresentation* = *Théâtre Repère*). When Louise, the *québécoise* heroine, leaves a miserable home life to "voir le monde," she does so in both senses of the

expression: she sets out to see the world but also to learn about life. However, the audience is expected not only to follow Louise's geographic and existential journey, but to explore with her as well the question of language. The play is billed as a trilingual production: "one third french [*sic*], one third english [*sic*] and one third movement" (Press kit, Ex Machina Archives). However, for Lepage, "In French and English" does not mean the simultaneous translation usually associated with bilingualism, as found on Canadian road signs and merchandise. "Bi- and trilingual" here mean instead the combination of languages, as all are used without translations. There is, therefore, neither an original nor a target language version of the play. The production alternates between French and English and operates very much on the interface of the two. Furthermore, by describing movement as a third language, Lepage conveys the idea that his theater is partially independent of traditional spoken language: indeed, as noted above, few of Lepage's plays have written texts. Matthew Fraser observed that ". . . language is secondary to thoughts and feelings. The text, therefore, is textured, a series of visual movements by the three actors, and reverberating sound effects created on the synthesizer" (*Globe and Mail* 1 March 1985).

Rather than a source/target text translation then, the play is instead a "play" on the very idea of translation. Louise sets out for her journey with a walkman and English language-learning tapes. Much of the dialogue takes place in wooden phrase book English: even a New York mugger excuses himself by stating, "I need soap . . . I need toothpaste." This is not, however, a language-learning dialogue, such as that used by Ionesco in *The Bald Soprano,* for the words are used for genuine, albeit stilted, communication: when Louise's "superman" utters, "the pleasure is all mine," he is trying to communicate, however superficially. English of this style, phrase-book English spoken by a Quebecer, appears foreign to both French and English audiences. It is in fact more like a third language that spans the two. Just like Louise, the audience must "circulate" between cultures and languages, finding itself curiously uprooted and at a cultural and linguistic intersection.

Fraser noted the importance of Lepage's arrival on the Toronto theater scene, claiming that "if it's true that the best thing for artistic complacency is a gust of creative influence from another culture, then *Circulations* . . . could be just such a catalyst" (*Globe and Mail*

1 March 1985). While the play was successful, not all critics were receptive to Lepage's innovative use of sound and language. Robert Crew labeled the production "multi-media mish-mash that's full of sound and fury but signifies very little" (*Toronto Star* 28 Feb. 1985) and noted that "some surtitles have been added to *help out* (my emphasis) with the French" suggesting that anything beyond a dutifully translated text was too demanding. Crew, however, came to recognize Lepage's talent, noting in a later article, "Robert Lepage's work has yet to receive the wide or prolonged exposure in Toronto that it deserves" (*Toronto Star* 15 Jan. 1988) and identified Lepage as "Quebec's hottest creator-director" (*Toronto Star* 20 Jan. 1988). Indeed, in subsequent productions, Lepage further expanded the multicultural, multilingual dimension: the "Other," which had previously been central to both the creation and reception of Quebec theater in Toronto, was no longer easily identifiable. In the *Dragons' Trilogy* (du Maurier World Stage from 31 May to 3 June 1986 and Factory Theater, 18–28 May 1988), a trilingual English, French, and Chinese play billed as a "lyrical epic about the meeting of cultures," the audience is taken on a cultural and linguistic voyage that spans three cities, Quebec, Vancouver, and Montreal, and seventy-five years. As Ray Conlogue noted during the first run, "It is spoken mostly in English, French and Chinese and, according to the company, is an attempt to understand the spiritual life of Canada where people live in the crash and cacophony of different cultures" (*Globe and Mail* 3 June 1986). As in *Circulations*, the confrontation of cultures and the volatile nature of the "Other" form the framework of the play. As Lorraine Camerlain notes:

> La multiplicité des cultures et des langues constitue un fondement de la *Trilogie* et de la quête intérieure dont la pièce est la manifestation. Jamais les langues ne se font véritablement obstacle; elles s'accordent, à la poursuite d'un objectif commun. On ne parle pas exotiquement, anglais, chinois ou japonais. Les langues étrangères s'intègrent au projet, au propos du spectacle. (Camerlain 85)

While it remained largely "an undiscovered treasure" (Ray Conlogue, *Globe and Mail* 5 May 1988) when it first opened in 1986, two years later it was heralded as "imagistic theater at its best" by the previously skeptical Robert Crew (*Toronto Star* 19 May 1988).

Furthermore, in *The Dragons' Trilogy* "where ordinary objects and body language are used to engender magical transformations" (John Bemrose, *Maclean's* 23 May 1988), the combination of languages was no longer seen as a barrier. Crew, who had relied on surtitles in *Circulations*, claims that "the use of three languages creates little problem" (*Toronto Star* 19 May 1988). Vit Wagner notes that "the tale is told in three different languages—French, English and Chinese—leaving very few audience members able to understand everything that is said." However, he adds, quoting production manager Michel Bernatchez, "We also discovered that the show could be appreciated even in English countries where people didn't understand a word of French. . . . We also discovered that the text might not be so important—that two actresses acting in French can be understood, if they're acting well. It's almost a cliché but the body talks as well as language" (*Toronto Star* 13 May 1988). "A rare adventure in [today's] theater," *The Dragons' Trilogy* became "one of the most acclaimed Canadian productions," suggesting that Toronto would indeed "be seeing a lot more of Lepage's innovative and spectacular work" (Robert Crew, *Toronto Star* 15 Jan. 1988).

Lepage "came and conquered" (Robert Crew, *Toronto Star* 20 Jan 1988) with *Vinci* (du Maurier Quay Works, 20–23 January 1988), a production in which the meeting of cultures is also central: the title is also a play on Caesar's victorious boast, "veni, vidi, vici" uttered as the "cultural" conqueror acquired new territories. The main character, Philippe, travels through Europe to conquer his anguish following the suicide of a close friend. Focusing in part on the Mona Lisa, played by Lepage, the play centers on the role of the painting as an international cultural icon. Languages (Quebec and Parisian French, Italian and English) and identities blend and clash creating both comic and poignant scenes such as that described by Ray Conlogue:

> Memorable characters. A girl in a Paris Burger King discourses like a French savant on the meaning of Burger Kingness satirizing philosophy. The "she"—this is still Lepage—suddenly throws her face in a certain way, and we see that she is the Mona Lisa. An Italian intellectual, speaking Italian (with subtitles), tells us that art is a subtitle to life. (*Globe and Mail* 21 Jan. 1988)

A one-man show, "accomplished and exotic" (Ray Conlogue, *Globe and Mail* 21 Jan. 1988), *Vinci* relied heavily, like *Elsinore*, another solo performance, on special effects to artificially create the presence of several characters. While critics reacted to this artifice, ready to accuse him of "being a mere party magician" (Ray Conlogue, *Globe and Mail* 21 Jan. 1988) and of behaving like "a kid in a toy store gleefully playing with all sorts of gadgets and gizmos" (Robert Crew, *Toronto Star* 20 Jan. 1988), they acknowledged the "magic" of the performance (Ray Conlogue, *Globe and Mail* 21 Jan. 1988).

In *Tectonic Plates* (du Maurier World Stage, 3–6 June 1988), the three central characters, a deaf-mute, an artist, and a bilingual transvestite, join, move, and are separated like the continents, the geographical land masses described by the title. "A masterful voyage through place, time and human evolution" (Stephan Godfrey, *Globe and Mail* 24 March 1990), the play brings together characters from South America, Italy, Alaska, and Quebec who switch freely from English to French to Spanish to Italian. Once again, the use of different languages and their interference is as important as the narrative, if not more. In the opinion of Groen:

> Here the symbols are the main course and the narrative only an appetizing spice. Consequently he [Lepage] uses the spoken word as a kind of musical counterpoint to the visual icons. The actors switch freely from English to French to Spanish to Italian, the different languages just another formidable barrier in our doomed quest for a universal grammar, a continental restoration. (*Globe and Mail* 7 June 1988)

For those willing to accept its status as a work in progress, *Tectonic Plates* was an exciting pairing of Lepage and the celebrated set designer Michael Levine, "a collaborative venture from two of Canada's most impressive talents" (Rick Groen, *Globe and Mail* 7 June 1988). With only five of the proposed twenty "plates" or sections ready for performance however, it was faulted for being too "fragmented" (Greg Quill, *Toronto Star* 6 June 1988).

Lepage was in "top form" (Robert Crew, *Toronto Star* 21 Feb. 1990) for his next Toronto performance,[7] *Polygraph* (du Maurier Theater, 20 Feb.-3 March 1990), "a metaphysical detective story"

(Press kit, Ex Machina Archives) involving an actress, a forensic doctor, and a student/waiter linked in various ways to the murder of a young woman. Set against the background of the Berlin wall, *Polygraph*, like previous plays, involves the clashing of languages and cultures and, in this case, the breaking down of "walls" that separate. It was less fragmented and more polished than *Tectonic Plates*, which was brought to Toronto in the very early stages of a work in progress. Toronto critics clearly better appreciated this "more contained and play-like work" (Ray Conlogue, *Globe and Mail* 23 Feb. 1990) that was a "structured, disciplined and cohesive work of art" (Robert Crew, *Toronto Star* 21 Feb. 1990).

Needles and Opium (du Maurier World Stage, 8–24 April 1994) provided an "adroit kick-off" to the world festival" (Geoff Chapman, *Toronto Star* 10 April 1994). A one-man show starring "Canada's most innovative performance artist" (Geoff Chapman, *Toronto Star* 10 April 1994), the play, set in 1989, recounts the story of Robert who desperately tries to contact his former lover from a hotel room in Paris where Sartre had also stayed. His imaginary encounter with jazz musician Miles Davis and poet Jean Cocteau, who also stayed in the same hotel, becomes a meditation on addiction as the play recounts the stories of the morphine-addicted musician and opium-smoking poet through the metaphysical experience of the love-sick Robert: he experiences "meaningful coincidences [that] give an opportunity for this disjointed metaphor for addictions to be interpreted in extraordinary fashion" (Geoff Chapman *Toronto Star* 10 April 1994). Critics recognized that the scope went far beyond individual, personal agonies, largely due, as Ray Conlogue points out, to the technical wizardry that created a surreal, timeless atmosphere and hence universal meaning:

> But when Lepage, suspended in front of that white screen, begins to somersault end over end in mid-air while the screen shows a frantic tableau of high-rise windows flashing upward, the image is of much more than a man falling to his death: he makes us believe that it is also the artistry of a whole generation that is in free fall, the meaning of things smashing into a thousand fragments on the sidewalk below. (Ray Conlogue *Globe and Mail* 15 Nov. 1991)

Translated into English by Lepage and Adam Nashman, the play provided Lepage with insights into the translation process. Commenting on this experience, he stated, "Translating your own work forces you to go deeper into meaning" (quoted in Kate Taylor, *Globe and Mail* 17 May 1995). A "triomphe" (Suzanne Dansereau, *La Presse* 11 April 1994) that earned two standing ovations and congratulations from international theater personalities who attended the performance (Brian MacMaster, Micheal Morris, Richard Castelli, and, by video, Peter Gabriel), *Needles and Opium* was awarded the prestigious Chalmers Award.

The Seven Streams of the River Ota (Harbourfront Center, 3–12 November 1995) was undoubtedly the most sensational, and perhaps best received, of Lepage's Toronto productions. Four years in the making, the play was created for the *Today's Japan* festival, held in Toronto to commemorate the fiftieth anniversary of the bombing of Hiroshima. (While the production was created for the festival, it was previously staged, unsuccessfully, in Edinburgh and Tokyo.) "Magnificent Seven: Robert Lepage's luxury river cruise" (Christopher Winsor, *Backstage* 9 Nov. 1995), "Awesome Ota" (*Now* 9 Nov. 1995), a "seven-hour masterwork" (Kate Taylor, *Globe and Mail* 6 Nov. 1995), was "critically cheered" (Sid Adilman, *Toronto Star* 20 Nov. 1995), drew capacity crowds, and generated a tremendous, unanimously enthusiastic critical response despite its "work in progress" status: only five of the seven segments were ready. However, "there [is] nothing half-baked or unpolished about the parts" (Vit Wagner, *Toronto Star* 5 Nov. 1995) and Lepage illustrated his ability to "create a seamless whole from international theatrical styles and influences" (John Coulbourn, *The Sunday Sun* 5 Nov. 1995) and to "tie up every strand" (*Globe and Mail* 6 Nov. 1995). It may indeed have been a turning point for the Toronto public and critics such as Kate Taylor, who began her review admitting:

> There were those among us who were not persuaded. We pointed out that the man [Lepage] was a brilliant reinterpreter of the classics but that his own shows revealed a creator too easily seduced by the startling imagery he conjures up with such apparent ease. We had seen *Needles and Opium* to cite the most recent example, a piece that was devilishly clever in its staging but thematically unresolved. We had heard the term "evolutionary creative process" used as an excuse by

an overextended artist for presenting half-finished material. We were skeptics, but we are no more. (*Globe and Mail* 6 Nov. 1995)

Six and a half hours long,[8] the production takes spectators to Hiroshima immediately following the bombing as well as to present day Japan, to a New York rooming house in the 1960s, to a central European concentration camp during World War II, to contemporary Amsterdam, and elsewhere. During this cultural, linguistic, and geographic journey, West not only meets East but the two cultures collide and combine: the main characters are the result of physical and/or psychological cultural interaction and, like the play itself, exist on the interface of the Occident and the Orient. For example, Jeffrey, the son of an American soldier ordered to photograph the "physical damage" in Hiroshima after the war, describes himself, to his New York landlady, as an "egg," white on the outside, for he looks Caucasian, and yellow on the inside, as he was brought up in the tradition of his Japanese mother. He meets his half-brother, also named Jeffrey, in New York. Another central character, Pierre, returns to Japan, his place of birth, where his *québécois* mother sought refuge with a Japanese friend during her pregnancy: he has become a *butoh* dancer. Jana Čapek, a Czech concentration camp survivor, turns to Zen Buddhism and is interviewed by the *québécois* ex-wife of the Canadian ambassador to Japan. Lepage gave the following overview of his production: "The River Ota flows through Hiroshima, is divided into seven streams, and then becomes the ocean. The seven streams point in seven directions and the idea was that we could build seven different stories that are all converging towards the same source which was in Hiroshima" (McAlpine 138). The playwright also sees and exploits the comic aspect of globalization: Sophie, Pierre's mother, was a *québécois* actress working with a Canadian company on tour in Osaka presenting a ridiculously silly door-slamming "théâtre du boulevard" play by Georges Feydeau.[9]

The dialogue switches back and forth between French, English, Japanese, Czech, and Polish. However, as in previous productions, the language mix, rather than confusing the audience, serves to underline a central theme. Vit Wagner noted, "His cosmopolitanism is embedded in a multilingual (but predominately English) script that emphasizes, at least in one sense, how small the world has become" (*Toronto Star*

5 Nov. 1995). As in other Lepage productions, titles are flashed across the set when languages other than English and French are used, but this practice in no way constitutes a traditional translation. While the audience, for practical purposes only, may be provided with a "target" text, they are nonetheless experiencing two, if not more, languages simultaneously, and, like the characters, are living on the interface: the translation process is deliberately evident. Furthermore, there is no "original text" nor language of origin as all of the languages used, including French and English, appear, at some point, to be the source language. The use of surtitles, frequently found in opera, compounds the deliberate source/target-language confusion as surtitles and subtitles are traditionally used to provide a target language translation rather than the original. Thus, while Lepage does not speak Japanese, his characters do and the English or French version appearing in the titles seems to be the translation rather than the original. Titles are also used, in this and other productions, when characters speak with heavy accents. In the opening scene, which takes place between the American military photographer, Jeffrey's father, and Nozomi, the Japanese bomb survivor and Jeffrey's mother, Nozomi's broken English appears in titles either in French or English depending on the audience. As in *Circulations*, this unfamiliar yet essentially correct English appears as a third language at the intersection of two tongues and cultures. In this case, Nozomi's broken English represents as well her submission to the dominant American invader.[10] Providing titles highlights the status as a "translated" idiom of the accented language. Lepage even exploits and exposes the act of translation during a conversation between Sophie, the *québécois* actress adrift in Japan (she is Pierre's mother) and Hanako. Sophie telephones Hanako, her Japanese friend, who is working on her Japanese translation of Baudelaire. The entire conversation is relayed by a translator who, at some point, is corrected by Hanako.

Like the translucent shifting panels that make up the Japanese house in which the play opens, walls and borders, linguistic, cultural and geographic, shift and become permeable boundaries that eventually disappear, become transparent, or take on new shapes: the Japanese house becomes, for example, the New York rooming house, the East European concentration camp or a coffee shop in Amsterdam. As in other productions, Lepage challenges traditional notions of cultural and linguistic origin and identity: neither the "Other" nor the target or

source culture or language is easily identifiable; instead they are constantly shifting. *Seven Streams* confirmed Toronto's "histoire d'amour" (Suzanne Dansereau, *La Presse* 5 Nov. 1995) with Lepage and firmly established him as a "theatrical genius" (Christopher Winsor, *Backstage* 9 Nov. 1995) in the eyes Toronto theater-goers and critics.

At the announcement of Lepage's next production, *Elsinore*, a critic prophetically remarked, "A new one-man show from Lepage diving financially. . . . Not 'til Birnam Wood comes to Dunsinane" (Christopher Winsor, *Backstage* 9 Nov. 1995). While it may not have been a financial disaster, *Elsinore: Variations of Shakespeare's Hamlet* (Harbourfront Premiere Dance Theater, 20–27 April 1996), his third solo and second all English performance, "was one of Lepage's few missteps" (Vit Wagner, *Toronto Star* 11 April 1996). Technical glitches, which earned for Lepage's newly-formed Ex Machina company the name *Machina imperfecta* (*Globe and Mail* 24 April 1996), marred a production that was otherwise labeled "brilliant . . . hypnotic, highly charged" (Geoff Chapman, *Toronto Star* 21 April 1996) and a "dazzling . . . tour de force" (Robert Cushman, *Globe and Mail* 22 April 1996). Described by Pierre St. Armand, the troupe's production and technical manager, as "the adventure of the computer . . . a kind of rock and roll show, but for the theater" (quoted in Sid Adilman, *Toronto Star* 6 April 1996), the show relied on visual effects that allowed Lepage to play all the parts, including Ophelia, the king, the queen, Polonius, Rosenkrantz, Guildenstern, Laertes, a steward, and a gravedigger, as well as to converse with others. This trick created technical problems such as those that closed down the première in Chicago. More significantly, however, his reliance on special effects and on the audience's knowledge of the text led Lepage to sacrifice the language: he spoke the text "indifferently" (Geoff Chapman, *Toronto Star* 21 April 1996) and "lost it" (Robert Cushman, *Globe and Mail* 22 April 1996). By taking on all the roles and relegating the text to second place in a technically dazzling production that was not, however, problem free, Lepage was accused of "spreading himself too thin" (Robert Cushman, *Globe and Mail* 22 April 1996) by Toronto critics in a production that London critics labeled "a cold array of theatrical effects" (*Globe and Mail* 13 Jan. 1997).

The negative criticism earned by *Elsinore* did not, however, dampen Toronto's enthusiasm for Lepage: *The Geometry of Miracles*

(du Maurier World Stage Festival, 16–20 April 1998), "the latest chapter in Lepage's 13-year affair with the city" (Vit Wagner, *Toronto Star* 11 April 1998), and one of "several hot shows," was sold out months in advance (Kate Taylor, *Globe and Mail* 11 April 1998). It is significant that Lepage chose the festival for the premier performance of *Geometry of Miracles*, which, unlike previous productions that were staged in Toronto further along in their "work in progress" development, had not yet been performed other than in a "trial run" in Ex Machina headquarters in Quebec City. The critics were clearly not ready for this "very rough" version that was criticized for being "all over the map" (Pat Donnelly, *Montreal Gazette* 18 April 1998), and labeled a "rickety structure of abstract ideas" (*Globe and Mail* 18 April 1998).

Lepage had, however, returned to the previously successful formula of using different and seemingly disparate languages, cultures, and stories and showing how they clash, coincide, and combine. As in *The Seven Streams of the River Ota*, *Tectonic Plates*, *The Dragons' Trilogy*, *Circulations*, and *Vinci*, characters from around the world—in this case from Quebec, the United States, France, and Russia—meet, frequently by chance, interact in a variety of languages, and confront each other and intermingle, taking the audience on a cultural journey that defies time and geographic and linguistic barriers. The play is based on a metaphysical link and mythical encounter between Frank Lloyd Wright, the father of "organic" architecture, and guru Georgei Gurdjieff, founder of the Institute for Harmonious Development in Paris and proponent of "organic living," who counted Wright's third wife, Olgivanna, among his disciples. The story moves from Russia, to Paris, to Wisconsin, and to the Arizona desert as the language switches back and forth between English, French, Serbo-Croat, and Russian. Surtitles are provided only occasionally, thus forcing the audience to experience two languages simultaneously or, when titles are not used, to rely on the play's other "languages": dance, a sort of tai-chi used by Gurdjieff, is used extensively and seems as curiously up-rooted in the Arizona desert as Olgivanna's Serbo-Croate. As in previous productions, the audience experiences several cultures and must remain on the interface.

However, the "beautifully staged exercise" (Janice Kennedy, *Ottawa Citizen* 18 April 1998) that brings together Mr. Johnson of

186

Johnson's Wax, for whom Wright designed a building, Lenin and Joseph Stalin, stockbrokers, members of Wright's Taliesin Fellowship, including a Quebecer, in addition to those mentioned above, "never quite delivers" as Frank Lloyd Wright remains "buried under the weight of theatrics" (Janice Kennedy, *Ottawa Citizen,* 18 April 1998). Condemning the production for being "underwritten" and "poorly acted," Kate Taylor compares this performance to previous Lepage work recognizing his innovative use of language while, at the same time, his failure to successfully incorporate language here. She states:

> Increasingly Lepage explores both multidisciplinary performance and exaggerated naturalism, writing scenes in whatever language they would normally occur, scripting resolutely unpoetic dialogue and at times delivering whole passages in real time. . . . This time an international cast with heavy credits in dance and laden with various accents rarely delivers a performance that is more than passable. With the largely English script spoken badly, the abstract speeches never achieve poetry and the minimalist dialogue never achieves naturalism. (*Globe and Mail* 18 April 1998)

"Half-baked, filled to bursting with abstract ideas" (Taylor), the production suggested that Lepage had not heeded Wright's philosophy that less is more. "More than a little disappointing" (John Colbourn, *Toronto Sun* 17 April 1998), *Miracles* suffered critically because it seemed unfinished. It was not, as one might have presumed a decade earlier, because of the Toronto public's unfamiliarity with his "multicultural and multi-faceted theater" (Matt Wolf, *New York Times* 6 Dec. 1992). Indeed, Lepage remains, for Toronto, a "Miracles Worker" (Vit Wagner, *Toronto Star* 11 April 1998) capable of further expanding the horizons of Canadian and Quebec theater and audiences.

Le Devoir columnist Robert Lévesque remarked: "S'il [Lepage] n'avait pas découvert le théâtre en 1974, c'est la géographie et les langues qui auraient préoccupé la vie de Lepage. Il a trouvé le moyen, par la spectaculaire percée de sa carrière, de rejoindre ces trois passions" (74).

Having made Toronto and Harbourfront Center "a creative home away from home" (Vit Wagner, *Toronto Star* 11 April 1998), Lepage brought to Toronto his passion for languages, geography, theater, and,

most importantly, their interaction. Global theater for the computer-wired age, Lepage's work defies both traditional linguistic and geographical boundaries by revolutionizing ways of viewing and doing theater; hence Lepage proposes to Toronto, and to the world, productions beyond translation and national origin rather than Quebec theater in English translation. Referring to Lepage, Liam Lacey noted, as early as 1988, "The move toward global theater, where text becomes secondary to sounds and images may be one of Quebec's most exciting contributions to theater" (*Globe and Mail* 19 Jan. 1988). This article has attempted to illustrate that, instead of merely transporting Quebec theater, Lepage transports the audience to a space beyond language, geographical limits, and cultural identity. As he himself has stated, "Le Québec est multiple, il est dans le village global et pas seulement dans la francophonie, il doit faire partie du monde" (Lévesque 70). Quebec has indeed become part of the world and the world can see itself reflected in Lepage's theater. No longer is theater from Quebec *québécois* theater produced in translation for an "outside" audience. Lepage's world class theater travels, speaks to, and is inspired by the world, and very much appreciated by Toronto. Suzanne Dansereau noted: "Le public torontois . . . entretient depuis longtemps une histoire d'amour avec Lepage" (*La Press* 5 Nov. 1995). David Homel and Sherry Simon noted, "translation is a vehicle through which cultures travel" (9). Lepage showed Torontonians, that "art [itself] is a vehicle" (*Vinci*) and, in doing so, redefined for them Quebec theater, theater in translation, the languages of theater and theater practice.

Notes

1. See Koustas, J. "From 'Homespun to Awesome': Translated Quebec Theater in Toronto," J. Donohoe and J. Weiss (eds.) *Essays on Modern Quebec Theater* (East Lansing: Michigan State University Press, 1995). 81–107.

2. It is not within the scope of this paper to consider co-productions and adaptations. These include *Echo* (1990), a co-production between Theater Passe Muraille and Theater 1774; *Romeo and Juliet* (1990); *Bluebeard's Castle/Erwartung* (1993), a co-production with the Canadian Opera Company; and Peter Gabriel's *Secret World Tour* (1993), Robert Lepage's set design for the pop star.

3. Gilles Maheu's and Carbone 14's *Le Rail* (23–28 October 1986) was not well received.

4. See for example, Jill MacDougall, and Jeanne Bovet.

5. Franck Rouesnel uses the term *"transculturel"* as opposed to *interculturel* and makes the following distinction: "Ainsi la notion de transculturalité sera ce qui traverse les spécificités culturelles, autrement dit le mouvement réciproque d'une culture à une autre et d'une identité à l'autre. La transculturalité apparait alors, comme un mouvement, un passage, un déplacement dans le temps et l'espace de l'identité a l'altérité et réciproquement" (2).

6. Bovet makes the following distinction between multi- and plurilingual:

 > Le multilinguisme consisterait en une intégration personnelle ou collective de plusieurs langues, dans un contexte étatique, le multilinguisme désigne les langues officielles, généralement égales en droit, tels l'anglais et le français au Canada. . . . Quant au plurilinguisme, il s'agit "d'une diversification linguistique librement consentie . . . par la coexistence d'un certain nombre de langues étrangères non-imposée." Un individu possédant plusieurs langues sera alors qualifié de multilingue, mais la communication qu'il établira avec des individus diverses sera, elle, qualifiée de plurilingue. Le multilinguisme est en quelque sorte un état de droit, le plurilinguisme un état de fait. (15–16)

7. *Echo*, an adaptation of Ann Diamond's *A Nun's Diary*, which played at the Theater Passe Muraille around the same time, received little critical attention. It was described as "a profound disappointment" in a review article of *Polygraph* (Robert Crew, *Toronto Star* 21 Feb. 1990).

8. Spectators are given the chance to purchase a *bento*, a Japanese box lunch along with their ticket.

9. Lepage's own situation is not without irony: this production, by a *québécois* separatist, was part of the *Today's Japan* festival in Toronto.

10. For a discussion of the significance of plurlingual dialogue in determining power relationships, see Bovet, Jeanne.

Between Wor(l)ds: Lepage's Shakespeare Cycle[1]

Denis Salter

When we start to work with objects in rehearsal, then our main pre-occupations are love and life—not separation, not nationalism. It's like going to a therapist: you're astonished to find out who you are. In fact, it is very political, but we don't try to make it that way.

Robert Lepage[2]

The whole notion of crossing over, of moving from one identity to another, is extremely important to me, being as I am—as we all are—a sort of hybrid.

Edward Said[3]

If staging means putting into signs, then acting means shifting those signs and setting them in motion without clearly defined limits of space and time—perhaps even setting them adrift.

Bernard Dort[4]

Coriolanus: tragically alienated, *fier,* stands waiting, enclosed within the frame of an antique frieze/large-scale TV screen embellished by a blown-up aerial photograph of Rome; and as he slowly undresses and steps *out,* away from the imprisoning frame—toward *us*—leaving Rome behind to make his way to Antium, to that "world elsewhere," we can see projected high at the top of the frame a ghostly XIII—an (ironic) marker encoding historical authenticity, superstitious dread, the irresistible linear force of Destiny, and the dialectical tensions of time past/time present, of Rome versus Antium.

Macbeth: tragically isolated, *derangé,* his body jerking in primordial terror—rushes back and forth, back and forth across a blasted

heath; a harsh white strobe strafes his body—now we see him—now we don't—this grotesque *tableau vivant* of Evil incarnate, desire shadowed by guilt, appearing and disappearing within splintered frames of light and dark.

Prospero: tragically self-sufficient, *puissant,* casually dressed in black trousers and a sweater, stands immobile, together with Ferdinand, upstage of a distorted one-way mirror; and as they gaze out at Miranda—right beside them, yet strangely alone, entirely absorbed by her ballet exercises on the dancer's *barre,* her image dispersed a thousandfold across the translucent surface of the mirrored wall—Prospero speaks through and for her in an echoing disembodied voice of Absolute Authority.

Here, I am trying to arrest three intertextual images from Robert Lepage's Shakespeare Cycle. But the task is, happily, impossible. The images—not just from one performance to the next, but in their very moment of execution—are in a constant state of flux. *The Tempest, Macbeth,* and *Coriolanus*: these texts, as "tradapted" (translated and adapted) by Michel Garneau, are forever crossing over from one fixed identity to another to another and then to another, creating new formations that cannot—and indeed should not—endure. Shakespeare, for Lepage and Théâtre Repère, does not exist to be memorialized. Rather, he is an occasion for the celebration of virtually *everything*—art, life, death, politics, ideology, performance itself—that is inherently transitory. I sometimes catch myself worrying that this kind of theater can only emerge from a director—and from a culture—suffering an acute and all-too-protracted *crise d'identité* aggravated by the ideological fracture between postcolonialism and postmodernism. This style of performance *seems* to be saying, "if we don't really know who we are, we won't be anyone; now you see us, now you don't, as we all make a virtue of protean self-evasion, and the hyperaestheticisation of political difference."

In cultures—like Québec, but like Canada as well—seduced by the chimera of freedom and agency teasingly promised by postcolonial theory, Shakespeare is a combined social/culture text that sometimes seems to exist only for the sake of interrogation, displacement, and, possibly, ironic reconfiguration. But this process of reverse colonization only works in actual practice if it is relentlessly programmatic and fiercely judgmental. We rewrite Shakespeare to write ourselves; we

reinvent Him to be free of Him; or, in more radical situations, we simply ban His works: He will not be read and studied in *our* schools, He will not be performed in *our* theaters. The problem is especially acute in English-speaking cultures that have been taught to think that Shakespeare should be their contemporary, when all the evidence around them suggests exactly the opposite. The result: alienated subject-positions, or what New Zealanders call "cultural cringe."

In Lepage's more relaxed response, insouciance, eclecticism, pastiche, desire *and* containment, trenchant irony, prolific innovation, generic inversion, and, above all else, an enduring preoccupation with the transgressive spaces existing *between* and *within* different kinds of performance texts are the salient aesthetic patterns. Always ideologically inflected they recur—with hallucinatory precision and vividness—throughout Lepage's entire Shakespeare Cycle. But given all the liberal humanist twaddle about embracing inter- and intra-cultural difference(s), I think that a little diffidence would not be out of place here. Lest we all begin to vanish down the memory-hole of revisionist history, let us recall that in-between-ness, borders, boundaries, walls, frontiers, frames, thresholds, contiguous spaces—real and metaphorical—are often very dangerous places to try to inhabit. Of course they are radically contingent, but they are also radically disorienting, and can all too quickly bring about an encounter with the existential void (given a trendy postmodern "turn," to be sure)—an absent identity from which absolutely *nothing* of value can ever be salvaged—especially if the centers of power remain elsewhere. The postmodernist game of identity politics is a very serious business; although borders might be places where enlightened crossing-over can take place, they are also faultlines that can destroy. Should we not we always think—and think again—in art, as in life—about the possible negative consequences of their idealistic transgression?

The key word in negotiating borders, is "survival." Who is trying to survive? And why? What values are being preserved? How? And who is likely to win the struggle? Garneau's twofold project of translation *and* adaptation is a sustained exercise in linguistic preservation of a kind peculiar to minority cultures struggling for autonomy on many different front(ier)s at once. Tradaptation is close to being oxymoronic, as it discloses the kind of prodigious doubling to which the translator's identity (personal and public) is necessarily subjected.

Shakespeare supposedly represents timeless and universal values; but to accept this as true, even for a moment, is an act of surrender—a qualified or perhaps even an absolute denial of your own time, your own space. Garneau admits, with characteristic whimsy, that Shakespeare terrified him ("j'ai eu terriblement peur de Willie; c'est un fétiche, Willie, on l'a rendu magique, on l'a mythifié, on se mystifie avec") when he attempted his first tradaptation of *The Tempest* in the early 1970s. But by reducing Shakespeare to size—by calling him, fondly, "Willie"—Garneau managed, however slowly, to begin finding his own voice, to figure out how to write Shakespeare from and for his own avowedly *québécois* identity. When Garneau came to *rewrite Garneau's Tempest* in the early 1980s, Shakespeare was no longer an All-Powerful Fetish but simply another playwright with whom he felt happy to "collaborate."

Notwithstanding his marginal status, Garneau's work is not only an exercise in linguistic survival, but a case study in how differing voices—dissenting, contradictory, paradoxical, and anachronistic—can be enabled to speak concurrently within the self-imposed borders of a single text. Despite its groping revisionist intentions, *Garneau's Tempest* now seems ideologically *un*committed, written in a kind of ersatz-universalist, no-name-brand, generic French that will not really offend anyone for very long, not even the people Mordecai Richler has pilloried as the "language police." Here Garneau seems willing to do little more than play Caliban ("this thing of darkness / I Acknowledge mine") to Shakespeare's Prospero.

But the 1960s and 1970s gradually altered, perhaps forever, the master/slave dialectic. The challenges to patriarchal values brought about by the Quiet Revolution, the election of the nationalist Parti Québécois in 1976 on a platform of political independence (or was it, even then, sovereignty-association in disguise?), the continual validation—by Michel Tremblay and other writers—of *joual* as a form of self-authentication: these and cognate historical achievements gradually gave Garneau the permission to *use* Shakespeare (rather than simply be used by him) as a dramaturgical instrument for the exploration of different types of *québécois*.

So when Garneau came to tradapt *Macbeth* in the late 1970s, he discovered that he now had the courage, in a deliciously perverse strategy of inversion, to construct Shakespeare as an ally within the project

194

of textual decolonization. In his *Macbeth,* Garneau refuses to play the mug's game of seeking to universalize Shakespeare. Instead, Garneau localizes Shakespeare, relentlessly and with so much poetic license, and with such pleasure in the playful heterogeneity of the linguistic sign, that his revisionist text is not constrained by any sanctioned temporal, national, on linguistic boundaries.

In *Garneau's Macbeth* we can hear echoes, traces, borrowings and parodies, alongside anachronisms, archaisms and neologisms, all reworked from the type of Québec French we find in the pre-1950s period (the second Witch's "Salut à toé, Macbeth, héritier d'la seigneurie d'Cawdor!" / "All hail, Macbeth! hail to thee, Thane of Cawdor!"); from even older forms of *québécois,* some of which are still in circulation (Banquo's "Non mé, à ton dire, y'éta'ent-tu vra'ment en nos vra'es présences, / Les espèces de mi-carêmes qu'on parle ou ben / C'est-y qu'on a'ra't sans s'en aparçevoér mangé / D'l'harbe du guiâbe qui dépossède 'el monde d'son bon sensse" / "Were such things here, as we do speak about, / Or have we eaten on the insane root, / That takes the reason prisoner?"); from the vivid names of North American animal species ("un chat sovage," "un grand ours noér," "l'portépique," "l'orignal ac'son panache," and "l'vieux loup") for the wildlife with which Shakespeare heightens the supernatural in his original text; and from traditional—though sometimes mordantly ironic—religious imagery (the old Porter, suffering from a hangover, is reminded of "un jésuite" and later imagines sinners on their way to "au feu d'joie étarnel!"). We can also hear the estranged subtextual voice of none other than "Willie" himself, especially in the kinds of words—"une calvette" (for "culvert"), "batt'rie" (linked to "battre" and now suggesting "assault and battery"), "gorgoton" (evoking "gorget" or "throat armor")—where, historically, both English and French have enriched each another.

Of course, to ideologically rigorous cultural nationalists, this kind of overt hybrid may not be a form of survival but an act of betrayal. But to a director like Lepage, and to a company like Théâtre Repère, committed to theater as a form of cross-cultural understanding, *Garneau's Macbeth,* together with the more tentative exploration of language in *The Tempest,* and the more confident use of contemporary *québécois* idiom in *Coriolanus,* is an ideal text to revive for a "globealizing" tour. It is not only a singularly *québécois* text—in which they can happily root themselves—it is a metonymic palimpsest for the

195

question being asked by all kinds of so-called marginal societies whose "development" has been arrested by the impasse between postmodernist and postcolonial forms of cultural expression. How can you speak authentically, ethically, and, yes, lastingly from a recuperated (if still somewhat decentered) sense of Self when you are confronted, at every turn, by ideologically driven transnational contexts in which the autonomous/sovereign subject, if not dead, is at least stunned; in which a-, perhaps even anti-, historical indeterminacy has been granted the status of Divine Ordinance; and in which a desire to speak in, to, against, and beyond the voices of other times, other places, so often results in charges of treason, of heresy, and of willful misrepresentation?

When I asked Lepage why he and Théâtre Repère have a compulsive need to place "borders" or "frames" both around and within *Coriolanus, Macbeth,* and *The Tempest,* his answer was as simple as it was revealing: "The frame is a way of putting *everything*—including the fragmented body—into parentheses." "Parentheses" is worthy, I think, of multi-layered Shakespearean wordplay, invoking, at least for me the bracketing off (and thus magnification) of the text so that it can be performed and experienced as if for the first time; the process by which marginalized societies are allowed to capture part, but of course only part, of a Cultural Object, since they do not have an inalienable right to take over the whole thing; the shaping of raw data into conventional, if sometimes disrupted, narrative patterns with clearly marked beginnings, controllable middles, and conclusive ends; and, finally, the oftentimes parodic reexamination of how the "picture frame" stage has sought, historically—and more recently with the complicity of film, television, and video—to colonize both the physical body *and* the body politic.

Consider Lepage's *Macbeth*: the set consists not of one but of many mini "picture-frames" created by monumental upright blackened timbers (excellent visual preparation, company members like to quip, for the eventual arrival of Birnam Wood) that are lashed together with crossbeams and arranged serially, with gaping cracks between them, across the whole width of the stage. While they look like primordial artifacts excavated from an archaeological dig site, these timbers also serve to evoke a dematerialized band of energy

emerging from a sinister force-field on the left and moving gradually, but irresistibly, toward an equally sinister, and oftentimes eerily illuminated, forcefield on the right. The spaces between the timbers allow for the equivalent of affective depth-shots into the murky upstage area. Scenes taking place in this area, such as Macbeth engaged in battle outside the walls of Dunsinane, can only be experienced voyeuristically through partial or fractured perspectives that, in distorting our sense of time and space, baffle our desire to apprehend the human body whole and not, as here, in estranged and estranging fragments.

The timbers, we eventually discover, have been built—literally—into large hinged frames that can be flipped up, over, and then down, as in a traditional *à vista* transformation, to create an immense acting platform high at the top. Following the age-old moral principle that like attracts like, this platform is mostly reserved for the intimate domestic scenes between Macbeth and Lady Macbeth *and* for the supernatural scenes of the Witches meeting to hatch their nasty plots and to practice their sorcery. The open area disclosed beneath this platform serves multiple functions. During the arrival, and later on the murder, of Duncan, about half the frames remain down, to form a dank, foreboding, and crenellated courtyard-cum-passageway of sand and rock irradiated by broken, mostly horizontal, beams of light. But during the Banquet, all the frames are raised and replaced with wondrously pliable sheeting to create a horizontal reel of translucent screens on which the silhouettes of the Banquet's guests—including, of course, the ghost of the murdered Banquo—can be projected, suggesting a vaguely Oriental shadow play and, concurrently, the flickering, permeable images of an early experiment in "cinematography."

The production's claim to originality does not come from the singular ways it re(con)textualizes these divergent sources; rather, its originality, however compromised, comes from its representative preoccupation with the now much-eroded boundaries between pastiche, parody, and mimicry. As a self-confessed, postmodernist *pasticheur,* Lepage imitates to create playful allegiances with directors whose work he admires; as a postcolonial parodist, he imitates to mock (and thereby defeat?) dry-as-dust Theatrical Traditions. In both cases, however, Lepage's artistic autonomy, like Garneau's in tradapting Shakespeare, is always, I think, under threat by "foreign" domination.

For him, as for all of us, it is ultimately impossible to ignore the ideology of the aesthetic: although pastiche and parody hold out the possibility of playing with, rearranging, and maybe even inverting, the sanctioned codes of signification, they are too close to being mere mimicry; that existential condition in which "I am not I" but, alas, a reflection of Somebody Else.

However, the Lepage *Macbeth,* precisely because it has so much invested in its hybrid origins, does succeed in laying claim to its own, necessarily partial, space of representation. Its off-center center of theatrical action is not Gérald Gagnon's Macbeth but rather Marie Brassard's Lady Macbeth. All productions of *Macbeth,* of course, have to resolve the perennial question: whose play is this: his? Or hers? It is a rare production that allows them to possess the play equally. But here it is not just a question of which actor is stronger. What matters more is that each of them inhabits space differently; and each of them therefore articulates a very different set of moral and ideological values.

Gérald Gagnon's Macbeth is given traditional, near stereotypical "male" attributes: he is stocky, pugnacious, feral; he is forever on the prowl; he gesticulates with enough histrionic frenzy to rival Hitler at the climax of a Nazi rally; and, nearing the close—with his long shaggy hair, black beard, coarse woollen breeches, and half-naked body—he is, as actress Ellen Terry once memorably said of Irving, "a great famished wolf" caught in a trap of his own devising. When we first see him, he and Banquo are sitting high atop the crossbeams, moving side to side, riding on horseback; but, before long, his world grows much, much smaller. We see him cornered, again and again, within the timbered picture frames; and then, final humiliation, he is imprisoned inside the walls of his castle as Birnam Wood inexorably approaches. The last (didactic) image, as the crepuscular light fades to utter black, is of his isolated decapitated head now ignominiously displayed on top of the very crossbeams where he once "dare[d] do all that may become a man" ("Chu capabe d'oser toute c'qu'un homme / À l'droét d'fére").

In marked contrast, Brassard's Lady Macbeth is given, or so it seems, traditional, near-stereotypical "female" attributes: she is petite, delicate, ethereal; and she is often perfectly still, a quasi-religious icon of spiritual grace and serenity, but infused with the kind of driving

ambition for absolute power normally reserved for men only. When we first see her, she is sitting—naked—on the top acting platform, within the privacy of Inverness castle, where she is reading by the aura of a solitary candle the fateful letter from Macbeth in which he reports his unsettling first meeting with the Weird Sisters. It would be difficult to imagine anyone more different from the Siddonian template of Lady Macbeth as criminal virago. Brassard's nakedness, her perfectly white skin, her intense concentration, and her dominant position all serve to transform her into the female-body-as-tabula-rasa.

When Macbeth arrives, he tries to make her into his object of desire; but it is she who decides when and how they will make love. She indeed possesses the kind of spiritual, domestic, and ultimately political authority that her mere physical size seems to deny her. Unlike Macbeth, she does not get trapped within the timbered picture frames; literally a free agent, she is most "herself" on the top platform, a large public space that she has nevertheless managed to transform into a room of her very own. This is the kind of redefinition of a role that can only occur, I think, within cultures preoccupied with their vulnerable minority status, where "smallness" is a code word for self-authentication. Brassard's Lady Macbeth is a partial, and therefore perversely "natural," embodiment of the mythopoetic principle of metonymy, by which the impasse between small particulars and large universals seems resolved, or at least kept open for constant renegotiation. But at the end, Brassard's nakedness no longer registers—at least, for me—as a source of metonymic reappropriation. Instead, it is transformed into a mere convention when we are urged to see her—naked, dead, strapped to a descending ladder (a cross?)—as a religious icon now fallen from her former state of grace.

Unless a text has been radically disarticulated, interrogated, and denied, it will inevitably invoke just this kind of traditional narrative (en)closure; the interpretative freedom enabled by the transience of performance has not a chance against the permanence of the written literary text. Performances like Brassard's that go directly against the grain of tradition—like "tradaptation," like "mimicry," and like Lepage's "parentheses"—seem destined for assimilation within the very discursive paradigms they were meant to supplant. Everyone suffers from border wounds; and no one—not Brassard, not Lepage, not Garneau, and

certainly not theater audiences in Québec or elsewhere—can ever escape from the all-pervasive boundaries laid down by Shakespearean Textuality.

The Lepage *Tempest* and the Lepage *Coriolanus* expose him, I think, as a director who is frustrated not only by Shakespeare but, even more urgently, by the limitations of theater itself. He assiduously invents ways to bypass, subvert, avoid, and ignore them. He is so impatient with the language of the stage that he often prefers experimenting with other forms; but again and again, he comes back to the theater—and back, as everyone must, to Shakespeare.

In both *The Tempest* and *Coriolanus* we can see him playing variations on two essential strategies: emptying the space so that, as with Brassard's Lady Macbeth, representation can begin as if for the first time; and/or enclosing the space, so that every nuanced compositional arrangement can take place under his exacting control. Although they seem quite unrelated, both strategies are driven, I think, by a preoccupation with being free: free from ideology, free from textuality, free from performance conventions, free from Shakespeare, and free, if only to a certain extent, from Québec itself. But no matter how much he tries, none of these things can be avoided for very long. His only recourse is to put artistic "freedom" itself on trial, to retest its significance for himself, for Théâtre Repère, and for the very future of theater, as a viable art form, in an emergent global culture.

In *The Tempest,* Lepage tries to reanimate the now clichéd practice of making performance into an instrument for the examination of Shakespeare as Metatheater. The production starts in a rehearsal hall with a couple of green tables, some chairs, a mirrored wall, a dancer's *barre*, some lockers, and a hanging neon light. The big clock on the wall says 12:15. Is it day? Or night? We cannot be too sure. It is from this minimalist, but strangely disorienting, environment that Lepage and his actors conjure up a New World. At the beginning, Prospero is clearly the director, but nobody else seems to be committed to a particular role. And then—slowly, inevitably, and yes, magically—everything in front of us begins to change.

As the hanging neon lamp crackles and flashes, the actors dive for cover under the tables; and then the tables, moving rapidly up and down, up and down, create a very rough sea where we watch a small model boat making its way through the heavy swells while Ariel (Marie

200

Brassard again) literally blows it along. Though we do not actually "see" them, we know that Alonso, Sebastian, Antonio, Ferdinand, Gonzalo, and the others are "in" that boat as it disintegrates at the climax of the tempest. Then, just as suddenly as it began, the tempest stops; the actors emerge from under the tables; and the work lights are turned on. Ariel, like a gymnast from the Cirque du Soleil, climbs up with astonishing ease onto the hanging neon lamp. As it moves ever so slowly back and forth, back and forth, she gazes from this spirit-world onto the human activities far below her. But apart from Ariel floating free, everything before our inquisitive gaze looks perfectly normal. Actors sit around at the green tables, reading their scripts; they do some improvs; they try on some roles, then they try on some others. Prospero looks on, waiting. Nothing of import seems to be happening here. But, as in Pirandello, this is a microcosm of the theater in search of nothing less than itself.

What the search produces is that monstrous, ambivalent figure, Caliban. Directors go through extraordinarily involved ideological contortions trying to figure out how to represent him. What, at base, is he: an (ig)noble savage? A cannibal? An African? An American Indian? A Freudian symbol of Evil embedded in the psyche? Or (a still fashionable tradition) a degraded trope in the allegory of Third World colonialism? Lepage refuses to be so overtly programmatic in his reading of the part. Anne-Marie Cadieux, with black, spiky hair, plays a crazed punk-rocker jacked up on speed and on dark anarchistic energy—outfitted in black tights, black leather jacket. She does not walk, she stomps around the stage, wanting to kill and be killed, and wanting, most of all, to get laid—right now. She, like Gagnon's Macbeth, tries to move freely through time and space; but everywhere she goes, she is thwarted, baffled, enraged. At her first appearance, she is hidden under the green tables, but then, suddenly, the tables are tipped up and back, disclosing her long sinuous body—strapped across the table legs—as she thrashes about like some creature mired in prehistoric slime.

Later, during the "man or a fish?" ("un homme? / ou ben un poisson?") scene, the actors tap their fingers—quietly, rhythmically—against the table top; we can hear the pitter-patter of rain; it gets louder and louder, faster and faster, and before we know it we are in the middle of a full-blown storm. Caliban suddenly appears wearing a green

plastic-bag raincoat in which, somehow, both she and Trinculo get entangled; they fight, spit, roll on the ground, and pull gaping holes in the bag, but it still will not . . . let . . . them . . . go The scene has all the ingredients of classic knockabout comedy; but it also has a dark metaphysical edge to it. This is Caliban as a grotesque, almost androgynous, Adolescent, fully convinced that nobody in the whole history of the universe has ever been imprisoned in this much existential *angst.*

Although Cadieux gives an overtly contemporary interpretation to the role, its larger ideological implications are not scanted: it forms a compelling metonymy for the "timeless" and "universal" struggle for freedom, not only because of the extraordinary intensity of her performance, but because the play has been set in a rehearsal hall where all the normal constraints of time and place have been effectively suspended. Paradoxically, a much more localized context could easily create a much less ideologically engaged interpretation.

But the suspension of time and place cannot continue indefinitely: theater—like ideology, like nature—abhors a vacuum. At some point the rehearsal hall, though (mostly) emptied of significance, has to be contaminated by a relentlessly traditional kind of performance. There is a marked transition in act five to the framing of a play-within-the-play when rich red velvet curtains plummet down from the flies, covering the walls, and everyone appears dressed in black quasi-Elizabethan costumes. Their faces painted a contrasting white, they move stiffly, like comical marionettes, under Prospero's all-powerful direction. Too many productions of *The Tempest* conclude in a state of forced, though sometimes genuine, happiness as Prospero dispenses justice and favors, putting the world aright, redeeming both it and himself. At one level, this seems to be what is happening in Lepage's production. Some of the life-size marionettes place restored model boats on the "sea," readying them for the return journey to Naples; Ariel, fittingly positioned on the *other* side of the red curtains, is now set free, carrying "her own book" with her; and Prospero, while delivering his famous speech ("maintenant tous mes sorts sont abolis" / "Now my charms are all o'erthrown") keeps his promise and throws down "his book" in a last, suitably histrionic display of relinquished authority. And they all live happily ever after.

But do they really? Lepage, though he creates the appearance of harmony inside this perfectly controlled last frame, is in search of a

dark, antiromantic, dissident rereading of the play, in which both the theater and ideology are interrogated and found wanting. At another level, we are being asked to see that the play-within-a-play reinstalls an imperializing—literally dark—Elizabethan world-view that is ridiculed as an exaggerated mechanical puppet show complete with puppet master (Prospero as Shakespeare himself?) and concealing curtains.

In fact, everything before us is corrupt and corrupting: not just Prospero's Eurocentric machinations, but Miranda's "brave new world," a didactic point underlined by this final performance which has supplanted the "purity" of the empty space with something stagy, crude, and patently manipulative. In hindsight, even the empty space itself does not look as innocent as it had pretended to be. Remember: its mirrored wall is a one-way mirror through which the characters— Prospero especially—engage in dangerous games of surveillance; its tables and chairs are really nothing more than physical objects that we have been tricked into imagining as something else.

Whom can we trust?—*Nobody*. Will we ever be free?—*No*. Everything is a shifting, decentered illusion, a (parenthetical) statement without stable meaning: this, *not* just Caliban, is the grotesque, ontological monster that the theater's search for itself has ultimately conjured.

Coriolanus: his image remains arrested, as if forever—under that ever-ghostly XIII—on the borderline between Rome and a "world elsewhere." Lepage's production takes place in a recording studio, enclosed by a Roman frieze-cum-TV screen, where we look in vain for empty spaces. We are confronted instead by a self-reflexive environment of frames replicating frames from which there is no escape: everything—and everyone—is magnified, controlled, and scrutinized here in microscopic detail. In this confining space, Jules Philip's Coriolanus is a completely alienated, completely postmodern anti-hero; although he might have had utopian ambitions once upon a time, now he has mostly interested in cutting (i)deals, and in sacrificing both family and friends on the altar of Upward Mobility during that never-ending journey to "world(s) elsewhere." Tragic deification, however paradoxical, would be far too good for him; instead, he has become an impersonal object of contempt in a world of fiercely Black Comedy.

Where, finally, does he want to take refuge? Not in Rome, not in Antium, but in the imaginary homelands in between. But they, as it turns out, are also tricky. Elusive. Volatile. Dangerous The key word in negotiating borders, is "survival." Who is trying to survive? And why? What values are being preserved? How? And who (if anyone) is likely to win the struggle?[5]

Notes

1. An earlier version of this article was first published in Theater 24, no. 3 (1993): 61-70. It was accompanied by "Borderlines: An Interview with Robert Lepage and Le Théâtre Repère": 71-79

2. Quoted in Denis Salter, "A State of Becoming," *Books in Canada* 20, no. 2 (March 1991): 27.

3. Quoted in Salman Rushdie, *Imaginary Homelands: Essays and Criticism 1981-1991* (London: Granta Books and Penguin Books, 1991): 182.

4. Bernard Dort, "The Liberated Performance," *Modern Drama* 25, no. 1 (March 1982): 66.

5. I am grateful to Jean-Luc Plat and Suzanne Pellerin for helpful information about the types of *québécois* language that Michel Garneau explores in his three Shakespearean tradaptations: *Coriolan/Coriolanus*, *Macbeth*, and *La tempête/The Tempest*.

Beyond the Director's Images: Views and Reviews of Robert Lepage's Production of A Dream Play at the Royal Dramatic Theater (Stockholm)
Willmar Sauter

In Robert Lepage's production of *A Dream Play,* which has now had its premiere at Dramaten, the actors never touch the floor. The scenic space consists instead of a seemingly free-floating cube with three walls. The floor—or the wall, which is at the bottom—slopes toward the audience.

The cube is not very big, creating a room of maybe 5 x 4 meters. The cube has a number of square openings, which serve as doors, windows or other passages. The cube can rotate. On these 16 square meters the whole dreamplay is acted out. Through sound and light, projections and this rotating cube, Lepage faithfully executes Strindberg's stage directions.[1]

The performance of *A Dream Play* begins with a transformation of the bright albedo-sphere of heaven into the heavier and denser atmosphere of the earth. The performance demonstrates a transformation from the materia prima of the unconsciousness of childhood, via the painful depressions of nigredo, to the communal initiation, during which all characters throw their old identities into the fire to purify them. When the old ego dies, a psychological rebirth takes place, after which they may enter the albedo phase.[2]

These quotations deal with the same production, Robert Lepage's staging of August Strindberg's *A Dream Play* at the Royal Dramatic Theater in Stockholm in November 1994. The first quotation originates from a review published in a Stockholm evening paper the day after the premiere, the second one is from a master's thesis in theater studies pre-

sented in spring 1996. The question is whether the considerable differences between the perspective presented by these two quotations reflect random choice or whether there are actual profound differences in perspective between reviews printed in the daily press on the one hand, and analytical essays, written by scholars in theater journals or as academic dissertations, on the other.

Assuming that substantive divergences exist between these two types of articles, I intend to explore, using the Lepage production as a case in point, the difference between a review and a scholarly analysis of a performance. On what levels do these differences occur and can these evaluations of theatrical performances even be compared? Weighing these questions, I can see that various reasons might exist for the differences to which I have alluded: 1) pragmatic reasons, such as different working conditions and a difference in readership; 2) conventional reasons such as the long-standing traditions of newspaper criticism versus the relatively new discipline of performance analysis; 3) methodological reasons that in part follow from journalistic and scholarly practices; 4) theoretical reasons, in the sense that critics and scholars do distinctly different things.

Going into more detail concerning these possible explanations, I will show where the differences lie and to what extent they involve more than obviously practical variations such as the different styles, taste, and goals of critics and scholars.

First of all, I will look at six randomly chosen reviews from daily newspapers, published between 13 and 16 November 1994, i.e., four days, at the most, after the first premiere of the Lepage production of Strindberg. I will then examine the scholarly perspective as it is represented in part by an article in a theater journal, *Teatertidningen* (75, fall 1995), and in part by the master's thesis from spring 1996 quoted above.

Critical Response in the Press

All of the newspaper critics struggled to describe the revolving, hanging, tipped and perforated cube that Lepage had mounted in the former painters' workshop under the roof of Dramaten. It is difficult to say whether any reader who had not seen the elaborate construction could ever properly picture the cube and its workings. But since it was

the centerpiece of the whole construction, all critics had to refer to it, first and foremost by trying to find an appropriate description of its appearance and operation.

Despite the limited space all critics are allowed in daily newspapers, almost all of them felt that they had to dedicate quite a few lines to describing this cube. Of course, the cube was the dominant stage device of Lepage's *A Dream Play* and deserved a thorough description, but I can also see an extrinsic reason for spending so much time on descriptions of the "thing." Robert Lepage is well known as an *enfant terrible* among theater directors, especially famous for his highly imaginative stage sets, and the upcoming premiere of *A Dream Play* was anticipated by interviews, during which Lepage talked about his fascination with virtual reality, video, and electronic music. Furthermore, he had successfully performed his one-man show *Needles and Opium* in Stockholm just a few month before. In other words, Lepage's stage devices were news and in this case even theater critics took it upon themselves to report as journalists. The readers, after all, had a "right" to be informed about Lepage's latest inventions.

Apart from being treated as news, the cube had also to be evaluated in relation to Strindberg's play. Since the printed program of the performance had Strindberg's short "Preamble to *A Dream Play*" reprinted on the first page, some passages from the author's idea of dreaming were frequently quoted as a reference to Lepage's stage. Imitating the "incoherent but seemingly logical form of dreams," says Strindberg, "everything can happen, everything is possible and probable. Time and space do not exist" Did Lepage really create a world in which time and space no longer existed? Did his cube dissolve reality? Did the characters of this production "split, double, triple, evaporate, condensate, float away and reassemble"?[3] There are, of course, many responses possible to these questions. Some found the cube a perfect tool to erase any sense of time, logic, and space, and thus to force the performers into unconventional actions, while others found the actors' endless climbing along the oblique walls tiresome and the turning cube a monotonous use of an initially cute toy. These differences in perception are generally not well developed in the critiques—the reviewer naturally having the right to express his or her own opinions. A closer look reveals that those differences are related not only to the critic's taste, but they imply a more profound conception of normative aesthetics.

One way of pronouncing on aesthetic convictions is to refer to Strindberg himself. Since it is his play, any kind of production should, according to some critics, be measured by the requirements of the text and the author. These references to the (play's) author do not solve the problem, however, because they are used by both sides—those in favor of Lepage's cube find as much confirmation in Strindberg's writing as those who oppose the director's "machinery." The aesthetic ground for the evaluation of the production is found instead in insignificant statements that are not supposed to be read as aesthetic principles. Two brief examples can offer support for this observation:

1) Hans Ingvar Hanson praises one of the actors for his "focus on detail, which makes him a living character every moment he is on stage." When he later remarks that in the confined space of the cube "no entrance or exit could be done in a natural way,"[4] it becomes apparent that this critic has problems in appreciating an acting style that does not emphasize psychologically realistic characters. Therefore, he also has difficulty seeing the advantage of setting the actions on an eternally revolving box. For him, Lepage's production does not create a dream, but only monotonous melancholy, if not simple boredom. This critic's concept of theater is firmly rooted in realist traditions and he is not prepared to change his mind.

2) Ulrika Milles underlines how faithfully Lepage respects the Strindberg text, compared to other productions she had seen. According to her, Lepage "plants a mixture of avant-garde circus and postmodern concepts of style into the very heart of a classical play from our cultural heritage." This conclusion illustrates that this critic was able to appreciate fully Francesca Quartey's character Indra's Daughter as a "white Modesty Blaise-type interfoliated with an Indian goddess." Agnes becomes a "knight in female form about to save her prince who is locked up in the castle."[5] These interpretations are admittedly quite personal, but they are clearly inspired by the dominant features of the production.

These examples also point out another general tendency illustrated both in this study and in other reception studies. The evaluation of a performance has a direct impact on the interpretation of what one hears and sees on stage. The lower the evaluation, the less the spectator is prepared to discuss the meaning of the performance. There is, however, a significant deviation from the standard behavior of audiences.[6]

208

While a spectator would normally judge a performance by the acting, especially that of the principal performers, most of the critics here make the peculiar cube the focus of their evaluation. This stage device occupies such a dominant place in the reviews that several critics did not even mention the main actress by name. Even in the most positive reviews the actors are barely mentioned, and are referenced mostly in collective terms in conjunction with the unusual movements required by the performance or in a description of costumes. The lack of attention paid to the actors and to their contribution to the performance seems to be a direct consequence of the domination of the stage machinery. Instead of observing the actors, the critics concentrated on the director and his devices.

Lepage's cubic box was described, evaluated, and related to Strindberg's technique of dreamplays, but interpretations beyond the director's images are hard to find. The question to ask is if this is characteristic of this particular production or if the lack of more profound interpretations is typical of reviews, and a result of working conditions and of professional traditions. Was it at all possible to transcend the overshadowing effect of the cube to advance into the deeper meaning of the characters, the circular narrative, and the significance of style and acting?

Scholars' interpretations

Under this heading I want to present two young scholars and their views on Lepage's production of *A Dream Play*. Their contributions to this discussion are so different in approach and format that I first will present each one separately and eventually try to point out similarities with other scholarly performance analyses.

Ola Johansson's article is entitled "Completeness Passing By—Three Guest Appearances in Stockholm 1994–95." After some general remarks on the aesthetic dream of turn-of-the-century theater artists to unite all artistic means into what Baudelaire called "divine unity art," Ola Johansson posed the question of how theater responds to its role of "performance art" in relation to other art forms. "The theatrical performance consists of the three dimensions of space, irreversible presence, and authentic human interaction."[7] Although such a statement seems commonplace, according to Johansson, these basic characteristics

209

of theater are not always so clearly taken into consideration. During the last two years, three visiting artists to Stockholm have emphasized the importance of presence, space, and interaction.

Johansson's first example is Lepage's *A Dream Play*. Even he describes the hanging cube as a kind of vertical revolving stage turned toward the auditorium. He interprets the anachronistic costumes—spanning the fashion of Strindberg's time to T-shirts and jeans—as a sign that tells the spectator that the narrative in a strict sense is not the director's central focus. The performance does nothing to conceal the director's intent to create a dreamlike world on stage, on the contrary, the prominent physicality of the set and the laborious movements of the actors distance the entire performance from everyday reality.

> With respect to both the verbal and the visual, theater is a plastic phenomenon, a space in which attention is directed toward the performative conditions of presence. Accordingly, Lepage has omitted illusions and instead brings to the fore a materialized interpretation of the dream of suffering mankind. In Lepage's version of the dream, the physical presence of actors and spectators materializes the theater's own reality, a concrete, physical reality in its own right, capable of expressing abstract ideas.[8]

Johansson reminds us that the "the boards, which signify the world" are used not only for the stage floor, but also for the benches upon which the audience sits. The unity of stage and audience, actions and reactions, material world and a world materialized, were the core experience of Lepage's *A Dream Play* as well as of Christoph Marthalers *Murx den Europäer* from the Volksbühne in Berlin and the Théâtre de Complicité performance of *The Three Lives of Lucie Cabrol*. They are all "in a consistent way evoking a physical presence" that in turn creates holistic unities of the kind that Ola Johansson wishes to see more of on the Swedish stage.

Katarina Thorell approached Lepage's production from a very different angle. Her point of departure can only be described in theoretical terms, which, in her case, means a special frame, into which she places the performance. This special frame is alchemy, on the one hand, and the Buddhist interpretation of the Hindu gods and goddesses on the

other. This latter view is of course close to the theme of the play, but enables Katarina Thorell as well to see the relationship between the three worlds of the Hindi gods: The Third World of the Earth, the Second World of the Not Yet Perfected Souls and the First World of the Nirvana. The god Indra, certainly a member of that first world, sends his daughter, who still has to be perfected, into the Third World to be purified through learning. Not only does he send her down on earth to check out the conditions of mankind—as do the three gods in Brecht's *Good Woman of Sezuan*—but also to purify and transform her. Such purification processes are also described in alchemy, especially in the eastern traditions.

The dramaturgy of the play then consists not only of a skillfully composed plot, but also of a description of alchemical operations. This starts in the *materia prima* of the stable, goes through *separatio* and *coagulatio* to *mortificatio* in the scenes with the lawyer to progress to *solutio* and to finally reach the *sublimatio* in the state of the Albedo, the whiteness of the Nirvana. Looking at this production of Lepage, as a movement through the alchemist's phases of the process of purification, lends to many of the scenes a surprising interpretation, such as the pains and tribulations people are experiencing in the Foul Beach scene: the pain is a mortification, the deadly state of transition a necessary step toward the pleasures of the Fingal Grotto. But the analysis also shows an overall understanding of the "female power which is needed to transform society."[9] Another example is provided by the three men surrounding Indra's daughter: the Officer, the Lawyer, and the Poet. Together they represent the basic elements. The Officer, earthbound, represents our physical development; he is played by three actors, a boy, a young man, and an old man. The Lawyer has reached the water element, during which our emotional life develops. The Poet has already jumped to the fire element, representing inspiration and mental power, but he had neglected the air element, through which our intellect is trained. The neglect of the air element, then, is the reason why all these men remain immature and incapable of reaching the same height as the daughter herself.

This interpretation is not restricted to Strindberg's text, but includes as well the physical, scenic elements: the water on the stage floor, the fire-like projections, the naïve movements and gestures of the actress playing the daughter, and the comportment of the three actors creating

the role of the Officer mentioned above. This last observation is interesting in principle. Katarina Thorell states frankly that she will not evaluate the actors in terms of their craft or the power they bring to their performance, but that she wants to see their characteristic style of acting emerge from the interpretation of a given fictional role. "Evaluations are not meaningful for this analysis, since I only interpret what I see on stage and not what I wanted to see on stage," she states.[10] Thus, she interprets both the positive and negative sides of the acting as function of features of the role, while including the acting style of each actor as well as the style of the ensemble.

Reviews versus Essays

The characteristics of these two essays can be summarized in a few points. Both proceed from a distinct frame of interpretation, one from aesthetic theory, the other from a concept of alchemical processes. Most of the reviews lack this quality. Only one of the critics made an attempt to see Lepage as part of the *avant-garde* tradition. On the other hand, this lack of foundation in aesthetic theory does not prevent the critics from expressing aesthetically based judgements, as we have seen.

The two scholars also show very little interest in the director and his intentions, a matter of major interest for most critics. The same is true for their discussion of the actors, whose stage personalities did not merit any comment in these two essays, although one of the critics at least views acting style as an integrated expression of the fictional character. The performance as such is the main focus of the young scholars, while the text and Strindberg himself are attributed less significance.

Turning back to my initial question, that of whether we can observe distinct differences between reviews and essays, I have already suggested different levels of comparison: pragmatic, conventional, methodological, and theoretical. Here I would like to offer some tentative answers, partly as conclusions from the material presented here, partly as results of my own professional experience as a reader of newspaper reviews and of scholarly essays.

The pragmatic reasons for different approaches to writing about performances are quite obvious. The newspaper critic has to write

quickly; often he has no more than twenty-four hours and the space allowed in the newspaper is limited. None of these limitations apply to scholarly work. In addition, it is important to realize that the critic as a journalist also has to consider the news value of his writing, while scholarly publications often appear after the production has long since disappeared from the theater marquee.

I think there are considerable conventional differences between critics and scholars, especially concerning attitudes toward the dramatic text, its author, and not least the director. The reviewer is very often strongly attached to the text and considers the playwright as a key figure of the theatrical event. In performance analysis, the dramatic text is just one of the elements to be analyzed, but it is less important than its presentation through the acting. Another difference is noticeable in relation to the director: it is striking that the director has become increasingly important to critics, who consider a director as the central creator of the performance.[11] Analysts of performance recognize the director as a unifying principle, certainly important, but not necessarily the main point of interest. For them, the importance of the director decreases over the years during which performance analyses have been published.

From a methodological point of view, it is obvious that different working conditions result in different approaches to the writing of analytical texts. Since critics usually see only one dress rehearsal, their writing has to be relatively spontaneous. Therein lies a special value, for both the reader of newspapers and the researcher of theater history: very often these are the only traces of audience reaction to be found. The scholar is able to see a number of performances of the same production, and can compare the effects on different audiences and the variations in each presentation. The scholar also has the time to develop a reasoned discourse; hence it is expected that his/her analysis will take in the whole of the performance. A critic, almost from necessity, has to choose certain moments of the performance to illustrate his or her opinions, while the scholar carefully selects dominant aspects that are significant to the interpretation.

There are also theoretical reasons for the differences between reviews and essays. I think it is reasonable to assume that critics are mostly engaged in searching for the meaning of a performance, meaning in the sense of an intended or at least possible meaning, primarily

213

related to the director as the creator of the event. Scholars, on the other hand, create or construct meaning by giving their interpretations a clearly established theoretical basis, which need not at all be related to a director. The differences between searching for and constructing the meaning of a performance are considerable.

In conclusion, I would like to render an opinion on what critics and scholars could learn from each other. Critics might be advised to make more use of explicit aesthetic and theoretical points of reference and to focus more on the actual performance than on the putative intentions of dramatists and directors. Scholars could learn to trust more their spontaneous personal experiences and to discover the value of evaluations. Finally, both critics and scholars ought to recognize the actor as the "real creator" of the theatrical event and to realize the impact of the actor upon the primary theatrical experience and its interpretation. This might promote an adequate understanding of the art of theater as specific space, irreversible presence, and authentic human interaction.

Notes

1. Claes Wahlin in *Aftonbladet* (13 November 1994). This and other translations from the Swedish are by the author.
2. Katarina Thorell, "En alkemisk dröm: Alkemisk analys av Robert Lepages uppsättning av Ett Drömspel på Dramaten 1994–95." Master's thesis in Theater Studies (Stockholm: Stockholm University, 1996), 35.
3. "Ett drömspel." Program notes of Kunglig Dramatiska Teatern (1994), 2.
4. Hans Ingvar Hansson in *Svenska Dagbladet* (14 November 1994).
5. Ulrika Milles in *Expressen* (13 Nov 1994).
6. Willmar Sauter, "Theater Talks—or How to Find Out What the Spectator Thinks." *Nordic Theatre Studies* 2/3 (1989), especially 144.
7. *Teatertidningen* 75 (1995), 11.
8. Ibid., 12.
9. Katarina Thorell, loc. cit., 35.
10. Ibid., 2.
11. Cf. Curt Isaksson, *Pressen på teater: Teaterkritik i Stockholms dagspress 1890–1941* (Stockholm: STUTS, Theatron-serien), 1987.

Robert Lepage and the Languages of Spectacle
Sherry Simon

ROBERT LEPAGE IS a Quebecer whose work in the theater has become internationally renowned. This internationalism defines an essential, not a contingent aspect, of Lepage's work. His plays are about the way culture travels, about the clash and interpenetration of cultures; they use and challenge stereotypes of ethnicity, questioning cultural identity in innovative ways. At the same time, Lepage's productions, despite their participation in an evolving tradition of interculturalism in theater and performance, despite their "transnationalism," are also outgrowths of a specifically *québécois* obsession with questions of identity and language. It is this interplay between the local, the national, and the transnational that I would like to examine here, particularly in relation to Lepage's use of languages. I will argue that Lepage's productions, specifically *The Dragons' Trilogy* and *The Seven Streams of the River Ota,* are *translational* in their very structure, that they challenge the idea of translation as transmission, to replace it with a concept of "translational culture."

This notion of translational culture can perhaps be best introduced by contrasting the form of Lepage's performances with the plays of another Quebec playwright, probably one of Lepage's closest rivals in terms of international celebrity: Michel Tremblay. Tremblay's plays have also traveled widely, but for reasons quite different from those that drive Lepage's productions across the globe, and according to quite different modes of transportation. It would be hard to find two more culturally dissimilar figures, two playwrights whose work assumes such radically different cultural configurations. Tremblay's plays are related

215

to "localness" in ways we are very familiar with: he evokes dramas of identity and marginality within a community defined by its language and by its situation in one well-defined urban space. His first play, *Les Belles-sœurs*, achieved instant notoriety when it was first presented in 1968, because it dared put on stage the downgraded, working-class vernacular of Francophone Montreal—in a city still obsessed by its colonial inferiority. Although the appeal of Tremblay's plays is very much related to his use of marginal figures, in his plays both outsiders and insiders share the reference points of a common culture. Dramas of identity are enacted within the space of the local. Therefore when Tremblay's plays travel around the world, they remain, even in translation, quintessentially "Quebec" plays. While they are "about" identity, and particularly sexual identity, they ask their questions through the thickness of one particular cultural space. Their language points to the depth of community, networks of associations and a common history; although recounting dramas of alienation and marginality, it also, paradoxically, speaks a politics of affirmation.

Lepage's performances use elements of Quebec culture, but these elements are always framed within a series of cultural references. The nation is not a single frame bounding the elements of the work, but one element in a dialogue of identities.

The formal differences between Tremblay's and Lepage's work become crystallized in their relation to translation. To travel around the world, Tremblay's plays are revernacularized. This has been done particularly successfully in Scotland, where Tremblay has become "a prominent Scottish playwright," several of his plays having been given popular and culturally relevant Glaswegian versions. (Findlay, in Simon) Lepage's performances, in contrast, cannot be transplanted in this way. Lepage's language remains closer to the surface; languages are signs in a vast array of cultural indicators, signs to be negotiated rather than penetrated. The polylingualism of his productions means that there cannot be a total transfer of meaning from one idiom to another; his plays move along the surfaces of cultural sites, slipping across national borders, appearing in the same fragmented and plural form in each new venue. Translation (the use of surtitles, or other strategies incorporated within the performances) is always partial, selective. Translation devices are part of the performance, and not a means of transportation. Lepage's productions, then, suggest revisions to the idea of translation

216

as the replication of one culturally-bounded product into another. They challenge the economy of cultural equivalence, suggesting instead forms of movement that do not resolve cultural tensions but maintain a sense of transnational dissonance. It is the notion of translational culture that I propose to explore in two of Lepage's productions, *The Dragons' Trilogy* (1986) and *The Seven Streams of the River Ota.* (1996–97)[1]

Intercultural Theater

The theater of Robert Lepage is "internationalized" in its very essence. Lepage has invented productions which, though constructed out of materials gathered from local contexts, are put together into performances that transcend these origins. This use of cultural collage places Lepage in the company of "intercultural" theater artists Eugenio Barba, Peter Brook, Robert Wilson and Ariane Mnouchkine (Pavis 1).[2] These directors have all used elements of distant cultures like the *Noh* tradition, *Kathakali* dancing from India, or African performances, as elements of their own theater. Like the other directors mentioned, Lepage uses the clash of traditions to construct his plays and *mise-en-scène*.

In the two plays I will discuss, the Asian tradition is the most significant source of cultural otherness. The recourse to Asian culture in theater has often indicated a desire to turn toward more stylized, ritualized forms of acting, a move against realism and naturalism, toward "an elevated artistic bearing," controlled emotions (Pavis, 17), and, according to the influential writings of Artaud, "a theater which eliminates the author in favor of what we would call, in our Occidental theatrical jargon, the director; but a director who has become a kind of manager of magic, a master of sacred ceremonies . . . "[3] Gesture, dance, stylized movements, have been some of the most powerful influences from the East. Both these plays, however, go far beyond the purely theatrical aspects of this encounter to actively explore the specific historical and social configurations that take form as the result of the encounter between distant cultures.

Both plays adopt specific language strategies to mirror and deflect the thematic concerns of the performances. *The Dragons' Trilogy* adopts a strategy of non-translation; while *The River Ota* foregrounds the "scene" of translation.

217

The Trilogy: Strategies of Non-Translation

Perhaps more than Lepage's subsequent productions, *The Dragons' Trilogy* gains from being understood within the specific context of Quebec society. The play was developed by Lepage and Le Théâtre Repère during the early 1980s, a period that saw a crucial shift in conceptions of ethnicity in Quebec. While immigrants had traditionally become integrated into the Anglophone community in Quebec, the period after the enactment of law 101 in 1977 (a law stipulating, among other things, that new immigrants MUST attend French-language schools) saw a reconfiguration of *québécois* cultural power and the realization that immigrants were henceforth to be part of the majority Francophone world. There was a new sense of the wider boundaries of Quebec culture, and its necessary heterogeneity. Theater was particularly attentive to these shifts, and, beginning in the early 1980s, cultural diversity became a preoccupation of a great deal of artistic creation.[4]

The Dragons' Trilogy was an early and spectacular contribution to this movement, focusing on the issue of cultural diversity in Quebec and across Canada, but choosing to investigate, not the more obvious and numerous groups like the Italians, Portuguese, Greeks or Haitians living in Montreal, but the archetypical figure of the lone Chinese living in the very small-town atmosphere of provincial Quebec city, a site not often associated with cosmopolitanism. In a sense, the play willfully distorts the sociological realities of Quebec, in bypassing Montreal, the multicultural metropolis of Quebec, to concentrate on the small provincial city of Quebec. The investigation of the reality of the Chinese in this provincial capital, however, becomes all the more unexpected and poignant, and underlines the way in which the play ventures well beyond purely sociological issues to investigate the material history of relations between "China" and "Quebec/Canada" since the Second World War, at the same time as it takes on a whole range of issues relating to the broader symbolic dimensions of Otherness.

The *Trilogy* is a six-hour performance that explores the meaning of "Chinese" through seventy-five years of the social history of Quebec and Canada, moving from Quebec city, to Toronto, to Vancouver. It begins in a parking lot in Quebec city, in a square of sand, which is all

that is left—on the surface—of Chinatown in Quebec city. It begins with the phrase "I have never been to China," spoken in three languages, English, French and Chinese.

I have never been to China
When I was small, there were houses here
This used to be Chinatown
Today it's a parking lot
Later, it may become a park, a train station, or a cemetery
If you scratch with your nails
you will find water and motor oil
If you dig further
you will surely find pieces of porcelain
jade
and the foundations of the houses the Chinese lived in here
if you dig even further
you will find yourself in China
When I die
I want you to throw me in a hole like that
so that I fall
eternally
So that I live eternally
Look at the old parking lot attendant
I say that he is not sleeping
It's as if he was the dragon
the dragon guarding the gate of immortality
He is the dragon
And this is The Dragon Trilogy (Toronto, 1986).

The archeological metaphor highlights the aspects of the play that are an "excavation of the buried past and its individuals, with their dreams and disappointments and the destinies that would carry them and their descendants on a temporal journey through the century and its changes and on a spatial journey westward, to Toronto, and Vancouver." (Garner 226) But while the play is "epic" in its historical and geographic scope, *The Dragons' Trilogy* derives its power from the "brilliance of its theatrical imagination . . . moving seamlessly from one theatrical style and mood to another, borrowing eclectically from

sources as varied as cabaret, pantomime, Asian shadow theater, Chinese festival, and theatrical expressionism." (Garner 226–27) The play transports us from west to east and then to the Orient, in three movements corresponding to three eras, three spaces, three colors, three rhythms. The movements of a Chinese family in Canada become an exploration of the interlinking histories of East and West, of their grounding in both social history and individual itineraries.

East and West are not, however, two different places, two separate realities, but pieces in an ever-moving and changing configuration of identities. First, Chineseness is the absolute strangeness inhabiting the familiar world of childhood, the closed world of provincial Quebec, with its visual and audible signs of strangeness: laundry, opium, the mispronunciations of French. But slowly it unfurls into a complex and swirling panorama of memory, loss, catastrophe and art. The "Chinaman" of the *Trilogy* at the start is a stereotype: first the watchman of the parking lot, the guardian of its subterranean secrets, then Wong, the silent laundryman, object of the taunts of the neighborhood children, who speaks strange French (*Mêci*) and an English that even Crawford, an Englishman, cannot always make out. When Wong says "The store is burn" Crawford repeats "A star is born?," evoking at the same time the astral theme and the reference to Halley's comet that runs through the play. This difficulty of communication, coming close to incommunicability, identifies the "Chinaman" as an absolute Stranger within the community. Although he lives in the midst of the community, he is not a member of it. He is separated from it by the veil of memory and by the heritage of anti-Oriental racism which Quebec, and North America in general, receives from the European tradition. The mode of existence of the "Chinese" in North America is marked by the specific patterns of their immigration: the large numbers of men recruited to work as coolies on the railways, then their dispersion across the continent, to the very smallest of localities, to be often the single Chinese person or family, working in laundries, then in restaurants. Men who immigrated to Canada before 1924 were obliged to remain single, as racist considerations put a total stop to Chinese immigration from 1924 to 1951. The veil of separation is stunningly represented by Lepage by the sheets that the laundryman hangs up, which become the sails of memory as they are attached to a Chinese junk, and then the canvas upon which the women members of Wong's family paint, in

more and more precise detail as the years pass, the landscapes of their childhood. Against the backdrop of the sails, Wong recounts his dream in Chinese—and it is translated by Jeanne and Françoise. The women, though, can express themselves only through their painting. Although they have lived in North America for much of their lives, they never learn any other language, and are condemned to communicating only with each other and their past.

The second and third parts of the play move to Toronto and then to Vancouver. The main element of the final section is the encounter of Pierre and Youkali, of Western and Eastern art traditions. In the hesitant, tender and difficult dialogue between the two young artists (difficult emotionally but also linguistically, as neither "masters" the English language), there is the suggestion of an opening out into worlds which are new for both of them. Each offers the other a quest, a promise, a hope. And finally Pierre announces to his mother that he wishes to study art in China. Although Chinese culture begins, in the parking lot of Quebec city, as that most foreign of Othernesses living "among us," the barriers of foreignness are forced open to reveal the interactions that construct identities, ideas, projects.

From the very beginning of the play we are struck by the difference between the intimacy and ease of communication between Jeanne and Françoise, the two main characters, and the formal, distant and difficult speech of some of the other characters. A particularly poignant drama of incommunicability is conveyed through the "typing lesson" when a young Japanese geisha recalls the abandonment of her mother by an American officer. "Il est venu, virgule, puis il est reparti, point. Puis il est reparti, point. Il a dit, deux points, ouvrez les guillements, je reviendrai, ouvrez les guillements, je reviendrai, fermez les guillements, point. Reviendra-t-il? Point d'interrogation. Personne ne l'a cru, point. Personne ne l'a cru, point." (*Jeu*, 63) This rewriting of the Madame Butterfly theme already looks forward to *The Seven Streams of the River Ota*.

The Dragons' Trilogy, though it is about two-thirds in French, one-third in English, was presented without translation in many venues. It played to large audiences in Montreal and London, for instance, even though the amount of English in the play is considerable, and it is spoken with a Chinese accent not at all easy to grasp. This decision is in contrast to plays like *Vinci* and *Needles and Opium*,

which were played in either English or French versions. The mixing of languages clearly highlights the thematics of the play: the investigation of the nature and degree of communication across cultures. The Chinese language is, for most of the audience, a surface of incommunicability, a texture of sound. But just as "China" is both near (physically proximate) and culturally distant, a reality that is at first an object of total incomprehension and ridicule, and then the envelope out of which emerges a barely imaginable world of dreams and possibilities, the language is also a surface that promises depth.

Referring to the *Dragons' Trilogy*, Lepage says:

> What I like to do is use words as music. People's talk becomes music and what they do are the real verbs, the real actions, the real phrases. The meaning of the show has to be what's up front. And the way we get there is by the different languages, to treat them as objects. I have an idea. I say it in a language that people don't understand so they're interested to know what it's all about. I say it again, but in another language they don't understand. But they understand a little more of it. They start to build up the show with me. It's very active. It's like saying the same thing over and over again, but with different images. People associate words and senses and objects and imagery." (quoted in Hunt, p. 112)

Languages in *The Trilogy* play an especially strong role because of the way they are played one against the other, not only languages as such, but registers—the intimate against the formal, the conversational against the declamatory, the familiar vernacular against the strangely accented foreign. Lepage does not always use language with such strength in all his plays. In *Needles and Opium*, for instance, Lepage seems to have reduced the registers of language to two, which are played one in dialogue with the other. In this play, Lepage plays two characters—Jean Cocteau and a *québécois* artist. The Cocteau character speaks from the air, from the space between two continents, Europe and North America. This voice of the hanging, floating, gesticulating Lepage is declamatory, incantatory. It is a beautifully modulated voice of recitation. When Lepage switches to his *québécois* character, he creates an atmosphere of intimacy, turning his chair at an angle toward the audience, speaking with the easy tones of familiarity. The conversation

that Lepage conducts with his public is in fact a brief synopsis of the history of Quebec, explaining at the same time his own personal breakdown, loss of inspiration, and the pain of the loss of a lover. The intimacy of this mode of address can have two kinds of messages. For a local audience, this speech will be received with the pleasure of complicity. For a foreign audience, this is an insider's view into a strange, intensely local culture. In either case, the change of linguistic register highlights the theme of the "local." Whether it is "our" local or "their" local does not matter. It is the localness itself, in dialogue with the language of the transatlantic Olympian universalized French author, which provides the interest. In operating the shift from atopic to local, the play inscribes the very logic of its mixed audiences within it.

The Seven Streams of the River Ota: The Scene of Translation

The Seven Streams of the River Ota has a very different structure and feeling from *The Dragons' Trilogy*. It is controlled, constrained, distilled, in contrast to the physicality, exuberance, and abundance of the first play. Where the *Trilogy* moved in a single direction from Quebec across Canada and then to the Orient, the action of *the River Ota* moves back and forth across wide intercontinental spaces, from Hiroshima to New York, Amsterdam, and the Nazi concentration camp of Terezin. In its final version, a show lasting eight hours and made up of seven separate acts, a prologue and an epilogue, the overarching theme of *The River Ota* is catastrophe and survival, destruction and recreation. Conceived to commemorate the 50th anniversary of the bombing of Hiroshima, it foregrounds the city of Hiroshima, while moving across the spaces of Europe and America, from the period of the Second World War until the present. As always, Lepage is interested in the spaces created by the encounter between cultures. These involve moments of violence and oppression but also of creativity.

The Trilogy was closely tied to the specificities of local sites and the particular narratives that emerge from them, relatively modest in its geographical reach, anchored in the historical realities and material culture of Quebec and Canada. *The River Ota* is hugely ambitious in its embrace of history, taking on the Holocaust, the bomb over Hiroshima and AIDS as the triple catastrophe of our times. The most

223

salient distinction between the two plays is their treatment of history. *The Dragons' Trilogy,* grounded in the sites and material history of Quebec and Canada, opens up new understandings of this history. *The Seven Streams of the River Ota* does not complexify historical events in the same way. *The Seven Streams,* as a whole, is regulated by a principle of containment, opting for an aesthetic of minimalism, often using the device of the frame (usually the house) to distance the spectator from the action. "Hiroshima" is defined as an element in two separate series: as an event in the ongoing relationship between East and West (through the Butterfly theme, most notably), and as an event that joins other catastrophes of recent human history, the Holocaust and Aids. The construction of this second series is a major flaw in the structure of the play: it reduces the complexities of history, banalizing the message of the play. The end of the December 1996 version celebrates, in the oneiric colors of a psychedelic sunset, the universal values of survival and reconciliation, when Hanako, the translator, and Jana Čapek, the Jewish survivor of the Holocaust turned Buddhist monk, join together in a ritual of mourning for Hanako's husband. The play suggests that the catastrophe of Hiroshima and the events of the Holocaust are in some fundamental way "the same thing," that they function on the same plane of history. One would wish for a more nuanced and problematized confrontation of these historical 'events.' This question of equivalence, of the arranging of historical events into series, and of their commensurability, is tied into the very structure of *The Seven Streams of the River Ota.* It suggests questions relating to the equivalence/translatability of cultures, cultural forms and historical events.

Both *The Trilogy* and *The River Ota* make extensive use of languages, *The Dragons' Trilogy* opting for an aesthetic of polylingualism and non-translation, as we have seen, *The River Ota,* a more polished and internationalized production, using the "scene" of translation as a central element of its content.

The play foregrounds a number of crossover figures: Jeffrey Yamashita, who migrates, as a musician, between Japanese and American culture; Jana Čapek, a Jewish survivor of the Nazi death-camps who becomes a Buddhist monk in Hiroshima; Hanako, who is blind, and who is an interpreter between French and Japanese. There is a significant shift in the relative importance given to these figures as the

performance evolved. In the version of the play shown in New York in December 1996, Jana Čapek is the central figure of the play; in May of 1997, in the final version presented in Montreal, Hanako had become this pivotal figure, displacing emphasis from the theme of survival and reconciliation to that of the (im)possibilities of communication.

In the final version of the play, Hanako is the first character to appear and almost the last. She becomes blind as a child, having been witness to the "end of the world," the bombing of Hiroshima. She is a character in one of the funniest but also most poignant scenes of the play, when Sophie Maltais, the *québécois* actress who has discovered she is pregnant, calls Hanako in distress. Their telephone conversation, in French, is interpreted by a deadpan interpreter into English, for the benefit of the audience. This staging of language involves the comic transposition of a process of formal interpretation, from its customary function in high-level political or scientific meetings to this unexpected presence in a very private and emotional conversation. At one point, the interpreter makes a mistake that Hanako herself corrects—at once reassuring the members of the audience who have picked up the error and acknowledging the presence of this figure who has been "intruding" on their conversation.

The expansion of Hanako's role and the symbolic importance she is given is amply justified by the themes of the play and the power of the character of the translator in a transnational enactment like *The River Ota*. That this play should put emphasis on the *scene* of translation is totally coherent with the logic of its structure and its mode of travel. It is an emphatic extension of the reversal of the Butterfly theme, which serves as the thematic core of the performance. Meaning is no longer imposed in the form of authoritative words from the outside (the false promises of Lieutenant Pinkerton) but is set into a frame of dialogue and negotiation. It is especially in the section called "Words" that different language games are foregrounded. Language is given a number of "faces" here. It is farce and pure display, as in the overblown emotions of the Feydeau play that inexplicably, the Canadians have chosen to put on as their contribution to the World's Fair at Osaka in 1970, the voice of the Japanese translator sounding a monotone against the excessively dramatic lines of the play; language is also mask and weapon, as in the barbs exchanged between Patricia Hébert, the wife of the Canadian ambassador, and Sophie Maltais; but language also represents the

attempt to convey deep and difficult emotions, as in the dialogue between Sophie Maltais and Hanako. This whole section is in fact a "staging" of language, a foregrounding of words, which does not occur in the rest of the play. (Supertitles, for instance, are used to translate the French in other parts of the play, where the use of French is mainly restricted to comic effect.)

These scenes of language passage and transfer are to be seen in relation to the other modes of passage presented in the play: Luke O'Connor's initial contact with post-war Japan, Jeffrey Yamashita's initiation into the youth culture of New York, Jana Čapek's voyage from Teresienstadt to Hiroshima, Pierre Maltais' passage from the art world of the West to forms of Eastern expression in *butoh* dance. Travel, photography, jazz, opera, dance: these are also vehicles of cross-cultural communication. Each of these movements begins in friction and even violence, to end in a moment of fusion. The passage from West to East, East to West, is continuous, each moment of contact setting off waves of repercussion, which generate new forms of cultural synthesis.

What is the status of translation in relation to these other forms of contact and interpenetration? One of the scenes involving simultaneous translation suggests that language can be the most opaque and trivial of signifying practices. What exactly is being "translated" to the Japanese audience in Osaka through the flat voice of the simultaneous interpreter of the Feydeau play? What is the meaning of the culture that is transmitted through the performance of this French play by a Canadian cast to a largely Japanese audience? There is no depth to be sought here, only a collage of surfaces. On the other hand, Pierre Maltais' anguished struggle to learn *butoh* dance involves engagement of a very profound kind. And he accedes to this knowledge through an identification with Hanako's blindness. We are reminded of the network of relations between art, blindness, and language that is set up in Lepage's much earlier play *Vinci*. What kind of vision is it that allows us to "see" art? In the early play Lepage uses the electric train to demonstrate the idea that "art is a vehicle," that the art form, like the sentence (like the cars of a train) must be "loaded with meaning. And to transmit the sentence, it must be motivated." He then switches metaphors, concluding that "as the subtitles in a film allow us to follow what is going on, and as 'art also serves the function of casting light on the chaos of our society, art is, to a certain extent, a sub-title." (Hunt, 107)

These figures draw attention to the association of art, language, and movement in the work of Lepage—and their relationship to vision. It is not surprising that photography comes to play a large role in *The River Ota*, photographs being on the one hand an instrument of the imposition of order (the photographic work of Luke O'Connor in postwar Japan) or later the means through which Jeffrey reveals his relationship to his father.

Language is alternately surface (it is like a "costume," Lepage has said) and depth. It is a superficial mark of identity (a signal, through which tourists identify one another) and also an instrument of self-exploration. It is also, in Lepage's plays, a signal indicating the plurality of codes, which circulate through singular moments and singular spaces. In this sense, both *The Dragons' Trilogy* and *The River Ota* could be said to embody within themselves a kind of 'translational culture', one in which idioms are in constant contact and interlap. Lepage's plays enact a kind of code-switching, using varieties of language interaction for specific types of effects. As such, they propose a vision of "cosmopolitan globalism" as a dialogue among differences. Pitting languages one against the other—at the risk of devaluing language, of declaring its relative inefficacy—is one of the ways that Lepage's productions express their mode of existence in the world, as circulation, as confrontation with diversity, as a coming together of disparate things. Lepage becomes then an exemplar of the transnational intellectual who exhibits heightened skill in manipulating differences, "as the cultivation of code-switching between local differences, not their anesthetization via incorporation." (Buell 293) The special knowledge of these individuals is not their contextualized knowledge but "their decontextualized knowledge [that] can be quickly and shiftingly recontextualized in a series of different settings," a knowledge that is "reflexive, problematizing, concerned with metacommunication" (Hannerz 1990, cited by Buell 293–94).

Increasingly, translation and writing become part of a single process of creation, as cultural interactions, border situations, move closer and closer to the center of our cultures. And so we are not surprised to see the scene of interpretation occurring more and more in contemporary art. Translation becomes a category of production, rather than a simple mechanism of transmission. A strong thrust of contemporary cultural theory involves the redefinition of the role of translation,

227

the refiguring of translation from a category of cultural exchange to a category of cultural production. This reconceptualization we see in the work of Jacques Derrida, but also in the postcolonial theory of Gayatri Spivak and of Homi Bhabha. Both are engaged in reconfiguring the boundaries of culture from the point of view of the postcolonial and the migrant, in rethinking culture as a category of *enunciation*, rather than a category of representation and knowledge. Instead of serving as a bridge between already-given cultural entities, translation becomes an activity of cultural creation. The bridge, in other words, brings into being the realities that it links. ("The boundary becomes the place from which *something begins its presencing*," Bhabha 1994: 5). By translation I first of all mean a process by which, in order to objectify cultural meaning, there always has to be a process of alienation and of secondariness *in relation to itself*. In that sense there is no "in itself" and "for itself" within cultures because they are always subject to intrinsic forms of translation (Bhabha 1990: 210)

James Clifford offers a similar insight when he argues that:

> Practices of displacement might emerge as *constitutive* of cultural meanings rather than as their simple transfer or extension. The cultural effects of European expansionism, for example, could no longer be celebrated, or deplored, as a simple diffusion outward—of civilization, industry, science, or capital. For the region called 'Europe' has been constantly remade, and traversed, by influences beyond its borders . . . Cultural centers, discrete regions and territories, do not exist prior to contacts, but are sustained through them, appropriating and disciplining the restless movements of people and things." (Clifford 1996: 3)

Clifford suggests that operations of transfer and exchange are not subsequent to a primary moment of cultural creation, but coeval with it. These perceptions lead us to reconfigure the circulation of cultural goods about the world. The economy of exchange gives way to a circulation governed by a "complex, decentered interactiveness" (Buell, 337) These terms aptly describe the dynamics at work in Lepage's productions.

Lepage's plays are mobile because the very logic of travel and mixed codes is at work within them. Is the transfer of this text from

one place to another to be called "translation"? Lepage's work nourishes our understanding of translation today as a reality and as an ideal that has more to do with discontinuity, friction, and multiplicity than it has to do with commonality, precisely because culture no longer offers itself as a unifying force. Language, nation, and culture no longer line up as bounded and congruent realities. It has become a commonplace of critical discourse to speak of the hybrid aesthetics of contemporary postcolonial writing, its creolization and multiplicity. Texts, like cultures, like national territories, are more and more the sites of competing languages, diverse idioms, conflicting codes. The way we imagine translation is changed by the fact that the worlds which it seeks to bridge are already to some extent informed by plurality, are *already* saturated with a logic of translation. And so translation is neither a mode of transportation nor a mechanism for regulating differences, but rather one of the elements contributing to the creative complexity of the work.

Notes

1. This reading of Lepage's plays is a reaction to performances of *The Dragons' Trilogy* in Montreal in 1986 (and reinforced by the extensive commentaries in *Jeu*) and *The River Ota* in New York in December 1996 at the Brooklyn Academy of Music and a *considerably* different and *much more successful* version of the play in Montreal in June 1997. The name "Lepage" refers of course to the collective work of Robert Lepage and his troupes, Le Théâtre Repère and the group Ex Machina.

2. In Pavis' attempt to create some definitional order, he distinguishes "Intercultural" from "Multicultural" theater and "Cultural collage." "Intercultural" is defined as: "hybrid forms drawing upon a more or less conscious and voluntary mixing of performance traditions traceable to distinct cultural areas. The hybridization is very often such that the original forms can no longer be distinguished" (8).

3. "The actors with their costumes constitute veritable living, moving hieroglyphs. And these three-dimension hieroglyphs are in turn brocaded with a certain number of gestures—mysterious signs which correspond to some unknown, fabulous, and obscure reality which we here in the Occident have completely repressed." Antonin Artaud, "On the Balinese Theater," *The Theater and its Double*, trans. Mary Caroline Richards, New York: Grove Press, 1958, pp. 60–61. Ariane Mnouchkine likes to repeat that the West has created no theatrical forms outside of the *commedia dell'arte*, which is itself of Eastern inspiration. She repeats Artaud's words that

229

"Theater is Oriental." *Rencontres avec Ariane Mnouchkine,* Josette Féral, Montréal, XYZ Editeur, 1995. Lepage's dialogues between East and West must also be read against the backdrop of other spectacles of difference, Peter Brook's *Mahabharata,* Hélène Cixous' *L'Indiade.*

4. In Peter Greenaway's film, *The Pillow Book,* for instance; in Gary Hill's video installation, "Disturbance among the Jars" (1988).

French Critical Response to the New Theater of Robert Lepage[1]
Guy Teissier

FRANCE DISCOVERED ROBERT Lepage rather late, progressively and prudently. He had to prove himself—brilliantly—at small-town festivals and in suburban theaters before conquering Paris. Suddenly he was all the rage. But the grand spectacles that he has produced and presented recently do not seem to have won complete approval: in the theater he has his passionate admirers and his fierce opponents, whereas on screen, his two productions in France were perceived as failures!

Festival Season (1986–87)

Unknown to the French until 1986, two years and two plays later Lepage has succeeded in presenting, at important festivals like Limoges and, especially, at Avignon, original works that attracted enough attention to lead him to the gates of Paris.

1986: Distinguished Activity in Limousin

19 October 1986, in an article entitled "Robert Lepage's *Vinci* a triumph in Limoges," Jean-Paul Bury described in Quebec's *Le Soleil*, and in other Montreal dailies, this first appearance of a Lepage piece in France:

> *Vinci* . . . played a revolutionary role at Limoges, in that it contrasted the other pieces presented, notably those by troupes from Francophone Africa.[2] Seized by an enticing play of light, sound, scenic

wonders and special effects, orchestrated by Daniel Toussaint, a veritable magician of all things musical, the room was entirely captivated. The approximately 100 spectators who squeezed into the mini-theater, *Expression 7*, demanded six curtain calls from the man that the newspapers present here as one of the most inventive creators of the young Quebec stage.

It was, in fact, under the following headline that *Le Populaire du Centre,* dated 18 October 1986, announced Lepage and his play: "a one-man show based on the doubling of the protagonist, on the visual and, above all, on sound effects." The journalist did not resist the temptation to compare him to René-Daniel Dubois, who represented Québec at the 1985 festival with *Bédouins.* Had not the Québec Theater Critic's Association just designated *Being at Home with Claude* as the best text created for the stage, whereas it considered *Vinci* the best production of the season (*La Presse,* 15 October 1986)?[3]

The other dailies expressed curiosity about this "reflection on art with the Quebecer Robert Lepage" (*L'Echo du Centre,* 18 October 1986) and invited the public to follow "Robert Lepage, the Québécois on the trail of *Vinci*" (*La Montagne,* 18 October 1986).

But it was J. Parneix who, evoking "a rare emotional shock," in *Le Populaire du Centre* on 21 October 1986, gave the most dithyrambic and substantial review by sending out this message: "The way in which he plays with words gives his production a force that is heavy with meaning . . . Behind humor hides despair. The despair of the artist who realizes how little space he has to maneuver in. Between accepting to commit himself to a society he despises and refusing to collaborate, there is but the narrowest space for individual liberty, a space so narrow it leaves one just enough room to suffocate." The article salutes as well his technical prowess: "The play of mirrors is constant among the luminous projections, the props, the music and sound. The entire production is regulated to the micron, to the nearly one-hundredth of a second, with the aid of computer science which makes its entrance into theater. A flashlight is enough to project grandiose images onto the background, a telescoping rod or a tape measure can evoke millions of things, a pitched tent creates the image of apocalyptic scenes . . . One comes away from all of that with a feeling of manifest simplicity. And

yet the scaffolding that one can make out behind the structure is incredibly complex."

In the general assessment of this still-young festival by Jacques Morlaud for the cultural column of the Parisian communist daily *L'Humanité* (31 October 1996), a special mention and a rather laudatory comment were reserved for the Lepage production: "the festival participants were sensitive to *Vinci*'s innovative formal aspect. . . . Even if the reflection on art might seem a bit superficial, this production surprises and incites dreams with its aesthetic beauty, its clever construction and its interpretation [an elegant and moving Robert Lepage]."

Vinci, which had had its European première in Limoges, was a master stroke. Avignon and Limoges were more than ready for the return of the young *québécois* producer.

1987: *From the* Coup de pouce *in Avignon to the Trial Run in Boulogne-Billancourt*

Vinci/Avignon/*Festival* OFF/Theater, La Condition des Soies
(July 1987)

"In the jungle of Avignon where he could easily have passed unnoticed, Robert Lepage triumphed by winning the "*Coup de pouce*" trophy which yesterday, in the City of Popes, was awarded to the best play of the 360 works presented at "OFF Avignon"; the festival parallel to, but not less prestigious than, the "grand happening français," trumpeted *Le Devoir* on 30 July 1987. On 2 August, Montreal's *La Presse* named the young producer "personality of the week" and explained: "The *Coup de pouce* trophy, as its name indicates, was instituted to promote a high quality play. That is why Robert Lepage won for the staging and scenic quality of *Vinci* a two week run at the Boulogne-Billancourt theater in Paris in December."

One could also find statements from Lepage in the article: "I admit that all of that is exhausting, but at the same time particularly stimulating. In the past, in Quebec, it was difficult to get out. . . . We succeeded, however, in finding a universal language and I believe that that could explain the success that we've achieved." In particular, he spoke about the differences in reaction of the French and *québécois* publics: "People

233

really feel that it's a *québécois* play because of its American style, also because of the accent, even if it's not an East Montreal accent. People also notice a new reading of European history. For them, history is heavy, *Vinci,* is still present, immense. For us it's a new way of looking, the freshness that one notices, and when the Mona Lisa bites into a Burger King, for us, history is full of surprises."

La Trilogie des dragons/Limoges/Fourth Francophone Festival (3–13 October 1987)

Did the capital of Limousin become that year—as writer Robert Lévesque stated in *Le Devoir* 29 September 1987—"the branch of Quebec theater in France," "the principal window on Quebec theater in France"? After Africa, honored in 1986, it was Quebec that was in the spotlight.[4] Naturally it came back to Lepage, whose *Vinci* "had elevated quasi-unanimous enthusiasm," to officially open the Fourth Francophone Festival[5] with his *La Trilogie des dragons*.[6] "The minister was front row center . . . on his right and left were all the personalities of the region. François Léotard, in fact, attended only the first part of the performance . . . So what!" "The Fourth Francophone Festival des Francophonies had officially begun," announced *La Montagne* on 5 October 1987 in the headline of its review. "*La Trilogie des dragons,* it is much more complicated in that it consists of symbols and correspondences. As in *Vinci*—but in a somewhat less sophisticated manner—Robert Lepage, with the help of his actors (the play is a collaborative effort) created strong images that moved one (however, by comparison, other less outlined scenes lost some of their interest). The last minutes of the second part are a must-see (a child traumatized by the war, it seems) in order to understand the meaning of emotion."

In *L'Echo du Centre* (6 October 1987), J. Morlaud concludes his critique with praise, this time without reservation: "A play whose force resides in aesthetic beauty, visual and gesticulatory force, the correspondence between dream and reality, judicious staging, a homogeneous rendition. *La Trilogie des dragons,* a trilingual production, distinguishes itself by the quality of its research, its modernity, its serious and sincere theme, anything but superficial content, theatrical form that opens the door to the imagination (by way of studied and

magnificent lighting), and a beautifully rendered interpretation. For more than one reason, we clearly preferred this play to *Vinci*. We can certainly justify that by the manner in which the subject of the play is treated, the refined staging, and the theatrical research invested by the entire team of the *Théâtre Repère*."

Vinci/Boulogne-Billancourt/the Boulogne Billancourt Theater (*TBB*) (3–13 December)

"A good springboard" is how Louis-Bernard Robitaille titled the long article (*Le Presse*, 8 December 1987) in which he details for *québécois* readers the advantages and disadvantages of this suburban Parisian theater, because Boulogne-Billancourt was not really Paris, and the *TBB* bore no resemblance to theaters in the city. "The Boulogne-Billancourt theater, if it now has a high quality program, well covered by the media, isn't creating a stir (like Mnouchkine at Vincennes or Chéreau at Nanterre)." But unlike private theaters (and without politics) the *TBB* has at least 3000 subscribers. And for them, *Vinci*, discovered at the Avignon festival, is a free performance. There are, therefore, apparently 300 subscribed spectators every night and dozens of paying spectators. This makes for "good" houses and a good number of spectators to further enhance the reputation of the play.

"On the critical side" (for the most part, politely disguised disappointment): "that may seem meager, but for an unknown in Paris, that's real success."

From Limoges to Avignon, from festival to festival, with *Vinci* and the Dragons, Lepage reached the outskirts of Paris. But the French capital was not yet ready to welcome this young unknown Quebecer: Lepage had to wait five years to make a triumphant appearance, with five performances in the program of the Parisian Autumn Festival, not, however, without having made another stop at Boulogne-Billancourt and having established himself at Maubeuge.

Consecration in Paris (1989–92)

Three years later, Robert Lepage passed through the gates of Paris and triumphantly settled—despite some dissent—in the Parisian theater scene for a dazzling autumn for which he had prepared in Maubeuge.

235

1989: Boulogne-Billancourt encore

La Trilogie des dragons/the TBB (20 April-12 May)

Liberation, in its Culture guide, announced the latest on the performance: "The set, where the Canadians of the *Théâtre Repère* unfold their smartly choreographed saga, is, on the surface, nothing but a common parking lot. But directed by producer Robert Lepage, the nine actors and co-authors of this imaginary voyage, dig and nearly unearth a fantastical Chinatown. In two versions—short (three hours) or long (six hours)—a trilingual soap opera (French, English, and Chinese) is woven throughout with unusual visual flashes." "Get there fast!" recommended *Les Nouvelles du Nord. . . .*[7]

This time in Quebec's *Le Soleil* (May 15), Jean St.-Hilaire was able to title his review with a splendid "Paris acclaims *La Trilogie des dragons!*"

Sophie Cherer (*7 à Paris*) found it at the same time a "happening with no dead time and without bombastic improvisations," in short, a "televised serial without vulgarity, without cliché, without a forgettable figure and, above all, without platitudes." In *Le Monde* (22 April), Odile Quirot subtitled her article "An armful of strong images and real sensations. One returns dazzled from the voyage to the land of *La Trilogie des dragons.*" "The performance is so rich, so dense that one does not know where to begin to describe the color, the flavor, and the intelligence" she declared, while applauding the comedians who "shift with remarkable freshness from naturalism to playful metaphor." Jean-Pierre Leonardini is, if possible, even more dithyrambic in *Humanité*: "This theatrical subject, which carries poetic and plastic expression to the highest point of stage art, constitutes without doubt the major attraction of a relatively poor Parisian season." In *Le Quotidien de Paris,* Valérie Dassonville found the comedians "absolutely remarkable" and concluded: "The Robert Lepage theater is an organic theater which privileges the intuitions and impressions of creators and the public. It's popular, accessible theater."

1992: Triumphant Autumn

Les Aiguilles et l'Opium/The International Theater Festival of Maubeuge/Manège Cultural Center[8]

Robert Lepage—"diva of Euro-American stages"—launched the European première of his play, *Les Aiguilles et l'Opium,* at Maubeuge. It was the most 'French' of his plays because it takes place in St. Germain des Près and evokes the Paris of the 1950s with the emblematic figures of Cocteau (reading his *Lettre aux Américains*), of Sartre, of Gréco[9] (singing Prévert's *Je suis comme je suis*), and of Jeanne Moreau crossing the screen of *Ascenseur pour l'échaufaud* (by Louis Malle) to the music of Miles Davis. This was riskier than anything else because this time Lepage used very contemporary cultural references that are quite present in the minds of French spectators. Reactions were very diverse.

Achmy Halley in *L'Humanité* (28 April) saw in it only a "general exercise," "a literal play with a rocking cinema screen, films of the period, and controlled special effects." He adds, unfortunately, save for the few beautiful emotional moments in the solitude of the room occupied by Sartre, in the hotel Louisiane, *rue de Seine*, and a few bursts of humor (contemporary historical anthology of Quebec in five lessons!) *Les Aiguilles et l'Opium* limits itself to conventional images and attention-attracting devices, which, in the end, are boring. By over-adorning feelings and by the abuse of dazzling effects, the play ends by suffocating all emotion.

"It's very beautiful," declared Olivier Schmitt in *Le Monde,* who nonetheless added: "Can we simply reproach Robert Lepage for an excess of egocentrism which makes him place himself too plainly on equal footing with the artists he admires? No doubt his talent is enormous, his imagination singular, but his play would benefit from a little more modesty."

On the other hand, Lucile Ghedira admits to being completely won over. "The dazzling technical production doesn't at all stifle the beauty of a text in which the poetry of Jean Cocteau mixes harmoniously with that of Robert Lepage. It's captivating." Applauding "the confirmation of his talent" she concludes: this "performance now deserves to triumph in Paris." Which is just what happened a few months later. And for *Télérama*[10] this "unidentifiable stage gem" became "a true poetic commotion, a quasi-surreal experience."

Autumn Festival in Paris (15 October–30 November)

From 15 October to 30 November, Robert Lepage was one of the invited guests at the Autumn Festival in Paris. He presented a veritable

cycle of five plays: three Shakespeare—*Macbeth, Coriolanus,* and *The Tempest*—and two of his own plays. "This time Paris could not ignore Lepage, who faced the French press and the public as he had never before been able to do."[11]

The Shakespeare trilogy/The Georges Pompidou Center (in October: Macbeth/15–17; Criolan/19–22; The Tempest/24–26)

Presented in the beginning of October at Maubeuge, where Lepage was invited as artist in residence, the three Shakespeares, "translated 'archaically' by Michel Garneau and staged by Robert Lepage in contemporary imaginative terms,"[12] were not discussed on the front page of Parisian newspapers. However, according to Gilles Costaz, in his excellent review article, "Robert Lepage in Paris,"[13] *Macbeth* was "a triumph! Standing room only, an extremely warm reception from the press."

"A ferocious beauty"—Colette Godart called it in *Le Monde* dated 16 October. "Robert Lepage invents nocturnal mirages, brings about visions of worlds disappeared, and erases them, transforms them without leaving time for them to be clarified. The spectator is dazzled, amazed. Robert Lepage is a magician." In *La Croix*, Phillipe du Vignal stated "With Macbeth, Lepage wins his bet: to try to find the proper breathing and rhythm, in short, a modulation of energy close to the English text." For Fabienne Pascaud (*Télérama* 25 November), Robert Lepage "cosmopolitan artist, half angel, half devil, creates a captivating and intoxicating atmosphere." "The production of *Macbeth* above all, marked by cartoon and kabuki styles, redrew, with a few shifts of lighting and a few shadows, an archaic world of primitive violence. Two or three objects, two or three pieces of wood are enough for Robert Lepage to suggest the inexpressible. He says that the poverty of the medium stimulates him; that the public today is too alienated by the grand effect of gadgets, that he must be given the freedom to dream."

But, Michel Dolbec pointed out in *Le Devoir* on 21 November—"The criticism of his three Shakespeares in its entirety was nowhere to be found. Public opinion was divided. At the première of *Macbeth*, several dozen people left the hall during the performance. This did not hinder those who did stay from calling for several encores from the comedians (with enthusiasm) at the end of the play. *Coriolanus* got an

even better reception, but it was without a doubt *The Tempest* . . . that will be the most successful."

Why, then, this surprising silence on the part of the critics? Gilles Costaz proposed an explanation: "Could Parisian criticism be particularly lazy? No, rather it's a matter of overload. In October, the Parisian halls offered between eighty and ninety new performances. Under these conditions, to go to three performances of the same producer, each of which is performed on three evenings only, verges on the impossible. This challenge was not met. In the French press, there was no critical treatment of the ensemble of the Lepage Shakespeares, if one accepts the declarations made by Lepage in his interviews, and a few allusions to his "three Shakespeares, presented the previous month to flabbergasted and enthusiastic audiences" (O. Schmitt, *Le Monde*, 21 November).

"The diversity of the Trilogy should have been discussed" regretted G. Costaz while successively recalling *Macbeth,* "a splendid vision of men before man, of humanity before the birth of the human"; *Coriolanus,* "a light performance, yes, but very bright, directed with diabolic skill and very well played"; and finally *The Tempest,* a "less successful" performance which perhaps, "at first shaky, . . . finished by finding its strength and beauty, unfolding a mystery, one of illusion, of theater and of familiar images, and yet, impenetrable, for our culture.[14]

Le Polygraphe/Théàtre du Rond Pont (19–29 November)

On the contrary, "There was a lot of hot debate over *Le Polygraphe.* Excitement and rejection appeared in the papers," according to G. Costaz.[15]

Frankly reticent, Pierre Marcabru, in the very conservative *Figaro* (23 November), analyzed this "visceral performance": "The story itself, a vague police investigation of a rape and murder in Quebec, presented like scrambled pieces of a puzzle, lacks strength, singularity, and meaning. What remains is the execution of style, the audacity, the tone, the irony, and the aggression that makes Robert Lepage an *auteur* and avant garde producer in Canada. Framed like a story told with photographs, the narrative borrows a lot from underground theater that Americans loved twenty years ago. Sex, sadism, masochism, brutal effects, underground violence, the will to disequilibrate as well as to condition the spectator. Sometimes it succeeds, sometimes it's almost

infantile, especially when they begin to speak." And his skeptical con-
clusion: "It's as carefully ruled as manuscript paper. So then what?"

More nuanced, Armelle Héliot, for the *Quotidien de Paris* (27
November), acknowledged: "A style, without any doubt. Soft interpre-
tations. But something is too caught up in a systematized aesthetics that
stifles meaning, that softens the exchanges. It was the exact same case
with *Coriolanus*: the overly forceful pursuit of effects pulverized the
complexity of the meaning. But *Le Polygraphe* is an interesting play and
Marie Brassard who wrote and performed it is someone who will not
be forgotten."

Frankly enthusiastic in *Le Monde* (21 November), Olivier Schmitt
devoted to this "strong and crazy play" a long article wherein he paid
homage to its multifaceted creator. "What could be more noble or
more fruitful for a man of theater, a man of art, than to live as he does
in step with his era? But that would not be worth anything if he did not
have a gift (unlike many of those involved in theater today) for bringing
to the stage the fruit of his research." Critics could not say enough
about the marvels of the mirrored *mise-en-scène*; it uses "reputed cine-
matographic techniques . . . never before seen on stage but from here
on evident," it questions theater genre by "multiplying the effects of
magic, as only the stage of a theater can." The concluding criticism of
this catalog of praise celebrates the plastic beauty created by Lepage:
"There's not a gesture, a movement that isn't carefully choreographed
. . . His nudes, sculpted by light, with nothing natural about them, are,
as is the whole play, a new, splendid and sulfurous page in the great
book of the arts."

More brief, but also enthusiastic, Caroline Alexander concluded
in *La Tribune Desfossés* (24 November): "It's new, it's cleansing, it
upsets the brain, it comes from Canada; it's called *Le Polygraphe* and
it's signed Robert Lepage, thirty years old. A revelation. Encountered
only every ten years. . . . A jolt."

Les Aiguilles et l'Opium / Centre Georges Pompidou (25–30 November)

This play had "less luck critically. Forced to choose, journalists had
preferred to see the performance of *Le Polygraphe* much earlier. In
addition, *Les Aiguilles et l'Opium* had already been seen in France, at
Maubeuge."[16]

In the "only critique that attempts to analyze the play by Robert Lepage," Jean-Pierre Thibaudat—enumerating the incongruous ingredients that constitute the plot of the play—stated in *Libération* (27 November): "All of this does not make a play; but assuredly Lepage is a man born for the stage. One who grew up with cinema, an art which is not only the constant metaphor of his plays but the roots." However, the critic expressed regret about "the weakness of the actors" already flagrant, according to him, in the version of *Coriolanus*: "Thus suspended in air, with the galaxy and the noise of propellers in the background, Lepage, a flying man, reads the beginning of the Cocteau text (while nicely imitating the somewhat drawling voice of the latter), it's a magic moment. But it's only a moment. Lepage is not a topnotch actor, the play is not a play, with the result that the whole enterprise moves in a belabored manner until, after a succession of scenes, it is exhausted, which is to say that it cancels out the range and variety of its themes. Representation turns to demonstration."

At the same time, however, "the public's reception," according to Gilles Costaz,[17] "was passionate, intense, and warm. It could be said that *Les Aiguilles et l'Opium* found a singularly receptive audience in Paris. Having also seen it in Maubeuge, we can say how different the atmosphere of the performance was in Paris. The play of reflections between this Quebecer talking about Paris, Cocteau, Miles Davis, Sartre, Gréco and himself, in a place supposed to be a Paris hotel room, was carried out in harmonious fashion, while the splendor of the technical effects didn't shatter the delicate emotion that was established and remained for a long while, a long while after the actor-poet had disappeared."

"Robert Lepage had Paris in the palm of his hand." Under this triumphant headline, the article in *Journal de Montreal*[18] developed with jubilation the Parisian consecration of the Quebecer:

> His success at the Autumn Festival in Paris . . . earned him recognition without precedent. He has been compared to the greatest, Peter Brook as well as Bob Wilson and Chéreau. Last Thursday night, at the *Le Cercle de minuit* show presented on *France 2*, they dared to compare him to Cocteau. Nothing less. . . . In Paris it's not the same, said Lepage, It's all or nothing. People don't open the door to you

because you're not hot. When you have toured the world two or three times, you're allowed to enter. Lepage is presented. They roll out the red carpet. They go all out. Contrary to London, which offers English theater, indeed exclusively British, Paris, is an international cross-roads. The selection there is more limited. But once you're there. . . .

However, not letting himself get carried away, Lepage wisely kept his distance: "To believe that France is the only natural market is false. That's the *québécois* mentality. On the contrary, you must go all over, look for other territories. The future of *québécois* theater is anywhere but France."

For his part, Gilles Costaz concluded his assessment of the season by claiming that the Quebecer had "finally become a regular face among amateur Parisian theaters": "He was adopted, given his rightful place (high on the scale) by the majority of spectators and observers, completely escaping the severity of which Paris has made a specialty. A shockwave was created, violently. Lepage has set off again, but now many people are asking "When is Lepage coming back?"[19]

On 21 June 1993, *Le Syndicat,* a professional journal of dramatic and musical criticism, proclaimed its annual honors list at the *Vieux-Colombier*: The cycle devoted to the Canadian Robert Lepage at the 21st Autumn Festival in Paris was awarded the title of best foreign play (*Le Quotidien de Paris,* 22 June).

The Grand Machines of Ex Machina (1994–1997)

Enthusiasm and Reticence

Lepage becomes a planetary writer with Ex Machina. And France—with Maubeuge and Créteil—shares in the co-production of these giant plays that Lepage presented thereafter in all corners of the world.

Les Sept branches de la rivière Ota[20]/La Maison des Arts de Créteil

This monumental play was presented on two occasions at La Maison des Arts de Créteil (co-producer of Lepage productions with The Autumn Festival) in two different versions.

1994/The Autumn Festival in Paris/18–26 November (second version—3:30 in length)

"New Lepage creation disturbs France": the 23 November edition of *Le Soleil* recounted that the welcome received in Paris—"went from purely dithyrambic to acidic criticism."

Known for his savage criticism, the critic from *Libération* (27 November) claimed to "not have the courage" to stay for the last part: "the absence of writing . . . ruins the ambition of the presentation which is reduced to a stream of images, of playlets, most certainly nicely done, but for what good? . . . Lepage is a good salesman, a good creator. But his images don't tell any more than this: look at how beautiful and clever I am, look at how well he can do that." And he concludes with perfidy: "It's an international 'visual show.' A product good for export."

Taking the opposite view, *Le Monde* affirmed that "nothing is ever conclusive" in this play, one "of the exceptional rendezvous of a theater that invents itself in front of and with those who welcome it, indispensable and invigorating theater."

On two occasions in *Télérama* Fabienne Pascaud deeply analyzed this "moving and mortally vivacious play . . . with its haunting visions, dazzling *mise-en-scène* and also, sometimes, irritatingly facile. Briefly, theater to share, that's ablaze." She concludes on a nuanced but generally positive note: "Robert Lepage attempts to reconcile us with ourselves. To tell us that horror can give birth to another form of art, barbarity, a new way to love . . . This discourse is not without ambiguity. But it is rich in contradictions, fortified by every sort of paradox. It's diabolically alive. And since he puts together images that are terrible and soft, rare and propagandist, tragic and burlesque, he creates strange voyages: to the heart of pain, to the heart of beauty."

"A marvel!" proclaimed Frédéric Ferney (*Le Figaro* November 22) with unbounded admiration: "Nothing is shown, everything is said. With taboo, with blind clarity, with that which cannot be a theme, with that which remains unrepresentable: the death camps, then Hiroshima, which he ties together with a golden thread, a woman's life, the hint of a storm, without comparing them, without mixing them, *québécois* Robert Lepage has created something that allies the fullness of catastrophe and the proximity of comedy, disaster and the love of life. This

243

incredible show, startling in its beauty and audacity, brings together the accents of an *Iliad* with the savor of *Déclin de l'empire américain.*" The critic goes on to detail his enchantment: "You're amazed. You're charmed, happy, dazzled, fascinated, and, nevertheless, you remain critical: right away Robert Lepage arouses in the spectator a state of awakening, which doesn't shut out the euphoria, allowing the reception of each image, each sound, each gesture, in its vacillating priority, in its lucid splendor, frightening, universal. The first part of the play is masterful, at the same time inspired and totally calculated. Eventually Robert Lepage leaves no stone unturned, he mixes genres (*bunraku*, sitcom, vaudeville, video), languages, and accents; but you feel regenerated, almost blessed, when suddenly a tropical rain beats on the world and patters on the roof of a pagoda, which will henceforth appear familiar."

1996/Autumn Festival in Paris/8–17 November (Four in their entirety and two in two parts)

"In close to seven hours non-stop, he offered a vision of our society today that was at the same time removed and visionary, realistic and wild. Love, sex, fear, horror, solitude, suffering and death. And laughter. And flamboyance," was the laconic summary of *Télérama* (n. 204, 13–19 November 1996). *Le Monde* on 12 November presented Lepage as "a Jack-of-all-trades," "a globe-trotter, always divided between the two cultures, Francophone and Anglophone, which nourished his childhood" and, recalled his "reputation for being a magical man of the theater, a master of trap doors, *trompe l'oeil,* and the creation of dazzling images of the imaginary." B. Salino analyzed the play at greater length. Recognizing that "the proposition is ambitious and salutary" and "calls for respect," she attacks it nonetheless: "*Les Sept branches de la rivière Ota* fails with respect to substance and form." If she admired the mastery with which cinema, marionettes, music, lighting, and special effects combine, she contested the results: "Everything is precise, clean, smooth in content. It releases a perfume of planetary ecumenism. . . . You travel around the world while remaining in place." Contesting certain "disarming allusions," and the "frankly painful" *naivéte,* the critic found that "the flesh that is cruelly lacking from this play" except in the two actors who personified Jana and Ada Weber. She concludes somewhat

paradoxically: "Robert Lepage excels in humorous scenes. His description of the New York underground in 1960, his old-fashioned staging of *La Dame de chez Maxim,* his 'soap-opera' treatment of household scenes between a Canadian diplomat and his wife, all of these moments are irresistibly funny—but we're a long way from Hiroshima at that point."

Elseneur 1996/Is Technology Crushing Man?

Elseneur, the solo play based on Shakespeare's *Hamlet* (the F.-V. Hugo translation) appeared in the 1996 season at Maubeuge, Créteil, and Avignon. It was not a great success. "If that's theater," one spectator confided to a radio journalist from France-Inter, "then I'm in shock."

Créteil/La Maison des Arts/Exit Festival (3–6 April 1996)

The Parisian productions received only a little press. The critic of *Le Monde* (April 3) was the only one, it seems, to write an article, with the ambiguous title, "The Shakespearean Follies of Robert Lepage." Olivier Schmitt "expected a lot, certainly too much," of Lepage, "who had been charming theater for fifteen years." He criticized less the special effects and "the incredible circular and mobile central mechanism, a great wooden panel open at the center by a door" than Lepage's interpretation. "His egotistical reading is a new opportunity for drama but it demands an irreproachable interpretation, which is not here." Because, the Lepage devotee added, his play "singularly lacks force." Five months later, Limoges was no more favorable to Lepage's version of *Hamlet.*

Limoges/Théâtre de l'Union/13th Annual International Francophone Festival in Limousin (26 September–6 October 1996)

"Unanimous praise at the Limoges première of *Elseneur,*" Jean St.-Hilaire[21] proudly announced in Quebec's October 4th edition of *Le Soleil* reporting the reaction of Silviu Purcarete, the new director of the Centre Dramatique Nationale de Limoges[22] ("A remarkable play! I don't have a single reservation about it") and of Monique Blin, director of the festival ("It's a success, it's very beautiful").

However, local critics turned up their noses and questioned the necessity of the play. In *Le Populaire de Centre* (5 October), under the

245

trendy headline *Super Lepage or Game over?* J. Parneix wondered "Is this still theater?", all the while admitting his pleasure as a spectator: "the creation of the Québécois is a true curiosity. With pleasure you let yourself be taken away by the imagination of the artist which multiplies itself on stage thanks to several video cameras concealed in the scenery, which changes voice with each reply (still with the help of technology) in order to identify all the characters that he interprets alone, which transforms the stage into a field of stars or into a cinema screen which appears and disappears by magic, all the while accompanied by background music that marries Elizabethan with techno." "But this pleasure," the critic regretfully recognized, owes "all to the magic of the image, whose televisual ravages we're familiar with, whose charm is interrupted only by the text and the 'tedious passages' which he imposes electronically . . . The last straw." He continues to argue his point in a rather conservative manner, although not without a certain aggressive pessimism: "Is it by removing what is substantial to the theater that we renew it? And in this case, must we admit that the future of theater is a sort of 'variety theater', closer to a Johnny Hallyday show at Bercy than a performance at the *Comédie Française*? That is the question, as Hamlet would say. Precisely. To be (itself) or not to be."

In *l'Echo du Centre,* J. Morlaud, who had devoted five columns on 25 September to "a portrait" of Robert Lepage as complete creative artist, "an artist who, closed up in his idea laboratory, completed a research project, almost in advance of our time," highlighted with acidity, on 4 October, the metamorphosis of a star in whom he no longer saw the newcomer of 1986–87: "Lepage, a theater professional, seems to glide into the vices of the star system. From the looks of it, he is no longer an artist in love with his work, who liked to put up for discussion the basic ideas of his work, were it only in the course of a meeting with the press, those journalists and photographers who contributed to the rise of his career." Personal disappointment alone explains the negative judgment that this early (or relatively early) partisan gave on a high-tech *Hamlet*: "What has *Elseneur* brought us? A demonstration that theater can do other things when it makes use of the most sophisticated technology at its disposition. But what will become of the actor? A being whose movement is limited by the service of machines that can break down at any moment. . . . In place of feelings, human warmth, is

an icy fluid that seizes the audience, more or less stunned by the strobo-scopic effects. Without at doubt innovative, but not without a price! In terms of price: this play, you can be sure, costs dearly."

Must we conclude by this reticence on the part of the Parisian critic that the amazement of 1992 was definitively forgotten? That Paris eas-ily and rapidly burns what it adored moments earlier? That the sceno-graphic inventions of Lepage are too modern, too American, for audiences and, above all, critics who are locked into a traditional and *dépassé* approach to theater? That the aesthetic and political intentions of the latest performances of this Quebecer appear to the French at the same time excessive and a little naïve?

Lepage's cinematic productions, which complemented his dra-matic creation served only to prove to the French spectators Lepage's sure talent for the imaginary and technological. Curiously, they hardly liked it.

Two Failures for Lepage the Filmmaker (1995–97)

If, in the theater, Lepage received mixed reviews depending on the play and the critic, Lepage, the film maker, received only very sub-dued attention from film enthusiasts; his two films were no great suc-cess on the French screens, neither in Paris nor in *province*.

1995 Le Confessionnal/*Cannes/May*

In the spring of 1995, while the Montreal and Quebec press were fever-ishly considering the presence of the first Lepage film, *Le Confessionnal*, in the official selection of the Cannes Film Festival, the *enfant terrible* was returning—under the unfamiliar rubric of cinema—to the foreground of French news: his film provided the opening of the *Quinzaine des réalisateurs*.[23] However, this Anglo-Franco-Canadian co-production was not greeted with the anticipated success. Louise Blanchard, who, in *Le Journal de Montreal* triumphantly announced the "first *coup de coeur*" at Cannes for *Le Confessionnal* (19 May), had to make a correction the next day: "The event did not exactly make headlines in Cannes."[24]

On 19 May, *Libération* ran the headline: "The *metteur en scène* of *Québécois* theater moves behind the camera for a schizo story," on a

page dedicated to the film[25]: "Robert Lepage did not escape the traps of theatricalness that he imposed on his characters, whose hieratic entrances are carefully calibrated at the expense, sometimes, of the credibility of their performance"; he "did not resist either, his fascination with the kind of editing that makes the film puzzling to read." *Le Monde* reported (20 May) some remarks of the producer,[26] before giving a rapid critique of the film (20): "The story, whose conclusion could have been anticipated by a mildly attentive spectator, is less important than the manner in which the cinematographer succeeds in organizing the chromatic or plastic rhymes and in dialoguing literally with the Hitchcock film."

More doubtful commentary is provided by *Cinéphage* (n. 21, July-August): "Why is it that the admiration caused by this masterful *coup d'essai* is not accomplished by the visceral response one might have expected? Without a doubt it's because the scenario concentrated more on the exercise of style than on the characters, and because of the terribly annoying absence of interaction between the protagonists and the movements of their own recollections . . . from which comes the feeling of being always inches away from a total emotional response (the final crescendo implies a high point that never comes) and that of experiencing something less than a major film." The critique in *Positif* (July-August) is completely negative: "The *mise-en-scène* of the making of the Hitchcock film is awkward and languid, while the present is entangled in melodrama attempting to pass itself off as tragedy. A falsely clever film which turns up empty."

Blois and Paris/October

Presented in the Vidéothèque de Paris (early June), *Le Confessional* opened the *Festival du cinéma québécois* in Blois in October. It was then released in French theaters. It received the usual attention from the press and provoked the same critical response. Despite a highly publicized launch of the film in fifteen or so Parisian theaters, *Le Confessional* had little appeal for the French.

248

May 1997 Le Polygraphe

Presented in the end of April in France and supported by a serious poster campaign, the second Lepage film was, nonetheless, a decided commercial and critical failure.[27]

In *Libération,* D. Péron was particularly ferocious: "Robert Lepage's *Le Polygraphe* is even worse than *Le Confessional,* the work of this frenetic Canadian scenographer who, at the very least, takes himself for Atom Egoyan and Bob Wilson. This time he presents us with a *fait divers* disguised as a pensum on truth, on lies, with *mise en abyme,* with varied parallels, incongruent effects (slow motion, fast motion, willy-nilly production). Unplug it!" J.M. Frodon of *Le Monde* scolded Lepage for using cinematic devices "with the singlemindedness of someone trying to prove that he knows the vocabulary of cinema," adding: "In spite of ordering disturbing, strange or ironic situations according to a brilliantly thought out structure, it seems that nothing happens on the screen." Finally, M. Frodon regrets that "a brilliant parable of power and freedom and of the uncertainty of truth on stage is transformed here into a fictional labyrinth and affected imagery." Even *Télérama,* one of the first all-out supporters of Lepage in France, regretted "that a head full of ideas weighed down this film with symbols (Berlin, city torn apart, paralleled with an autopsy . . .) and clues to follow; one gives up on following all of them." More sympathy appeared, however, in *Le Nouvel Observateur* where J. Artus evoked "Cocteau for the part on 'truth and lies'" and "Chaplin in the accelerated form of certain sequences" and in *Le Canard enchaîné,* which judged "the black line between truth and lies diabolical," and expressed appreciation for this "film that takes your breath away."

The status of Lepage the filmmaker is thus far from being established in France. Perhaps his third film will succeed in winning over his critics.

1998/La France acceuille *Le Géométrie des miracles*

Lepage came back to Paris for the Autumn Festival—more precisely to the *Maison des Arts de Créteil* for the Autumn Festival: from 20 to 29 November he presented his new production, *La Géométrie des miracles.*

The French had already heard about the new production by the Canadian *metteur-en-scène*: *Le Monde* on 5 May devoted an entire page to the 1998 edition of *Du Maurier World Stage*, Toronto's International Theater Festival. Two-thirds of the page was given over to O. Schmitt's article, "Toronto Quarrels over Robert Lepage's Ghostly Ballet." Unlike his Canadian colleagues, who demolished this "choral, musical, and choreographic work," the French critic appreciated its "real ambition" and its "total originality"[28]: "the plastic structures, enhanced by projections on the mobile velum in the back of the stage, are very moving." His conclusion is made up of three adjectives: "simply funny, magical, and gripping."

Will Parisian criticism side with that of Toronto, or will it share, on the contrary, the enthusiasm of O. Schmitt, a dedicated Lepage admirer? To be continued.

Notes

1. Text and citations translated by Betsy Evans, 1998.
2. Fabienne Pascaud, *Télérama*, 25 November 1992.
3. Lepage developed this comparison: "We have, it's true, a very tiny but dense starting point in common that we enlarge, that we unfold throughout the performance. But I draw my inspiration from techniques of the Théâtre Repère, such as the priority given to the sensibility or the intuition of the actor over the text. So I use computers, technology that allows me to create poetic, visual, musical and sonorous scenery. These are the new theater techniques that are replacing the masks, costumes and scenery of the past: it seems more interesting to me, for example, to evoke a cathedral with sound than with painted scenery."
4. Michel Garneau was invited to read his last play *Les Guerriers* and René-Daniel Dubois his *Being at home with Claude*. The CEAD ran these two lectures.
5. His six-hour version of *La Trilogie des dragons* won the grand prize of the Festival of the Americas at Montreal in 1986. The three-hour intermediary version was presented at Limoges, "We regret that at an event like that of Limoges, the public was unable to take delight in the complete six-hour version," lamented J. Morlaud in *L'Echo du Centre* (6 October 1987).
6. Noting the mixture of languages in *La Trilogie des dragons*, *La Montagne* ironically stated "The play is spoken in French (with an accent) and English (for a good part) with even a little Chinese. Without subtitles. Perhaps that's why this year they made *francophonie* plural."

250

7. The authors of the article further stated that "One would have to return to the golden age of Spain and to antique *chorégies* to find 'something' comparable that succeeds in being at the same time popular and very ambitious."

8. "The Manège theater provides the downtown area with a superb six-hundred seat house and is run by an extraordinary young man, Didier Fusillier . . . In the middle of a cultural desert, in 1987, he created a theater festival wide open to the world which in five years became the meeting place for well-known professionals seeking renewed dialogue with the public. We're speaking about *l'Avignon du nord*. There's really nothing to laugh about: it's true!" (O.S. *Le Monde*, April 1992).

9. Juliette Gréco, emblematic singer of the Existentialist cellars of St. Germain des Près, played a secondary role (*Aglaonice, chef des bacchantes*) in Cocteau's *Orphée*. Lepage took certain symbols from this cult film, such as the gloves worn by the *Princesse-mort*, incarnated by Maria Casarès.

10. 2 September 1992.

11. This Lepage series seemed to theater journalists to be a true event: "Before the debut of the performances, information about it was rather numerous in the press with all sorts of interviews in *Le Nouvel Observateur*, *Télérama*, *Libération*, and *Le Figaro* and on *France Culture*" (Gilles Costaz, "Robert Lepage in Paris," *Jeu*, n. 65 (4 December 1992): 160–64.

12. *Amateurs de l'insolite* urgently needs to be researched.

13. Ibid., 160.

14. Ibid., 161–62.

15. Ibid., 162.

16. Ibid., 163.

17. Ibid., 164.

18. Article by Franck Nuovo in *Le Journal de Montréal*, 5 December 1992.

19. Gilles Costaz, *Robert Lepage à Paris*, p. 164.

20. The title of this play—sometimes shortened to *Hiroshima*—echoes the obsessive reply of the heroine (played by Emmanuelle Riva) in *Hiroshima mon amour*, the film by Alain Resnais, for which Marguerite Duras had written the staging and dialogue: "The seven branches of the estuary of the Ota river delta empty and fill at the usual time, very precisely at the usual time with fresh water full of fish, gray or blue according to the time and season. People no longer look at the slow rise of the tide along the muddy banks of the seven branches of the delta-shaped estuary of the Ota River" (Marguerite Duras, *Hiroshima mon amour*, Paris: Gallimard [coll. Folio], 1997, p. 34).

It must be mentioned that the connecting role that the expression *"sept branches"* (unfortunately translated into English as "seven streams") which, beyond the geographic reality, suggests a menorah-with seven candles. The

French title thus juxtaposes, at least for the subconscious mind, two worlds of martyrs, one Japanese, because of the bomb, and one Jewish because of the concentration camps.

21. In the 28 September edition of *Le Soleil,* the *québécois* journalist recalled that this festival "has been a springboard of choice for dramatic artists and people involved in *québécois* stage." Works from Michel-Marc Bouchard, Michel Garneau, Daniel Danis, René-Daniel Dubois, Marie Laberge and Robert Lepage have all been presented there. He also mentioned the important role that *Le Théâtre Blanc,* in co-production with Belgian and Swiss theaters, has played in this festival season.

22. The local daily newspapers pointed out that the Minister of Culture had approached Robert Lepage "to take over the Centre dramatique national de Limoges after the eviction of the Téphany-Meyrand pair." An offer that was not pursued, as we know.

23. Founded in 1968, at the high point of the protests, *la quinzaine,* organized by the *Société des Réalisateurs de films,* still remains today a sort of clandestine organization, that the official Festival pretends to "ignore completely."

24. Evoking linguistic problems, the journalist reported this significant exchange: "To a French viewer who complains about not having completely understood the film because of the *québécois* accent and its idiomatic expressions, Robert Lepage replied that it was out of the question to omit *québécois* culture in order to give the film a better chance, and too bad if the French choose to see it with subtitles!" "Language can be an obstacle to comprehension," he admitted, "but there is danger in making too many compromises. We are part of a colonized society and we are trying to rid ourselves of that attitude."

25. Interview obtained by A. Boulay, a critic of E. Lebovici.

26. "The French—and I include myself somewhat in that group—like to tell more metaphoric, more poetic, and less logical stories. The English are more attracted to characters that perform logically, with greater rigor in the construction; from the beginning, through the middle, to the end. The definitive aspect of a film horrifies me!

27. "In Paris *Le Polygraphe,* shown in a single hall, will have a hard time getting more than the six-hundred spectators who attended during the first week. In province, the numbers are *catastrophic*" (*La Presse,* 6 May 1997).

28. "The amateurs of modernist sensations will be out of luck. *La Géométrie des miracles* is above all an 'old-fashioned' play accompanied by almost rudimentary visual effects in comparison with previous stage experiences."

252

Appendix

Lepage in France

DATE	CITY	PLACE	PERFORMANCE	COMMENTS
1986				
October	Limoges	3rd Francophone Festival	*Vinci*	European première
1987				
July	Avignon	*Festival OFF*	*Vinci*	*Coup de Pouce*
October	Limoges	4th Francophone Festival	*Trilogie des dragons*	
December	Boulogne-Billancourt	TBB	*Vinci*	
1989				
	Boulogne-Billancourt	TBB	*Trilogie des dragons*	
1990				
6-7 July	Maubeuge	CC du Manege	*Le Polygraphe*	*Chevalier de l'ordre des Arts et lettres*
1992				
April	Maubeuge	CC du Manege	*Les Aiguilles et l'Opium*	European première
October	Maubeuge	CC du Manege	Shakespeare Trilogy	artist in residence
October	Paris	21st Autumn Festival	Shakespeare Trilogy	Pompidou Center
November	Paris	21st Autumn Festival	*Le Polygraphe*	*Théâtre du rond-pont*
November	Paris	21st Autumn Festival	*Les Aiguilles et l'Opium*	Pompidou Center
1993				
June				Best foreign film prize
1994				
	Créteil	23rd Autumn Festival	*Les sept branches de la rivière Ota*	*Maison des arts*
May	Cannes	*Quinzaine des realisateurs*	*Le Confessional*	film
October (4–8)	Blois	Festival of *Québécois* Film	*Le Confessional*	
(11)	Paris		*Le Confessional*	

1996

April	Créteil	*Festival Exit*	*Elseneur*	*Maison des arts*
October	Limoges	13th Francophone Festival	*Elseneur*	
9-17 November	Créteil		*Les sept branches de la rivière Ota*	*Maison des arts*

1997

May	Paris		*Le Polygraphe*	film

1998

20-29 November	Créteil		*La Géométrie des miracles*	*Maison des arts*

Works Cited

Adorno, Theodor. *Philosophy of Modern Music*. London: Sheed and Ward, 1973.

Appadurai, Arjun. "Disjuncture and Difference in the Global Cultural Economy." *Public Culture* 2, no. 2 (1990): 1–24.

Arcand, Denys, dir. *Jesus of Montreal*. With Robert Lepage. Quebec, 1989.

Aristotle. *Poetics*. Trans. Preston Epps. Chapel Hill: University of North Carolina Press, 1942.

Armitstead, Claire. *Financial Times*, 7 December 1990. In *London Theatre Record* 10 (3–21 December 1990): 1649.

Artaud, Antonin. *The Theater and its Double*. New York: Grove Press, 1958.

Barnes, Clive. "Hamlet of your Nightmares." Review of *Elsinore*. *New York Post* (9 Oct. 1997): 63.

Barthes, Roland. *Fragments d'un discours amoureux*. Paris: Seuil, 1977.

Bassett, Kate. *The Times*, 25 October 1994. In *London Theatre Record* 14 (8–21 October 1994): 1283.

Bayley, Clare. "Edinburgh Festival Day 12" *The Independent* (London) 27 August 1993.

Bazin, André. "Hitchcock versus Hitchcock." In *Focus on Hitchcock*, edited by Albert J. LaValley. Englewood Cliffs: Prentice Hall: 60-69, 1972.

Beecher, Donald, and Massimo Ciavolella. "Introduction." In Bernini, Gian Lorenzo, *The Impresario*. Ottawa: Dovehouse Editions: 5–28, 1985.

Bell, Celina. "Hit Play Plans to Keep Moving." *Montreal Daily News,* 7 June 1988, 23.

Belzil, Patricia. "L'Instant et l'éternité." *Jeu* 66 (1993): 141–44.

Bemrose, J. M. "A Sorceror of the Stage." *MacLean's,* 23 May 1998, 53.

Bennett, J. G. *Gurdjieff: Making a New World.* New York: Harper and Row, 1973, 8–9.

Bhabha, Homi K. *Nation and Narration.* London/New York: Routledge, 1990.

Billington, Michael. *Guardian,* 24 September 1996. In *London Theatre Record* 16 (9–22 September 1996): 1195–96.

Billington, Michael. *Guardian,* 6 December 1990. In *London Théâtre Record* 10 (3–31 December 1990): 1649–50.

Billington, Michael. Review of *The Dragons' Trilogy* (Théâtre Repère) at Riverside, London. *Guardian,* 12 November 1991. Reprinted in *Theatre Record* 11, no. 23 (1991): 1412–13.

Birringer, Johannes. *Theatre, Theory, Postmodernism.* Bloomington: Indiana University Press, 1993.

Bloomer, Jennifer. *Architecture and Text: The (S)crypts of Joyce and Piranesi.* New Haven and London: Yale University Press, 1993.

Bovet, Jeanne. "Une Impression de Décalage: Le Plurilinguisme dans la Production du Théâtre Repère." Master's thesis. Quebec: Université Laval, 1991.

Branigan, Edward. *Narrative Comprehension and Film.* London: Routledge, 1992.

Brassard, Marie, and Robert Lepage. *Polygraph.* Trans. Gyllian Raby. In *CTR Anthology,* edited by Alan Filewood. Toronto: University of Toronto Press, 1993.

Brynix. Christophe. *Cinopsis,* http://cinopsis.be

Buell, Frederick. *National Culture and the New Global System.* Baltimore and London: The Johns Hopkins University Press, 1994.

Butler, Robert. *Independent* on Sunday, 29 September 1996. In *London Theatre Record* 16 (9–22 September 1996): 1195.

Camerlain, Lorraine. "O.K., on change!" *Cahiers de théâtre Jeu* 45, no. 1 (1987): 83–97.

Cameron, Alasdair. "*Tectonic Plates.*" *The Times,* 28 November 1990. In *London Theatre Record* 10 (3–31 December 1990): 1648.

Charest, Rémy. *Robert Lepage: Connecting Flights*. Trans. Wanda Romer Taylor. London: Methuen, 1997.

Charest, Rémy. *Robert Lepage: Quelques zones de liberté*. Québec: L'Instant même/Ex machina, 1995.

Clarke, Jocelyn. "The théâtre is dead: Long live the théâtre." Review of *Elsinore. Sunday Tribune Magazine* (Dublin) (26 Oct 1997): 35.

Costaz, Gilles. "Robert Lepage à Paris." *Jeu* 65 (4 December 1992): 160–64.

Côté, Lorraine. "Points de repère." *Cahiers de théâtre jeu* 40, no.4 (1987): 180.

Coveney, Michael. *Observer*, 13 October 1994. In *London Theatre Record* 14 (8–21 October 1994): 1283.

Coveney, Michael. *Observer*, 9 December 1990. In *London Theatre Record* 10 (3–31 December 1990): 1649.

Coveney, Michael. Review of *The Dragons' Trilogy* (Théâtre Repère) at Riverside, London. *Observer*, 17 November 1991. Reprinted in *Theatre Record* 11, no. 23 (1991): 1412.

Curtis, Nick. Review of *The Dragons' Trilogy* (Théâtre Repère) at Riverside, London. *Time Out*, 13 November 1991. Reprinted in *Theatre Record* 11, no. 23 (1991): 1411.

de Jongh, Nicholas. Review of *The Seven Streams of the River Ota* (Ex Machina) at Lyttelton, London. *Evening Standard*, 23 September 1996. Reprinted in *Theatre Record* 16, no. 19 (1996): 1193.

Deleuze, Gilles, and Félix Guattari. *Rhizome*. Paris: Minuit, 1976.

Deleuze, Gilles. *Cinema 2, the Time-image*. Trans. Hugh Tomlinson and Robert Galeta. Minneapolis: University of Minnesota Press, 1989.

Denis, Jean-Luc. "Questions sur une démarche." *Cahiers de théâtre jeu* 45, no. 4 (1987): 159–63.

Dort, Bernard. "The Liberated Performance." *Modern Drama* 25, no. 1 (March 1982): 66.

Ducharme, André. "The World at His Feet." *Enroute Magazine* (March 1998): 45–51.

Durgnat, Raymond. *The Strange Case of Alfred Hitchcock*. Cambridge: MIT Press, 1974.

Dvorak, Marta. "Représentations récentes des *Sept branches de la rivière Ota* et d'*Elseneur de Robert Lepage*," in *Nouveaux Regards sur le théâtre québécois*, edited by Betty Bednarski and Irène Oorc. Montréal: XYZ, 1997.

Edwardes, Jane. *"The Seven Streams of the River Ota."* *Time Out* 2 November 1994. In *London Theatre Record* 14 (22 October - 4 November 1994): 1371.

"Élnek, élnek, itten élnek." *Bluebeard's Castle.* London: Decca Sound Brochure.

"Ett drömspel." Program notes of Kunglig Dramatiska Teatern (1994), 2.

Feldman, Susan. "When Cultures Collide." *Theatrum* (24 June/July/August 1991): 9–13.

Felman, Shoshana. "Education and Crisis: Or the Vicissitudes of Teaching." In *Testimony: Crises of Witnessing in Literature, Psychoanalysis, and History,* edited by Felman and Dori Laub, M.D. New York and London: Routledge, 1992. 1–56.

Féral, Josette. "Performance and Media: The Use of Image." *Canadian Literature* 118 (Autumn 1988): 83–95.

Féral, Josette. *Rencontres avec Ariane Mnouchkine: Dresser un monument à l'éphémère.* Montréal: XYZ éditeur, 1995.

Féral, Josette. "Pour une Autre Pédagogie du Théâtre: Entretien avec Alain Knapp." *Jeu* 63 (1992): 55–64.

Findlay, Bill. "Tremblay in Scots." In *Culture in Transit. Translating the Literature of Quebec,* edited by S. Simon. Montréal: Véhicule Press, 1995.

Fontanille, Jacques, and Claude Zilberberg. "Valence/Valeur." *Nouveaux Actes sémiotiques* 46–47 (1996): 13–69.

Fraser, Matthew. *Globe and Mail,* 1 March 1985.

Fréchette, Carole. "'L'arte è un Veicolo' Entretien avec Robert Lepage." *Jeu* 42 (1987): 109–26.

Fricker, Karen. "Apocalypse Now." *Guardian,* 18 September 1996, G2, 12.

Frieze, James. "Channelling Rubble: *Seven Streams of the River Ota* and *After Sorrow.*" *Journal of Dramatic Theory and Criticism* 12, no. 1 (1997): 133–42.

Frow, John. "Tourism and the Semiotics of Nostalgia." *October* 57 (1991): 123–51.

Fusco, Coco. *English is Broken Here: Notes on Cultural Fusion in the Americas.* New York: The New Press, 1995.

Gabriel, Peter. *Secret World Live* (video). Los Angeles: Geffen Home Videos, 1994.

Gallivan, Joseph. "Oh, and the Songs Were Good, too." *The Independent* (London), 3 June 1997.

Garber, Margery. "The Occidental Tourist: *M. Butterfly* and The Scandal of Transvestism." In *Nationalisms and Sexualities*, edited by Andrew Parker, et al. New York and London: Routledge, 1992.

Gardner, Lyn. "Tournez Lepage." *Guardian*, 14–15 August 1993. Weekend section, 32.

Garner, Stanton B. Jr. *Bodied Spaces: Phenomenology and Performance in Contemporary Drama*. Ithaca and London: Cornell University Press, 1993.

Geis, Deborah R. *Postmodern Theatric[k]s*. Ann Arbor: University of Michigan Press, 1993.

Gignac, Marie. Telephone interview with Micheal Hood (13 Jan. 1998).

Gignace, Marie. *Jeu,* n.d.

Gilbert, Helen, and Joanne Tompkins. *Post-Colonial Drama: Theory, Practice, Politics*. London and New York: Routledge, 1996.

Godfrey, Stephen. "Beds, Bells, and the NAC." *The Globe and Mail,* 4 November 1989. From the National Arts Centre's press clippings on *Tectonic Plates*.

Gravel, Claude. "Robert Lepage." *Forces* 100 (1993): 148–49.

Green, André. *Narcissisme de vie narcissisme de mort*. Paris: Minuit, 1983.

Greimas, Algirdas Julien, and Jacques Fontantille. *The Semiotics of Passions: From States of Affairs to States of Feelings*. Trans. Paul Perron and Frank Collins. Minneapolis and London: University of Minnesota Press, 1993 [translation of: *Sémiotique des passions: des états de choses aux états d'âme*. Paris: Seuil, 1991].

Greimas, Algirdas Julien, and Joseph Courtès. *Sémiotique: dictionnaire raisonné de la théorie du langage*. Paris: Hachette, 1993 [the first volume of the original edition appeared in 1979 and the second in 1986; both were published by Hachette].

Greimas, Algirdas Julien. *De L'Imperfection*. Périgueux: Pierre Fanlac, 1987.

Greimas, Algirdas Julien. *Du Sens II*. Paris: Seuil, 1983.

Groos, Arthur. "Lieutenant F.B. Pinkerton: Problems in the Genesis and Performance of *Madama Butterfly*." In *The Puccini*

Companion, edited by W. Weaver and S. Puccini, New York and London: W.W. Norton & Co., 1994.

Halprin, Lawrence. *The RSVP Cycles: Creative Processes in the Human Environment*. New York: George Braziller, 1969.

Hannerz, Ulf. *Transnational Connections: Culture, People, Places*. London and New York: Routledge, 1996.

Hansson, Hans Ingvar. *Svenska Dagbladet* (14 Nov 1994).

Harasyn, Sarah, ed. *The Post-Colonial Critic: Interviews, Strategies, Dialogs*. New York: Routledge, 1990.

Harrington, Richard. "The Secret Tour." *Washington Post*, 20 June 1993.

Harvie, Jennifer, and Erin Hurley. "States of Play: Transnationalism and Performance." Paper presented to the Association for Canadian Théâtre Research. Memorial University, St. John's, Newfoundland, May 1997.

Hénault, Anne. "Formes sémiotiques." In *Le pouvoir comme passion*. Paris: PUF, 1994.

Hodgdon, Barbara. "Splish Splash and The Other: Lepage's Intercultural Dream Machine." *Essays in Theatre/Etudes théâtrales,* vol. 12, no. 1, Nov. 1993.

Homel, David, and Sherry Simon. *Mapping Literature*. Montréal: Véhicule Press, 1988.

Hoyle, Martin. Rev. of *The Dragon's Trilogy* (Théâtre Repère) at ICA, London. *Financial Times,* 30 July 1987. Reprinted in *London Theatre Record* 7, no. 16 (1987): LIFT Supplement, 25.

Huffman, Shawn. "Mettre la scène en cage: *Provincetown Playhouse* et *Le Syndrome de Cézanne*." *Recherches théâtrales au Canada/Théâtre Research in Canada* 17, no. 1 (1996): 3–23.

Hunt, Nigel. "The Global Voyage of Robert Lepage." *The Drama Review* 33, no. 2 (summer 1989): 104–18.

Hutcheon, Linda, and Michael Hutcheon. *Opera: Desire, Disease, Death*. Lincoln and London: University of Nebraska Press, 1996.

Isaksson, Curt. *Pressen på teater: Teaterkritik i Stockholms dagspress 1890–1941*. Stockholm: STUTS, Theatron-serien, 1987.

Janaczewska, Noella. *The History of Water/Huyen Thoai Mot Giong Nuoc. Théâtre Forum* 5, (1994).

Johnson, Brian J. "A Festival Zeros in on Quebec: Robert Lepage Re-examines the October Crisis in His New Feature." *Maclean's* (7 September 1998): 52–53.

Jones, Amelia. *Body Art/Performing the Subject.* Minneapolis: University of Minnesota Press, 1998.

Johansson, Ola. "Completeness Passing By—Three Guest Appearances in Stockholm 1994-95." *Teaterdringer* 75 (1995).

Jubinville, Yves. "Un Théâtre du vide et du plein." *Spirale* 98 (1990): 7.

Kager, Reinhard. "Grauen im Spiegel der Schönheit." *Opern Welt* 8, no. 54 (August 1996).

King, Francis. Review of *The Dragon's Trilogy* (Théâtre Repère) at ICA, London. *Sunday Telegraph* 2 August 1987. Reprinted in *London Theatre Record* 7, no. 16 (1987): LIFT Supplement, 24–25.

Kirkland, Bruce. *Toronto Sun,* http://www.canoe.ca/TheatreReviews/home.html

Koustas, Jane. "From Homespun to Awesome: Translated Quebec Theater in Toronto." Donohoe, Joseph and Jonathan Weiss (eds). *Essays on Modern Quebec Theater.* East Lansing: Michigan State University Press, 1995, 81–109.

Lafontaine, Jean de. *Fables.* Critical edition by Jean-Pierre Collinet. Paris: Gallimard, 1974.

Lahr, John. "Astonishments and Prat Falls." *New Yorker* (28 Dec 1992): 190–92.

Lampe-Wilson, David. "Something rotten on the stage of Elsinore." Review of *Elsinore*, by Robert Lepage. *The Hour* (Norwalk, Connecticut), 18 Sept 1997, sec. C, p.7.

Laponce, Jean A. *Langue et territoire.* Québec, PUL [Travaux du Centre international de recherche sur le bilinguisme, A-19], 1984.

Larrue, Jean-Marc. *Le Théâtre yiddish à Montréal.* Montréal: Editions Jeu, 1996.

Lavoie, Pierre, and Lorraine Camerlain. "Points de repère entretiens avec les créateurs." *Jeu* 45, no. 4 (1987): 177–208.

Lefebvre, Paul. "Coïncidences et l'intuition: Entretien avec Robert Lepage." *Cahiers de la NCT* 6 (Jan 1993) 17–19.

Lepage, Robert, and Ex Machina. *The Seven Streams of the River Ota.* London: Methuen, 1996.

Lepage, Robert. "Collaboration, Translation, Interpretation."
Interviewed by Christie Carson. *New Theatre Quarterly* 33 (IX.3,
1993): 31–36.

Lepage, Robert. "Lepage's struggle to stay free." Interview by Richard
Ouzounian. *The Globe and Mail,* 12 Aug 1997, sec. A, pp.13-14.

Lepage, Robert. In rehearsal at La Caserne Dalhousie, 13 March 1998.

Lepage, Robert. Interview with Michael Hood. 15 February 1995.
Quebec City, Quebec.

Lepage, Robert. Interview with James Bunzli. 3 June 1994. Chicago,
IL.

Lepage, Robert. Interview. *In Contact with the Gods: Directors Talk
Directing,* edited by Maria M. Delgado and Paul Heritage.
Manchester, N.Y.: Manchester University Press, 1996: 140–41.

Lepage, Robert. *Jesus of Montreal.* Film.

Lepage, Robert. *Needles and Opium.* Unpublished ms.

Lepage, Robert. Telephone interview with author, 17 July 1997.

Lepage, Robert. *La Trilogie des Dragons.* Unpublished ms.

Lepage, Robert. *Vinci.* Unpublished ms.

Lévesque, Robert, "Robert Lepage." *Les Entretiens du Devoir:
1990–94, Arts et Littérature.* Sainte Foy: Les Presses de
l'Université du Québec, 1995, 65–75.

Lévesque, Solange. "Harmonie et contrepoint." *Jeu* 42 (1987):
100–108.

MacDougall, Jill. *Performing Identities on the Stages of Quebec.* Ph.D.
diss., Department of Performance Studies. New York: New York
University, 1993.

Manguel, Alberto. "Theatre of the Miraculous." *Saturday Night* 104
(Jan 1988): 32–42.

Marranca, B. and Gautam Dasgupta. *Interculturalism and
Performance.* New York: PAJ Publications, 1991.

Mathews, Shirley. "High-tech *Elsinore* is more like cinema than the-
ater." Review of *Elsinore* by Robert Lepage. *Connecticut Post*
(Bridgeport, Connecticut), 19 September 1997, F4.

McAlpine, Alison. "Robert Lepage in Conversation with Alison
McAlpine, at *Le Café du Monde,* Quebec City, 17 February,
1995,"In *In Contact with the Gods: Directors Talk Theater,*
edited by Maria Delgado and Paul Heritage. New York:
Manchester Press, 1996, 130–57.

Macdougall, Jill. *Performing Identities on the Stages of Quebec.* Ph.D. diss. Department of Performance Studies, New York University, 1993.

Mettler, Peter, dir. *Les Plaques tectoniques/Tectonic Plates.* Adaptation of the play by Robert Lepage and Théâtre Repère. Videocassette. Rhombus Media (Toronto), 1992.

Milles, Ulrika. *Expressen* (13 Nov 1994).

Monelle, Raymond, and Paul Taylor. "Edinburgh: The Best of Two Minds" *The Independent* (London), 31 August 1993.

Morlaud, J. Morlaud. *L'Echo du Centre* (6 October 1987).

Morley, David, and Kevin Robins. *Spaces of Identity: Global Media, Electronic Landscapes and Cultural Boundaries.* London and New York: Routledge, 1995.

Namaste, Ki. "L'Idéologème de genre et l'énonciation transexuelle." *Protée* 22, no. 1 (1994): 81–88.

Nero, Bianca Nero. "Sounding out Robert Lepage; Stage Director, Actor, Writer." *The Financial Post* (London), 29 October 1994.

Nuovo, Franck. *Le Journal de Montréal,* 5 December 1992.

O.S. *Le Monde,* April 1992.

Pascaud, Fabienne. *Télérama* (25 November 1992).

Pavis, Patrice, ed. *The Intercultural Performance Reader.* London and New York: Routledge, 1996.

Pavis, Patrice. *Dictionnaire du théâtre.* Paris: Éditions sociales, 1980.

Pavis, Patrice. *Dictionnaire du théâtre.* [New edition]. Paris: Dunod, 1996.

Pavis, Patrice. *Le Théâtre au croisement des cultures.* Paris: José Corti, 1990.

Pavlovic, Diane. "Du Décalage à l'envol." *Jeu* 42 (1987): 86–99.

Pavlovic, Diane. "*La Trilogie des dragons* reconstruction de *la trilogie.*" *Jeu* 45, no. 4 (1987): 37–82.

Pavlovic, Diane. "Le Sable et les étoiles." *Cahiers de théâtre jeu* 45 (1987): 121–40.

Pavlovic, Diane. "Reconstitution de *la Trilogie.*" *Cahiers de théâtre jeu* 45 (1987): 40–82.

Perelli-Contos, Irène. "Le Jeu de vaincre." *Québec français* 69 (March 1988): 66–67.

Peters, John. "Reflecting our Split Lives." *The Sunday Times,* 2 December 1990.

Pleasants-Faulkner, Isolde. Promptbook for *Bluebeard/Erwartung.*
C.O.C., 1993.

Quill, Greg. "Fragmenting Civilization Too Heavy for One Sitting."
Toronto Star, 6 June 1988, C8.

Ratcliffe, Michael. "The Magical Sandpit." *Observer,* 2 August 1987.
In *London Theatre Record* 7 (30 July–12 August 1987; LIFT
Supplement): 24.

Rewa, Natalie. "Clichés of Ethnicity Subverted: Robert Lepage's *La
Trilogie des dragons." Theatre History in Canada/Histoire du
théâtre au Canada* 11, no. 2 (fall 1990): 148–61.

Ricoeur, Paul. *Time and Narration.* Vol. 3. Trans. Kathleen Blarney
and David Pellauer. Chicago: University of Chicago Press, 1988.

Rouesnel, Franck. *La Mise en scène de la transculturalité chez Robert
Lepage,* Mémoire de maîtrise. Rennes: Université de Haute
Bretagne, 1993.

Roy, Irène. *Le Théâtre repère: du ludique au poétique dans le théâtre
de recherche.* Québec: Nuit Blanche Éditeur, 1993.

Rushdie, Salman. *Imaginary Homelands: Essays and Criticism
1981–1991.* London: Granta Books and Penguin Books, 1991.

Said, Edward W. *Orientalism.* London: Routledge and Kegan Paul,
1978. Reprint, London: Penguin, 1991.

St. Michael, Mick. *Peter Gabriel in His Own Words.* London:
Omnibus, 1994.

St-Hilaire, Jean. "Le Plaques Tectoniques à Implanthéâtre: Quatre toute
petites heures de transports poétiques." *Le Soleil,* 23 Nov 1989.
From the National Arts Centre's press clippings on *Tectonic Plates.*

Salter, Denis. "A State of Becoming." *Books in Canada* 20, no. 2
(March 1991).

Salter, Denis. "An Interview with Robert Lepage and Le Théâtre
Repère." *Theater* 24, no. 3 (1993).

Salter, Denis. "Between Wor(l)ds: Lepage's *Shakespeare Cycle.*"
Theater 24, no. 3 (1993): 61–70.

Sauter, Willmar. "Theatre Talks, or How to Find Out What the
Spectator Thinks." *Nordic Theatre Studies* 2/3 (1989).

Schmitt, Olivier. "Robert Lepage inaugure à Québec son centre de
création multimedia." *Le Monde,* 7 June 1997, 26.

Schwartz, Lillian. "Leonardo's Mona Lisa." *Art & Antiques* (Jan
1987): 50–54.

Shakespeare, William. *Macbeth*. Directed by Robert Lepage. Toronto: Hart House (Graduate Centre for Study of Drama, University of Toronto), 1992.

Shakespeare, William. "Hamlet," *The Complete Works*. General Editors: Stanley Wells and Gary Taylor. Oxford: Clarendon Press: 653–90, 1988.

Shuttleworth, Ian. *Financial Times*, 24 September 1996. In *London Theatre Record* 16 (9–22 September 1996): 1195.

Simon, Sherry. *Le Trafic des langues*. Montreal: Boréal, 1994.

Spencer, Charles. *Daily Telegraph*, 10 December 1990. In *London Theatre Record* 10 (3–32 December 1990): 1648–49.

Spencer, Charles. *Daily Telegraph*, 23 September 1996. In *London Theatre Record* 16 (9–22 September 1996): 1192.

Steegmuller, Francis. *Cocteau: A Biography*. Boston: Nonpareil, 1986.

Taylor, Paul. *Independent*, 23 September 1996. In *London Theatre Record* 16 (9–22 September 1996): 1193.

Teatertidningen 75 (1995), 11–12.

Thorell, Katarina. "En alkemisk dröm: Alkemisk analys av Robert Lepages uppsättning av Ett Drömspel på Dramaten 1994–95." Master's thesis in Theatre Studies. Stockholm: Stockholm University, 1996.

Treat, John Whittier. ". . . Hiroshima's America." In "America's Hiroshima, Hiroshima's America," edited by Peter Schwenger and Treat, *boundary 2* 21, no. 1 (1994): 233–53.

Ubersfeld, Anne. "Pédagogie du fait théâtral." In *Théâtre, modes d'approche*, edited by André Helbo et al. Bruxelles: Labor/Méridiens Klincksieck, 1987.

Ubersfeld, Anne. *Les Termes clés de l'analyse du théâtre*. Col. "Memo." Paris: Seuil, 1996.

Ubersfeld, Anne. *Lire le théâtre*. Paris: Messidor/Éditions sociales, 1982.

Vaïs, Michel. "Entre le Jouet de pacotille et la voûte céleste: le voyage des personnages à travers les objects." *Cahiers de théâtre jeu* 45 (1987): 98–110.

Villeneuve, Rodrique. "Les Îles incertaines: l'objet de la sémiotique théâtrale." *Protée* 17, no. 1 (1989): 23–38.

Vinci tour program. Montreal: Théâtre Quat'Sous, 1987.

Wahlen, Claes. *Aftonbladet* (13 Nov 1994).

Wallace, Robert. *Producing Marginality: Theatre Criticism in Canada.* Saskatoon: Fifth House Publishers, 1990.

Wardle, Irving. "Chopin, Geology and Not Too Much to Connect Them." *The Times,* 18 July 1988) From the National Arts Centre's press clippings on *Tectonic Plates.*

Winsor, Christopher. "Robert Lepage: Beyond the Spotlight." *Shift* (Summer 1994).

Wollen, Peter. *Readings and Writings.* London: Verso Editions, 1982.

Worthen, W. B. "Shakespeare and Postmodern Production: An Introduction." *Theatre Survey* 39 (May 1989) 1–5.

"Was soll ich hier allein tun? In diesem endlosen Leben . . . In diesem Traum ohne Grenzen und Farben . . ." *Erwartung.* Vienna: Universal Edition, 1996.

Biographical Notes on Contributors

JEANNE BOVET is instructor of French and Québécois Literature at Laval University, Quebec. She has collaborated for several years on *Etudes Littéraires* (Laval University) and is presently working on "The Poetics of Voice in 17th-Century French Theater."

JAMES BUNZLI is Assistant Professor of Theater and Interpretation at Central Michigan University. He was awarded a Canadian Government Grant to complete his doctoral dissertation on Robert Lepage and has since published several articles on the Lepage one-man shows in *Annuaire Théatrale* and *The Drama Review*.

CHRISTIE CARSON has a Ph.D. from the University of Glasgow and is currently Research Fellow at the Department of Drama and Media Arts at the Royal Holloway University of London. She has published numerous articles in *New Theater Quarterly* and the *Canadian Theater Review* and is presently working on a production history of *King Lear* for Cambridge University Press.

PIET DEFRAEYE teaches Modern Drama and Theater History at St. Thomas University, New Brunswick. His work has focused on gender studies, dramatic theory, and performance and he has published among others articles on Howard Brenton and Michel Marc Bouchard. He is currently engaged in research for a book on the "Theater of Shock."

JOSEPH I. DONOHOE JR. holds a Doctorate from Princeton University and is at present Professor of Romance Languages at Michigan State University. Professor Donohoe has authored a number of books and articles on French and Quebec theater and film. His most recent book is *Essays on Modern Quebec Theater* (1995) and he is currently working on a study of post World War II theater in Quebec.

HENRY A. GARRITY holds a Ph.D. from Yale University and is Chair of the Department of Romance Languages at Bowling Green University. He is also Director of the annual Toledo Film Festival. He has written extensively on theater and film and is presently studying the political references in the late theater of Pierre Corneille.

JENNIFER HARVIE has a Ph.D. from the University of Glasgow and is a Lecturer in the Drama Department at Goldsmiths College of the University of London. Her research centers on performance, interculturalism, and identity politics. She has contributed a number of articles to *Theater Research in Canada* on the theater of Michel Tremblay and on dialogism in contemporary Canadian theater.

MICHAEL HOOD is Dean of the College of Art at Indiana University of Pennsylvania. Professor Hood is an eminent scholar and practitioner of theater with scores of papers and articles on *mise-en-scène,* and hundreds of credits relating to the staging of theater, radio, and television productions in a myriad of venues across the globe. He is, in addition, an internationally recognized expert in the staging of combat scenes with edged weapons.

SHAWN HUFFMAN teaches Québécois literature in the Department of Foreign Languages and Literatures at the State University of New York-Plattsburgh. He has published a variety of articles that have appeared principally in *Protée, Theatre Research in Canada* and *RS/SI*.

JANE KOUSTAS holds a Doctorate from Queen's University and is at present Professor of French at Brock University (Ontario). She has published a series of articles pertaining to translation theory and practice in *Traduction, Terminologie et Rédaction* and in the *University of*

Toronto Quarterly. Her current research focuses on the theory and practice of theatrical translation.

DENIS SALTER teaches Theater Studies at McGill University. He has published widely in books and journals on Canadian Theater, Post-colonial Theories of Performance (especially in connection with Shakespeare), and Victorian Stage History. He is currently working on a research project examining problematic key words in Canadian Theater Historiography

WILLMAR SAUTER is Professor of Theater Studies and Dean of Humanities at the University of Stockholm. He has written on theatrical reception processes (*Teaterögen,* 1986 and *Braaavo!,* 1987), Swedish Theater History, Strindberg's "Intimate Theater," and the theater and politics of the late 1930s (*Theater als Widerstand,* 1979). His work on the theories of the theatrical event are summarized in a recent book on performance analysis (*Understanding Theater,* 1995).

SHERRY SIMON is Professor in the *Département d'études françaises* at Concordia University, Montreal. Professor Simon has authored a number of books and articles on the interplay of culture and translation. Her most recent books include: *Culture in Transit: Essays on Translating Quebec Literature* and *Gender in Translation. Cultural Identity and the Politics of Transmission.*

GUY TEISSIER is Professor Emeritus of the Comparative Literature Institute of François Rabelais University, Tours. Professor Teissier has published a critical edition of Giraudoux and collaborated on the first two volumes of the Pléiade edition of the same author. Co-director of the *Cahiers Jean Giraudoux,* he has taught classes on European, North African, and *québécois* theater.

269